GREEK
FROM THE BENAKI MUSEUM IN ATHENS
TREASURES

Edited by Electra Georgoula

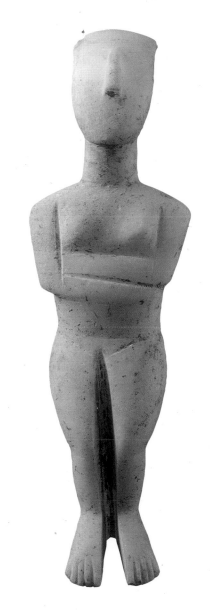

ph|m powerhouse publishing
part of the Powerhouse Museum

in association with

BENAKI MUSEUM

Front cover image: Ivy wreath,
1st century BC, from Macedonia(?)
(see cat no. 45)
Back cover images (left to right):
Female figurine-pendant, Middle/Late
Neolithic period (5800–4500 BC),
perhaps from the Peloponnese (see
cat no. 4); Appliqué ornament, 5th c.,
probably from Syria (see cat no. 77);
Fragments of a painted chest, 18th c.,
from Mytilene (see cat no. 130)

First published in 2005

Powerhouse Publishing, Sydney
PO Box K346 Haymarket NSW 1238 Australia
www.powerhousemuseum.com/publications
Powerhouse Publishing is part of the Museum of Applied Arts and Sciences,
a statutory authority of, and principally funded by, the NSW state government.

in association with

Benaki Museum, Athens
1, Koumbari Street 106 74 Athens Greece
www.benaki.gr

National Library of Australia CIP
Greek treasures from the Benaki Museum in Athens
Bibliography.
ISBN 1 86317 113 4
1. Mouseio Benaki - Exhibitions. 2. Greece - Antiquities -
Exhibitions. I. Georgoula, Electra. II. Powerhouse
Museum. III. Title.
709.38

Design: 2birds, Sydney, Australia
Translations: Alexandra Doumas (Athens)
Text editing: Electra Georgoula (Benaki Museum) and Anne Savage (Sydney)
Project management: Electra Georgoula (Benaki Museum) and Julie Donaldson
with Nicole Bearman (Powerhouse Museum)
Additional image scanning: Spitting Image
Printing: BPA Books Pty Ltd, Victoria
Distributed in Australia and New Zealand by Bookwise International
Distributed in other territories by Lund Humphries part of Ashgate Publishing, London
This book has been published in conjunction with the exhibition *Greek treasures from the Benaki Museum
in Athens* jointly organised by the Powerhouse Museum (Sydney), Museum Victoria (Melbourne) and the
Benaki Museum (Athens).

Supported by Consulate-General of Greece, Sydney

National partner

CONTENTS

FOREWORDS

There are many reasons for cultural interaction between Greece and Australia, not least among which is the warm collaboration between two museums in 2004, when Sydney's Powerhouse Museum and Melbourne's Museum Victoria, with the beneficial mediation of the Cultural Olympiad, presented in the new multiplex centre of the Benaki Museum in Athens, the remarkable exhibition entitled *Our place: Indigenous Australia now*, awakening the Athenian public's awareness to one of the most sensational chapters in the story of humankind. This had been preceded, of course, four years earlier by the official Greek participation in the celebration of the Sydney Olympic Games and the exhibition *1000 years of the Olympic Games: treasures of ancient Greece*, which widened the channels of communication and reduced the radius of distance, thanks to another seminally important chapter in the same story. The contents of the exhibition with which the Benaki Museum amicably reciprocates are scattered elements from corresponding pages of the same human story, which are composed to narrate an equally fascinating adventure: human resilience in the geographically limited space of Greece, as well as to the fluctuations of a vast time, but mainly the creativity with which he dynamically transmuted the effects of not always propitious historical circumstances.

However, those who are involved in the international coordination of cultural events know full well that the laurels for bringing these to fruition are not due to impersonal services but personal efforts of those who believe in the one and only language of understanding, the language of history and culture. It is to them that I address my thanks for what they have achieved and my wishes for new initiatives and prospects. On the Greek side, to the colleagues in the Benaki Museum, Stavros Vlizos, Electra Georgoula and all the authors of this catalogue. On the Australian side: to the hospitable Powerhouse Museum in Sydney, the President of its Board Nicholas Pappas, the Director Kevin Fewster and its personnel; to Museum Victoria in Melbourne, to the Director Patrick Greene and his colleagues; and to the Western Australian Maritime Museum in Fremantle. Above all, however, I address them to friends old and new who welcome us wholeheartedly, in the certainty that the fertile dialogue which has already begun will not cease.

Prof Angelos Delivorrias
Director of the Benaki Museum

Greek treasures: from the Benaki Museum in Athens is another success in what is now a long and fruitful relationship with the cultural institutions of Greece, and most notably the Benaki Museum. The basis of this relationship is the close political and social ties between Australia and Greece, thanks in large part to Australia's sizable Greek-Australian population, with Greek the second most-spoken language in Australia.

I first discussed the possibility of an exhibition from the Benaki Museum with its renowned director, Professor Angelos Delivorrias in 2001 when negotiations were progressing on the Australian Indigenous exhibition *Our place* for its display in the new Benaki Museum complex as part of the Cultural Olympiad of the Athens 2004 Olympics, and was in response to an idea suggested by the Premier of NSW Mr Bob Carr stated at the opening of *1000 years of the Olympic Games: treasures of ancient Greece*. This exhibition of magnificent sports-themed antiquities was the Hellenic Republic's ground-breaking gift to Sydney for this city's own Olympics in 2000. That exhibition's beginnings in the mid 1990s marks this year as a decade of fruitful Greek collaboration.

The magnificent breadth of time, media and geography that is represented in the Benaki Museum collection has been excellently represented in this expertly chosen selection by Professor Delivorrias and his staff. The exhibition is further enhanced by this catalogue which, in addition to the objects, includes four essays that bring together the massive span of eight millennia seen in this collection. It is the opportunity to observe the development and creativity of a nation over such an immense period of time that makes this exhibition and its catalogue unique.

I would like to sincerely thank Prof Delivorrias and his staff for sharing their collection and admirable expertise. I would also like to recognise the involvement of the other Australian institutions to which the exhibition is travelling: the Immigration Museum (a branch of Museum Victoria) in Melbourne and the West Australian Maritime Museum in Fremantle whose staff have shown great enthusiasm and commitment to the exhibition. Special thanks to the President of the Powerhouse Museum Trust, Nicholas G Pappas, Dr Patrick Greene, Director of Museum Victoria, Mr Iaonnise Raptakis, the Consul-General of Greece in Sydney and the National Australia Bank for their essential support for this project. My thanks also to the staff of the Powerhouse Museum who have been involved in this project, especially Jennifer Sanders, Brad Baker, Julie Donaldson, Paul Donnelly and Tara Kita who I know, have enjoyed this opportunity to demonstrate their great admiration for Greek history, art, and culture.

Dr Kevin Fewster AM
Director, Powerhouse Museum

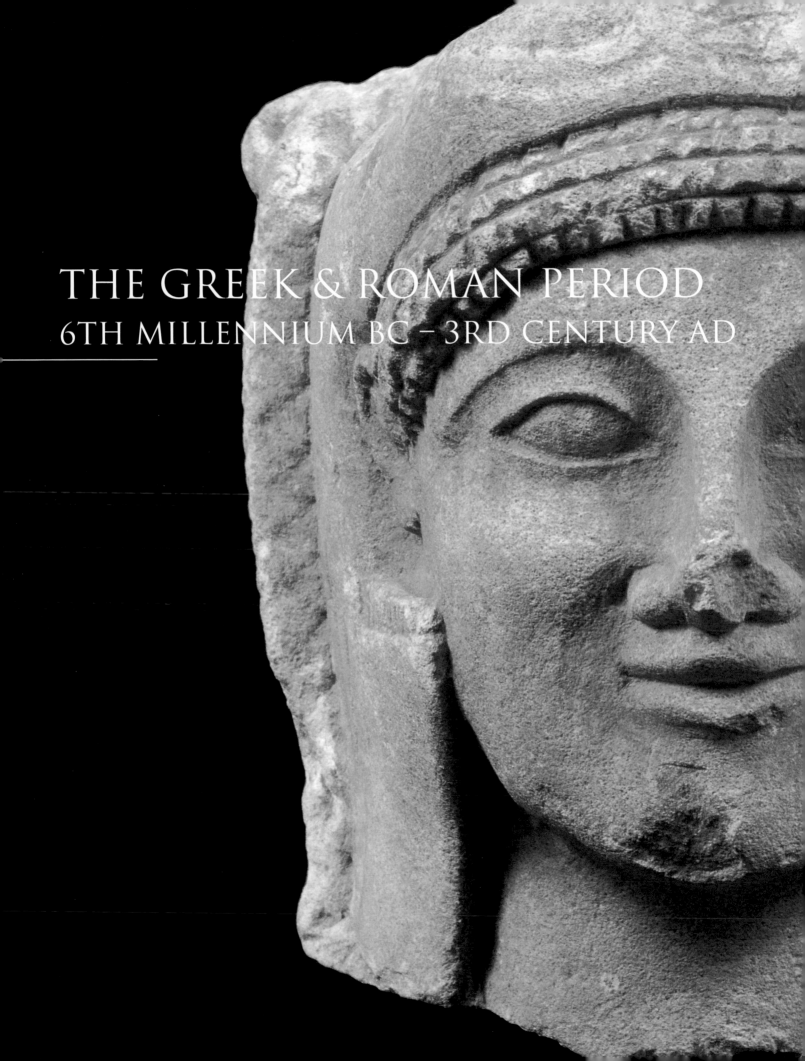

THE GREEK & ROMAN PERIOD
6TH MILLENNIUM BC – 3RD CENTURY AD

TRAVELLING IN GREEK ANTIQUITY WITH MAN AS PYXIS

Irini Papageorgiou

The Palaeolithic universe, in which man was both victimiser and victim of the ecosystem for a long period (1,000,000-10,000 BC), was to change dramatically with the transition of the economy from the hunter-gatherer-foraging stage to the agricultural-animal husbandry-food producing stage. This was essentially the greatest 'revolution' the human race has experienced, possibly a consequence of the climatic changes during the tenth millennium BC in conjunction with the 'impasses' into which the nomadic way of life had led. This radical transformation came gradually and through experimental processes that still elude us. Nonetheless, the birth of Neolithic Culture in Greece is dated around 7000 BC and its cradle was the region of the Middle East, from where it diffused throughout the eastern Mediterranean basin, to Crete, the islands of the Aegean Sea, the Balkan Peninsula and Italy. Man created permanent dwellings close to water, systematically cultivated cereals and pulses, and domesticated the animals essential for farming and stock-raising.

In Greece, Neolithic communities were created from the Ionian Islands to the far reaches of the Aegean and from Macedonia and Thrace to Crete. Between these developed, through land and sea routes, a complex system of trade and transactions of products. Two highly important 'metropolitan' settlements in these networks were those at Sesklo and Dimini in Thessaly.

Using stone, flint and Melian obsidian, Neolithic man made more composite types of tools, which served the farming economy (cat nos 5, 6). The need for storing the produce of his own labour led him to fashion the first vases, mostly of clay and more rarely of stone (cat nos 1, 2, 3). On the surface of his clay vessels he experimented with colours, reproducing flowing forms and geometric shapes, images of his conversation with the environment.

His efforts to understand and to be initiated in the mystery of life are imprinted on objects alluding to the symbolic sphere, among which are figurines (cat no. 4). The dominance of the female figure, with emphasis on those anatomical features associated with maternity, should be correlated with the necessity of reproduction and consequently of the survival of the community. As excavation data reveal, figurines of clay, stone and marble were associated with domestic rites concerning the transmission of knowledge, initiation or magic and not necessarily with some cultic rite. Religious consciousness is still a matter for speculation, although the fact that man buried his dead with great care, and furnished them with grave goods, points to a belief in the continuity of life after death.

The dynamic presence of bronze in the later fourth millennium BC – the provenance of which is still an open question – ushered in the Early Bronze Age (3200-2000 BC) throughout the Aegean. The use of metals – silver, lead and gold in addition to bronze – brought the development of trade and seafaring, the intensification of transactions and exchanges, and consequently shifted the centre of activity to the coastal sites and the Aegean islands. In this period, four distinct cultures, with strong relations between them, developed in the Aegean region: the Early Helladic in the southernmost part of the Greek mainland, the Early Minoan in Crete, the Early Cycladic in the islands of the central Aegean (cat nos 8-11), and the Trojan in the northeast Aegean and the opposite coast of Asia Minor, with overt influences from neighbouring Anatolia (cat no. 7). Man in the third millennium BC, farmer, trader and craftsman, processed raw materials to manufacture goods, acquired technical specialisations and accumulated knowledge and wealth. The division of labour and the necessary concentration of people in settlements with access to resources led to the emergence of the first 'urban' centres, with a 'town plan' and an organisation orientated towards the needs of the community. Defensive walls were frequently raised around these proto-urban centres, in response to the disturbances that broke in the Aegean, perhaps due to population movements. The inhabitants of Early Bronze Age Greece embarked on long voyages, exploiting the sea currents and observing the heavenly phenomena, forming in embryo the principles of astronomy and meteorology. Interwoven with this empiricism is the suspected transition from the magical symbolism of Neolithic times to the elaboration of specific religious beliefs. Cycladic marble figurines (cat no. 11), whose morphology continues the Neolithic tradition, reveal an anthropomorphic conception of cosmic powers of creation and regeneration.

'AND HEAR THIS TOO. ON THE MOON
THE STATUES SOMETIMES BEND LIKE THE REED
AMIDST LIVING FRUITS – THE STATUES;
AND THE FLAME BECOMES REFRESHING RHODODENDRON,
THE FLAME THAT BURNS IN MAN, I MEAN.'
G. SEFERIS, *THRUSH* II, V. 12-16

The zenith which art achieved in the Early Bronze Age receded in the late third and the early second millennium BC, due to important economic or social changes which earlier scholars linked with the descent from the north of the Indo-European tribe of the Proto-Hellenes. The inhabitants of mainland Greece in the Middle Bronze Age (*c.* 2000-1600 BC) lived in settlements of rural character, in a state of poverty and social insecurity. The paucity of raw materials in this period, the reduction in maritime trade, the simpler social organisation and the struggle for survival were not conducive to the creation of high art. The systematic use of the potter's wheel and the creation of new vase shapes are perhaps the sole achievements of the Middle Helladic spirit, the discipline and the geometric conception of which were henceforth stable components of Greek art.

In contrast to the situation in mainland Greece, in the early second millennium BC the first palaces appeared on Crete, in already existing cities, first at Knossos, later at Phaistos, Malia and Zakros, and the first high civilisation on European soil began to take shape. The Minoans – a term coined by the imaginative excavator of Knossos, Sir Arthur Evans – reaping the benefits from the fertile soil of Crete, articulated their life around the palaces, which were the commercial, agricultural and redistribution centres of extensive regions. And when these palaces were destroyed by earthquake around 1700 BC they were rebuilt, more splendid, and Crete entered the most glorious phase of the Minoan civilisation. Outcome

of the thriving economy and the need for an accounting system to keep track of the movement of goods was the use of script for the first time in Europe. At first with pictograms, later with hieroglyphs and finally with syllabograms (Linear A), the Cretans brought the Aegean into the world of literate peoples. The art of the period not only emanated from the palaces but also served them, as agent of both the political and the religious ideology of the supreme sovereign, at once king and high priest. Refined customs of daily life, harmonisation with the rhythms of nature and familiarity with the watery element all coexist in Minoan art. The Minoans were dominant in the sea surrounding them and even further afield, imposing the so-called *Pax Minoica*, with the help of a mighty fleet. As 'rulers of the seas' they founded trading stations or 'Minoanising' settlements in the Aegean islands and intensified their commercial dealings, with an international ambit for the time, in the eastern Mediterranean and Egypt. Religion was predominant in all aspects of human life, closely interwoven with nature and the seasons of the year. The Minoans worshipped the Nature Goddess in all her various qualities, as a familiar and humanised deity within their home, on the peaks of mountains or in the depths of caves, continuing a tradition going back thousands of years.

Minoan civilisation held a powerful and extremely beneficial attraction for the Greek mainland. With the Peloponnese as epicentre, the Mycenaean civilisation (cat nos 13-17) was formed at the beginning of the Late Bronze Age (1600-1050 BC),

as direct continuation of the 'provincial' Middle Helladic Culture. A new ruling class of warriors emerged from the rustic Middle Helladic society, accruing wealth – by means unknown to us – and imposing its presence by founding the institution of kingship upon a strong ideological substrate, that of the heroised past. In order to use art as a medium of propaganda, the Mycenaean rulers soon turned to flourishing Crete, inviting artists from there to settle on the mainland. From the Minoan world the Mycenaeans adopted whatever was not contrary to their traditions: the organisation of trade, the administrative system with the interdependent relations of priesthood and political authority, the manner of dress, the ceremonial of worship and, to a lesser degree, the religious beliefs. When they settled in Crete, around 1450 BC, ousting the Minoans from the entire Aegean region, the Mycenaeans adapted the Minoan Linear A script to their own language, an early form of Greek, creating Linear B. The Mycenaean texts reveal that the Helladic religion was a mixture of Minoan Nature worship and earlier elements, and record for the first time the Indo-European names of several of the gods of the dodecatheon of Classical times, who dwelt on Mount Olympos, at the northernmost edge of the Mycenaean world. The building of impressive palaces with monumental fortification walls, during the fourteenth century BC, marked the beginning of the 'golden age' of Mycenaean civilisation. Throughout this century and the next, Greece presented a common cultural identity, and a standardised thematic

repertoire. In these years *emporia* (trading stations) and more permanent settlements were founded in the eastern Mediterranean, while their quest for raw materials led the Mycenaeans as far as southern Italy, Sicily and the Euxine Pontus (mod. Black Sea). Into the major Mycenaean kingdoms was woven the web of the mythological cycles which essentially negotiate the prevailing of the logical human element in the illogical, and were narrated in the art of later centuries.

In the late thirteenth century BC the raids of the 'Sea Peoples' (tribes living in the littoral zones of the eastern Mediterranean) brought the decline of Mycenaean civilisation. Sometime between 1220 and 1200 BC, the search for resources led the Achaeans, united for the last time, in the campaign against Troy. The almost simultaneous destruction of the palaces around 1200 BC and the consequent population movements to safer homelands, as well as the settlement in Greece, in the eleventh century BC, of the Dorians – a Hellenic tribe which brought with it the knowledge of iron-working – marked the end of the Bronze Age.

Greece entered the period of the so-called 'Dark Age' (10th-9th c. BC). Despite the activation of sea routes from the tenth century BC onwards, the small urban centres were isolated. With the non-existence of script and figural art, the only means of keeping the glorious past alive in memory was oral tradition. The merging of the old Mycenaean populations with some of the newcomers and the consequent amalgamating of religious traditions

gradually shaped a common religious, ethnic and moral consciousness which was to play a decisive role in the historical course of Hellenism. In art, Mycenaean memories are latent, without ever being abandoned, as is apparent primarily in the new pottery style created in Athens *c.* 1000 BC, from the 'geometric' thematic repertoire of which the period from 1000 to 700 BC is named Geometric (cat nos 18-22).

Rapid demographic growth in the eighth century BC and the search for new resources propelled the citizens to intensive cultivation of the earth, to trade and, inevitably, to the founding of the first colonies in the eastern Mediterranean and, from 770 BC, in the western. The concept of the *polis* (city) entered the forestage of history, concurrently with the consolidation of the dominance of the *eupatrides*, archons from leading lineages with large land ownership. Then the Greeks, with their religious beliefs crystallised, built the first temples and founded major sanctuaries, some with local (Athens, Samos, Eretria) and others with panhellenic (Olympia, Delphi, Dodone) appeal, where they most probably worshipped members of the Olympian pantheon. At Olympia, the first quinquennial Olympic Games were celebrated in 776 BC. The regaining of script, forgotten for centuries, in 750 BC, and the creation of the Greek alphabet from the Phoenician are perhaps related to the composition of the epics in the latter years of the eighth century BC by Homer, from Asia Minor. These texts refer to the heroic past, using a fusion of anachronistic

details deposited in the collective memory through centuries of oral tradition. The inhabitants of Geometric Greece put down roots into their past, strengthening it with the glorifying power of myth, as the entry of the human figure into the Geometric pictorial repertoire denotes. In pottery and in metalwork (cat no. 21), which served both utilitarian and cultic needs, the human figure is rendered abstractly, given that what was important for the artist was not the essence but the structuring of the figure.

The beginning of the seventh century BC coincided with the dawn of the Archaic period, which lasted until the end of the sixth century BC. The colonising expansion of the Greeks in the Mediterranean reached its climax from 600 to 500 BC, when the Hellenic world radiated from the Euxine Pontus to the Atlantic Ocean, radically rearticulating economic, political and cultural life. The rapid growth of trade, shipping and manufacturing was intensified by the invention of coinage, which was adopted in mainland Greece in the late seventh century BC, while the increasing economic prosperity is reflected in the gold *ex-votos* in the major sanctuaries of the period. The creation of a strong middle class and its struggles for a more active participation in public affairs led frequently to bloody clashes with the noble aristocrats. Timocratic regimes, in which income underpinned the rise to power, were established from when the Athenian lawgiver Solon instituted the written recording of legislation after 594 BC.

In the so-called Orientalising art of the seventh century BC, the Geometric tradition was enriched with subjects from the mysterious world of the East, which were assimilated creatively. The birth of the black-figure style in Corinth (cat no. 24) and its adoption by the Attic workshops *c.* 630 BC permitted the narration of myth. Attic vases (cat nos 25-27), which conquered the markets of the age, today offer the fullest exposition of Greek mythology. Myth should be sought in the first attempts at monumental sculpture in Crete, which were to remain pinned down in a two-dimensional frontality. During the Archaic period the Geometric *polis* was transformed into the city-state with a consolidated consciousness of common origin, language and customs. Gods and heroes constitute the cohesive warp of the institutions through which man conquers his relationship with the divine, promotes the value of personal initiative, enhancing individualism to a right and freedom to a bounty.

By the sixth century BC, in the flourishing Ionian cities of Asia Minor the natural philosophers systematised ideas on man's place in the cosmos, laying the foundations of critical thought, while poetry was transformed from 'a gift of the Muses' into a medium of political expression; in the lines of the lyric poets Archilochos and Alkaios and the poetess Sappho, the individual is elevated to a political being with its own share of responsibility for demanding liberty and justice.

In sculpture, the spirit of mobility released the human figure from the static poses rooted in the Orientalising style as well as in Egyptian tradition, known to the Greeks after their settlement in the land of the Nile in the second half of the seventh century BC. Under this influence and the anthropocentric worldview, the first monumental sculptures were created in Greece, carved in island or Attic marble. The dominant types were the *kouros*, the statue of the nude male, and the *kore*, the statue of the clothed female, both intended for funerary as well as votive use. These are youths and maidens of the aristocratic classes, who are represented in their prime in a way that enhances male virtue and valour, female modesty and grace. Many of the works of sculpture and pottery of the period bear the signatures of their artists, who thus claim proudly the paternity of their creation, at the same time pointing to a firmly formed consciousness of individuality and personality. Trust in man and the rational approach to the cosmos are perhaps the most important achievements of Archaic civilisation, since these lasted unchanged until the prevailing of Christianity, constituting one of the basic poles of the contradiction which Western civilisation experiences today.

However, it is to the 'Classical Miracle', which took place in Athens during the fifth century BC, that the Western world owes the most: 'Classical' because it is identified with universal values and perfection, 'Miracle' because, in the course of just one generation, art conquered planes of unrivalled expressive fullness and unique intellectual impact. Many were the factors responsible for this phenomenon.

The reforms of Kleisthenes (507 BC) established the first democratic processes in the social system of Athens, instituting the *demos* (citizens' body) as an autonomous political entity and thus preparing the way for the founding of participatory democracy. But it was the resounding victories of the Greeks in the Persian Wars (490-479 BC), in which Athens played a leading role, which set their seal on the transition from the Archaic to the Classical period, ushering in the Golden Age for the city. Athens was enhanced as an economic and cultural centre, with a consolidated democratic regime. Having survived the danger of absorption into the vast Persian Empire, the Greeks, fully aware of the value of their freedom, confronted the moral order governing the universe. They consequently invented the concept of *hubris* as overstepping human measure and so incurring divine wrath and justice.

In order to protect themselves against the Persian threat, the Ionian Greeks united in the First Athenian League (478/7 BC), rallying around the 'authority' of a single city, which was gradually to acquire the dimensions of a hegemony, especially after the treasury of the alliance was transferred from Delos to Athens in 454 BC. The reforms of Pericles (451/0 BC) created a new order in which the dominance of the *demos*, the election of the archons by lot and their duty to give account of themselves made the citizen participant in the decision-making process and the management of the affairs of his city. The Greeks conquered self-knowledge, illuminating man's relationship with the world around him and with himself.

This is apparent first and foremost in Classical art, which left its indelible imprint for future generations by defining the multidimensional content and the ingenious coalescing of opposites. The tranquillity of Classical figures is not due to the absence of internal conflicts but to the harmonious coupling of *ethos* and *pathos*, of youthful prime with temperate maturity, and to the reciprocal relationship between structural stability and refined nobility, between form and content. Undoubted pinnacle of this art is the architectural creation of the Parthenon and its sculpted decoration (447-432 BC), in which harmony coexists with rhythm and the divine is interwoven with the human element, defining man as constant measure of the values of this civilisation. In sculpture the bodies move freely in space, shifting their centre of gravity and turning the head to one side. The athletes of Polykleitos and the monumental creations of Pheidias impose with their superb symmetry and serene majesty. The same spirit is expressed by vase-painters with the expressive potential of the red-figure style, an Athenian invention of the years around 530 BC. On their vases of exquisite quality, heroes of myth and legend parade alongside ordinary mortals in diverse scenes from daily life, which should not be read as conventional renderings of reality but as idealised representations of an imaginary world (cat nos 34, 36, 38).

Man and his eternal existentialist angst formed the subject of the tragic poetry of Aeschylus, Sophocles and Euripides,

the acerbic criticism of the comedies of Aristophanes, and the philosophical meditation of the Sophists, of Demokritos, Anaxagoras and Socrates. Awareness of the past culminated in the historical consciousness of the works by Herodotus and Thucydides, the latter chronicling the Peloponnesian War (431-404 BC) as the dramatic climax of the expansionist designs of Athenian policy. The defeat of the democracy of Athens by the oligarchy of Sparta and the maelstrom of the war-torn years affected not only Athenian society but also, inevitably, art. The world of harmony began to crack, as *pathos* became ascendant over *ethos*.

By the fourth century BC, Athens and Sparta had lost their status as protagonists. The Persian Empire – after its contribution to Sparta's victory in the Peloponnesian War – secured its political influence in Greek affairs and the rest of the city-states were embroiled in local conflicts. The consequent destabilisation of political life facilitated the rise of the Macedonians under King Philip II who, after the conquest of the cities of southern Greece (338 BC), finally brought peace. In the course of this transitional period, the Greeks once again resorted to their past and turned towards exploring human experience (cat nos 31, 39-41). Personal passion was to be the elixir of art in the fourth century BC. A new generation of renowned sculptors capitalised on the achievements of the fifth century BC, at the same time honing their own sensitivity and shaping the new artistic trends. In the divine figures by Praxiteles and in the statues by Skopas, the bringing

down to earth of earlier ideals is annealed with the struggle between what 'is' and what 'appears to be'. Art imprints the new ideals which, in the domain of philosophical meditation, led to the transcendental interpretation of the basic concepts of life, as formulated in Plato's Theory of Ideas, while, combined with empirical observation, they set the bases of scientific research in the work of Aristotle.

These processes portend what was to follow. Alexander the Great ascended to the Macedonian throne in 336 BC, uniting the cities of the Greek mainland in a panhellenic campaign against the Persians. The gradual break-up of the Persian Empire, the conquest of all lands as far as the African deserts in the south and the rivers Jaxartes and Indus in the east, the founding of new Greek cities and the transplanting of Greek culture to the outermost margins of the then-known world, signalled the beginning of a new era: that which became known as Hellenistic and is conventionally confined between 323 BC, the year of Alexander's death in Babylon, and 31 BC, the year when Augustus came to power in Rome (cat nos 42-49).

During this period the Hellenic world widened its frontiers, from the western Mediterranean to the borders of India, and from the Crimea as far as the fringes of the Sahara Desert. The division of this vast empire into kingdoms, outcome of the conflicts which broke out between the successors to Alexander the Great, did not inhibit the creation of a common

cultural expression (*koiné*) throughout the Mediterranean, overt in art as well as in language. The Greeks, enjoying cosmopolitan freedoms, coexisted with the local populations in Pergamon, Antioch and Alexandria – to mention just the most important political and cultural centres of the age. Influences between the Greek and local cultures were reciprocal, and the Greeks came to acknowledge in foreign gods the archetypal qualities of their own deities and to embrace them, either by assimilating them with members of the Olympic pantheon or by merging the old tradition with the new in what is known as 'religious syncretism'. The regime of monarchy, which the Macedonians imposed, inevitably diminished citizens' involvement in community affairs. The creation of a wealthy urban aristocracy enhanced personal gain as a new social value. Monarchical ideology sought after luxury (cat nos 45-49) – the East, after all, generously provided gold and precious materials – and man, having lost the balance of self-sufficiency, was coerced into a never-ending struggle with his environment. Hellenistic art transmutes the complete liberation of feelings with the rendering of expressionistically contorted bodies, and the shift towards individualism with the realism of the portrait. Artists represented aged flesh or persons on the fringes of society, subjects that would have been unthinkable in the idealised sphere of the Classical period. The same tendency turns satire into grotesque, with the caricaturing of human characters in New Comedy, on which later European theatre was to draw.

The cultural pluralism of the Hellenistic period was heightened by the appearance of the Romans in Greek lands from the late third century BC. The subjugation of Macedonia in 168 BC and destruction of Corinth in 146 BC brought political freedom in Greece to an end. The annexation of Asia was followed by the declaration of Egypt as part of the Roman state, after the naval battle of Actium in 31 BC. For over four centuries Graeco-Roman civilisation, with its strong bases in the Hellenistic past grafted onto Roman tradition, was established in Europe from the Atlantic Ocean to the rivers Rhine and Danube, in Africa to the fringes of the Sahara Desert, and in Asia from the Caucasus Mountains to the Red Sea and the River Euphrates. Greek intellectual and artistic creation survived in a wondrous manner within this amalgam of different cultural traditions, religious systems and social structures, in which men and gods, products and ideas circulated freely (cat nos 50-59).

Roman emperors, firstly Augustus (31 BC-AD 14) but mainly Hadrian (AD 117-138), admired the illustrious cities of mainland Greece (Athens, Sparta and Corinth) and Asia Minor (Miletos, Ephesos), which they supported with monetary gifts and ambitious building programmes. In the climate of the *Pax Romana*, in the first and second centuries AD, there was a burgeoning of the arts in general.

However, the centre of the ancient world had now shifted to Rome, where men of letters and artists from Greece gravitated, disseminating Greek education and establishing knowledge of the Greek language as an insignium of intellectual prowess. Rome was adorned with statues – mostly of bronze – looted from Classical Greece, and Roman artists so appreciated Greek sculpture that they copied the originals extensively in marble (cat no 50). Indeed, it is thanks to them that the mostly lost Greek creations of the fifth and fourth centuries BC are known today. Noteworthy too are the authentic achievements of Roman art, among which are the perfection of the portrait and the birth of the historical relief, irrefutable documentations of imperial ideology and propaganda.

The era of zenith was followed by a period of crisis, in the third century AD. The territorial and economic integrity of the *imperium* was put in jeopardy by enemy incursions and civil strife. The division of the immense state into four realms in AD 293, known as the Tetrarchy, and the transfer of the capital to Constantinople in AD 330, signalled the birth of a new age.

Throughout this period the Roman world, continuing a tendency apparent from Hellenistic times, turned increasingly towards eastern mystery and monotheistic cults, to be conquered finally by Christianity, the promises of which are illumined by the belief in the salvation of the soul. ■

ILLUSTRATIONS

Basin

Cat no. 1
Middle Neolithic period
(5800–5300 BC)
From Thessaly, find-spot
unknown
Clay, restorations in plaster,
handmade, painted
7.9 (h) x 18 (rim diam) x 9
(base diam) cm
On permanent loan from the
Larisa Archaeological Museum

The basin has been restored
from a shard of the body and
rim. It has a flat base, flaring
walls and slightly everted rim.
The decoration is painted in red.
On the outside, a band encircles
the rim, while a denticulated
zone with parallel bands is
placed obliquely on the body.
On the inside are three groups
of concentric arcs, pendent
from the rim.

This is an example of one of
the most representative classes
of painted pottery encountered
in Thessaly during the period of
the Sesklo Culture, so named
after the important prehistoric,
fortified and admirably organised
settlement of the Middle Neolithic
period in Central Greece. The
subjects of flame-pattern or
'Tsangli-type' decoration, which
hark back to the rhythmical
movement of the zigzag, are
strongly reminiscent of weaving
patterns or embroidery motifs,
which they perhaps imitate.
The spare and limited thematic
repertoire, the harmonious
relationship between the
decorated surface and the shape
of the vase, and the balanced
ratio between pattern and field
are general characteristics of the
Sesklo Culture decoration.

Neolithic pottery epitomises the
new relationship established
between man and his environment.
The food-producing economy of
the Neolithic Age was based on
the domestication of animals,
the cultivation of plants and the
creation of permanent settlements,
with which pottery production
was closely associated.

Specifically, during the five
hundred years of the Middle
Neolithic period – according
to the conventional division of
the Neolithic Age – vase-making
attained a high artistic level. It is
thus probable that the clay vessels
of this particular phase were
made by specialist craftspeople.
Moreover, the observed regularity
of their production presupposes
the existence of well-organised
workshop units. It is also possible
that the best-quality pottery
travelled large distances, in the
context of the wider network
of exchanges and trade between
Neolithic communities. This
perhaps explains the similarities
in shape and decoration between
contemporary vases from
Thessaly and others found
at sites in Macedonia, as well
as in the Balkans. IP

Unpublished. For the pottery type
and decoration cf Theocharis 1973,
fig 31; *Neolithic Culture in Greece*
1996, 256–257, no 105 (V Rondiri).

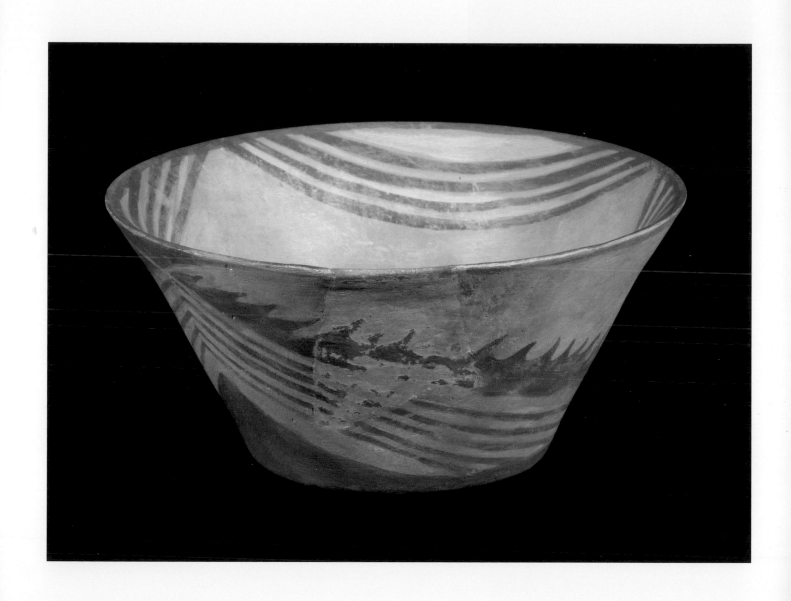

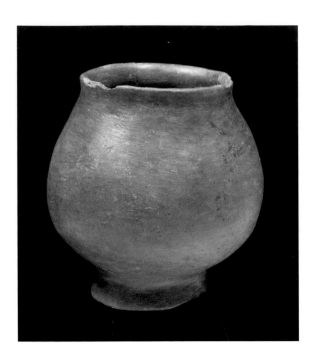

Bell-shaped cup

Cat no. 2
Middle Neolithic period
(5800–5300 BC)
From Thessaly, find-spot
unknown
Clay, brown with inclusions,
handmade
9.5 (h) x 7.2 (rim diam) x
5.7 (base diam) cm
Inv. no. 32605

The cup is intact. There are chips on the rim and the perimeter of the base and two cracks from the rim to mid-body. The cup has a ring base, an everted rim and walls of S-shaped profile. The outside, superbly burnished, is coated with brown slip, brownish black in places due to firing conditions.

Neolithic potters selected suitable clays, which they prepared accordingly, in order to ensure that the items they produced, all handmade, had the desired qualities for their intended use. For example, the presence of specific inclusions in the clay can increase significantly a pot's resistance to very high temperatures, a property extremely useful for vessels to be used on a fire. The next step after preparing the clay was the shaping of the vase, which was done without mechanical assistance, since the potter's wheel was not introduced to Greece until after the Early Bronze Age. The Neolithic vase was built up from several coils or slabs of clay and then formed to the desired shape by paring the surface inside and outside, and thinning the walls.

The surface was often coated with slip, a fine layer of diluted clay, usually of a different colour from the body. The next stage was the burnishing of the surface, a mechanical process, with the aid of a smooth, hard object – a pebble or even an obsidian blade core could be used. Sometimes the vessel was decorated with painted motifs, for which pigments of exceptionally fine clays, rich in iron or manganese oxides, were used and, finally, it was fired. The presence or absence of oxygen during firing, which laboratory analyses have demonstrated took place at a temperature of 850-900°C, determined the colour of the final product.

It is clear from this that the manufacture of a vase demanded knowledge, experience and certainly considerable time, which facts justify the role of pottery in the network of exchanges and relations between Neolithic communities. IP

Unpublished. For the pottery type see: Mottier 1981, pl 37 no 8; Aslanis 1992, 85, pls 13A no 7, 13B no 2, 26 no 5.

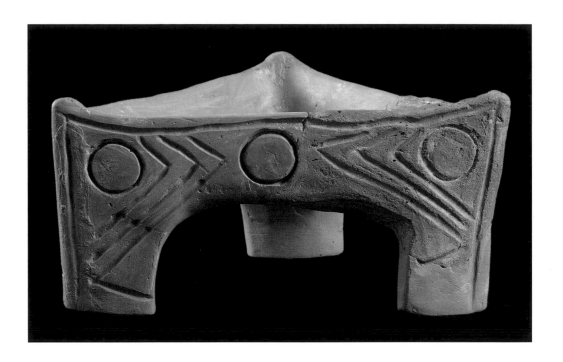

Miniature tripod table

Cat no. 3
Middle Neolithic period
(5800–5300 BC)
From Arkadiko, near Drama,
Macedonia
Clay, restorations in plaster,
handmade, incised
7 (h) x 14.5 (max l of side) cm
On permanent loan from the
Kavala Archaeological Museum

The tripod table has been
restored from a fragment of the
body, which includes parts of
the sides joined at an acute angle
and a leg. The incised decoration
on both sides consists of circles,
in one case enclosed by multiple
chevrons and in the other by
multiple arcs. Preserved in the
incisions are traces of the white
paste with which they were
initially filled.

Miniature tripod tables represent
one of the most distinctive shapes
in pottery of eastern Macedonia
during the Middle Neolithic
period, which displays close
affinities with the pottery of
Aegean Thrace and southeastern
Bulgaria. The geographical
division of Macedonia in three
parts – western, central and
eastern – largely determined
the development of cultural
relations and interactions with
the Neolithic communities of
the Balkan north and the
Thessalian south, the Aegean
and the Near East.

It has been argued that vessels of
this class were intended perhaps
for ritual use. However, this
particular piece comes from the
Neolithic settlement at Arkadiko,
near Drama, where almost all
the fragments of tripod tables
have been found inside buildings.
It seems more likely that they
were associated with domestic
activities, perhaps used to carry
kindling, rather than with cultic
rites, particularly since in the
Neolithic Age religious structures
as encountered in the succeeding
Bronze Age had not been
consolidated. IP

Published: Delivorrias, Fotopoulos
1997, 48, fig 49. For typological
parallels see: Touloumis, Peristeri
1991, 361–362, fig 3; Aslanis 1992,
402, pls 62 no 6, 65 no 13.

Female figurine-pendant

Cat no. 4
Middle/Late Neolithic period
(5800–4500 BC)
Perhaps from the Peloponnese
Marble, white and fine-grained,
possibly Lakonian
4.9 (max pres h) x 2.5 (max w) cm
Gift of Elizabeth French in
memory of her father
Alan J B Wace (31350)

The object is preserved in very good condition, with only the legs missing from below the knees. The figurine, with violin-shaped outline, represents a sitting female figure with the arms joined just below the bosom. The head or face is denoted in a totally abstract manner by a deep notch at the top of the long, columnar neck. The abdomen is modelled naturalistically, with a breast-like protuberance. The legs, separated by a deep groove, had crossed calves directed sideways. A suspension hole at the back of the figurine, at the level of the abdomen, indicates its use as a pendant.

The figurine displays a striking typological affinity to marble and stone female figurines from Aegina and the Peloponnese.

However, only two of these examples represent a sitting figure and were also used as pendants. They were found at Malthi and at Mycenae, in the Peloponnese, in excavation contexts dated to the second millennium BC, considerably later than the period in which it is supposed they were made. Thus it seems that they were either in continuous use for an extremely long time span or abandoned and brought to light and reused perhaps thousands of years later. The same is probably true in the case of the Benaki Museum figurine, as inferred by the smoothing, due to wear, of the fracture surfaces immediately below the knees.

The total nudity and the exaggeration of the lower body displayed by the three female figures cited, as well as their obvious ornamental function, would certainly have been alien to those who discovered them in the second millennium BC – when it is assumed that they were brought again to light – and who possibly attributed them with magical properties, perhaps relating to cult practices of the time. The representation of the human body, primarily the female, or parts of it, in Neolithic ornaments was undoubtedly associated directly with the magical and religious beliefs of the social groups which used such objects. Ornaments of this kind, with overt amuletic/apotropaic character rooted in the sphere of magical symbolism, were perhaps bearers of supernatural powers. At the same time, charged with the knowledge, beliefs and practices of the community, they epitomised its social and ideological identity to such a degree that they were recognisable ciphers between its members. In particular, ornaments representing the female body, directly linked with fertility, life and death, may have been magic charms owned by women who wanted to conceive, or even instruments in the process of initiation into reproduction. IP

Published: Wace 1949, 423–426, pl 64; Papageorgiou 2002, 9–18; *Mouseio Benaki – Glyptiki* 2004, 24–26, no 2 (I Papageorgiou).

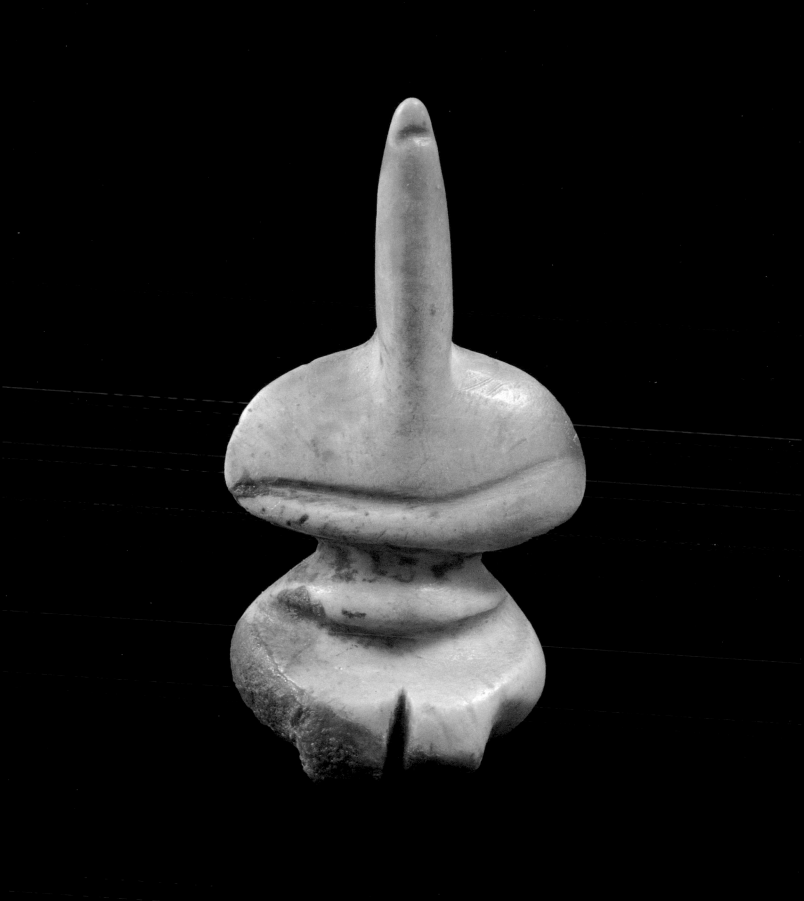

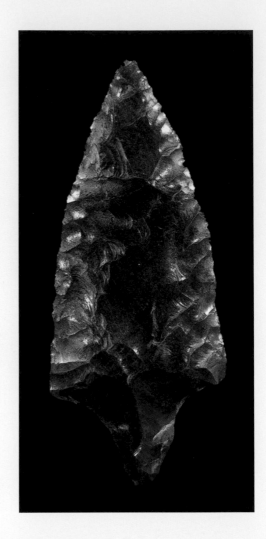

Triangular tanged arrow-head

Cat no. 5
Final Neolithic period
(4500–3200 BC)
Provenance unknown
Obsidian
6.8 (l) x 2.75 (max w) cm
Gift of Nikos Hadjikyriakos-Ghika
(32518)

Arrow-heads, most of them fashioned from obsidian, appear in the Aegean region at the beginning of the Late Neolithic period (5300-4500 BC) and are the earliest incontrovertible proof of the use of the bow. They are common finds in Neolithic settlements, mainly in southern Greece and the Cyclades.

Obsidian, a black glassy stone of volcanic origin, was used for making tools throughout the Neolithic and the Bronze Age in the Aegean, with the principal source of production and distribution the Cycladic island of Melos. Melian obsidian circulated in the Aegean from early times, as is confirmed by finds from Franchthi Cave in the Argolid, in the Peloponnese, where small quantities of obsidian tools were found in Mesolithic levels (10 000-8000 BC). However, the spread of the use of obsidian can be documented from the late seventh millennium BC onwards, that is, when the first Neolithic settlements were established, and took off after the mid-fifth millennium BC, when the Cyclades were first inhabited permanently. Then the radius of distribution exceeded 200-300 km from Melos and reached northward as far as central Macedonia. With regard to the mechanisms of circulation over such large distances for the period, it has been argued that during the early phases of the Neolithic Age small teams of specialist craftspeople had direct access to the source of obsidian, where the material was quarried and knapped. After the mid-fifth millennium BC, however, when means of sea transport improved, it is reasonable to suppose the active participation of the Cycladic islanders in trafficking obsidian to such distant regions. IP

Published: Delivorrias, Fotopoulos 1997, 44, fig 40. For parallels see: Evans, Renfrew 1968, 49–58, figs 16, 62 nos 3–5, pl 37a; Cherry, Torrence 1984, 15, fig 1b; *Neolithic Culture in Greece* 1996, 226, no 37g (G Papathanassopoulos).

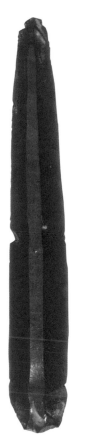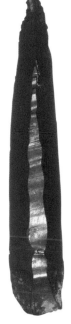

Two blades and a blade core

Cat no. 6
Early Bronze Age (3200–2000 BC)
Provenance unknown
Obsidian
(left to right) blade 10.8 (l) cm,
7828a; blade 8.4 (l) cm, 7828b;
core 6.5 (l) cm
Gift of Rena Andreadi (32515)

The blades are characteristic of the Early Bronze Age. Though little different from those of the Late Neolithic period, they are nevertheless less wide and less thick, with narrower facets and clearly defined tectonic parts.

A blade was fashioned by first removing the cortex (weathered surface) from a lump of obsidian and then producing the tool by pressure-flaking and appropriate retouching. The core is the final, redundant part of the raw material remaining after the production of a number of blades and could be used in a second stage for other tasks, such as burnishing or smoothing. It is easy to 'read' on a core the negative imprints of the blades knapped from it.

Whereas during the final phases of the Neolithic Age the percentage of obsidian tools increased significantly, the development of metallurgy during the Bronze Age tended to displace them. They continued in use even to the end of the Late Bronze Age, however, though in appreciably reduced numbers.

Among the commonest obsidian tools, blades were used as razors, knives and so on, as well as grave goods. Indeed, in poorer burials they are the sole offering to the deceased. Some of them were made specifically for this purpose and bear no traces of use. In the sepulchral deposition of blades a symbolic dimension should perhaps also be sought for the raw material, particularly when the find-spot is at a great distance from the source of the stone. IP

Unpublished. For the technology see: Cherry, Torrence 1984, 12–24; *Neolithic Culture in Greece* 1996, 103–106 (A Moundrea-Agrafioti). For the symbolic dimension of obsidian in the Near East see: Cauvin 1998, 379–382.

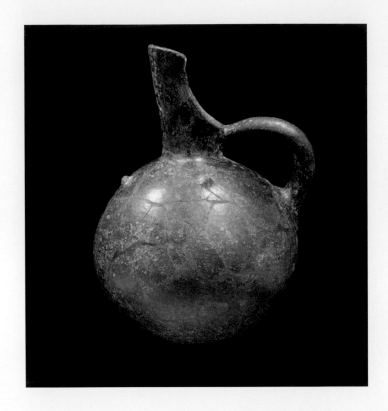

Globular jug with cut-away spout

Cat no. 7
Troy I–II (*c.* mid-3rd millennium BC)
From the area of Troy
Clay, handmade, fine polished
24.5 (h) cm
Gift of Helen Naoum-Garezou in
memory of Georgios and Kyriaki
Naoum (39292)

The jug is mended from many
shards and is partially restored,
mainly on the body and the base.
It has a globular body and
rounded base, a short, cylindrical
neck and a long, wide, cut-away
spout placed vertically on the
body. Three plastic, breast-like
protuberances decorate the
shoulder. The outside is black –
grey in places due to firing
conditions – and highly burnished.

The jug belongs to the class of
Fine Polished Ware with black
or grey, well-burnished surface.
The short neck assigns it to
a rather rare type which is

encountered in western Asia
Minor during the first half of
the third millennium BC. Exact
parallels for the Benaki Museum
vase have been found in the
Yortan cemetery at Mysia,
a site southeast of the Troas.
A few examples of a variation
of the type, but with the same
morphological traits, occur in the
first city of Troy, at Iasos in Karia
in southwest Asia Minor, and at
some sites in the northern
Aegean islands opposite the Asia
Minor littoral (Thermi on Lesbos
and Emporio on Chios).

It is apparent from the above that
the indicated provenance of the
Benaki Museum vase is valid.
Troy, on the hill of Hisarlik in
northwest Turkey, at the entrance
to the Dardanelles (anc. Hellespont),
is one of the oldest and best-
known archaeological sites in
the world. In this area, which
was inhabited continuously from
the early third millennium BC

into Late Roman times, nine
successive cities were built. The
vase is dated to the transition
period from the first to the
second city (ie *c.* 2500 BC).

Excavations have shown in fact
that already from the mid-third
millennium BC Troy, thanks
to its important position at the
crossroads of maritime and
overland routes linking southeast
Europe with the East and the
Aegean with the Black Sea
(anc. Euxine Pontus), as well
as to the existence of abundant
metal ore deposits, was an
important trading station.
Consequently the city developed
into a centre of accumulation
of wealth, which had a catalytic
effect on its subsequent course.
Its geographically strategic
location in conjunction with
the possibility of access to raw
materials must have been the
causative factors of the Trojan
War, waged in the latter years

of the thirteenth and the
beginning of the twelfth century
BC, a time of generalised
political insecurity and economic
instability in the Aegean. IP

Unpublished. Cf parallels from Yortan:
Bittel 1934, pl III no 1; from Troy:
Blegen 1950, 67 B15, figs 223a, 227;
from Iasos: Pecorella 1984, 49–50,
fig 3 nos 22–24, pl 4 nos 204–205;
from Chios: Hood 1981, 390, fig 176
nos 1160–1162, pls 67, 68; and from
Lesbos: Lamb 1936, fig 26A nos 3–4,
fig 28B no 1, pl VIII nos 14, 69, 163,
pl XII nos 203, 252.

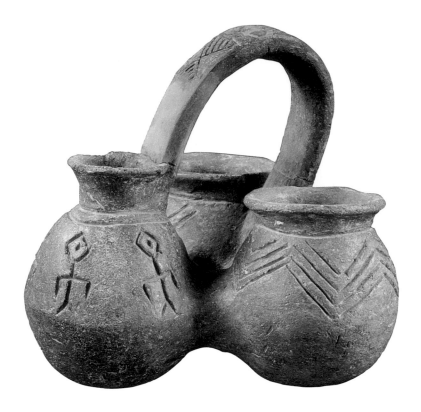

Composite vessel

Cat no. 8
Early Cycladic III period
(2300–2000 BC)
From the Cyclades, perhaps
from Phylakopi on Melos
Clay, grey with inclusions,
handmade, incised
13 (h) x 3.5–5.4 (rim diam) cm
Gift of Peggy Zoumboulaki in
memory of her husband Tasos
(30908)

The composite clay vessel, known also as a *kernos*, is formed from three individual vases joined together in a triangular arrangement at about mid-body. Two vases are pyxis-shaped, with flat base, almost globular body, rudimentary neck and slightly everted rim. The third is taller, has a flat base, piriform body and relatively high neck ending in a mouth with everted rim. A strap handle, the greater part of which is now restored, arises from the piriform vase and ends at the point of union of the two pyxis-shaped vases. The handle slopes

slightly backwards, which suggests that the piriform vase was used as a jug for pouring liquids. The entire vessel has a burnished surface.

The special use of the vessel is perhaps emphasised also by the unusual decoration of the piriform vase with four incised, highly schematic human figures. The head is denoted by a dotted lozenge and the body by a vertical line which is intersected by a horizontal line for the arms and has oblique lines indicating the legs. The decoration on the two pyxis-shaped vases is simpler, consisting of a system of successive zigzags. The preserved part of the handle is covered with incised hatched triangles.

Composite clay vessels are encountered in Crete and in the Cyclades during the Early Bronze Age. Whereas in Crete they belong mainly to pottery styles with painted decoration, in the Cyclades a preference for dark-ground incised ware is observed.

The Benaki Museum example represents this latter tendency, which is perhaps related to an imitation of stone models. This particular pottery style survives in the Cyclades throughout the Early Bronze Age and, specifically at Phylakopi on Melos, it appears also on novel shapes. The Benaki Museum vessel is also a novel shape, for although the types of the piriform jug and the globular pyxis-shaped vase occur in the Cyclades, their combination is without precedent in Greece.

The Benaki Museum kernos is unique, to date, in terms of its decoration, given that the representation of the human body is extremely rare in the Early Bronze Age Aegean. Obviously, from its peculiar shape, this vessel did not serve everyday needs. The two pyxis-shaped vases were probably receptacles for some solid precious material, unguents or pigments, while the third was most probably

intended for liquid content. Given that the Cycladic islanders used pigments for cosmetic and, primarily, religious reasons, and that the stone vases for preparing pigments come almost exclusively from cemeteries, it can be argued quite convincingly that the Benaki Museum vessel was intended for ritual use. This view is supported in the best possible way by the choice of the human figure as a decorative motif. IP

Published: Delivorrias, Fotopoulos 1997, 48–49, fig 53; Mastrapas (in press). For the pottery style see: Barber 1984, 89–92; Betancourt 1985, 40–41; Barber 1987, 93–96. For the representation of human figure on Early Cycladic pottery see: Mastrapas 1991, 97–98, 137–138.

Footed cup

Cat no. 9
Early Cycladic II period
(2700–2300 BC)
Provenance unknown
Marble, white with ochre
encrustation
7.3 (h) x 11.4 (rim diam) x 4.9
(base diam) cm
Gift of Peggy Zoumboulaki in
memory of her husband Tasos
(30895)

Part of the rim is broken and mended. A small area of the body is restored. The *kylix* or footed cup has a conical body with incurving walls, endowing the vessel with an almost undulating profile; the trumpet-shaped foot has a slightly hollow base. There is extensive grey shading on the inside of the walls and considerable traces of a dark substance are preserved. This extremely elegant type of marble vase, of masterly simplicity,

appears in the Cyclades in the advanced phase of the Early Cycladic Culture.

The invention of new types in Cycladic stone-carving of this period is probably related to the development and widespread application of metal-working, which supplied the craftsperson with more durable tools. The Early Cycladic II period is in any case the time when stone-carving attained its zenith, since in the succeeding phase the fashioning of stone vessels virtually ceased.

Cycladic stone vessels, the majority carved in white island marble, available in abundance on most of the islands in the Archipelago, have almost all been found in cemeteries. The absence of traces of use on most of these is further strong evidence of their intended mortuary character. In some cases, of course, erosion of the work surface and repairs

made in antiquity indicate clearly their previous use by the living.

It is very unlikely that vases of this type served everyday needs, and they are counted among those intended exclusively for funerary use. Their shape, ideal for drinking vessels – it is from this that they were named, by analogy with the clay kylix of historical times – is possibly associated with Cycladic islanders' beliefs about the afterlife. Equally possible, however, is their use in specific funerary rites, perhaps involving the offering of libations. IP

Published: Getz-Gentle 1996, 165, 294, no L33, pl 100d; Delivorrias, Fotopoulos 1997, 57, fig 65. For parallels see: *Art and Culture of the Cyclades* 1977, 322, 506–507, nos 315–316 (P Getz-Preziosi); *Silent Witnesses* 2002, 62, no 14. For Early Cycladic vessels of this type see Getz-Gentle, *op cit*, 164–167, pls 91d, 98–101.

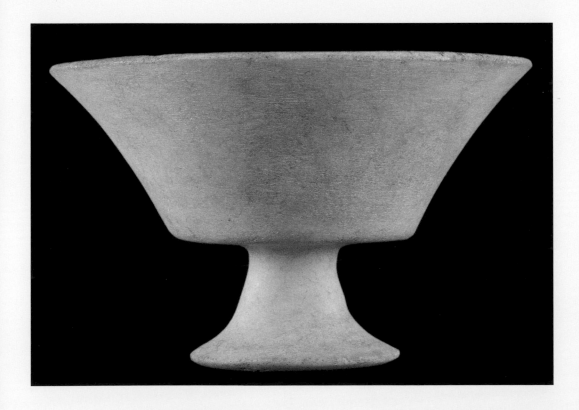

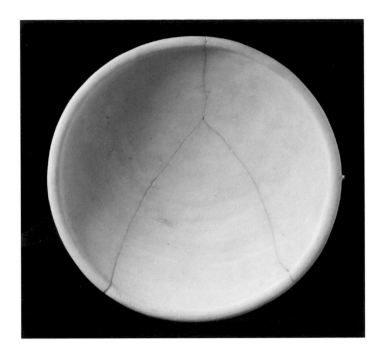

Bowl

Cat no. 10
Early Cycladic II period
(2700–2300 BC)
Provenance unknown
Marble, white with grey veins
3.5 (h) x 17.2 (rim diam) cm
Gift of Peggy Zoumboulaki in
memory of her husband Tasos
(30905)

The bowl is mended from three fragments. The body is shallow, almost hemispherical, the rim is defined inside by a shallow groove and the base is dimpled. This is an example of the commonest type in the Cycladic repertoire of stone vases.

Most Cycladic bowls are found in graves. This does not preclude their use by the living, as suggested by the erosion on the work surface of some of them or the traces of repairs made in antiquity. It is noteworthy that they usually preserve remnants – and sometimes appreciable quantities – of red pigment inside, on the basis of which they have been interpreted as pigment containers or vessels intended for processing and preparing pigment. Given that in some cases they are found together with stone tools suitable for crushing/grinding, it has been argued that they were used mainly as mortars or grinders for pulverising pigments. When the inside of the bowl is covered with red up to the rim, it is reasonable to assume that they were painted, perhaps because in this way they gave symbolically the illusion that they were filled with pigment.

Red is the most frequently occurring colour on Early Cycladic vessels and figurines. According to technical analyses to date, in the majority of cases this is from the mineral cinnabar (mercuric sulphide), from which vermilion is produced, and which is not native to the Aegean region but is found in Spain, the Balkans and Asia Minor. Less common sources of red are the iron oxides (haematite) found in various regions of Greece.

The red pigment covering the inside of marble vases found in graves is perhaps associated with the renascent symbolism of this particular colour and consequently with burial habits or mortuary beliefs. In fact, excavation data confirm that marble vessels and figurines to which pigments have been applied, or objects associated with the preparation of pigments, accompany rich burials and are therefore counted among the status symbols of the early island societies. IP

Unpublished. For parallels see: *Art and Culture in the Cyclades* 1977, 319, 503–504, nos 300–303 (P Getz-Preziosi); *Cycladic Art* 1983, 79, no 51, 82, no 59, 89, no 73, 98, no 93, 102, no 103. For Cycladic bowls see Getz-Gentle 1996, 99–105, pls 50–55. For the use of pigment on Cycladic marble vases and figurines see Birtacha 2003, 263–276.

Female figurine
Fitzwilliam Master

Cat no. 11
Early Cycladic II period
(*c.* 2700–2300 BC)
Provenance unknown
Marble, white, fine-grained,
translucent, painted
20.7 (h) x 5.9 (w of shoulders) cm
Gift of Christos Bastis (32530)

The object is an example of the canonical or 'folded-arm' figurine which is exclusive to the mature phase of the Early Cycladic period and enjoyed wide dissemination in the Aegean region. The stylistic traits securely identify it as an early Spedos variety (*c.* 2600-2500 BC), a class of Early Cycladic figurines named after an important cemetery in the locality of Spedos on Naxos. In addition to its alluring vitality and rhythmical movement, this particular sculpture is of especial interest because of the preservation, albeit patchy, of pigments on the surface of the marble. Most of the figurines of this type bear traces of painted decoration, which usually picked out

anatomical details. Thus it is surmised that their original aspect was somewhat different from the abstract simplicity they display today.

On the Benaki Museum figurine, red pigment emphasises the anatomical features in the area of the neck and face. On the forehead and the lower part of the face are traces and ghosts of red dots. Discernible on the temples are vertical wavy lines. On the back of the head, at about the height of the eyes, is a small red circle, a motif observed here for the first time. Equally rare is the indication of the mouth, which was originally painted in red. The grey shading in the area of the eyes is all that remains of the black pigment used to denote the eyes and the eyebrows. The traces of colour on the forehead appear to belong to a double row of dots, most probably representing a metal diadem. If this is the case, the wavy lines on the temples could be plausibly interpreted as decorative elements pendent from the diadem, and the red

circle on the back of the head as a head ornament. Perhaps, however, they relate to tattooing or to face-painting of the participants in the burial, or even of the deceased, in the context of some funerary ritual, as may also be the case with the random dots on the lower part of the face. Laboratory examination has demonstrated that the red pigment is from cinnabar (mercuric sulphide), a material imported to the Aegean and therefore precious. Charged perhaps with a specific magical/ symbolic potency, this mineral is known in the ancient sources primarily because of the vivid red (vermilion) produced from it.

Of unknown provenance, the Benaki Museum figurine has been ascribed to the same Cycladic sculptor as apparently carved three other figurines of the same variety. One of these pieces, reputedly found in Amorgos, is now kept in the Fitzwilliam Museum, Cambridge, and the anonymous artist who created it is known in the international bibliography

by the conventional name Fitzwilliam Master.

Clear as the stylistic approach to a Cycladic figurine may be, the question of its use remains open. Given that most of the figurines from systematic excavations have been recovered from graves, the interpretations proposed at various times tend more to deciphering their mortuary use, without ruling out the fact that the overwhelming majority represent female figures. Thus they have been considered as figures in the service of the dead, leaders of souls, protective spirits, toys, effigies of ancestors, nymphs, heroes, adorants or even deities, principally the Mother Goddess of fertility, as mistress of birth and of death. IP

Published: *Collection of Christos Bastis* 1987, 116–117, no 48, figs 48a–48b (P Getz-Preziosi); Papageorgiou 1996, 29–34; Delivorrias, Fotopoulos 1997, 54–55, figs 59–61; *Mouseio Benaki – Glyptiki* 2004, 27–33, no 3 (I Papageorgiou).

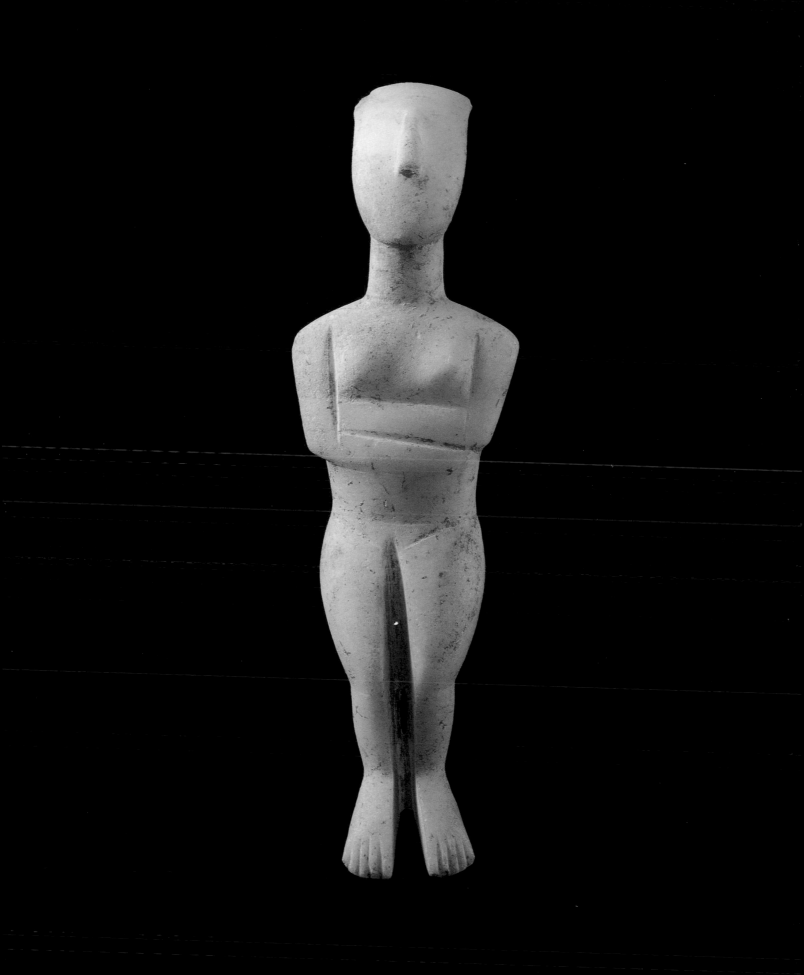

Tulip-shaped bowl

Cat no. 12
Early Bronze Age I–II
(2300–2100 BC)
From Cyprus
Clay, handmade,
red-polished, incised
Gift of Tatiana and Roger Milliex
(30854)

The bowl is handmade, typical of the pottery of Cyprus until the Late Bronze Age II (1450–1050 BC), when the potter's wheel was adopted on the island. The tulip-shaped body with rounded base is provided with two everted lugs as handles, opposite each other on the rim.

Both inner and outer surfaces are coated with highly burnished red slip. The variegated colour is due to experimentation during the firing process, which most probably involved immersing the lower part of the pot in sand to protect it from the blackening caused by the reducing conditions in the kiln. The bichrome effect on the surface is enhanced by the rich incised decoration, which is developed in three horizontal zones encircling the body and consists of contiguous chevrons, parallel lines and hatched geometric motifs. The incisions, possibly made with a pointed tool of bone or wood, are filled with white paste to create a contrast with the red background of the surface of the bowl and to bring out the patterns.

The bowl is an example of Red Polished Ware, the principal kind of pottery produced on Cyprus during the Early Bronze Age until the beginning of the Middle Bronze Age (2300–1800 BC). Tulip-shaped bowls constitute a well-known type of Red Polished I–II ware which was produced on Cyprus during the Early Bronze Age I–II (2300–2100 BC) and, according to recent excavation data, may have appeared for the first time in the north of the island.

The fact that most of our information on this period comes from cemeteries, since there are very few excavated settlements (eg Sotira-Kaminoudia, Marki-Alonia), makes it difficult to interpret the use of these bowls. Judging by their shape, they were probably used for carrying liquids, while their round base indicates they were set in hollows in the floor of the house. In many cases the decoration is completed by appliqué elements in relief or in the round, such as horned animals, which perhaps endowed the vessels with a ritual character or were indicative of a thriving economy. NM

Unpublished. For typological parallels cf *SCE* IV:1A, fig CXXXIV no 8; Stewart 1999, fig 21 no 4, pl XVIII no 4. For Cypriot Red Polished Ware see: Herscher 2003, 145–204.

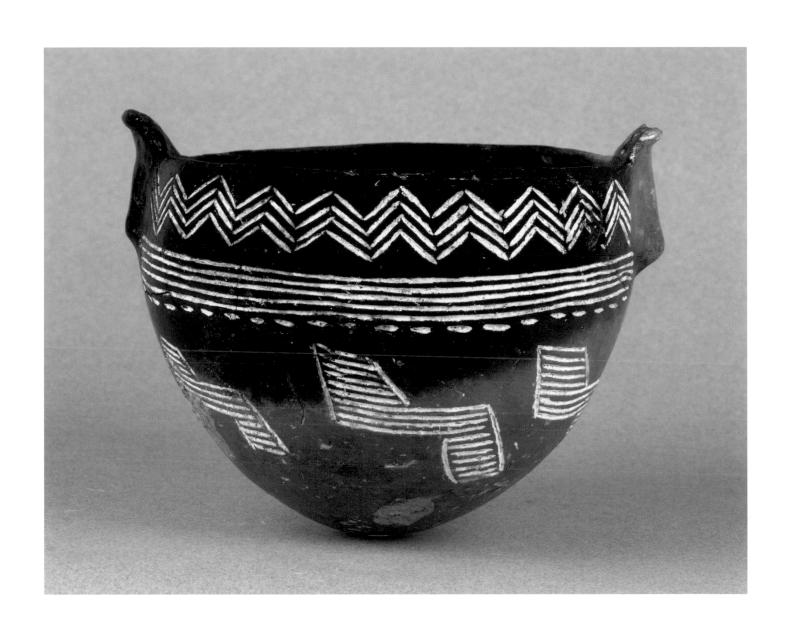

Beak-spouted jug

Cat no. 13
Late Helladic IIIA 1 period
(1400–1350 BC)
Perhaps from Attica
Clay, wheel-made, painted
23.2 (h) x 6.6 (base diam) cm
Bequest of Penelope Vlangali
(32535)

The jug is intact. It has a flat base, an ovoid body and a high neck of concave profile ending in a beak-shaped spout. Encircling the base of the neck is a modelled ring, marking it off from the body. A central rib runs down the back of the vertical strap handle. The jug bears painted decoration in brown, turning to brownish red in places due to firing. The beak-shaped spout is decorated with transverse lines and the neck with parallel bands. At the base of the neck is a wavy line, and below the handle, on the body, is a tassel. On the light ground of the belly are three stylised argonauts (*nautili*) with curtailed body and spiral tentacles.

The lower body of the jug is defined by two monochrome zones.

This outstanding example of the mature phase of Mycenaean pottery presumably imitates a metal prototype. The clarity of form, the careful design and the free rendering of the decorative subject on the light ground contribute to a pleasing aesthetic impression. The argonaut motif, deriving from the marine world and rendering the nautilus (a mollusc), appears in vase-painting in the Late Helladic IIIA 1 period, that is, the late fifteenth and the first half of the fourteenth century BC, in highly schematic form.

Schematisation and standardisation of decorative subjects, as well as homogeneity, are characteristic of pottery and art in general in this period, during which the heyday of Mycenaean Civilisation commences, its expansion dependent most obviously on the achievement of political unity with Mycenae as centre.

This phenomenon is in tandem with the now well-embedded common artistic language (*koiné*) which spread throughout the Greek mainland, the Aegean Islands, Crete and Cyprus. In many cases the prevailing uniformity makes it difficult to identify the local workshop, even though some regions, such as Crete, maintained a certain originality of artistic expression.

The beak-spouted jug in the Benaki Museum, with the distinctive nautilus motif, represents a pottery style of which examples are usually found in Attica. IP

Published: Delivorrias, Fotopoulos 1997, 60–61, fig 69. For the pottery type see: Mountjoy 1986, 59–61, fig 67 FS 144. For parallels see: Benzi 1975, 163–164, no 25, 185, no 80, 196, no 104, 251, no 245, 306, no 437, pls IV, XV; Mountjoy 1995, fig 40.

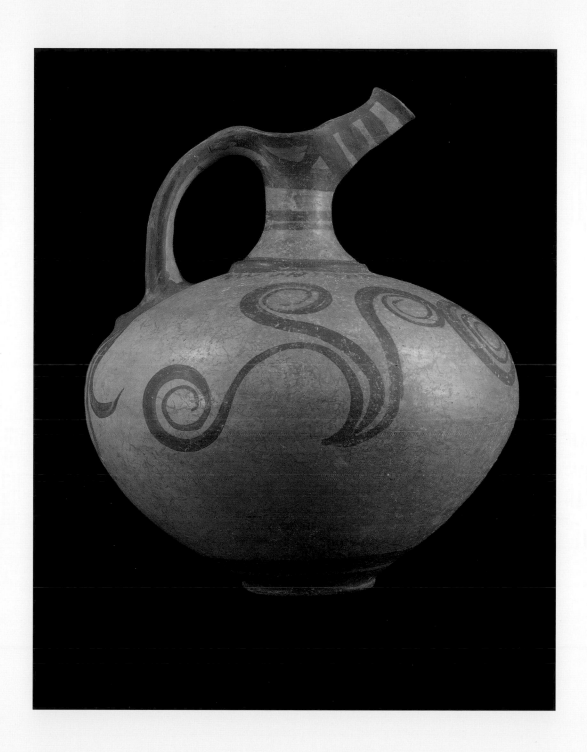

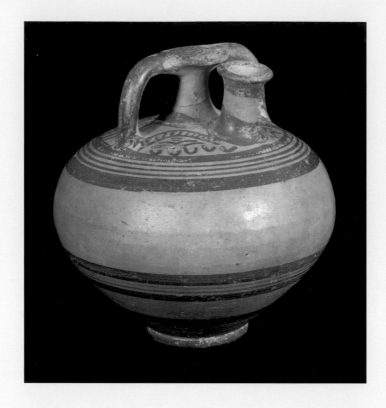

Stirrup jar

Cat no. 14
Late Helladic IIIA 2 period
(1350–1300 BC)
Provenance unknown
Clay, wheel-made, painted
13 (h) x 2.5 (rim diam) x 4.5
(base diam) cm
Gift of Maria Vellini-Koelling
(37644)

The false spout with the handles is mended. The paint is flaked locally. The stirrup jar has a ring base and globular body. The false spout has a narrow, solid neck of concave profile, which is defined at its base by a modelled ring and is covered by the horizontal disc of the handles. The functional spout is taller and terminates in an everted rim. The vase bears painted decoration in brown: systems of bands on the shoulder, the belly and the lower body, concentric circles on the disc of the handles and a zone with chevrons, multiple stem angles, U-pattern and hatched double arcs on the shoulder.

Stirrup jars, very common in the Late Bronze Age, were used primarily for olive oil and secondarily for wine. Provided with one solid (i.e. false) vertical spout and one functional one, obliquely set, they were suitable for transporting olive oil and aromatic oils. The narrow functional spout reduced the possibility of loss or spoilage of the valuable contents and when sealed by a lump of clay secured them for transportation.

In Linear B tablets from Pylos in the Peloponnese and Knossos on Crete, stirrup jars are listed in large quantities with the word *chlareis*, accompanied by the corresponding ideogram of the vessel. It is noteworthy that, according to Hesychios, the Alexandrian lexicographer of the fifth century AD, *chlaron* is a vessel for olive oil. Originating from Minoan Crete, this pottery type enjoyed wide distribution during Mycenaean times and was mass-produced – as evidenced by excavation finds and palace archives of Pylos and Knossos – becoming the 'hallmark' of the oil trade.

The trade in olive oil and perfumed oils was under royal palace control, as indicated by archaeological data, the reading of the tablets and the distribution of the product in markets both in the Aegean and abroad (Syro-Palestinian littoral, Cyprus, Egypt, South Italy, etc.). Most of the oil recorded in the palace archives was either aromatic or intended for the preparation of perfumes and unguents; oil, of course, was also used in tanning and weaving, carpentry and ivory carving, as well as for lighting. The frequently recorded consignments of oil to shrines and deities in all probability covered practical and cultic needs (performance of libations, perfuming of ritual or sacerdotal vestments, anointing, etc.).

Small stirrup jars were almost certainly used in the retail supply of small quantities of ordinary or aromatic oils, while the range of sizes of the larger ones points to the distribution of olive oil in differing quantities depending on its destination. Towards the end of the Late Bronze Age, the presence of small stirrup jars in graves attests to the use of olive oil or perfumed oil in funerary rites. IP

Unpublished. For the pottery type see: Haskell 1985, 221–229; Mountjoy 1986, 77–79, fig 93 FS 171. For the use of stirrup jars and oil in Mycenaean Greece see: Boulotis 1996, 19–58; Hadjisavvas 2003, 117–123; Palmer 2003, 127–128, 130–140.

One-handled kylix

Cat no. 15
Late Helladic IIB–IIIA 1 period
(late 15th *c.* BC)
Perhaps from Dendra in the
Argolid, Peloponnese
Gold, repoussé
10.5 (h) x 8.5 (rim diam) x 4.2
(base diam) cm
Inv. no. 2108

This precious vessel has a deep
hemispherical body, a horizontal,
flattened and everted rim, a high
cylindrical foot with disc base,
and one vertical strap-handle
from the rim to about mid-body.
The kylix is fashioned from two
hammered gold sheets, one for
the body and the other for the
foot. These parts must have been
joined by soldering, using either
gold or some other metal alloy.
The handle is made from a third
sheet and is attached to the vase
by three gold rivets. The back of
the handle is decorated down its
long axis by a row of repoussé
ivy leaves, as a kind of central rib.

The body of the vessel is also
decorated in repoussé: three
dogs are represented running
one behind the other, in 'flying
gallop', according to a well-
known Mycenaean iconographic
convention. Despite the highly
schematic depiction of the
animals, the scene emanates
an air of vitality, the indication
of anatomical details and the
backwards slant of the ears
enhancing the vigour of the
hounds in the chase.

The decoration of metal vases
in repoussé, the earliest and most
widespread technique in Aegean
metal-working, demands both
skill and experience. The
representation is first sketched
on the front of the vessel with a
pointed tool, the tracer. The vessel
is then placed on a bed of yielding
material and the design embossed
from the back, within the outlines,
using round-faced punches.
Details on the relief are finished
off from the front by chasing
with fine punches and chisels.

The provenance of the Benaki
Museum kylix is said to be Dendra,
one of the most important
Mycenaean centres in the
Argolid, where an extremely
rich cemetery was discovered.
The tombs at Dendra have
yielded some of the most
wonderful Mycenaean gold
vessels, the iconographic
repertoire of which displays
overt Minoan influences. All date
to the Late Helladic IIB–IIIA 1
period – around the end of the
fifteenth century BC – and are
distinguished by their refined
craftsmanship and high aesthetic
standards.

The ivy leaves decorating the
handle of the Benaki Museum
vase are a familiar motif from
Minoan Crete, where this plant
seems to have held religious
connotations. However, the main
representation on its body is
typical of the Helladic style.
It belongs to the class of scenes
rendering wild animals galloping,
that is, in contest. A gold cup of

different type, of the second half
of the sixteenth century BC, from
Mycenae, now in the National
Archaeological Museum in Athens,
is decorated with a scene of
running lions, a favourite subject
in Mycenaean art.

As most Helladic vessels in noble
metals are dated to the period
when Mycenaean Civilisation
was at its zenith, it is reasonable
to suggest that the Benaki
Museum kylix was made in the
late fifteenth century BC, if not
earlier. It must have been among
the valuable personal effects
of an eminent deceased which
accompanied him in his final
resting place as insignia of social
rank and status. IP

Published: Lemerle 1938, 448, pl
XLVII B; Brommer 1939, 226, fig 4;
I affineur 1977, 122, no 114, fig 44;
Delivorrias, Fotopoulos 1997, 63,
fig 74. For the gold vessels from
Dendra see: Davis 1977, 263–291,
figs 210–234.

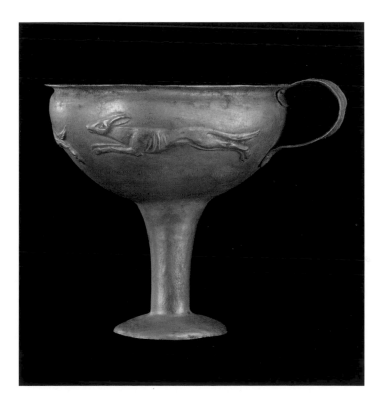

Two female figurines

Cat nos 16, 17
Late Helladic IIIA–B period
(14th–13th c. BC)
Provenance unknown
Clay, handmade, painted
(left to right) 11.5 (h) cm (35243);
14.6 (h) cm (39018)
Gift of Peggy Zoumboulaki
in memory of her husband
Tasos (35243)
Gift of George Mavroides (39018)

These Mycenaean female figurines represent the types Phi (Φ) and Psi (Ψ), named after the similarity of their outlines to the corresponding letters of the Greek alphabet. Each is mended from three fragments and restored in places. The face is bird-like, the torso flat with modelled breasts and the cylindrical lower part of the body terminates in a conical, hollow base. The hair, disc-shaped eyes and mouth are painted in dark brown, which is also used to emphasise the nose and to enhance the garment. The folds of the garment are indicated by parallel wavy lines on the chest and by three vertical bands on the cylindrical lower part of the body.

On the Phi-type figurine the arms, implied but not actually represented, unite at the level of the abdomen, giving the body a circular outline. The hair is drawn behind in an appliqué braid which, reaching down to the level of the hips, is denoted on the back of the body and decorated with horizontal hatching.

The female in the Psi-type figurine wears a headdress decorated on the circumference with oblique hatched lines, possibly a summary rendering of the hair. The wing-like edges of the torso are upraised, suggesting the arms in a pose of supplication or glorification. The relief, biconcave protrusion on the left side of the chest is most probably part of the body of an infant. Although the head and arms are missing, this 'child' possibly embraced its mother's shoulder and hung at her breast. If this interpretation is correct, we have here a rare representation of a mother and child (*kourotrophos*) in a Psi-type figurine, given that most comparable examples of this subject are encountered in the Phi type, in which the pose of the arms is more appropriate for holding a child.

Figurines in these categories occur throughout the Mycenaean world during the fourteenth and thirteenth centuries BC, and as excavation data indicate were mass-produced. Despite their pronounced schematisation, in many pieces obvious care has been taken in the modelling and the finishing process. Exclusive creations of Mycenaean civilisation, they were made by the hands of potters who in the same period and probably in the same workshops were producing vases in analogous styles.

Intended to function as overt symbols, these figurines are usually found in children's graves or in shrines. Research has been much preoccupied with their interpretation, which tends towards multiplicity of meanings in their use. Depending on their find-spot, the figurines might have represented deities, divine nursemaids or even children's toys, attendants and companions of the tender souls as they set off on their final journey. IP

Unpublished. For Mycenaean clay figurines of these types see: French 1971, 102–177. For an analogous example of a Psi-type kourotrophos figurine see: *In Pursuit of the Absolute* 1996, no 63.

35

Neck-handled amphora
Attic workshop

Cat no. 18
Middle Geometric II–Late
Geometric IA period (*c.* 760 BC)
Perhaps from Eleusis in
Attica or the area of the
Areopagos in Athens
Clay, wheel-made, painted
47.8 (h) x 19 (rim diam) x 14.5
(base diam) cm
Gift of Iro Ghiol (7704)

The vase is mended from many shards and restored on half the neck and the rim, one handle and part of the shoulder and the body. It has a conical ring foot, plump body, a short neck of concave profile flaring towards an everted, rounded rim, and strap handles from the shoulder to below the rim. It bears dark-ground decoration with panels on the neck, fine bands encircling the body and foot, and a reserved band with vertical bars on the rim. The shoulder and lower body are glazed. The decorative field on each side of the neck is divided into three panels: the central one is filled with a multiple M-pattern, while in the lateral ones are a hatched waterfowl facing inwards and schematic rosettes. The panels are defined at the sides by groups of three vertical lines, and above and below by parallel bands. On the back of the handles, within a panel framed above and below by bands, is a multi-petalled rosette.

The vase belongs to the rather rare class of balloon-shaped amphorae which appeared in about 760 BC and remained popular until the end of the eighth century BC. This date is indicated not only by the shape of the vessel but also by the style of decoration on the neck. Aquatic birds – single, confronted or aligned – first occur after the collapse of the Mycenaean civilisation, in Geometric vase-painting of the first half of the eighth century BC. In most cases it is impossible to identify the species because of the summary rendering of details and the use of the silhouette technique characteristic of Geometric pottery. The depiction of birds in antithetic arrangement flanking a decorative device is, of course, a Mycenaean legacy. It has been argued, with regard to the revival of elements of Mycenaean art in the Geometric thematic repertoire, that the re-use of an earlier iconographic subject is perhaps symptomatic of an orientation towards traditional values. The same can be maintained for the rosette, a familiar Mycenaean motif, which is associated with the rebirth of Nature and which is closely linked with waterfowl in Geometric vase-painting. The presence of the rosette, with its latent mortuary symbolism, underlines the semantics of the aquatic bird which, according to various views, should be connected with beliefs concerning the metamorphosis of the soul into a bird.

Thus the provenance of the Benaki Museum amphora from a funerary context seems possible. Indeed, this is almost certain if we take into account the type of vessel, which in Geometric times is normally associated with male burials as a cinerary urn (holding the ashes of the dead), and the alleged place of its discovery. Important burials of the Middle Geometric period have been excavated both in the environs of the Areopagos in Athens and at Eleusis in Attica. At both sites, cremation of the dead was practised. In view of the fact that the Areopagos cemetery was no longer in use at the time the vase was made, Eleusis is perhaps the more likely candidate. IP

Published: Delivorrias, Fotopoulos 1997, 72–73, fig 93. Cf parallels for the shape: Kübler 1954, pl 37 nos 3978, 3979, pl 38 nos 3968, 3375; Kourou 2002, 32–36, pls 25–29. For the Areopagos cemetery see: Smithson 1974, 325–390. For the Geometric burials in the west cemetery of Eleusis see: Mylonas 1975, 257–269.

High-rimmed bowl
Attic workshop

Cat no. 19
Late Geometric IB-IIA period
(745-730 BC)
Possibly from Attica
Clay, wheel-made, painted
10.4 (h) x 15.9 (rim diam) x 7
(base diam) cm
Inv. no. 7683

The high-rimmed bowl is
mended from several shards.
Painted on the high rim and the
body are linear motifs, hatched
inside and inscribed in square
panels: a swastika with four rows
of dots parallel to the arms, a
schematic quatrefoil rosette with
triangles in the interstices between
the petals, and a meander pattern.
The panels alternate with systems
of three vertical lines and, on the
rim, with systems of three vertical
zones, in the central one of which
is a checkerboard pattern and in
the lateral ones oblique parallel
lines. In the area below the
handles are aquatic birds and
on the lower body is a zone of
tangential blobs. The back of
the handles is decorated with a
row of dots. Inside the rim are
banded decoration and a zone
with systems of short vertical lines.

The Benaki Museum bowl
is a characteristic example of
Attic Late Geometric pottery,
distinguished by the triglyph-
and-metope style decoration in
an alternation of zones covering
the entire body. The vertical
division of the main field
into square panels and their
alternation with systems of three
vertical lines, reminiscent of the
metopes and triglyphs of a Doric

temple – after which this style
of decoration is named – is
concurrent with the use of a
continuous decorative web, which
does not occlude the underlying
shape of the vase. All these
characteristics, as well as the
linear motifs, the most popular
in the Late Geometric repertoire,
refer to a genuine Athenian style
of the third quarter of the eighth
century BC.

In this particular period Athens,
a city introverted in character,
maintained a network of contacts
with the eastern Mediterranean
and continued to keep its
mercantile and maritime interests
very much alive. Nevertheless,
exports of Attic pottery seem
to have fallen off, although its
influence on other local schools
in Greece remained pronounced.
Thus the triglyph-and-metope
style decoration, typical of the
Attic Late Geometric I period,
as well as many of the pictorial
subjects, appear in the pottery
of other regions, from Boeotia
and Euboea to the Cyclades
and Samos. IP

Unpublished. For Attic Late Geometric
IB-IIA vase-painting see: Coldstream
1968, 47-54; Coldstream 1977,
110-119.

Flask
Skyros workshop

Cat no. 20
Late Protogeometric period
(950-900 BC)
From Skyros, Sporades
Clay, wheel-made, painted
28.6 (h) x 6 (rim diam) cm
Gift of Rena Andreadi (28190)

This intact, one-handled flask
with lentoid body and high
cylindrical neck with funnel-
shaped mouth, bears dense
painted decoration over its two
sides. With the exception of the
neck and mouth, which are in
monochrome black, the motifs
are painted against the light
ground. The centre of both sides
is defined by a system of
concentric circles, towards which
the radially articulated decoration
converges. On one side, cross-
hatched zones alternate with
systems of hatched chevrons.
On the other side, groups of
chevrons are framed by a cross-
hatched zone and zones of a
continuous zigzag pattern or
triangles painted in silhouette.
In the two central panels, below
the neck, are groups of horned
animals – caprines (goats) or deer
– either side of a schematically
rendered 'tree of life'. On the
back, the vase-painter represented
a second tree with two horned
animals to the left of it.

Whereas the funnel-shaped
mouth refers to corresponding
Cypriot flasks, in the decoration
of the vase there are visible
influences from the Protogeometric
pottery of Attica and Euboea, as
well as of the Cyclades. During
this period, that is the tenth

century BC, a common artistic
language (koiné) was formed in
Thessaly, Euboea, the Cyclades
and Skyros, from where –
according to information from
the donor – the Benaki Museum
flask comes. This information
can be validated by the similarity
of the decoration to a parallel
vase of the same shape now in
the Skyros Archaeological
Museum, and on the basis
of its style in general.

Recent research has demonstrated
that the provenance of the
assemblage of Protogeometric
vases in this particular gift to the
Benaki Museum must be a
cemetery on the east coast of
the island, where several graves
of this period have been located.
The significant finds, in both
quantity and quality, consolidated
the view that from the early first
millennium BC Skyros was a
dynamic centre of trafficking
goods and ideas. Its geographical
situation at the southernmost end
of the Sporades, opposite Euboea
and at virtually the centre of
the northern Aegean, certainly
favoured communication with
the shores of the Archipelago.

On a vessel most probably
intended for funerary use, such
as this flask, the presence of the
'tree of life' with the animals
either side acquires particular
importance. This is an
iconographic subject known
already from the Minoan world,
which is used with explicit
religious symbolisms not
unrelated to the life-giving force
of the earth and consequently to
beliefs concerning the afterlife. IP

Published: Kalogeropoulou 1984,
147-148, figs, 4-5; Lemos, Hatcher
1986, 335, fig 16. For Skyros during
the Early Iron Age see: Sapouna-
Sakellaraki 2001/02, 163-192.

19

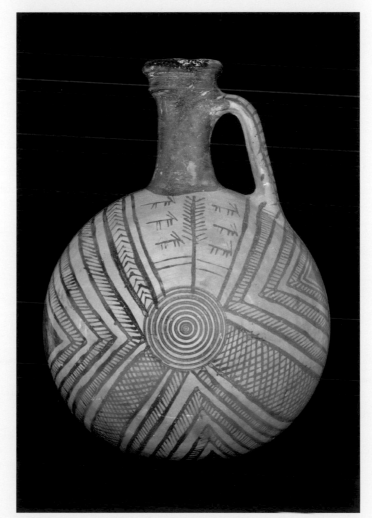

20

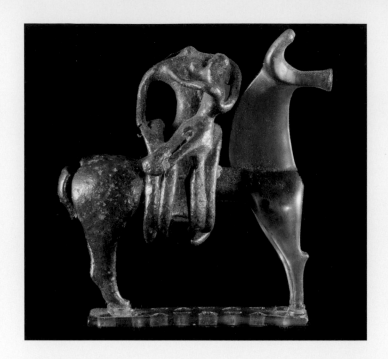

Figurine of a *kourotrophos* goddess on horseback
Peloponnesian workshop

Cat no. 21
Late Geometric I period
(*c.* 750 BC)
Provenance unknown
Bronze, solid cast
7.5 (h) x 7.6 (l restored) cm
Gift of Maria Chorafa (31475)

The figurine has been partly restored. Missing from the horse are the forequarters with the legs, part of the tail and the base. Mounted sidesaddle is a naked female figure, its head missing. The torso is triangular and the bosom is rendered with two slightly curved breasts. The female sits upon a packsaddle, and holds a boy-child in her embrace with her left arm. The child, naked, with legs outstretched and joined at the feet, brings his left hand towards the right shoulder of the female, so covering one breast, while with his right he embraces her at the height of the waist. His head rests beside her left breast and he turns towards her now-lost face.

The work is solid-cast in bronze, in a mould, by the lost-wax (*cire-perdue*) process. In this technique a wax model was covered with successive layers of clay. As the molten metal was poured into the clay casing, the wax melted and escaped through a special duct as the metal took its place.

Stylistic criteria suggest that this figurine, with its extremely rare iconography, was produced in a workshop in the Peloponnese, the region which is the provenance of the majority of Geometric bronzes of females on horseback. Despite the close iconographic and consequently conceptual affinity of the specific subject of the *kourotrophos* (mother and child) on horseback with female figures on horseback, only two examples are known from Geometric Greece: the Benaki Museum figurine and the figurine, also in bronze, discovered in the sanctuary of Hera (Heraion) on Samos. However, the Samian *ex-voto*, dated to the eighth/seventh century BC, apparently comes from the Caucasus region – an earlier view which has been reinforced by the relatively recent discovery in ancient Colchis (mod. western Georgia) of two related coeval bronze figurines of a kourotrophos on horseback.

The Benaki Museum example is unique because it is so far the only evidence of an equestrian kourotrophos in the art of Geometric Greece. The extreme rarity of the subject, the total nudity of the figures, as well as the emblematic character of the composition, give the impression that what is represented here is the epiphany, in the locus of cult, of a kourotrophos goddess, undoubtedly with chthonic hypostasis, associated with the underworld and with the cycle of reproduction and therefore birth and death. In approaching the recondite identity of the divine figure represented, we should also take into account the inherent symbolic value of transference, of journey. The journey is inevitably linked with 'travelling' gods, that is, gods not considered autochthonous to Greece, or gods who come and go periodically like the seasons of the year. IP

Published: Delivorrias, Fotopoulos 1997, 68, fig 84; Papageorgiou (in press).

'Jug-stopper' or pendant with crouching figure

Cat no. 22
Macedonian Iron Age (c. 700 BC)
From Macedonia
Bronze, solid cast
7.1 (h) cm
Inv. no. 8023α

The intact object forms a cylindrical shaft from which sprout, in circular arrangement, four columns of button-shaped elements. Button-shaped too is the lower end of the central shaft, while the upper end is crowned by a spool-shaped finial, upon which is a crouching, possibly human figure, with the legs bent to touch the ground. The arms, also bent with the elbows resting on the knees, are raised towards the face, so that the hands touch the peculiarly elongated, muzzle-like mouth. The head is spherical, the body flat and triangular, and the four limbs inordinately slender. The exaggerated elongation of the arms verges on the extreme in relation to the proportions generally governing the rendering of the human body in Geometric art.

This piece belongs to a particularly enigmatic category, in terms of use, of Late Geometric bronze-work, most examples of which

are of northern Greek (Thessaly and Macedonia) provenance. The overwhelming majority of those found in systematic excavations accompanied burials; only a few had been dedicated in sanctuaries.

Initially these objects were interpreted as 'jug-stoppers', since the intervals formed between the rows of button-shaped elements around the central shaft would have facilitated the winding of rope or twine so as to seal the mouth of a vessel. In corroboration of this view, the crouching figure was considered a daemon or satyr, with the majority of scholars deciding in the end that it was a human drinking out of a cylindrical vessel.

However, careful reading of the excavation data has confirmed that those specimens found in graves were hanging as pendants from a cloth or a leather belt wound around the waist of the deceased, with nothing precluding their equivalent use by their owners when alive. This observation kindled new attempts to interpret the crouching figure. Quite recently it has been argued that it may represent a monkey, which would explain the

elongation of the arms as well as the peculiar cylindrical end of the mouth.

The monkey is encountered in Aegean iconography from as early as the Bronze Age, very often in fact in exactly the same type, imitating a natural pose of the animal. The motif entered Greek art from the Near East and Egypt, where it was employed with overt connotations of fecundity, not unrelated to the sexual behaviour of the monkey.

It is therefore possible that the Greeks adopted not only the form but also the allusory content of this particular subject. It is thus quite possible that the monkey as symbol of fertility, and therefore of rebirth, could have featured on objects destined for mortuary or votive use. IP

Unpublished. For pendants of this type and their interpretation see: Makridis 1937, 512–521, esp. 517, pl IIγ–ζ; Jantzen 1953, 56–67; Langdon 1990, 407–424.

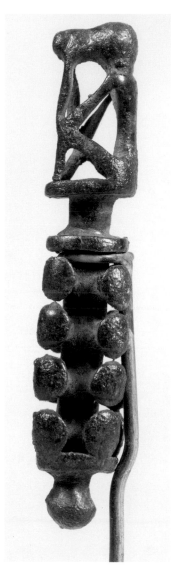

Head of a statue of Herakles
Cypriot workshop

Cat no. 23
c. 500 BC
Provenance unknown
Limestone, soft, off-white
14 (max pres h) cm
Gift of Stephen and Francis
Vagliano (30257)

The head and part of the neck are preserved. There is minor damage to the face, with chips on the nose, cheeks and chin. The head most probably belongs to a votive statue representing Herakles as a young man, without beard but with the *leonté* (a lion's head with wide-open muzzle) as head-gear. The chin is rounded, the lips describe the Archaic smile – typical in statues of the sixth century BC – the nostrils are broad and the long nose ends above in two fine, arched eyebrows crowning the almond-shaped eyes. The face is framed by rows of schematic curls, which simultaneously render the teeth of the lion's open mouth. Denoted on the animal's head are the flat nose, the half-closed eyes, the small ears and, by an incised double row of triangles, the mane.

The type of the Benaki Museum head belongs without doubt to the iconographic tradition of the Cypriot Herakles, which emerged from the conflation of the Phoenician god Melqart and the panhellenic hero. The type is identified from about 500 BC, with numerous examples in the Late Archaic sanctuary of Melqart-Herakles in the region of Kition-Bamboula (mod. Larnaca). In accordance with its parallels, the Benaki Museum Herakles originally would have been represented as a young man dressed in a lion-skin, holding a club in his raised right hand, like a warrior in battle.

Melqart, an old Eastern war-god, was introduced to Cyprus with the arrival of the first Phoenician kings who colonised Kition, in order to protect their dynasty. In his homeland he had the status of 'Master of Animals', Lord of Nature with protective qualities for the natural environment, and as such he was always accompanied by a lion. The common characteristics of the Phoenician god and the panhellenic deified hero, whose cult spread in Cyprus during the fifth and fourth centuries BC, were several and their merging was inevitable. Indeed, according to other examples, specific Labours of Herakles – the Lion of Nemea, the Hydra in the Lerna marshes and the Birds in Lake Stymphalia – were seminal to generating the hero's assimilation with the Phoenician Melqart. Thus an autonomous type was created, that of Melqart-Herakles or Cypriot Herakles, which diffused not only to the eastern part of the island but also to Phoenicia, Ionia, Samos and Rhodes.

The Benaki Museum head, an exquisite quality work, was made to be seen only from the front. The horizontal bar along the back of the sculpture was probably used for affixing the statue to the wall of a sanctuary. As the rest of the finds from the sanctuary at Kition-Bamboula show, examples of this type had been brought as *ex-votos* to Cypriot Herakles, the main local male deity, in whom Eastern and Hellenic influences coexisted on equal terms. IP

Published: Delivorrias, Fotopoulos 1997, 80–81, fig 111; *Mouseio Benaki – Glyptiki* 2004, 63–65, no 12 (St Lubsen-Admiraal).

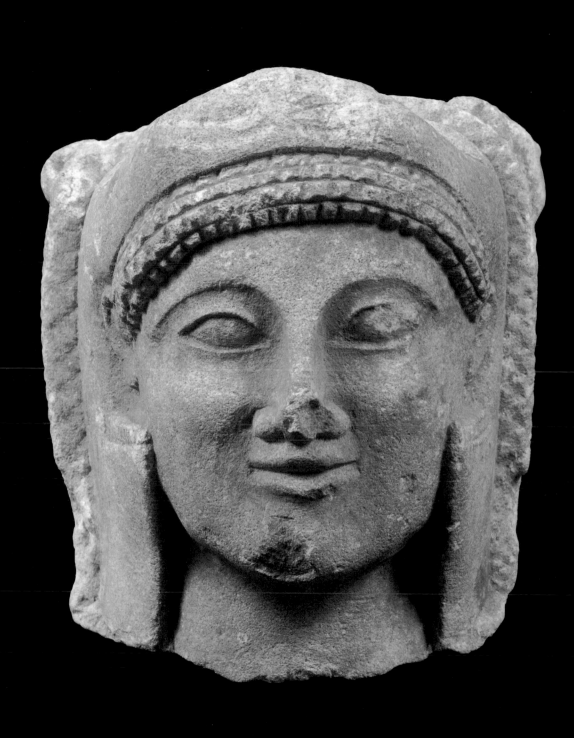

Pyxis
Corinthian workshop

Cat no. 24
Middle Corinthian period
(590–565 BC)
Provenance unknown
Clay, wheel-made, black-figure
14.5 (h) x 10 (rim diam) x 11.9
(base diam) cm
Gift of Ioanna Messinezi-Bazaiou
(25884)

The pyxis is intact, excepting a
small part of the rim, which has
been restored. The paint is badly
flaked in places. The vessel has
a conical base, a compressed
globular body and a horizontal,
flattened rim. With the exception
of the lower body, on which there
is a ray motif, and the glazed
base, the surface is filled with
decoration in successive zones.
In the central zone, defined
above and below by rows of dots,
is a frieze of three pairs of felines
and ibex, a duck and rosettes. On
the shoulder runs a second frieze
of ibex, lion, panthers, bull, boar,
sphinxes and siren, depicted
on a small scale with a clear
miniaturist tendency. The field
on both friezes is filled mainly
with rosettes and dots, creating,
in combination with the animal
figures, the sense of a rich
tapestry. Painted on the vertical
surface of the rim is a zigzag line.

The Benaki Museum pyxis,
a container for cosmetics or
jewellery, is distinguished by the
liberal use of purple pigment and
abundant incision, which reveals
the colour of the clay. In this
way the craftsman achieved
an impressive bichrome result,
failing, however, to enhance the
animal figures within the overall
'embroidered canvas'.

The type of vase, the characteristic
yellowish colour of the clay,
the decorative subjects, the
exaggerated elongation of the
body of the animals and the
schematisation of the filling
motifs are all distinctive
characteristics of Corinthian
pottery production in the first
quarter of the sixth century BC.
The use of incision for denoting
details, the rendering of the
figures in black silhouette and the
added white and purple paint
were combined for the first time
by Corinthian potters *c.* 700 BC,
when a revolutionary new
technique, the black-figure style,
was created. And if the use of
black silhouette is a vestige from
the Geometric past, the inclusion
of incision is possibly due to the
influence of bone and metal
objects with such decoration
imported from the East.

Excavation finds confirm the
intense mercantile activity and
contacts between Corinth and
the eastern Mediterranean, as
well as with southern Italy and
Sicily, from the second half of
the eighth century BC. Through
these routes, the fascinating
world of the oriental thematic
repertoire, with its penchant for
mythical and hybrid animals –
sphinxes, sirens, griffins – as well
as felines and complex floral
ornaments, flowed into the
imagination of local craftspeople.
This world, adapted to the
canons imposed by the tradition
of Geometric times – such as
the division of the vase surface
into zones – continued to be
illustrated without interruption
on Corinthian vases of the
seventh and sixth centuries BC.
IP

Unpublished. For typological parallels
see: Amyx 1988, 205, pl 86; Knoll
1998, 38–39, no 11. For Corinthian
vases of the seventh and sixth
centuries BC see: Tiverios 1996,
24–26, 33–34.

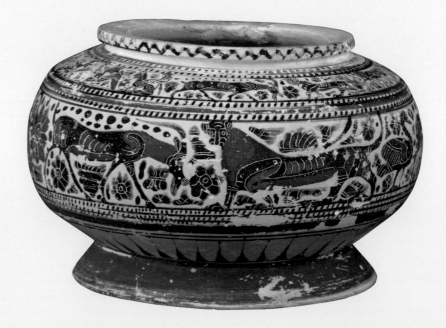

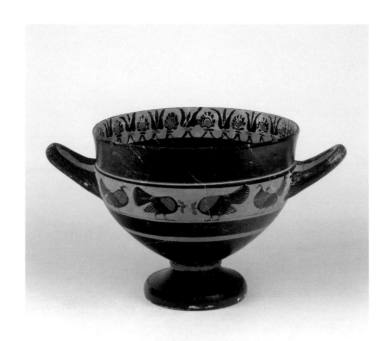

Banded cup-skyphos
Attic workshop, Circle
of the Amasis Painter

Cat no. 25
c. 540 BC
Provenance unknown
Clay, wheel-made, black-figure
13.4 (h) x 15.8 (rim diam) x 8.3
(base diam) cm
Gift of Christos Spiliopoulos
(31623)

The vase is mended from many
shards. Part of the rim is restored.
With low foot, deep
hemispherical body, fillet at the
junction of foot and body, and
high rim with slightly flaring
walls, it combines features of two
classes of vessel, the cup (kylix)
and the bowl (skyphos). The
decoration is confined to the
reserved handle zone and on
both sides consists of a pair of
cockerels confronting each other
in fighting pose – as assumed
from their lowered heads and
open beaks. The cockerels are
flanked by two other birds,
probably hens. A reserved band
encircles the vase at about the
middle of its body, while the
remaining outside surface is
coated with shiny black glaze.
On the black-glaze inside of
the vessel only the rim zone is

reserved, on which is painted
a chain of palmettes and lotus
flowers. Details to the floral
decoration on the inside of the
rim, the breasts of the birds and
the combs and wattles of the
cockerels are added in purple.

Cockfights appear in the art
of Archaic and Classical times,
sometimes as principal
representations, alone or
flanked by young male figures,
and sometimes as subjects
accompanying mythological
scenes of combat or contest.
Although this sport was patronised
by aristocratic circles in Athens,
its depiction in Attic vase-
painting acquired a symbolic
dynamic and possibly
propagandised the ideals and
values of the new social forces.
Because of the cockerels' physical
abilities and behaviour, as well
as the violence characteristic
of altercations between them,
the depiction of cockfights has
been equated with the expression
of the agonistic spirit and of
male valour. However, this
iconographic subject could also
be read at another level. Given
the references in ancient Greek
literature to the offering of
fighting cocks by the mature

lover to his adolescent protégé –
an action that has been interpreted
in the context of the educational
system of ancient Athens as
symbolising a wish to strengthen
virility and the ability to resist –
and given the known cause of a
contest between the birds, that is,
sexual domination, the cockfight
could symbolise homoerotic rivalry.

A recent study ascribes the
Benaki Museum vase to the circle
of the Amasis Painter, a well-
known potter, who apparently
also painted his vases with
representations of remarkable
dexterity and frequently with
innovative subjects in the Attic
black-figure style. Probably
of Egyptian origin – as the
etymology of his name suggests –
Amasis began his career in the
workshops of the Athenian
Kerameikos *c.* 560–555 BC and
apparently created a circle of
'pupils' who were influenced by
his artistic inquiries. IP

Published: Malagardis, Iozzo 1995,
204–205, pl 54a–b. Cf similar
examples: Pipili 1993, 22–23,
pl 11 no 17798. For the symbolic
dimension of the cockfight in Attic
iconography see: Hoffmann 1974,
195–220; Csapo 1993, 1–28.

Amphora
Attic workshop

Cat no. 26
530–520 BC
Provenance unknown
Clay, wheel-made, black-figure
36 (h) x 16.5 (rim diam) x 12
(base diam) cm
Gift of Stephen and Francis
Vagliano (30248)

The amphora is intact, with some chips on the rim area. The painted decoration on front and back extends from the neck to the base. On the neck is a palmette chain and on the upper part of the shoulder is tongue-pattern in alternating black and purple. The representations are framed by groups of palmettes below the trilobe handles. A chain of lotus flowers encircles the lower body. A ray ornament arises from the base. Depicted on side A is Athena, armed and in a chariot drawn by four horses (*quadriga*). The goddess wears a peplos, aegis with characteristic snake-heads and a helmet with high crest. In her right hand she holds a spear, the horses' reins and a charioteer's goad. The S-curvature of her body is probably due to her effort to restrain the rushing chariot. Side B of the amphora features a second quadriga with horses in frontal pose. Peplos-clad Athena stands in the chariot, holding two spears in her hand and with a helmet on her head. Certain details of the vegetal decoration on the neck and the aegis, as well as the horses' manes and reins, are picked out in purple. Added white has been used for Athena's flesh, as well as for the dotted rosettes embellishing her aegis.

The vase is decorated with a 'degenerate' variation of the subject of the Gigantomachy (the battle between gods and giants), one of the most important episodes in ancient Greek mythology, in which Athena is usually represented fighting alongside her fellow gods and with Herakles as companion in her chariot. Although the scene is abstracted from its battle context, since the adversaries are absent, its association with the martial nature of the goddess is obvious. Moreover, the chariot is not only a symbol of divine epiphany – by analogy with the Homeric descriptions of gods and goddesses moving in chariots – but also underlines here the agonistic virtues of the daughter of Zeus, projecting her as sovereign deity who guarantees the security of the city and its citizens. The depiction of a variation of the central subject on the back of the vase emphasises its significative connotations, which presumably were immediately perceptible to the viewer at that time.

Athena holds a special place in Attic vase-painting, mainly of the Archaic period, due primarily to her ties with the city she protected. However, her depiction in a chariot, as in the case of other gods, is limited to the last quarter of the sixth century BC and to specific workshop circles. It is clear that the choice of such iconographic subjects and the short-lived but considerable popularity they enjoyed is linked with the needs and the social structures of the period, as well as, perhaps, with current beliefs in the living presence of the gods in diverse aspects of human life.
IP

Published: Delivorrias, Fotopoulos 1997, 86–87, figs 118–119. Cf parallels: Vian 1951, 67–68, nos 298–307, pl XXXII nos 298–299. For representations of gods in chariots in the late black-figure style and their meaning see: Manakidou 1994, 135–141.

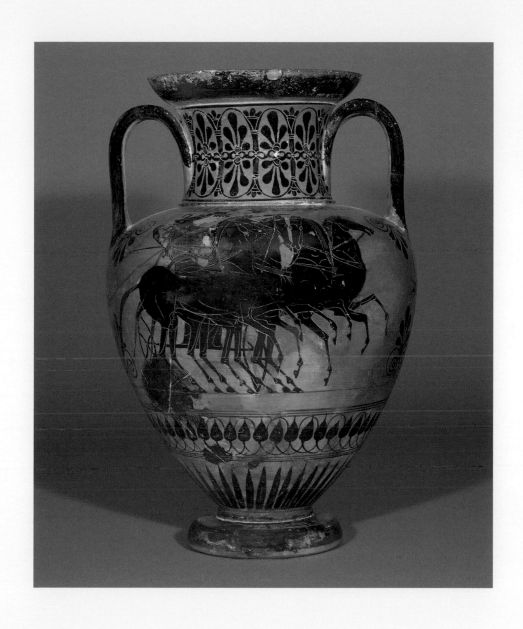

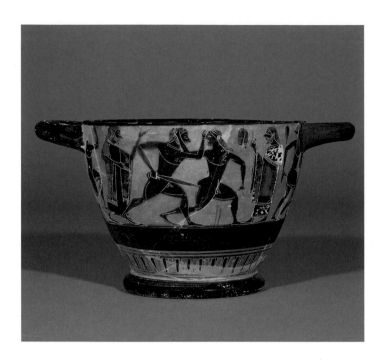

Skyphos
Attic workshop, 'Affecter'

Cat no. 27
c. 540 BC
From Attica or Boeotia
Clay, wheel-made, black-figure
11.1 (h) x 14.5 (rim diam) x 9.3
(base diam) cm
Gift of Peggy Zoumboulaki in
memory of her husband Tasos,
with shards on permanent loan
from the Metropolitan Museum
of Art, New York, and the
American School of Classical
Studies, Athens (33042)

The vase was mended from
shards donated by Peggy
Zoumboulaki, a shard in the
collection of the American
School of Classical Studies,
Athens, and three other shards
in the possession of the
Metropolitan Museum of Art,
New York. A few parts of the
body and one handle are
restored. The skyphos had been
broken and mended in antiquity,
as deduced from the repair
drill-holes on its body. A zone
of tongue-pattern, executed
alternately in black and red,
encircles the lower part of the
body. The representation is
developed upon a broad glazed
band on both sides of the vessel.

Depicted at the centre of side
A are two nude male figures
running to the right between
two bearded figures clad in chiton
and himation, with one hand
raised. Both central figures, one
bearded and holding a sword,
the other turning his head, could
be participating in a scene of
pursuit. The same subject, with
some variations, is depicted on
side B: the two men at the centre
are bearded and the first from
the left, with his arms outstretched,
probably chases the second,
whose short cloak is passed over
his extended right arm. The
scenes on both sides are framed
by nude male figures, dancing or
simply running. Below the handles
are a waterfowl and a panther.
Some anatomical features and
details of the garments are
denoted in added white and red.

The skyphos has been attributed
to the 'Affecter', conventional
name of an Athenian vase-maker
and vase-painter, who was active
in the third quarter of the sixth
century BC. Although most of
the vases by him have been found
in Italy, the Benaki Museum
skyphos must come from Attica
or Boeotia, given that the shards
from which it was mended were
all purchased in Athens.

The 'Affecter' habitually decorated
his works with, among other
things, male couples in scenes
of conversation or erotic pursuit.
Although the representation on
side B could be included in the
second category, the presence
of the sword on side A perhaps
denotes a quarrel between heroes
or merely underlines the violence
of the scene. This Athenian
painter had a particular
preference for non-narrative
representations, the content
of which frequently defies
decipherment. He also displays
the same tendencies of deviation
from the norm as a potter, since
in most of his known vases traits
of earlier types coexist. As is
the case in the Benaki Museum
skyphos, the blending of different
chronological and stylistic traits
creates the sense of originality. IP

Published: Delivorrias, Fotopoulos
1997, 86, fig 117; Pipili 1997, 87–94.

Figurine of standing female
Boeotian workshop

Cat no. 28
Mid-6th c. BC
Provenance unknown
Clay, handmade, painted
15.3 (h) cm
Gift of Stephen and Francis
Vagliano (30215)

The figurine is almost complete,
excepting the left arm which is
restored. The figure wears a
peplos and a cylindrical headdress
with modelled volute. The face
is bird-like and the arms, which
bend slightly towards the body,
are schematically rendered as
a horizontal extension of the
shoulders. The neck is short and
quite cylindrical. The figurine
widens in its lower part, for greater
stability. The large almond-
shaped eyes, the shoulder-length
hair, the horizontal band on the
neck, presumably part of a
necklace, and details on the
garment are denoted in brownish
black paint. The upper border of
the peplos is indicated by a wide
zone of triangles on the bosom.
Below this is a horizontal zone
of S-motifs, followed by three
groups of vertical wavy lines.
The hem of the garment is
outlined by a row of tongue-
ornaments. Horizontal short lines
embellish the front of the volute.

The figure belongs to the class of
singular Boeotian figurines with
flat, plank-like body, peculiar
ending of the arms and of the
head – which in the later examples
is mould-made – and embellished
garment. During the nineteenth
century, these objects were found
in large quantities by the Boeotian
peasants as they ploughed their
fields. They called them *papades*
(priests) because of their
resemblance to Greek Orthodox
priests in their long cassock and

stovepipe hat, a name which
passed into international
archaeological terminology
and is still in use. In systematic
excavations in the twentieth
century an impressive number
of figurines of this type was
recovered from cemeteries at
various Boeotian sites (Rhitsona,
Tanagra and elsewhere).

The interpretation of these pieces
remains a problem. The exclusive
presence of this type of figurine
in graves supported the original
hypothesis linking them with
the cult of Demeter and of
Persephone, goddesses associated
with the underworld. However,
according to Pausanias, the well-
known Roman traveller of the
second century AD, during the
rites celebrated in honour of
Hera at Boeotian Mount
Kithairon, participants carried
wooden effigies – known as
daidala – in procession, in order
to burn them along with the
sacrificed animals (Pausanias
IX, 3, 4–5). The morphological
similarity of these figurines to the
wooden effigies, as well as their
mass production only in Boeotia
during the sixth century BC,
permitted their association with
the daidala of literary tradition.
Their discovery solely in
mortuary contexts could be
justified by the many qualities of
Hera, a goddess of pre-Hellenic
origin, probably linked initially
with the renascence of Nature
and consequently with death,
as well as by the acknowledged
persistence of tradition which is
distinctive of Boeotian art overall.
IP

Unpublished. For parallels see:
Schmidt 1994, 36–37, no 23, pl 7b;
Peege 1997, 27, no 1. For the type,
its naming and its interpretation see
collected bibliography in: Marangou
1996², 125–126.

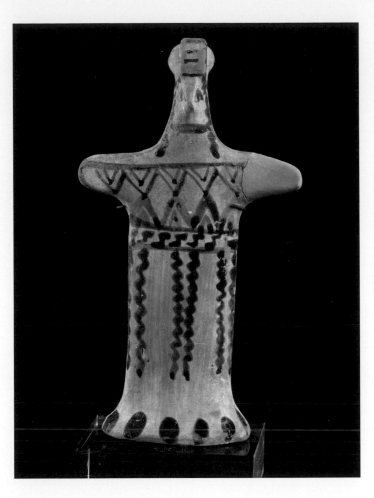

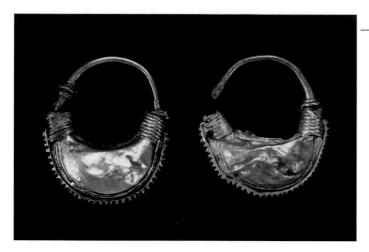

Boat-shaped earrings

Cat no. 29
550–500 BC
Perhaps from Macedonia
Electrum sheet, filigree
3.1 (h) x 2.9 (w) cm
Inv. no. 1520

The earrings are hollow, made of two soldered sheets of electrum (alluvial gold with a high silver content), and damaged. The boat-shaped pendants hang from a wire suspension loop. The joins between the metal sheets are masked by clusters of simple wires, while at the point of union with the suspension loops are wire rings. Soldered along the length of the outside edges is a row of 'spurs'.

Earrings of boat-shaped type are first encountered in Sumerian jewellery of the third millennium BC. In that region they enjoyed long and probably continuous use. In the Aegean they were introduced during the Archaic period, via the Greek colonies in Asia Minor. Their form and decoration are simple during the sixth century BC, to which the Benaki Museum example dates, becoming more ornate from Classical times onwards. Throughout the fifth and fourth centuries BC, these earrings are lavishly decorated in granulation and filigree, while figures modelled in the round fill the hollow 'hull' of the boat, which now hangs from a rosette and has additional pendants hanging from chains. By the late fourth century BC, craftsmen fashioning boat-shaped earrings were active in various workshop centres, spread as far as Bulgaria, western Asia Minor, the Crimean Peninsula and the shores of the Euxine Pontus (Black Sea) and the Hellespont (Dardanelles), and vied with one another in the skilled execution, inspiration and opulence of their products. Indeed, such is the wealth of decorative details that the subject of the boat is no longer obvious and disappears completely from the thematic repertoire of jewellery in Hellenistic times.

The Benaki Museum earrings, together with the necklace cat no. 30, were first published as part of a mid-sixth century BC hoard of Ionian provenance. However, it has been argued that the origin of most of the items in this assemblage should rather be sought in Macedonia. Parallels for the earrings discussed here are to be found in the silver examples from Trilofos in the Chalkidiki and from Olynthos in Central Macedonia. The fact that both earrings and necklace are made of electrum possibly corroborates their suggested common provenance. IP

Published: Segall 1938, 19, no 5, pl 5; Amandry 1953, 47, no 1; *Benaki Museum Greek Jewellery* 1999, 132, fig 86. For a similar example see: *op cit*, 132–133, no 34 (St Lymperopoulos). For the type of boat-shaped earrings see: Despini 1996, 34–35.

Necklace

Cat no. 30
Mid-6th c. BC
Perhaps from Macedonia
Electrum
20 (l) cm
Inv. no. 1525

This piece of jewellery consists of 30 globular beads and one tubular segment, all decorated with parallel ribs. The necklace elements, which might have been greater in number, have been threaded on modern yarn, not necessarily in their original position. The beads are made of electrum, like the boat-shaped earrings (cat no. 19). According to the Roman writer Pliny the Elder (AD 23-79), electrum was the name of the metal in which the ratio of silver to gold was one to five, which accounts for the pale colour of the natural alloy (*Natural History* XXXIII, 80). The Greek historian Herodotus (*c.* 480-420 BC) refers to the same metal as white gold (I 50, 2-3).

Ribbed beads are encountered from as early as Mycenaean times, in various materials, usually semiprecious – glass paste, faience, rock crystal,

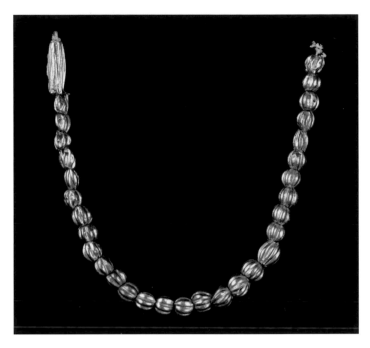

lapis lazuli, cornelian, amethyst – and reappear in the goldsmith's art of the Archaic and Classical periods. Their shape recalls flowerbuds or possibly pomegranates, although the calyx below and the cylindrical element above are absent from the model of the fruit. Both buds and pomegranates are symbols of fertility and had a prominent place in the adornment of young women, not only as ornaments but also as bearers of magical properties which potentially presaged their future reproduction.

The necklace was first published as part of a mid-sixth century BC hoard, possibly of Ionian provenance. The proposed date is confirmed by comparable examples of beads of the sixth century BC. Their provenance, however, has been doubted by plausible argumentation, given that several of the items of jewellery in this particular assemblage find parallels in Macedonia (see cat no. 29). IP

Published: Segall 1938, 19, no 8, pl 5; *Benaki Museum Greek Jewellery* 1999, 129, no 32 (St Lymperopoulos).

Bow fibula

Cat no. 31
4th c. BC
Possibly from northern Greece
Gold, filigree, granulation
4.5 (l) cm
Gift of Georgios and Athanasia
Pappas (30005)

The fibula was a piece of jewellery used to fasten female garments on the shoulder or at the side, and from Archaic times was also used for holding chest ornaments in place. Affixed to the bow of this intact example are three barrel-shaped beads, each bearing in the middle a row of rosettes with globules at the centre. The row of rosettes is framed by granulation and two rings either side, surrounded by twisted wire. The catch-plate is formed as a Pegasus protome, between two solid globules. The hinge-plate is in the form of a flat box decorated on both sides with a relief head wearing the lion-skin of Herakles. The pin, of plain wire with pointed tip, is preserved.

The fibula is classified as an ornate variation of the northern Greek type, which is a further development of the bow fibulae from Asia Minor. After the seventh century BC the type reached Thrace, from where it spread to the Balkans, Greece – mainly Macedonia and Thessaly – and to other regions where it occurs sporadically. The fourth century BC examples in gold from Macedonia display so many stylistic affinities with the Benaki Museum fibula that it can be convincingly argued that they were made in the same workshop.

The Pegasus protome on pieces of jewellery of this class has an almost emblematic character, in that it probably symbolises the Hellenic ideal, that is, man's everlasting struggle with Nature. According to the myth, which appeared in Corinth in the seventh century BC, Pegasus, the winged horse, was tamed by Bellerophon, mythical king of Corinth, and together they vanquished the Chimaera, a monstrous creature which was destroying the realm of Lykia on the coast of Asia Minor. In ancient Greek literature, this adventure was projected as an allegory for human passions, thus acquiring a dynamic corresponding with – though not equal to – the Labours of Herakles and of Theseus.

It has been argued that the head with the lion-skin represents the mythical queen of Lydia, Omphale, for whom, literary tradition has it, Herakles – as her paramour – had performed various feats. According to another view, it represents the Thracian goddess Bendis, since fibulae of this type have been found in Thrace, where her worship was widespread. More plausible is the recent suggestion that it portrays the young, beardless Herakles, who in these years was enhanced as a 'symbol', his effigy featuring on Macedonian coins or on metal vases and other decorative objects. If this is the case, then the coexistence of Herakles and Pegasus in this fibula emphasises their common symbolism. IP

Published: Delivorrias, Fotopoulos 1997, 112–113, fig 162; *Benaki Museum Greek Jewellery* 1999, 165, no 51 (St Lymperopoulos). Cf similar examples: *op cit*, 164, no 50 (St Lymperopoulos). For fibulae of this type see also: Despini 1996, 42.

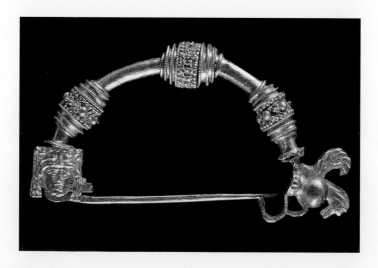

Signet ring

Cat no. 32
Late 6th c. BC
Provenance unknown
Gold, cast, intaglio
Hoop 1.5 (diam) cm;
bezel 2.3 (max diam) cm
Gift of Imre Somlyan (27514)

The ring has a plain hoop and an oval bezel with intaglio representation of a kneeling archer, facing right, stretching a bow with his left hand. The warrior has long hair falling to the shoulders and wears a close-fitting breastplate and greaves. His armour is completed by a dagger hanging obliquely from his waist. In the field of the device, bottom left, is a wreath. The dotted line upon which the figure kneels represents the ground. The anatomical details on the torso of the male figure are described beneath the breastplate, the existence of which is denoted by the lines on the arms, the neck and waist. Similar lines on the ankles and below the knees indicate the greaves.

The iconographic subject of the kneeling figure is used widely in ancient Greek art to decorate circular surfaces, on jewellery, coins or tondos at the bottom of clay vases. In many of these scenes the filling motifs allude to the identity of the figure depicted. If the wreath accompanying the archer on the Benaki Museum ring does not confirm a past victory or predict the successful outcome of a future contest, it could denote Apollo Ekebolos (Far-Shooting), the archer-god, whose sacred wreath is of laurel. If this is the case, the kneeling male figure possibly depicts a devotee of the god.

Finger rings with intaglio bezel of the same metal or of semiprecious stone are attested from prehistoric times. They were used to seal doors, vessels with lids and, of course, documents. Normally the imprint was stamped on a lump of clay placed over a tied cord, as known from discoveries of the seal impressions themselves. Seal rings belonged to private individuals as well as to officials charged with safeguarding public property or supervising sanctuaries. As valuable personal objects they accompanied the deceased in the grave or were offered as *ex-votos* in sanctuaries. As the provenance of the Benaki Museum ring is unknown, it is impossible to speculate on its original purpose or possible owner. IP

Published: Delivorrias, Fotopoulos 1997, 74–75, fig 98; *Benaki Museum Greek Jewellery* 1999, 142–143, no 38 (St G Miller).

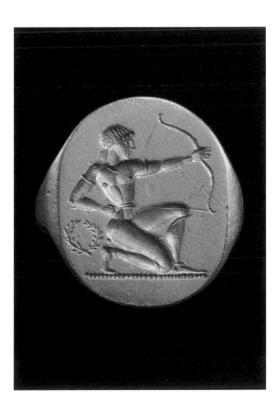

Head of Hermes from a herm
Attic workshop

Cat no. 33
Early 5th c. BC
Possibly from Athens
Marble, Pentelic
23 (max pres h) cm
On permanent loan from
Panayiotis Theodorakopoulos
(33097)

The head originally stood on a stele, now lost. Missing are the back of the head, the tip of the nose, the lower part of the beard and the ends of the locks of hair behind the ears. The god is represented with long wavy beard, thick moustache and fillet in the hair. A double row of spiral curls forms the hairstyle above the low rectangular forehead and in front of the ears. A wavy lock, beginning behind the ears, would have hung to the shoulders. The eyes are narrow with thick eyebrows and the cheek-bones are pronounced. Most probably a metal earring was inserted in the hole in the right earlobe.

The head of Hermes crowned a herm, as this class of semi-iconic representations of the deity was called, in which the column or stele – an iconic symbol of the god – coexists with his representation in anthropomorphic form. Herms, which first appeared in the late sixth century BC, marked central points in cities and crossroads or adorned the entrances to houses. They represented not only Hermes but also other gods or daemons, or were crowned by the heads of eminent mortals.

The Benaki Museum head of Hermes displays striking stylistic affinities with the Severe Style sculptures from the metopes of the temple of Zeus at Olympia, as well as with herms of the late sixth and the early fifth century BC. Although it does not belong to any known type of herm, and despite the survival of several traits of the Archaic period, primarily in the treatment of the hair, it can be dated quite confidently to the years of the Severe Style (490/489-460/450 BC). The austerity and severity with which the facial features are imbued are consistent, in any case, with the dating of the sculpture in this particular period. IP

Published: *Mouseio Benaki – Glyptiki* 2004, 77–78, no 17 (O Palagia).

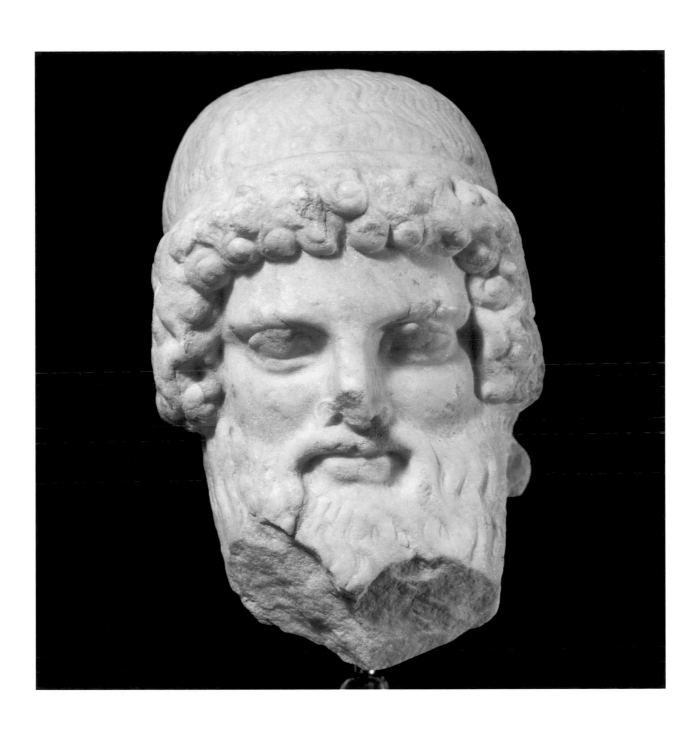

Kylix
Attic workshop, Circle of the Penthesilea Painter

Cat no. 34
c. 450 BC
Provenance unknown
Clay, wheel-made, red-figure
8.8 (h) x 22.5 (rim diam) x 8.4 (base diam) cm
Gift of Peggy Zoumboulaki in memory of her husband Tasos (31116)

The kylix is mended from many shards. Parts missing from the body, half of one handle and of the foot, as well as part of the tondo, have been restored. Depicted in the tondo, which is encircled by a zone of stopped-meander pattern, is a scene of conversation between two male himation-clad figures. The man on the left sits on a cuboid seat and the one on the right stands with his body slightly bowed, as if leaning forward to ensure that his words are clearly understood. Represented on each side of the kylix are three figures. On side A, two youths, each dressed in himation and resting on a staff, flank a central female figure clad in chiton and himation with a snood on her hair, and proffering a leather flute-case. Between the figures hang a ribbon and a writing tablet. On side B, the central female figure, of which only the lower part of the body is preserved, is flanked on the right by a youth in himation and resting on a staff, and on the left by a woman seated on a stool and holding a casket. Between the figures hang a ribbon and a shield in its case. Below the handles, the representation is complement by a palmette with sprouting stems ending in lotus flowers.

The three representations on the kylix are governed by an internal relationship, since they refer to the educational system in the ancient Greek city and the gradual incorporation of Athenian ephebes (youths) into adult life. So the writing tablet and flute-case relate to tutelage in letters and music, the shield to training for the battlefield, the casket and the ribbons to the female domain and marriage. The scene in the tondo, typical in Attic vase-painting, renders an erotic conversation between the mature lover and the adolescent protégé, in the context of a relationship which should however be understood as a necessary stage in the initiation of boys into the society of citizens.

The Benaki Museum vase is a product of the workshop of the Penthesilea Painter, the conventional name of an Athenian kylix-painter, coined from the scene of the death of the Amazon queen Penthesilea on a well-known kylix of his, now in Munich. His workshop was evidently active between 470 and 430/25 BC, and its products include several examples in which two vase-painters have collaborated. This is true of the present kylix, the tondo and the outside of which are the work of two different painters. IP

Published: Delivorrias, Fotopoulos 1997, 85, fig 116. For attribution and discussion of the iconography of the kylix see: Sabetai (forthcoming). For the Workshop of the Penthesilea Painter see: *ARV* [2], 877–971, 1673–1676, 1707.

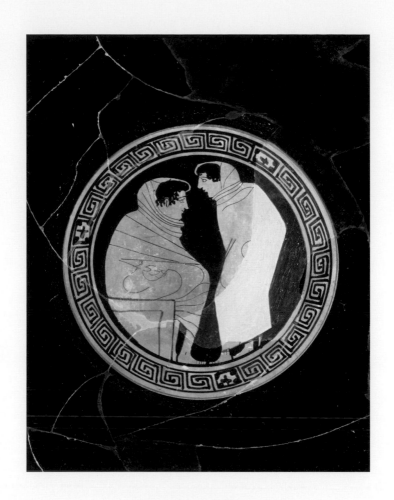

White lekythos

Attic workshop, Workshop of the
Aischines and Tymbos Painters

Cat no. 35
475–450 BC
Provenance unknown
Clay, wheel-made, white-ground
22.9 (h) x 4.5 (rim diam) x 5.6
(base diam) cm
Gift of Apostolos and Maria
Argyriadis (32968)

The base is mended and there
are chips all over the body.
The paint is badly flaked in
places. The shoulder is decorated
with zones of ray and tongue
patterns. Black glaze, in parts
brown due to firing conditions,
coats the mouth, the back of the
handle, the lower body and the
upper surface of the disc-shaped
base. On the body is a white-
ground representation of a
female figure advancing towards
a wool-basket, holding a flat
basket with wreaths in her right
hand and a lekythos in the left.
She is attired in a multi-pleated
chiton and a himation, with a
snood over her hair. Depicted
behind her is a stool, and
hanging top left is a ribbon.
The representation, defined
above by a zone of meander
pattern, is executed with rapid
yet firm brushstrokes in lustrous
glaze with a golden sheen.

This scene is of an Athenian
lady preparing to visit the tomb
of some dear deceased, or of a
bride getting ready for a marriage
which will never take place because
of her untimely death. In both
cases the semantics are registered
primarily by the type of vase.

White lekythoi, perfume vases *par
excellence*, were made exclusively
in Athens from the second
quarter of the fifth century until
400 BC and destined solely for
funerary use. The subjects
decorating them always derive
from the iconography relating
to death and burial customs –
scenes of visits to a grave,
bedecking of the funerary
monument, transport of the
dead to the underworld, etc.
With the white ground of the
representations, the painted
outlines of the figures and the
frequently impressive polychromy,
they transmit to us the echo
of the now lost monumental
painting of Classical Greece
and are justly included among
the loveliest painted creations
to have survived from antiquity.

The Benaki Museum lekythos
has been ascribed to the
workshop of two Athenian
painters. One is known
conventionally as the Aischines
Painter, because of the dedicatory
inscription to a certain Aischines
on one of his vases. The other
is conventionally referred to as
the Tymbos Painter – *tymbos* is
the Greek word for tumulus –
because of the emphatic
rendering of funerary
monuments in his creations.
Although some painters of
white lekythoi were also involved
with the decoration of red-figure
vases, the Tymbos Painter seems
to have depicted the inert world
of the dead only upon the
shimmering white of these
Attic works. IP

Unpublished. For attribution and
discussion of the iconography of the
lekythos see: Sabetai (forthcoming).
For the type of lekythos see *ARV* ²,
675, 709; *Paralipomena*, 753–758.
For the Tymbos Painter see recently:
The City Beneath the City 2000,
251, no 231 (G Kavvadias), with
bibliography. For Attic white lekythoi
in general see: Kurtz 1975.

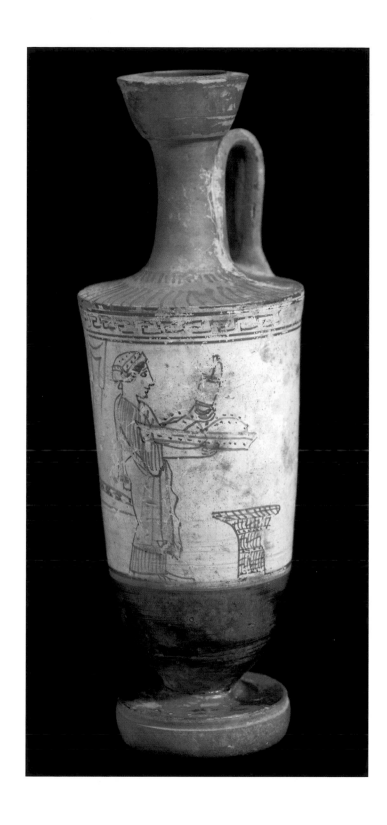

Hydria

Attic workshop, Villa Giulia
Painter

Cat no. 36
460–450 BC
Provenance unknown
Clay, wheel-made, red-figure
34.5 (h) x 13.1 (rim diam) x 13.3
(base diam) cm
Gift of Peggy Zoumboulaki in
memory of her husband Tasos
(35415)

The vase is mended from many shards and restored. Large parts of the body, part of the left handle, almost all the right handle and about half the base are missing. The representation on the front of the hydria, defined above by a zone of running spiral between rows of dots and below by a zone of meander pattern, depicts the Apollonian Triad. On the left Artemis, wearing a peplos, with fillet in her hair and quiver on her shoulder, holds an oinochoe (jug for dispensing wine) and a phiale (flat open bowl), essential vessels for performing a libation. At the centre of the composition stands her brother Apollo, in long chiton and wreathed with laurel, holding a lyre in his hands. Opposite him is their mother

Leto, clad in chiton and himation, with a diadem decorated with meander-pattern in her hair, holding a sceptre. Between Leto and Apollo is an *omphalos*, a sacred stone symbolising the navel of the earth.

The three Delian deities are presented together in the form of bronze cult statuettes from as early as the seventh century BC in Crete. They decorate Attic vases from the mid-sixth until the later fifth century BC, with a notable frequency in the years just after the end of the Persian Wars (479 BC). In the view of some scholars, this particular choice might have been dictated by political expediency, since in 478/7 BC the First Athenian League was founded, with the island of Delos as seat. It is thus to be expected that this coalition was placed under the protection of Apollo and Artemis, who were born there, and of their mother Leto.

The depiction of the omphalos on the Benaki Museum hydria alludes to the sanctuary of Apollo at Delphi, where the god was worshipped as Pythios. This epithet refers to the well-known myth of Apollo's slaying of the

dragon Python, guardian of the sacred site that originally belonged to the goddess Ge (Earth). It was from the chthonic worship of the Great Mother Goddess that the new lord of Delphi took over the omphalos as attribute. Noteworthy is the fact that the combination of iconographic elements from the spheres of Apollo Pythios and Apollo Delian is by no means usual in Attic vase-painting.

The Benaki Museum hydria has been attributed to the Villa Giulia Painter, a conventional name for an Athenian vase-painter first identified from a vase in the Villa Giulia Museum in Rome. The best works by this particular painter, whose preferences include the depiction of the Apollonian Triad, are distinguished by the serenity and dignity in the rendering of the figures. IP

Unpublished. For attribution and discussion of the iconography of the hydria see: Sabetai (forthcoming). For the depiction of the three Delian deities just after the Persian Wars see: *Collection of Stavros Niarchos* 1995, 152 (M Tiverios).

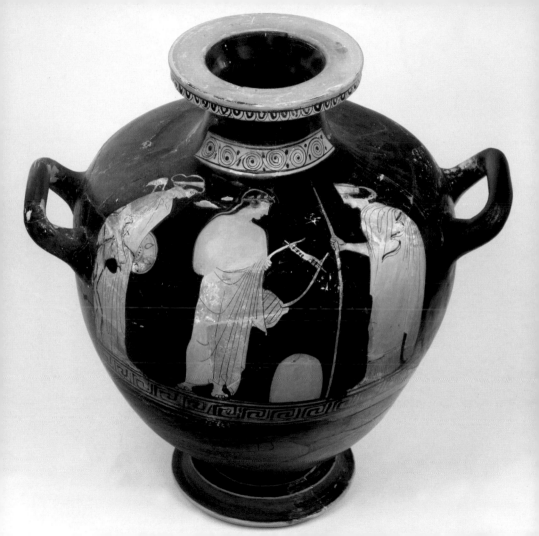

Figurine of a *hydriaphoros*
Boeotian(?) workshop

Cat no. 37
c. mid-5th c. BC
Provenance unknown
Clay, mould-made, hollow
19.8 (h) cm
Gift of Peggy Zoumboulaki in
memory of her husband Tasos
(31097)

The figurine is mended from
three pieces and has limited
restoration at the height of the
left shoulder. The female figure
is represented standing on a low
rectangular base, with the left
leg firm and the right leg relaxed.
She wears a peplos and with her
raised left hand holds a hydria
(water container) on her head.
The vase is identified mainly by
its shape since of its three handles
only the two horizontal ones are
visible. The vertical handle at the
back of the vessel is not shown
because the back of the figurine,
for the most part open, is flat and
roughly formed.

Terracotta figurines of *hydriaphoroi*
(hydria-bearers) are common
ex-votos in sanctuaries of Demeter
and Persephone throughout the
Mediterranean. This type appears
in the late sixth century BC and
lives on into the Hellenistic period.
Of special significance for the
interpretation of this particular
class of figurines is not only
their find-spot but also the kind
of vase they hold. The hydria,
as its name indicates, was used
almost exclusively for carrying
water (Greek *hydor*), essential
for everyday cleansing, ritual
purifications and libations.
Hydriaphoroi could thus be
considered representations of
devotees of Demeter, candidates
for initiation into the Eleusinian
Mysteries, in which ritual ablutions
were of paramount importance.
The re-enactment of the Sacred
Marriage during the Mysteries,
by the top-ranking priests of the
goddess, could also justify the
use of the water borne in these
vessels, in the virtual nuptial bath,

thus imparting to these figurines
a dynamic symbolic potency.
Their 'reading' from the point
of view of the myth is equally
credible. They could be
interpreted as representations
of the daughters of King Keleos
of Eleusis, who, on reaching
the fountain to fill their bronze
pitchers with water, encountered
Demeter lamenting the loss of
her daughter and led the desolate
mother to their palace (*Homeric
Hymn to Demeter*, 105-110,
169-170).

However, there are no indications
or testimonies concerning the
celebration of *hydrophoria* (water-
bearing) from any sanctuary
of Demeter. The act as such,
incorporated in some ritual
ceremonial, took place on the last
day of the Anthesteria, a major
three-day Dionysiac festival of
ancient Athens. The final day
was dedicated to the dead and
included offerings to Hermes
Chthonios ('of the underworld')
or Hermes Psychopompos

('conductor of souls'). The ritual
of water-bearing could be
understood as the offering of
water to Hermes, counter-gift
of the invocation of the living
for him to show forbearance
to their deceased loved ones.

Thus, given the use of water
in mortuary rites also, and with
the known chthonic implications
in the cult of Demeter, it is
not unlikely that these figurines
represent part of some ritual
relating to beliefs surrounding
death. Their ritual references
perhaps also imposed the
conservation of their form,
which varies very little
throughout their presence
in ancient Greek art. IP

Unpublished. For parallels see:
Mollard-Besques 1954, 104, nos
C119-120, pl LXXV, 112, no C175,
pl LXXXI, 121, nos C235, C240, pls
LXXXVI-LXXXVII; Schürmann 1989,
37-38, nos 73-79. For the type
of the hydriaphoroi, their relation to
Demeter and Persephone and for the
hydrophoria see: Diehl 1964, 130-
134, 187-193; Simon 1983, 93, 99.

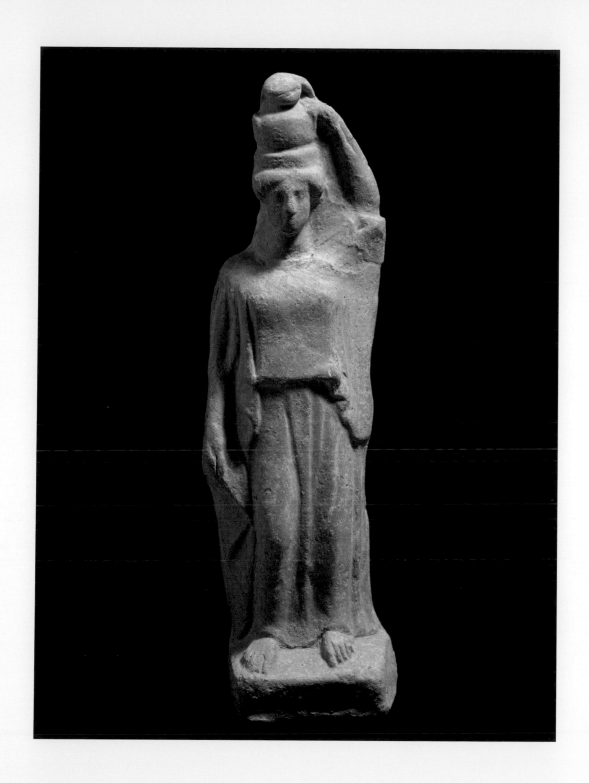

Nolan amphora

Attic workshop, Painter
of London E342

Cat no. 38
460–450 BC
Provenance unknown
Clay, wheel-made, red figure
29.2 (h with lid) x 10.7 (rim diam)
x 6.7 (base diam) cm
Acquired with the contribution
of the A G Leventis Foundation
(33631)

The amphora is intact. It also preserves its lid, from which a very small fragment is missing, now restored. The entire exterior of the vase is covered by exceptionally lustrous black glaze. On side A, upon a zone of continuous meander-pattern, is depicted a pair of standing confronted figures in a scene of conversation. On the left, a young woman clad in a peplos and with a fillet in her hair fashions a wreath of leaves, perhaps myrtle. Opposite her stands a young man, dressed in a long himation and also with a fillet in his hair, who proffers a ball or a round fruit (apple or pomegranate) with his right hand. Between the two is a duck. On both figures the fillets in the hair and the objects they hold

(wreath and fruit or ball) are executed in added red. On side B of the vase, depicted upon a zone of continuous meander-pattern, is a young male figure facing left, wearing a long himation and a fillet in the hair, and holding a stave in his right hand. Noteworthy are the traces of the preliminary drawing on all three figures, as well as the form of the lid, with the broad, flat 'button' on the upper surface. It is highly likely that the lid when inverted was very stable and could have been used as a vessel for liquid, being reminiscent in shape of the kylix.

The amphora is of the Nola type, the name given to the specific class of red-figure vases found in large number in the town of Nola in Campania, southern Italy. These relatively small amphorae, displaying a high degree of uniformity, were Attic products of the years 490-430 BC, which were almost exclusively exported to Italy.

The Benaki Museum example has been ascribed to an Athenian vase-painter with the conventional name Painter of London E342, whose identity was codified from the inventory number of the first

vase considered to be one of his works, which is in the British Museum, London.

As far as the semantics of the central representation on the amphora are concerned, the encounter between two young persons could essentially be an erotic conversation. In this case we should consider that the objects they hold are gifts to be exchanged. Moreover, the duck standing emblematically between them, apart from its affinity with the world of women, also covertly conveys its association with Aphrodite, a connotation established in these years. In any case, the making of a wreath occurs in contexts relating to preparations for marriage. If these hypotheses are correct, the identification of the object held by the man as a fruit seems not unlikely. IP

Published: Delivorrias, Fotopoulos 1997, 96, fig 138. For discussion of the iconography of the amphora see: Sabetai (forthcoming). For the Painter of London E342 see: *ARV*², 667–672, 1664.

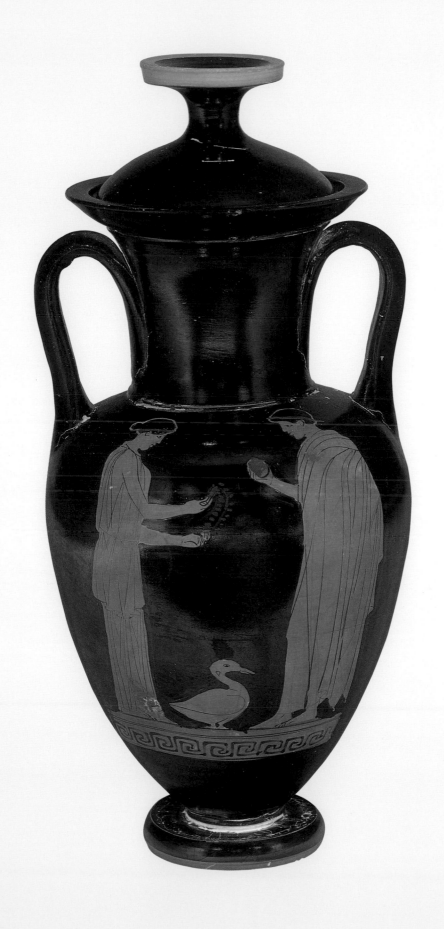

Head of a girl
Attic workshop

Cat no. 39
First half 3rd c. BC
Provenance unknown
Marble, Parian
17 (max pres h) cm
Inv. no. 35980

Represented is the head of a prepubertal girl. Her long hair, parted down the middle and framing the face, is drawn back into a braid and held in place by a fillet.

The sculpture was most probably an *ex-voto* in the sanctuary of a deity, to whom it had been dedicated by the girl's family. Votive offerings of this kind were normally made by parents to solicit the protection of their child, or as a token of gratitude if the child had been endangered by illness or some other misfortune and the deity had come to its assistance.

Children were a popular subject in Greek sculpture, particularly in the Hellenistic period. Most Hellenistic works representing children are preserved in Roman copies, confirming just how beloved these creations were in the ensuing years too.

Many sculptures of little girls, usually holding a small animal in their arms, were dedicated in sanctuaries. A large number of such *ex-votos* comes from the sanctuary of Artemis Brauronia at Brauron (pres. Vravrona) in Attica, where the goddess was worshipped as protectress of the family. According to textual evidence dating back to the fifth century BC, girls aged between five and ten years old served Artemis in this sanctuary, participating in mystic rites in which the goddess prepared them for the passage to puberty and their future role of motherhood.

Statues of little or even prepubertal girls, such as this particular example, represented sitting, offering sacrifices or simply playing with a pet, belong to a large category of Hellenistic sculpture known as genre-sculpture, principal subjects of which were the rendering of moments and persons from everyday life, a thematic repertoire with which sculptors had barely concerned themselves until that time. DD

Published: *Mouseio Benaki – Glyptiki* 2004, 114–115, no 28 (I-L Choremi).

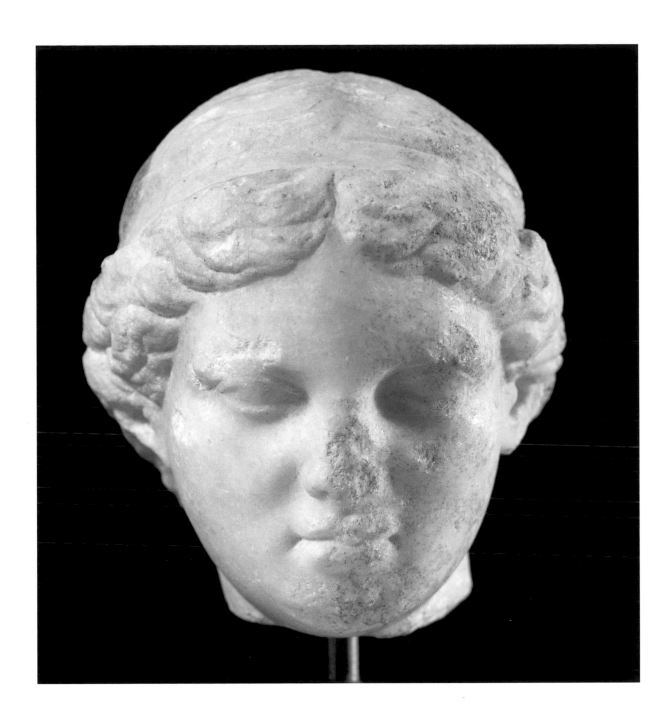

Bell krater
Boeotian(?) workshop

Cat no. 40
380–360 BC
Provenance unknown
Clay, wheel-made, red-figure
17 (h) x 17.6 (rim diam) x 8.4
(base diam) cm
Bequest of Maria Magdalini
Kousta (38369)

The krater is mended from many shards. Part of one handle has been restored. Represented on the main face is a young, naked Dionysos, sitting on his cloak, with an ivy wreath on his head. In his right hand he holds a staff with a pine-cone ornament (*thyrsos*); his head turns left, where a maenad stands. She wears a peplos decorated on the breast with a sea monster and on the lower part with little circles, corresponding to those on the god's cloak. In her left hand she too holds a thyrsos, while her right rests on Dionysos' shoulder. Her hair is drawn back in a ponytail and her head is crowned with a wreath of ivy leaves. On the god's right stands a satyr, his left arm raised and his tail passed over his right leg, watching the pair. Depicted on the back of the vase is a standing, himation-clad youth with his head turned right. Two zones of decoration, one of strokes and the other of chevrons, border the representations above and below on both sides of the krater.

The stylistic rendering of the scene on the obverse of the vase, which is associated with the cycle of Dionysos, refers to an Attic painter. However, the stroke pattern and the chevrons are not common on Attic kraters of this period, whereas they do occur on Boeotian examples. Perhaps the krater was made by a Boeotian painter who copied an Attic model, or by an Attic painter working in Boeotia.

The krater, a symposium vessel for the mixing of wine and water, was closely linked with Dionysos. God of wine and of joy, but with a paramount underworld connection, he was associated with symposia of the living as well as of the dead.

Scenes from the Dionysiac cycle, as well as analogous figures such as the himation-clad youth on the reverse, were familiar and popular in vase-painting of the fifth and fourth centuries BC. Nonetheless, fifth-century BC representations feature Dionysos-elderly and bearded, in moments of ecstasy, together with his entourage (*thiasos*), extolling the god's power and his divine gift of wine. From the late fifth and in the fourth century BC, the image of the god changes. Dionysos is now represented as youthful, as on the Benaki Museum krater, and from the Hellenistic period onwards frequently in a nonchalant pose, with faltering gait, or inebriated and leaning on a satyr or silenus for support. In this way the amalgam of the divine and the human is conveyed, signifying the turn towards the world of human sentiments, which is distinctive of the art of the post-Classical centuries. AZ

Unpublished. For attribution and discussion of the iconography of the krater see: Sabetai (forthcoming). For the iconography of Dionysos in general see: *LIMC* III, sv *Dionysos*, 414–419 (A Veneri), 509–512 (C Gaspari).

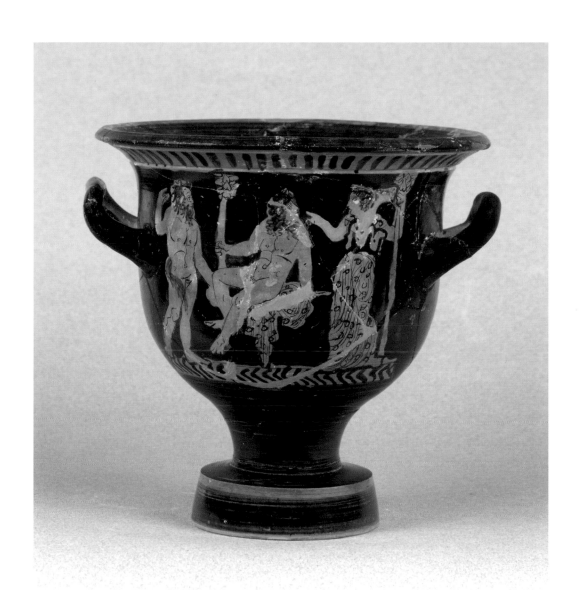

Aryballoid lekythos
Attic workshop

Cat no. 41
400–375 BC
Provenance unknown
Clay, wheel-made, painted
14.5 (h) x 3.7 (mouth diam) x 6.4
(base diam) cm
Inv. no. 7698

The vase is mended on the neck. The surface is coated with shiny glaze and is flaked in places. At the base of the neck is a zone of tongue-pattern and below the handle a composition of double palmettes, either side of which sprout spiralling stems. Depicted on the body is a scene with female figures clad in chiton and himation, and Eros. At the centre, Eros, leaning on his staff, proffers a wreath to the seated female figure looking in a mirror or beating a drum. Between them is an incense-burner. Behind Eros is a seated female figure drawing back her himation and revealing her face, which is most probably identified as Aphrodite. The representation is framed by two zones, of myrtle branch above and of egg-pattern below. The body and wings of Eros and the flesh of the female figures are rendered in added white, while the wreath, the fillet, the staff and details of the wings of Eros, the bracelet of one female figure and the myrtle berries are executed in relief clay appliqués.

Representations relating to the everyday life of women are particularly popular in Attic vase-painting from the mid-fifth century BC onwards. Scenes of nuptial preparations or of the women's quarters (*gynaikonites*) frequently decorate vases associated with the female toilet, such as arybolloid lekythoi, which were containers for aromatic oils. Aphrodite, as protectress of the family and go-between in love, had pride of place in such scenes. From the closing decades of the fifth century BC, the presence of Eros, who was initially servant and attendant of the goddess, became increasingly frequent, so that by the fourth century BC the god acquired a primal role, whereas Aphrodite was absent or portrayed as a common mortal. Eros, as spirit of the women's quarters, now intermediates energetically and plays the role of interlocutor between Aphrodite and mortals, while in scenes of preparations for marriage he accompanies the bride and assists at her bedecking.

The representation on the vase may be interpreted as a cultic offering of incense to Aphrodite, with the active participation and intermediation of Eros. The goddess, most probably identified in the figure at the right edge of the scene, is consistent with an iconography common on small vases in the fourth century BC.

The incense-burner, a vase linked with rituals and ceremonies, is often depicted in a domestic–familial milieu and in scenes of wedding preparations. Censing was mainly associated with Hera and Aphrodite, goddesses who have a direct relationship with marriage and the family, as is documented by the numbers of incense-burners recorded in the inscribed inventories of *ex-votos* in their temples.

Scenes relating to the luxurious world of women, the preference for certain deities, such as Aphrodite and Eros, the added pigments and the focus of interest on the private domain, as well as the intrusion of the divine element into the human world, are all characteristic of Attic red-figure vase-painting of the early fourth century BC. A Z

Unpublished. For attribution and discussion of the iconography of the lekythos see: Sabetai (forthcoming). For scenes relating to marriage in Attic vase-painting see: Oakley, Sinos 1993, 45–46.

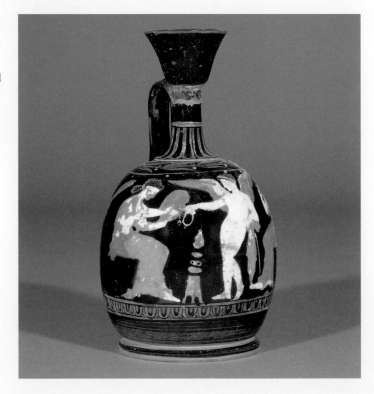

Hydria

Cat no. 42
Early 3rd c. BC
From Alexandria, Egypt
Clay, wheel-made, black-glaze,
relief, painted
36.6 (h) x 15.8 (rim diam) x 13.7
(base diam) cm
Gift of Loukas Benakis (22876)

The hydria bears an emblem with a relief female protome at the root of the vertical strap handle. The two horizontal cylindrical handles on the shoulder are bent upwards. The horizontal rim is wide and two incised lines encircle its vertical edge. The painted decoration on the neck consists of ivy leaves in white, with incised stalk and circular motifs between two zones of dots. The body is decorated with vertical ribs. The base is high with a modelled ring at its junction with the body. The paint is flaked in places.

The hydria belongs to a large class of black-glaze vases which includes mainly amphorae and hydrias, with a very few column kraters, intended exclusively for funerary use. They are distinguished by the strictly standardised system of vertical ribs, the appliqué emblems on the shoulder or the root of the handle, the characteristic painted ivy-leaf pattern and primarily

the peculiar foot, the same on all three vase shapes, with the high base and the pronounced modelled ring marking it off from the body, a transference of metal models to clay. The emblems, the majority of which bear mythological representations, are mould-made and considered to be re-workings of relief decorations on metal vessels. Their production is dated between the beginning and the end of the third century BC.

Vases of this type are found in large number in Alexandria, provenance of the Benaki Museum example, and in Crete. Their relatively frequent presence in the Cyrenaic Peninsula and their limited or sporadic appearance in mainland Greece, the Aegean Islands, Cyprus, southern Italy, the Asia Minor littoral and the Euxine Pontus (Black Sea) documents their spread to regions which were under the sovereignty or the political influence of the Ptolemies in that period.

The painted decoration of the vases with emblems is without doubt influenced by pottery of the West Slope class – a name relating to a find-spot on the west slope of the Acropolis which appeared in Athens around the end of the fourth

century BC, as well as by the coeval pottery of Gnathia in southern Italy. Studies of the existing material indicate that many of the appliqué emblems probably derive from relief decorations on southern Italian metal vessels.

Several views have been expressed concerning the place in which vases with emblems were produced, the most prevalent being that which assigns them to Alexandria. In all cases of this ware, as on the Benaki Museum hydria, Greek mainland traditions are combined creatively with southern Italian influences. AZ

Published: Aupert 1975, 592, fig 12.
For black-glaze hydriae with emblems see: Zervoudaki 1997, 107–120.

Askos
Athribis workshop, Egypt

Cat no. 43
200–150 BC
From Egypt
Clay, white, made in two moulds
10.9 (h) x 4.1 (base diam) cm
Gift of Loukas Benakis (22651)

The vase is mended from many shards and parts of the mouth, handle and body are missing. It is decorated in relief on both sides. On one side is a scene with a fox and a peasant, on the other only a duck is preserved. The peasant is elderly and on his left shoulder bears a long pole, like a scale-beam, from which hang two baskets. Behind one basket is a fox, trying to stand on its hind legs and stretching its muzzle to reach the contents. The scene is enlivened by aquatic plants and on the lower part of the vase by acanthus leaves, on one of which the peasant leans.

The subject of the vase refers to the bucolic poems of Theokritos and specifically to the *First Idyll*, which is entitled 'Thyrsis' or 'Ode' and relates the conversation between the shepherd Thyrsis and a goatherd concerning the amorous misfortunes and death of Daphnis – son of Hermes and a nymph – in Sicily. The poem contains a detailed description of the decoration of a carved wooden vase with, among other things, an analogous scene (lines 45-51). In the representation on the askos, however, there are derisory nuances characteristic of Alexandrian art in Hellenistic times and far removed from the idyllic atmosphere Theocritos describes. The poet, who hailed from Syracuse in Sicily, lived at the court of the Ptolemies in Alexandria from about 280 to 270 BC, where he wrote a large part of the *Idylls*. The vase, however, is dated to the Late Hellenistic period, thus attesting to the perpetuation of popular subjects in Theocritos' poetry for a long period in Alexandrian art.

Another two vases with a corresponding scene are known, one in Cairo and one in Stockholm. However, absent from both is the figure of the fox, along with the flora and fauna of the Nile. The fusion of elements from Egyptian iconography, such as the Nilotic landscape, with a subject from Hellenistic literature, make the Benaki Museum askos a particularly interesting example.
AZ

Published: Adriani 1966, 31-34.

Figurine of young male with breastplate

Cat no. 44
Late 4th–early 3rd c. BC
From Tanagra(?)
Clay, light brown, mould-made
21.5 (h) cm
Inv. no. 35303

The figurine is mended from three pieces and part of the wreath is missing. The youthful male figure is represented standing on a rectangular base, in frontal pose, with his head turned slightly to the left. He wears a breastplate (cuirass) over a short chiton and a himation which is fastened on the right shoulder and falls obliquely, covering the left shoulder and the chest as well as the right wrist. His weight is planted on the right leg, while the left is relaxed. A wreath crowns his short hair, which is denoted by curls above the forehead. The sandals are painted in black. The surface of the figure is coated with a thick white slip. Traces of pink pigment are preserved on the flesh and of greenish blue on the cuirass. The back is unformed, with a square firing-hole.

The work belongs to a group of figurines of conscripts in military uniform – bronze breastplate, short chiton and himation swathed around the body and fastened with a fibula on the shoulder, and frequently a wreath on the head. According to one view, these figurines of wreathed and cuirassed males represent ephebe (young male) participants in a ceremony in honour of a warrior departing for battle.

The work is included in a large class of Hellenistic terracotta figurines which made their debut in the late fourth century BC and represent moments and persons from daily life. Figurines of dancing girls, schoolgirls, boys and girls playing games, young kithara-players, soldiers, orators and actors reflect the transfer of interest from the divine to the human sphere and the more general tendency of their creators to render the inner world of the various characters, and provide valuable information on the dress, the hairstyles, the jewellery and the everyday activities of people in Hellenistic times.

The love of polychromy in Hellenistic art is reflected in the bright colours in which the figurines were painted. Chemical analyses have shown that organic (vegetal) and inorganic (mineral) pigments were used, produced from charcoal, ochre, madder, azurite and malachite, and applied to the white slip.

Most Hellenistic terracotta figurines have been found in mainland Greece, the eastern Mediterranean, Asia Minor and southern Italy, mainly in graves, and have been interpreted as companions who protected the deceased in the afterlife or as gifts to the gods of the underworld. Figurines have also been recovered in excavations of sanctuaries, where they were dedicated as *ex-votos* by devotees of the deity worshipped there, as well as of settlements, where they were perhaps used as ornaments or protective objects in the house, children's toys or even presents.
AZ

Unpublished. For the type see: Burn, Higgins 2001, 65, no 2120, pl 22.

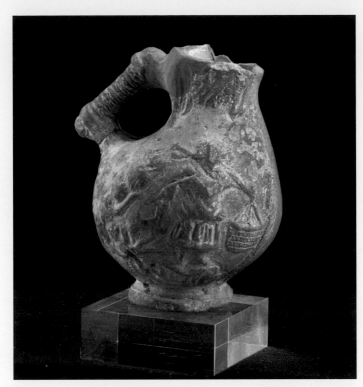

43

44

Ivy wreath

Cat no. 45
1st c. BC
From Macedonia(?)
Gold sheet, embossed, chased,
filigree, granulation, garnet
25 (diam) cm
Inv. no. 2061

The wreath comprises a tubular, open hoop from which sprout wire stems bearing ivy leaves and berries. The free ends of the circlet are inserted in terminals decorated with filigree and granulation, which fasten by means of two loops which interlink and are masked by a garnet set in a granulated bezel. The front part of the hoop is decorated by a radiate ornament of granulated circles and triangles.

Gold wreaths come mainly from royal tombs of Macedonia, Asia Minor and southern Italy. The earliest metal wreaths known date from the seventh century BC and were votive offerings. The majority of gold wreaths, which are almost exclusively finds from funerary contexts, date to the second half of the fourth century BC and to certain phases of the Hellenistic period which are distinguished by an abundance of gold jewellery. These are exquisite examples of the goldsmith's art of Hellenistic times, rendering with particular sensitivity and detail the foliage and the fruits of the plant they represent.

Gold wreaths imitate natural ones. The preference for a particular plant species was presumably related to the deity worshipped by the family of the deceased or by the wider community to which he belonged. Wreaths of myrtle are associated with Aphrodite, Demeter and Persephone, of oak with Zeus, of olive with Athena and of ivy with Dionysos. Ivy wreaths, however, are rather rare, even though of all the mystical deities of vegetation Dionysos was the most closely connected with death and rebirth. This fact is perhaps related to the popularity of the god, mainly among the commonfolk, who obviously could not afford to wreathe their dead with gold and used actual ivy in its place.

Wreaths from real plants were very widespread in antiquity. They were presented as prizes to the victors in games and contests, they were an essential element of attire in cultic rites and other ceremonials, and were a precondition for participation in the games of the Dionysiac festival known as the Anthesteria. They later appeared at secular symposia, in which the male participants were wreathed.

The earliest clear archaeological evidence of the wreathing of the dead dates from the sixth century BC. According to the teachings of ancient Greek eudemonic philosophy, which finds its moral standard in the tendency of actions to produce happiness, the gods led the righteous dead to Hades, where they offered them a banquet for wreathed participants. The crowning of the dead with a wreath signified that they were worthy of demanding and being rewarded with eternal life after death. The deep-rooted faith in these beliefs is frequently expressed by the contents of the grave too, which include not only wreaths but also symposium vessels.

The ancient sources refer also to a large number of gold votive wreaths in temples and sanctuaries. These *ex-votos* of usually affluent individuals or rulers of foreign states enriched the treasuries of the temples and were used by the official priesthood in religious processions or as prizes in games.
AZ

Published: *Benaki Museum Greek Jewellery* 1999, 242, no 87 (E-B Tsigarida). For wreaths in general see: Despini 1996, 25–28 and cf fig 1; Williams, Ogden 1994, 30, 31, 37.

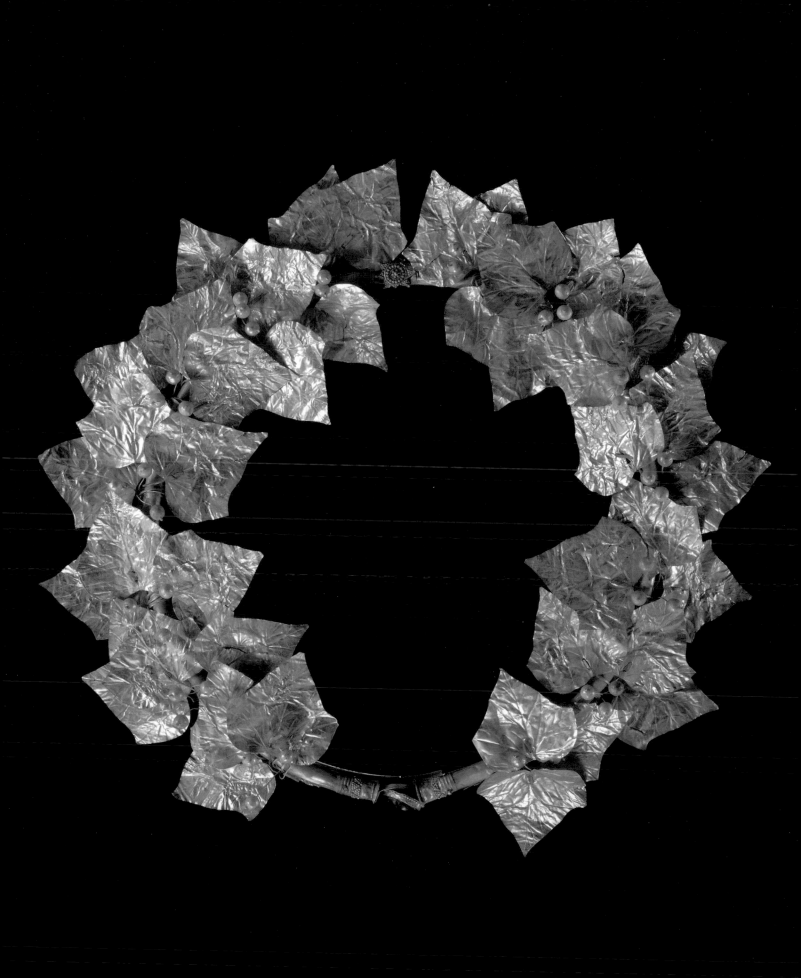

Earrings with amphora pendants

Cat no. 46
2nd–1st c. BC
Provenance unknown
Gold sheet, filigree, glass paste
3 (h) cm
Inv. no. 7333

The earrings consist of discs and amphora pendants. The disc is embellished with an appliqué multi-petalled rosette outlined in twisted wire, with a globule at the centre. On its lower part are two spiral motifs with chains formed from links alternating with globules. The main body of the vase is of white and blue glass paste, while the neck, the handles and the lower part, together with the base, are of gold sheet. On the shoulder and the lower body of the amphora is tongue-pattern of twisted wire, with globules. One chain is missing from one earring and the gold sheet of the discs is in a fragmentary state on both.

Earrings consisting of discs and pendent elements in a diversity of shapes were particularly popular during the Hellenistic period. Small amphora pendants prevailed in the second century BC. Frequently, as on this example, the body of the vase is fashioned from semiprecious stones or glass paste.

The earrings are worked in filigree, a technique which was known from the third millennium BC in Mesopotamia, Syria and Asia Minor, and appeared in Greece, in Crete, c. 2000 BC. In this technique, wires of varying thickness and shape are used usually to decorate a sheet-metal surface, as here, or more rarely to create openwork lacy patterns in which the wires are soldered to each other, not to a solid ground. In contrast to openwork filigree, the application of filigree to a ground enjoyed wide dissemination and remarkable longevity, surviving without interruption into recent times.

During the Hellenistic period, with the conquest of Asia and North Africa by Alexander the Great and the appropriation of the treasuries of the subjugated lands, there was a spectacular rise in gold-working in Greece, while precious stones inundated Greek markets as products of trade and relations with the East. The jewellery of the Hellenistic period, from the late fourth to the mid-first century BC, is distinguished by the conspicuous display of luxury, the ever-increasing use of precious and semiprecious stones, and the enrichment of the thematic repertoire with oriental elements.
AZ

Published: *Benaki Museum Greek Jewellery* 1999, 174, fig 119. For the type see: *Gli ori di Taranto* 1989, 134–135, no 80 (T Schojer); Higgins 1961, 166, pl 48G; Despini 1996, 35, fig 102.

Necklace with spear-head pendants

Cat no. 47
Late 4th c. BC
Provenance unknown
Gold sheet, repoussé, granulation
30.2 (l) cm
Inv. no. 2099

The necklace consists of a braided strap formed from interlinked loop-in-loop chains, and spear-head pendants. Attached to the lower edge of the strap are wire loops, masked by six-petalled rosettes from which the pendants hang by a wire ringlet. The ends of the strap are affixed to square sheets decorated with repoussé lion-heads, to which rings have been soldered. Two rosettes and one spear-head pendant are missing. The absence of a hook on the terminal of the necklace perhaps indicates that it was originally worn on the chest, affixed to the fibulae which held the garment in place on the shoulders.

Braided strap necklaces with pendants appeared after the mid-fourth century BC and spread throughout the Hellenic world, from southern Italy to Asia Minor and from southern Russia to Egypt. Documented in excavations, principally as grave goods but also as *ex-votos*, they can be distinguished as two types depending on the shape of their pendants, which are either spear-heads or vases. Necklaces with vase pendants were more popular, as attested by their survival into the early second

century BC. The fashion for spear-head pendants does not seem to have outlived the early third century BC.

Necklaces of this type are mentioned in the inscribed inventories of the votive offerings that belonged to the temple of Artemis on Delos, from the year 279 BC onwards. One necklace with spear-head pendants is recorded as an offering from an aristocratic lady named Simiche from the island of Mykonos. Testimonies concerning the cult of the goddess on Delos, particularly during the Hellenistic period, as helpmeet in childbirth and protectress of the family, shed light on the nature of these *ex-votos*. These qualities are enhanced by a version of the myth claiming that Artemis was born on Delos, shortly before her brother, and promptly helped their mother Leto to deliver Apollo.

The dedication of gold jewellery in the Delian sanctuary of the goddess, possibly by women about to give birth or who had just given birth, thus acquires a specific dynamic, especially in the light of some faint indications of the significance of jewellery, other than simply for adornment, for women of reproductive age in antiquity. AZ

Published: Walter 1940, 140–143, fig 17. For the type of necklace see: Hoffmann, Davidson 1965, 4–5; Williams, Ogden 1994, 74, no 30; Despini 1996, 22–23, 38–39, figs 147–152. For the cult of Artemis on Delos see: *LIMC* II, 751, sv *Artemis* (L Kahil).

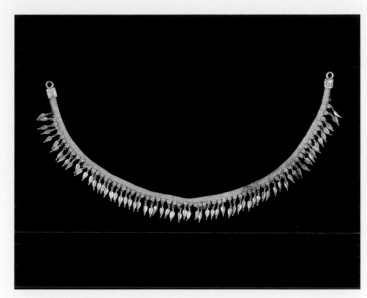

Pendant with bust of Aphrodite and Eros

Cat no. 48
Late 2nd c. BC
From Alexandria, Egypt
(former Antoniades Collection)
Gold sheet, repoussé, chased,
garnet, glass paste
3.3 (h with loop) cm
Inv. no. 1750

Represented on a gold-sheet disc in high relief is the bust of the goddess, with Eros on her shoulder. She wears a long-sleeved chiton and a himation, and a diadem set with a lunate garnet. Her left arm is bent across her breasts with the hand touching her right shoulder. An Eros with childlike hairstyle looks over her left shoulder, holding her with his hands. Above her right shoulder is an appliqué rosette with filigree decoration and globule at the centre. The necklace, the hair and the facial features of the goddess are rendered by chasing. The drapery of the chiton and the wings of Eros are denoted by repoussé dots. A relief band of spherical and spool-shaped motifs encircles the disc. On the front of the loop is a bezel set with green glass paste.

The vibrant contrast between the red garnet and the green glass paste is heightened by the gleam of the gold. The sense of polychromy thus achieved, in conjunction with the flawless execution of the head of Aphrodite, reflect the more general trends in Late Hellenistic jewellery. The same organisation of the composition, the position and pose of the torso within the disc, and primarily the pronounced repoussé head, are encountered on corresponding medallions from well-known assemblages of finds securely dated to the second half of the second century BC down to the early first century BC, which date is proposed for the Benaki Museum example.

Initially the piece must have been worn hanging from a chain, as an amulet, although its possibly funerary use cannot be precluded. Comparable medallions have been found in settlements, such as on Delos, and in cemeteries, such as in the Late Hellenistic grave at Pellina in Thessaly. The subject represented does not rule out the dual use of the piece, given that Aphrodite, like many other deities, belongs to both the earthly world and the underworld. Aphrodite, goddess of love, protected lovers, marriage and the family, but was also linked with death, in her initially chthonic hypostasis. Eros, her son, who originally had nothing to do with death, also began from Hellenistic times to appear on grave goods, such as terracotta figurines or pieces of jewellery, while he acquired explicit mortuary symbolism during the Roman period. AZ

Published: Segall 1938, 133, no 202, pl 42; Delivorrias, Fotopoulos 1997, 117, fig 170; *Benaki Museum Greek Jewellery* 1999, 224, no 78 (K Meletakou).

Pair of bracelets

Cat no. 49
Late 2nd–1st c. BC
From Alexandria, Egypt
Silver-gilt sheet, chased,
punched
6–6.4 (diam) cm
Inv. nos 1722, 1723

The bracelets consist of a double coil of gilded silver sheet, with one end terminating in the head of a snake, the other in the tail. A central rib runs down the entire length of the outer surface. Close to the head and the tail of the snake, the scales are indicated by chasing. The remaining surface is devoid of decoration. One bracelet is mended.

Snake bracelets have a long tradition in Greek jewellery. The earliest type, made of bronze or silver and with a snake-head on both terminals, dates back to Geometric times and was diffused during the Archaic and Classical periods. In Hellenistic times, perhaps under the influence of serpentine symbols associated with Egyptian cults – such as the Egyptian cobra symbol (*uraeus*) – snake bracelets took on a new form and their protective character was emphasised. From the early third century BC they were rendered as full-bodied coiling snakes with distinct head and tail, a type which held sway with minor variations in the ensuing centuries.

Snake bracelets were extremely popular in antiquity, both because their shape fitted snugly on the wrist, achieving a highly attractive effect, and because they had apotropaic properties. Their geographical spread is wide: they have been found in Greece, Italy, Cyprus, southern Russia and Egypt. They are frequently depicted adorning women's arms in vase-painting and in objects in the minor arts, as well as in the funerary portraits from Fayum. The snake, chthonic symbol linked with fertility and rebirth, was an attribute of many deities, such as Athena and Asklepios. Popular beliefs in the protective properties of snakes were deeply rooted in antiquity, as attested also by the cult of the *oikouros ophis* (household snake), the guardian-protector of the house. Indeed, one of the cults of Zeus was of the ephestian god (patron god of the household), in which he had the form of a snake, as did his sons the Dioskouroi. AZ

Published: Segall 1938, 125, no 181; *Benaki Museum Greek Jewellery* 1999, 245, no 88 (S Pingiatoglou).

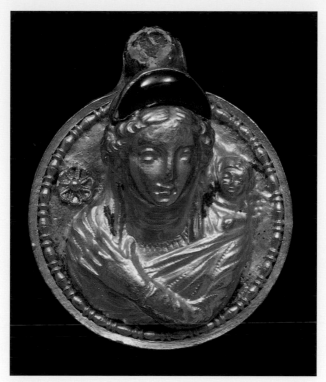

48

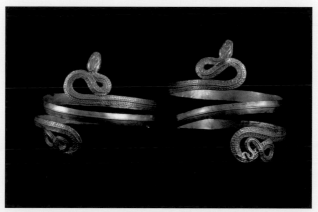

49

Head of a statue of Paris

Cat no. 50
2nd c.
From Crete
Marble, Pentelic
32.5 (max pres h) cm
Gift of Spyros and Korina
Skarpalezos (31318)

The Trojan Paris, son of Priam and Hecuba, is represented in a Phrygian cap, the characteristic headgear of shepherds. His hair forms small spiralling curls beneath the cap, the nose is fine and straight, the half-open mouth reveals the upper teeth. The surface of the face is smooth, in contrast to the sides and the back of the head, on which tool-marks are visible. The head inclines slightly to the right.

According to the ancient myth, when Hecuba was pregnant she dreamed that she would give birth to a flaming torch. An *oneiroscopist* (interpreter of dreams) foretold that the child would bring the destruction of Troy and urged her to kill the infant at birth. But Hecuba decided to leave her newborn son exposed in the mountains of Troy, where he was found by shepherds who brought him up until he came of age and returned to the royal family. The cap alludes to those years that Paris spent in the mountains, in the company of the shepherds.

The sculpture can be restored on the basis of surviving works of Roman times, which copy an earlier statue type. Paris is shown standing, with legs crossed, leaning on a tree trunk. In some cases he wears a short himation hanging behind on the back, in others he is nude. The pose of the body is comparable to that of known statues of the fourth century BC, thus it could be argued that the head copies works of that time. However, the spiralling curls falling in front and at the sides, and the details of the face, which are characteristics of fifth-century BC sculptures, lead us to the conclusion that the original work is a Classicistic creation of the first century BC or the first century AD. In those years, earlier statue types of Classical times were remodelled and adapted to the taste of the Early Roman period. DD

Published: *Mouseio Benaki – Glyptiki* 2004, 240–241, no 67 (O Palagia).

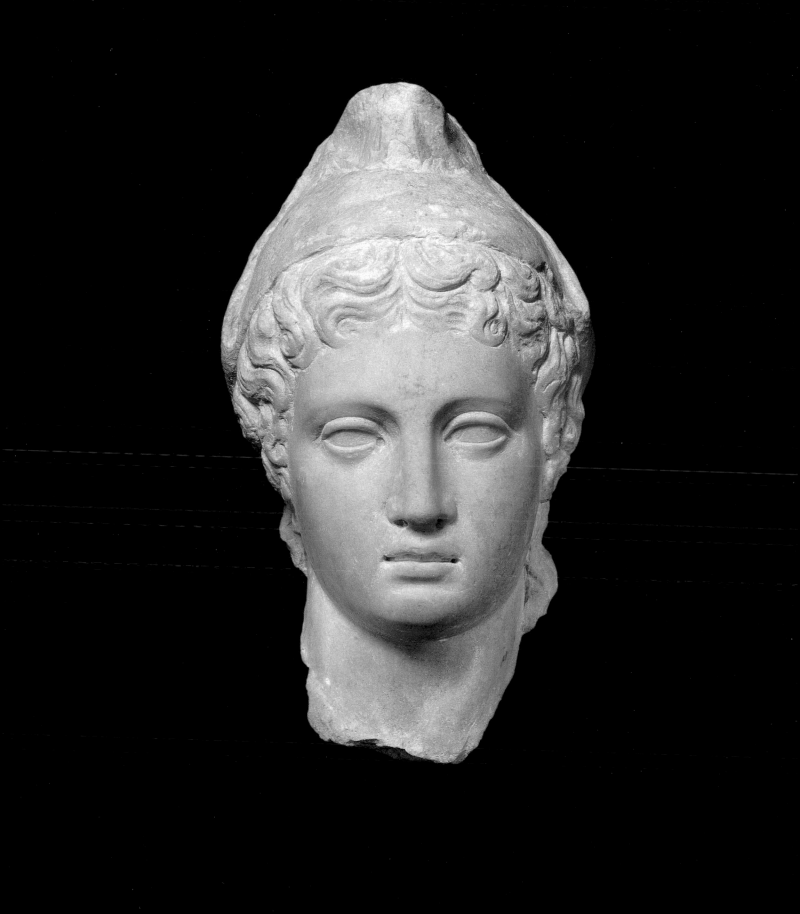

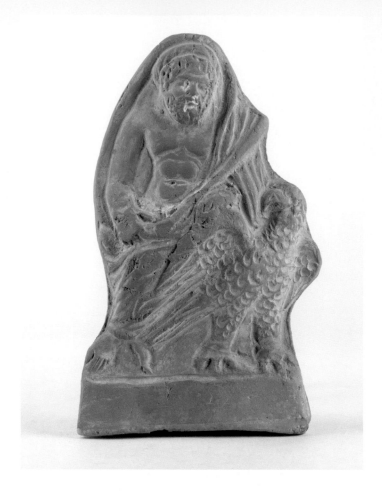

Figurine of Zeus with eagle

Cat no. 51
Mid-2nd c.
From Egypt
Clay, reddish brown, mould-made
15 (h) cm
Gift of Loukas Benakis (12831)

Zeus is represented on a plain, rectangular base, seated behind an eagle with outspread wings. He wears a himation covering his head, left arm and legs but revealing his feet, abdomen, chest, and right arm and hand, with which he holds the garment. His sceptre rests upon his left forearm. His face is turned slightly to the right and he has a thick beard. A fillet adorns his luxuriant curly hair. Preserved are traces of the white slip which coated the surface of the figurine and was the base for the added pigments. The back of the figurine is roughly formed, with a round hole through which the hot air circulated to prevent cracks during firing.

Egyptian terracotta figurines of Zeus are few in number. With minor differentiations in individual motifs, virtually all present the same iconographic type, in which it is not clear whether Zeus sits upon the eagle or upon a seat behind it. The similar representations of the subject on Roman coins of the second century AD show Jupiter (Zeus) clearly sitting upon his eagle. This is an iconographic type unknown in Greece, which draws its inspiration from a motif of oriental origin, of a god mounted upon a bird.

The gods of the Greeks were known in Egypt from the seventh century BC, with the first settlement of Greeks in that land. However, the official introduction of their worship took place under the first Ptolemies during the last quarter of the fourth century BC, initially in Alexandria, the Ptolemaic capital, from where it was disseminated to the whole of Egypt. According to the

testimony of the Alexandrian coinage, cults of the Greek gods constituted an important part of public worship until Late Roman Imperial times, the closing years of the fourth century AD.

According to myth, Zeus was brought up by the two daughters of the King of Crete, Ida and Adrasteia, to whom he was entrusted by his mother Rhea in order to save him from his father Kronos, who swallowed his children. The princesses fed their charge on ambrosia and the milk of the she-goat Amalthaea, whose horn filled with goods (cornucopia) symbolised abundance. The eagle took part in his upbringing too, becoming one of the god's attributes, along with the thunderbolt and the sceptre. AZ

Published: Pingiatoglou 1993, 60, no 60.

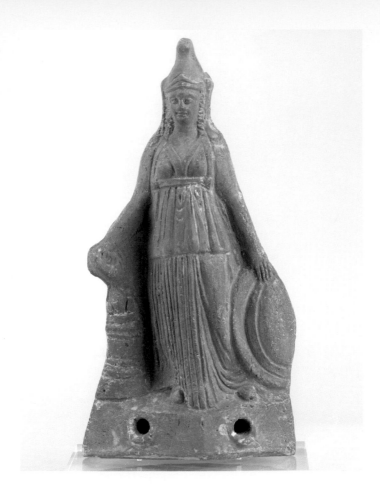

**Modelled lamp in
the form of Athena**

Cat no. 52
1st–2nd c.
From Egypt
Clay, reddish brown, mould-made
19.3 (h) cm
Gift of Loukas Benakis (22920)

The goddess is represented in frontal pose on a rectangular base with two holes for filling the vessel with oil. Her weight is placed on the right leg, the left is slightly bent and drawn behind. With her left hand she steadies her shield, standing on the ground beside her, while in her right hand she holds a phiale. She wears a peplos girdled high on her chest, and a crested helmet. To her right, on the ground, is a little altar. The back of the figure is not formed and has a round firing-hole.

The iconographic type of Athena in Egyptian statuettes of Hellenistic and Roman times is Greek, strongly influenced by Attic art. The goddess is always shown helmeted, usually holding a shield in the left hand and a phiale or sometimes a spear in the right. Occasionally she wears an imbricated aegis, without snakes, with or without a *gorgoneion* (the monstrous daemonic face of the Gorgon, which averts evil).

The worship of Athena in Egypt, apparently limited during the Hellenistic period, enjoyed wide diffusion during Roman times thanks to the support of the Roman emperors. Its spread was favoured by the identification of Athena, patron goddess of Athens, with local Egyptian deities, primarily with the martial goddess Neith, who was protectress of the city of Sais, one of the largest in Egypt, located on the Nile Delta.

The martial hypostasis of the goddess Athena, already crystallised in Archaic times, is rooted in the Bronze Age. In the Linear B tablets from Knossos on Crete she is referred to as Potnia (Mistress) and in the Homeric epics she appears as protectress of the Mycenaean citadels and of their royal lineages. These qualities are echoed in the myth cited by the Greek historian Herodotus (*c.* 480–420 BC) concerning the goddess's dispute with Poseidon over the domination of Athens, which must date back to Archaic times (VIII, 55). According to this myth, the citizens preferred Athena, after whom the city was named, when on striking the sacred rock of the Acropolis with her spear an olive tree sprouted, whereas when Poseidon struck the rock with his trident, salt water gushed forth. AZ

Published: Pingiatoglou 1993, 54, pl 2δ. For the type of Athena see: *LIMC* II, 1045, no 3, 1048, sv *Athena* (H Cassimatis).

Figurine of crouching Aphrodite
Egyptian workshop

Cat no. 53
1st–2nd c.
From Egypt
Clay, brownish grey, made in two moulds
15.7 (h) cm
Inv. no. 21815

The figurine is partially preserved. Missing are the right leg from the thigh and the left foot. The goddess is represented crouching, as evident from the position of the legs. Her hair, crowned by a wreath, is parted down the middle and drawn to the sides, forming modelled locks which she clutches with her hands at the height of the ears. The left arm rests on the knee. The back of the figure was made in a separate mould.

The original type of crouching Aphrodite taking her bath was created by the sculptor Doidalsas, as a commission from King Nikomedes I in Bithynia, in 264 BC. Copies of crouching Aphrodite are extremely rare in mainland Greece during the Hellenistic period, whereas the type was very popular in the eastern Mediterranean. Encountered mainly in Egypt, the Near East and Rhodes, its popularity continued into Roman times. A variation of the crouching Aphrodite, with Eros behind her, on the right, considered to have been created in the eastern Mediterranean region in the first century BC, appears on the reverse of Roman coins from Bithynia and in the Roman copyist tradition.

The Benaki Museum figurine is a miniature remodelling of the type by Doidalsas, with elements from the iconography of Aphrodite Anadyomene, which represents the goddess standing and nude at the moment she is emerging from her bath, wringing her wet hair with her hands.

Terracotta figurines in general could have served more than one purpose. In the absence of specific information on the context in which the Benaki figurine was found, it is difficult to determine its original use. Since it represents a divine figure, however, and indeed one of those most frequently occurring in Egyptian figurines, it might have been an *ex-voto* in a sanctuary or a grave good, without excluding its possible use as an ornament for the decoration of the house. In those figurines that imitate works of monumental sculpture, ideological expedience or simply dependence on current fashion might be detected. AZ

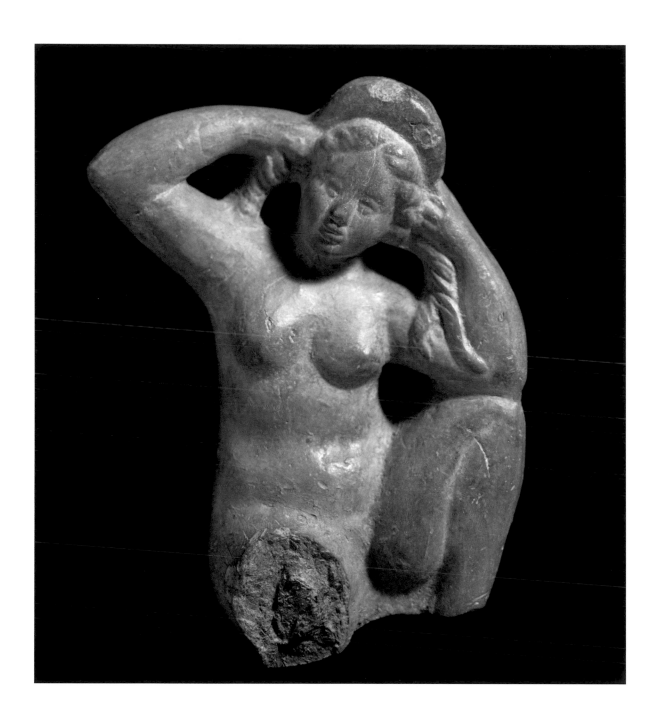

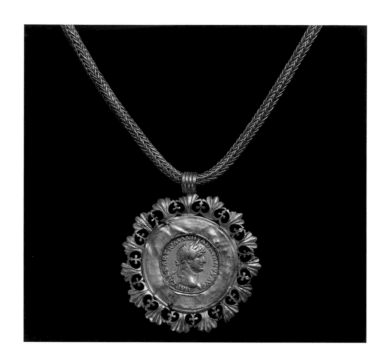

Chain with coin pendant

Cat no. 54
3rd c.
Provenance unknown
Gold sheet, pierced work,
embossed
Chain 31 (l) cm;
pendant 4 (diam) cm
Inv. no. 1640

A bezel-set gold coin of Hadrian (AD 117–138) hangs from a thick, tightly braided chain. The mount consists of a plain flat band, around which is a row of pierced-work multi-leafed palmettes separated by small trefoils.

Jewellery in pierced-work technique, known from the Latin sources as *opus interrasile*, constitutes a separate branch of the goldsmith's art of Late Roman and Early Byzantine times (see cat nos 77, 78). The designs were traced with a fine-pointed tool onto a gold sheet and then began the process of piercing the ornament on a slab of wax or resin, with a sharp iron chisel. *Opus interrasile*, a purely Roman contribution to the existing techniques, dominated the art of jewellery throughout the Mediterranean from the third to the seventh century AD. The first notable creations in this technique were the frames of pendants with medallions, precious stones or cameos and mounted coins, as in the example discussed here. The delicately worked compositions of the pierced-work frames feature vegetal motifs, such as stems or scrolls – plain, ivy and vine – and palmettes, subjects of Hellenistic origin which enjoyed wide dissemination in all regions of the Roman realm, demonstrating the strong influence of Hellenic tradition.

The practice of mounting coins, known from Hellenistic times and the years of the Roman Republic, was established from the third century AD and soon became a tradition. It was perhaps a means of saving in a period of spreading inflationary pressures and political instability, or maybe a phenomenon of fashion. The savings theory is supported by the discovery of many hoards – presumably hidden out of fear of a possible enemy attack, as attested by the historical events of the period – which include a wide variety of coins and jewellery items of the third and fourth centuries AD. Later, from the reign of Constantine the Great (AD 324-337) onward, pieces of jewellery of this type were as a rule offered as imperial gifts to state officials on special occasions.
AZ

Published: Segall 1938, 91, no 106, pl 31; Delivorrias, Fotopoulos 1997, 158, fig 275; *Benaki Museum Greek Jewellery* 1999, 265, no 99 (A Yeroulanou); Yeroulanou 1999, 33, no 35.

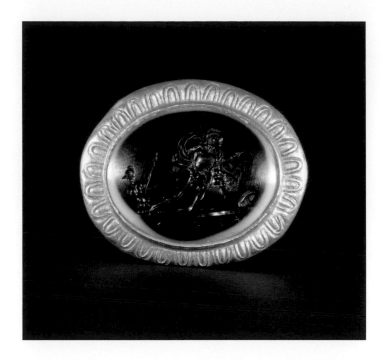

Signet ring

Cat no. 55
1st–2nd c.
Provenance unknown
Gold sheet, chased, banded
agate intaglio
3.5 (diam) cm
Inv. no. 2091

The oval bezel of the ring, of gold sheet with chased decoration of tongue-pattern, is set with an agate gem with intaglio representation of Menelaos bearing the corpse of Patroklos. The dead warrior's armour is stacked at the left, his shield nearby. Under the ground-line is the name of the ring's owner, ΑΡΙΣΠΟΣ (Arispos), written from left to right. When impressed on clay or wax, the intaglio device of the gem appeared in reverse, and the name could then be read correctly. The sealing thus produced by the signet ring was equivalent to the owner's signature.

The representation renders a dramatic episode narrated in rhapsody XVII of Homer's *Iliad*. Patroklos persuaded Achilles, who was sulking in his tent and refusing to fight after his quarrel with Agamemnon, to let him don his panoply, in order to defend in his stead the Achaean fleet, which was in danger of being set alight. Carried away by the battle into which he forced his adversaries, Patroklos advanced as far as the walls of Troy, invoking the wrath of the god Apollo, protector of the Trojans, who disarmed him by smashing the spear in his hands, untying his breastplate, and throwing his shield and helmet to the ground. Two of the Trojans, Euphorbos and Hektor, killed Patroklos and took his armour and weapons, so provoking a full-blown battle to retrieve the corpse. Menelaos slew Euphorbos and rescued the dead body of Patroklos. It is this moment which is shown on the agate gem.

The representation is known from several life-size Roman marble sculptures, thought to be copies of a Hellenistic bronze original of the third century BC, in which Menelaos is portrayed helmeted, as on the ring, raising the corpse of Patroklos, whose left arm and head hang down limply. The popularity of the subject is attested by the frequency with which similar representations appear throughout the Roman Imperial period. AZ

Published: Delivorrias, Fotopoulos 1997, 159, fig 278; *Benaki Museum Greek Jewellery* 1999, 260, no 97 (A Oliver, Jr).

Bracelet

Cat no. 56
3rd c.
Probably from Egypt
Gold, engraved, chased, sardonyx
7.5 (diam) cm
Inv. no. 1739

The hoop of the bracelet is of thick wire twisted into a cable pattern and terminating in ribbed capsules, to which are soldered the fastening and the hinge. The clasp is formed from two wires tied in a 'Herakles knot' (reef knot), with bead-and-reel pattern on the inner side. Mounted at the centre is a truncated conical sardonyx framed by semicircular decorative motifs.

Twisted-wire bracelets of this type were in vogue during the third and fourth centuries AD. In fact they were in such high demand that from the third century onward it is very possible that they were made by casting to speed up production.

The 'Herakles knot' is one of the most widely diffused decorative motifs in Greek and Roman jewellery, and is also encountered frequently in other art genres. Its origin should be sought in Egypt, where it occurs from the second millennium BC and lived on into the time of the Ptolemies. It consists of two antithetically interlocking loops which form a knot. It is not known why it was named the 'Herakles knot'.

According to one explanation, the name is due to the frequent representation of Herakles, common already from Archaic times, with the two front legs of his lion-skin tied in the same manner on his chest. From the mid-fourth century BC, the Herakles knot dominates in jewellery, especially as the central motif on diadems and necklaces. Its popularity should be related to contemporary ideologies on man's fate after death, immortality and beliefs concerning the heroisation of the dead, which the allusion to Herakles – the Hellenic hero *par excellence* from the fourth century BC onward – served. However, the wide dissemination that the Herakles knot enjoyed as an ornament in its own right is due to popular belief in its protective, even therapeutic properties. The Roman author Pliny the Elder (AD 23-79) mentions in his *Natural History* (*NH* XVIII 17, 63) that the wound bound with such a knot healed quicker. AZ

Published: Segall 1938, 130, no 193, pl 41. For the 'Herakles knot' in general see: Despini 1996, 14.

Bracelet

Cat no. 57
3rd c.
From Egypt
Gold, engraved, chased, sardonyx
6.5 (diam) cm
Inv. no. 1735

The bracelet is of thick wire twisted into a cable pattern, with snake-head terminals fashioned separately in a mould and soldered to the ends of the open hoop. The individual details are engraved and chased. Loops soldered to the snake-heads, on both sides of the central ornament, form the fastening and the hinge of the bracelet. The clasp comprises a disc-shaped mount, set with a conical sardonyx at the centre.

The bracelet is of the twisted-wire type, like cat no. 56. Its simplified form and marked schematisation, and the prominence of the semiprecious stone in its decoration, are characteristic of Late Roman jewellery in general.

The snake is one of the most widespread decorative subjects in Greek and Roman jewellery.

Even when it is used as a partial rather than a central decorative element, as in examples from Hellenistic times (see cat no. 49), it embodies conscious references to its apotropaic power. In Egypt, in particular, from where the Benaki Museum bracelet comes, the snake played a principal role as symbol of fertility and of life after death, in mystery rites linked with the cult of the Egyptian goddess Isis-Thermutis and of the deity Dionysos-Sabazios – a conflation of qualities of the Greek god Dionysos with the Phrygian god Sabazios. The great popularity of mystery cults in Late Hellenistic and Roman times in Egypt led to the enrichment of the snake's semantics and the consolidation of its mystical character.

The frequent appearance of the snake in Egyptian jewellery of this period probably alludes to the reptile's quality as a fertility symbol, though without precluding possible references to the hypostasis of a specific deity. Such a potent symbol must have endowed the bracelets' wearers with special power. AZ

Published: Segall 1938, 128, no 190, pl 41.

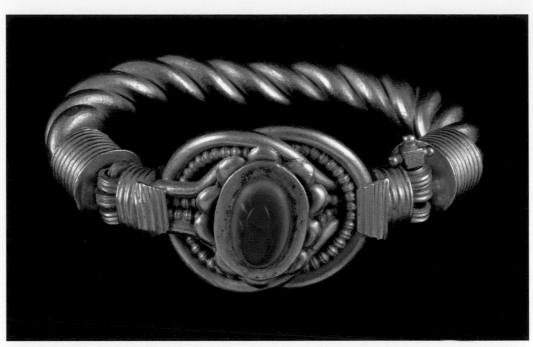

56

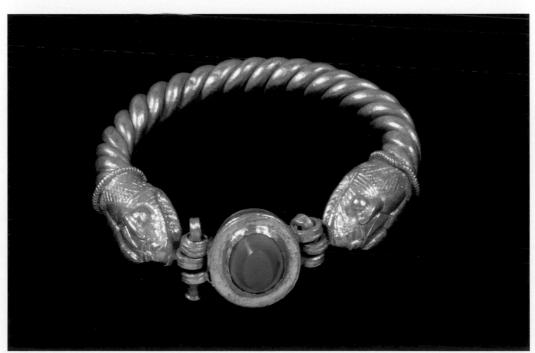

57

Plaque with Aphrodite

Cat no. 58
2nd c.
From Egypt
Bone, carved in relief
15 (h) x 4.6 (w) cm
Gift of Loukas Benakis (18854)

The white, convex plaque is mended from two parts. A crack runs down the length of the bone, through the torso and between the legs of the figure. The goddess Aphrodite is represented standing and naked, with her head turned slightly right. Her arms are bent at the elbows and she holds a shell at the height of the abdomen. Discernible behind the right, firmly placed leg is an object which resembles an altar, while beside the left leg, slightly flexed at the knee, is a vase reminiscent of a lagynos (pitcher). A peplos spreads in an arc behind the figure's head. The anatomical details and the outlines are rendered with plasticity, the facial features and the hair are carved with care, the wavy tresses on the forehead and the details of the shell are picked out by very fine incisions. The surface is lightly polished.

The iconographic type of Aphrodite on the Benaki Museum bone plaque is unique. The subject alludes to the Knidian Aphrodite, c. 340 BC, the most famous statue by Praxiteles. The sculpture, created for the sanctuary of the goddess at Knidos in the Asia Minor littoral, is the first known representation of the goddess completely nude, trying to cover her abdomen and pubes with her hand because she has been surprised while taking her bath. This type of the Knidian Aphrodite was very influential, as is apparent from the many subsequent variations. The shell is undoubtedly one of the most characteristic attributes of the goddess, but the way in which she uses it to cover the pudenda is alien to the statue types of Aphrodite, who is traditionally, almost invariably, represented naked. It is obvious that the craftsman who carved the plaque created his own iconographic type, by selecting traits from various representations of the goddess and combining virtually all her attributes.

Bone plaques, encountered in Egypt from 3000 BC, enjoyed a particular heyday in late antiquity. They were used to revet luxurious items of furniture or vessels associated with the female toilet and caskets intended for the safekeeping of precious objects. The precious metal or ebony caskets of wealthy dignitaries were clad with appliqué or inlaid ornaments of silver or ivory, where as those destined for the less affluent classes were made of wood and clad with metal strips or bone plaques which imitated ivory.

Little is known about the technique of their manufacture. Usually various tools, such as chisels or knives, were used to carve the surface and pointed tools to incise the facial features or anatomical details. Flaws in the plaques were masked by adding ceromastic (mixture of wax and natural resin) and lastly the representation was coloured with basic pigments such as red, black and pink to achieve a polychrome effect. Frequently several plaques were joined together with nails or glue to create a larger decorative composition.

The iconography of the bone plaques is normally drawn from mythology, with a particular penchant for Aphrodite, the Nereids and the cycle of Dionysos. Very often gods are represented in renowned statue types. According to one view, the frequent representation of Aphrodite – patron deity of marriage and the family – on the revetments of wooden caskets is due to the fact that these were intended as wedding gifts. AZ

Published: Marangou 1976, 112, no 138, pl 37a. For the use and technique of bone carvings see: Loverdou-Tsigaridas 2000, 33–64.

Plaque with Dionysos

Cat no. 59
2nd c.
From Egypt
Bone, carved in relief
15 (h) x 5.1 (w) cm
Gift of Loukas Benakis (18904)

The white bone plaque is slightly convex. A small part of the right side is missing. Dionysos is represented standing, naked, with his legs crossed left over right and his head inclined slightly towards the left shoulder. The right arm, bent at the elbow, is raised above the head. A himation falls from the left shoulder; the left arm rests on a partly preserved pillar. Remnants of an ivy wreath are visible on the head. The wavy hair hangs on the shoulders. The anatomical details are assiduously rendered, the outlines are clear and lightly rounded, and the facial features are modelled with plasticity. Discernible in the field, behind the figure's legs, is a panther with stippled pelt and head turned right. To the right of the figure, a bunch of grapes hangs from a stalk. The plaque has two rivet-holes. The surface has been polished.

Dionysos is represented with his attributes, the panther and the bunch of grapes, and is rendered in a statue type which is considered to be a transcription of Apollo Lykeios, a work by Praxiteles of the mid-fourth century BC. The original stood in the gymnasium known as the Lyceum, the oldest and largest athletics and intellectual foundation in Athens, frequented by Socrates (469-399 BC), who taught there, and where Aristotle (384-322 BC) established his Peripatetic School of philosophy around 335 BC. The gymnasium was named after the old sanctuary of Apollo on the same site, who was worshipped as protector of flocks of sheep from wolves (lykoi). The type of Apollo Lykeios is known in Attic sculpture through numerous copies and variations.

Dionysos, son of Zeus and Semele, god of the creative force which fertilises Nature, was, along with Aphrodite, one of the favourite deities of the ancient Greeks. The cult of Dionysos enjoyed wide dissemination in Egypt and played a significant role in the religious policy of the royal family, from the first Ptolemies down to Cleopatra VII (69-30 BC) and Mark Anthony (83-31 BC). The Ptolemies, wishing to stress their divine origin, placed the cult of Dionysos in the service of their personal glorification and political propaganda. The Roman emperors inherited and continued the same policy, supporting the Dionysiac cult and the mysteries until late antiquity.

Dionysiac subjects, the god Dionysos alone or with Ariadne and members of his entourage (thiasos) – satyrs, silenes, maenads, Pan, etc. – were extremely popular in Egypt. In addition to their presence in monumental art, such as on many sarcophagi, which reflects the tastes and preferences of the upper echelons of society, Dionysiac subjects occur on a large number of works in the minor arts and objects for everyday use. The abundance of representations from the cycle of Dionysos could be related to folk beliefs in the mystery cult or simply to the faith in the divine apotropaic power of Dionysos and his thiasos. It is notable that Dionysiac subjects continued to decorate works in the minor arts even after Christianity had prevailed and Christian iconography had supplanted the old pagan themes or endowed them with new content. AZ

Published: Marangou 1976, 87, no 3, pl 2a.

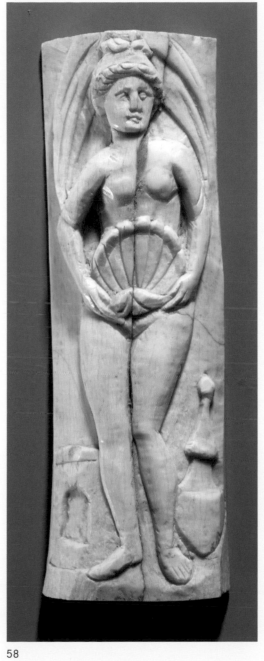

58

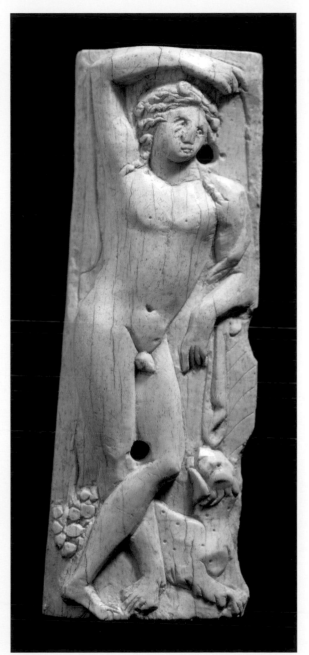

59

BYZANTINE PERIOD
4TH – 15TH CENTURY

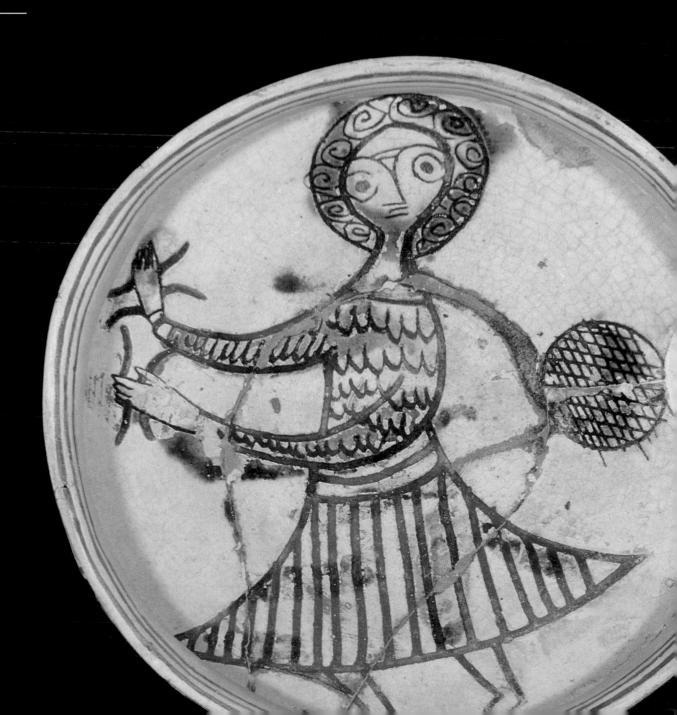

FROM LATE ANTIQUITY TO MEDIEVAL BYZANTIUM: THE ECUMENICAL EMPIRE UNDER DIVINE PROVIDENCE

Anastasia Drandaki

The transition from antiquity to the Christian Byzantine world was a long and complex process in which each novel element that emerged was deeply rooted in the traditions and heritage of the Graeco-Roman Age. A Byzantine Empire, with this title, was never actually founded, since to the end it remained in the minds of its people as the empire of the Romans – Christian, Greek-speaking and very shrunken during the final period but always continuer of and legitimate heir to the universal Roman Empire. The term Byzantium was coined much later by Western men of letters, who gave to the medieval continuation of the Eastern Roman state the name of the ancient Greek colony located in the area where Constantinople was founded.

Although scholarly opinions differ concerning the periods of Byzantine history, it is certain that from the fourth to around the mid-seventh century the basic structures – economic and political – and the characteristics of the state were an unbroken continuation and evolution of the Roman Empire. Nevertheless, two important events in the fourth century stimulated processes that eventually modified the nature of the state: on the one hand the tolerance toward Christianity proclaimed by Emperor Constantine the Great (306-337) in 313, with the Edict of Milan, and on the other his founding of Constantinople in 324. The ascendance of Christianity marked the onset of the outburst of monumental Christian art, as well as the gradual transformation of the official Church into a fundamental state institution which developed in parallel with imperial authority. With the founding of Constantinople, the empire's centre of gravity began to shift steadily to the East, where Greek learning and the Hellenistic legacy prevailed, but with the particular character this had acquired through centuries of coexistence with local civilisations in the syncretistic milieu of the Near East. The shift was reinforced by the official partition of the Roman state, in 395, into a western part with Rome as centre and an eastern part with New Rome, that is, Constantinople, as capital, and was completed with the final dissolution of the western part by Germanic tribes in 476. Within this turbulent period from the fourth to the seventh century, rich tradition and dynamic innovative elements clashed and coalesced, synthesising the nucleus of the subsequent identity of medieval Byzantium.

Predictably, the most splendid objects are those associated with imperial commissions or possessed by members of the aristocracy (see cat nos 77-81). The luxurious materials such as gold, silver and precious stones, used to make these works, as well as the iconographic subjects chosen for their decoration, express the official imperial ideology. These are at once objects of conspicuous display and media of promotional propaganda, which were presented frequently as diplomatic gifts. Some of the most characteristic artefacts of the period – both utilitarian and decorative – are adorned with mythological subjects, for, despite the dissemination and indisputable domination of Christianity, themes from the ancient repertoire continued in use. The opulent vessels with mythological themes, conscious choice of an aristocracy whose education was based on the ancient Greek Letters, set the fashion of the time and numerous mass-produced, cheaper imitations in clay are encountered (see cat no. 73). Moreover, the representation of heroes such as Achilles and Herakles was not at variance with Christian ideology, since their feats and deeds were paradigms of virtue. The grafting of ancient tradition onto the new Christian religion was reinforced by the Fathers of the Church, well-versed in the Classics, such as St Basil the Great, whose writings extol the merit of the Greek Letters and their significance for Christians, acknowledging that some pagan values are consistent with the Christian spirit.

The most luxurious jewellery and objects of the age are known mainly from hoards or treasures discovered buried at various parts of the empire, such as in Switzerland, Italy or East Anglia. The existence of such treasures, never retrieved by their owners, is most probably linked with the systematic, aggressive penetration of the Germanic tribes into the territories of the empire throughout the fifth century. However, despite the Germanic raids and the gradual political alienation of the eastern from the western part of the empire, the once single Roman *imperium* maintained basic elements of cohesion for virtually the entire period. There was continual trafficking of goods in the Mediterranean and the old trade routes remained open. From Syria and Egypt to East Anglia, objects with common traits, which can sometimes even be attributed

to the same workshop, are located in excavations, thus documenting mercantile transactions between the regions.

In this period, the first Christian subjects were also established as official emblems of the state. The most widespread of these was the Chi-Rho monogram of Christ or Christogram, which Constantine the Great and his sons used as an apotropaic symbol on the army's weapons and banners, and as official insignium of the imperial triumph. From there it passed as a Christian motif to monuments and utilitarian objects (see cat no. 74). The development of Christian iconography from the fifth century reflects the new key role played by the Church as an institution and as a power-base, within which context it drew elements from imperial pictorial tradition.

The reign and achievements of Emperor Justinian (527-565) set their seal on the sixth century, during which gradual but seminal changes took place in the empire. The role of Constantinople was bolstered in relationship to its rival great cities of the East, such as Ephesos and Alexandria, but even more critical was the gradual diminution and decline of the small and medium-size urban centres, as attested by archaeological data from Cyprus to Italy. By the middle years of the century Greek had already replaced Latin as the principal language of law, administration and literature.

Justinian's protracted military operations united the lands around the Mediterranean Basin into a single Roman state, for a short period and for the last time. Imperial ideology and Justinian's vision were manifested clearly in portable artworks and, primarily, in the extensive building programme implemented at various places in his realm. The seal of imperial propaganda is stamped on monuments and mosaic decorations from Italy to Egypt, such as the famous mosaics in the church of San Vitale in Ravenna and the fortress-like monastery of St Catherine in the Sinai Peninsula. Without doubt, however, the most important project, which through its bold and innovative form had a decisive and lasting influence on ecclesiastical architecture, was the rebuilding of the church dedicated to the Holy Wisdom of God – Hagia Sophia – in Constantinople. On the site of an earlier church of the same name, which was burnt down during political riots (the so-called Nikas Revolt, 532), Justinian raised the new and magnificent Great Church. Liturgical centre and symbol of the capital throughout the life of Byzantium, Hagia Sophia inventively combined two existing architectural types, the longitudinal basilica plan and the centralised domed church. In this new architectural type, which determined the development of Byzantine architecture henceforth, there is ample illumination and elaborate articulation of volumes, yet no loss of the unity of the space, which embraces man without negating him despite the huge dimensions of the building (the nave alone, without the two narthexes, measures 78 x 72 metres).

From the same period are the earliest portable icons, preserved in the monastery of St Catherine on Mount Sinai. Executed in encaustic technique – with wax as the binder for the pigments – the early icons display a close affinity with traditional Roman portrait painting, mainly as expressed in the Egyptian funerary portraits. The Christian icons share with the Fayum portraits not only a common technique but also the same philosophical and aesthetic values in rendering the human figure. In both genres the likeness of the depiction to the physical model was definitive for the function of the work. Christian icons drew their status and sanctity from the likeness to living holy persons, which also guaranteed the spiritual presence of the sacred person in the locus of veneration of the image. Nevertheless, this likeness is not identified with the naturalistic representation of the human figure but with the illustration of the spiritual, inner world of the person. This element, the essential trait of Byzantine iconography, already characterises the portraits of Late Antiquity.

The seventh century, with its dramatic events, was a watershed in the history of Byzantium. Although Emperor Herakleios (610-641) crushed the Persians, age-old foes of the Roman state, in 627, a new power was springing up in the East. Arabs converted to Islam were advancing at lightning speed, depriving the empire of its vital eastern provinces of Egypt, Syria and Palestine. Its territory was now limited to the regions that were to be the heartland of Byzantium in the centuries to come, the Balkan Peninsula and Asia Minor. The shrinking of the empire and

the consequent economic and social changes coincided with the great religious conflict of Iconoclasm, which lasted from 726 until 843. The theological nucleus of Iconoclasm concerned the correctness or not of venerating icons, and the roots of the clash can be found in the texts of the first Church Fathers. In the eighth century this dispute acquired a new dimension which shook the empire, since iconoclast views were adopted by a succession of emperors and imposed as official state policy. As was usually the case with theological disputes in the Middle Ages, Iconoclasm had much deeper political and social ramifications which reverberated on the life of the empire, which was trying to adjust to the new geopolitical circumstances imposed by the Arab advance. Iconoclasm ended with the victory of the iconolaters and the adoption of their views by the imperial authority. After the final Restoration of the Icons in 843 (see cat no. 108), apologetic and other theological treatises, *vitae* of saints and liturgical texts constituted the basis for the splendid burgeoning of Byzantine iconography. At a political level, the essential victor of the conflict was the imperial authority, which was enhanced as regulator and guarantor not only of political but also of religious order in Byzantium.

From the tenth century the medieval Byzantine state enjoyed a period of recovery under the Macedonian Dynasty (867-1056), and for the next two hundred years remained the great power in the wider region. Constantinople, 'Queen of Cities', was the indisputable hub of the empire's economic and political life. Equally conspicuous was her supremacy in the production and distribution of luxury goods, as well as in the creation and transmission of new artistic currents, which diffused to every corner of

Byzantium and to regions within its sphere of influence. In the tenth century, the predominant current in aristocratic circles in the capital turned towards the empire's illustrious past and revived, within a spirit of eclecticism, classicist subjects characteristic of the art of the sixth century. Maenads, infant Eros figures (*amori*) and personifications of natural phenomena and abstract concepts adorn sumptuous objects, such as the numerous ivory caskets and minor artworks of the period. This thematic repertoire, and corresponding classicist values in the treatment of the human figure and the natural environment, passed also to the margins of religious iconography, to the illumination of the luxurious manuscripts which constitute one of the most important bequests of the period (see cat no. 91). Analogous emphasis was placed on collecting and studying ancient Greek literary texts. Theology, philosophy and rhetoric developed. Through these choices the reviving empire of the Macedonian Dynasty evidently shaped the ideological identity of Byzantium, documenting its continuity with the single, flourishing Roman state of the past. The medieval Byzantine state perceived the *oecumene* (universe) as a hierarchical system in which the emperor, God's representative and instrument of Divine Will on earth, formed through relations of dependency and subjugation the web of Christian peoples and states around it. Different ethnic groups – Armenians, Georgians, Normans and Slavs – sometimes with martial conflict and sometimes with peaceful settlement and incorporation in the empire, were parts of the Byzantine commonwealth (see cat no. 82).

Byzantine art of the period, pioneer in aesthetic trends and decorative techniques, was concurrently a political medium, and

had a catalytic influence on artistic developments over a wide geographical ambit. For mosaics – the most lavish form of monumental decoration – in particular, the unsurpassed Byzantine mosaicists were invited to execute important commissions in regions from Sicily and Venice as far as Kiev, to which they passed on the highest expression of Constantinopolitan art. The iconographic programme of church decoration, based on the theological texts that were the legacy of the debates of Iconoclasm, was devised and crystallised in the same period. The different parts of the church are charged with special symbolism, which is imprinted in the representations. Thus, the sanctuary is dominated by eucharistic subjects, while the nave is covered in the upper zones by Christological scenes and in the lower zones, close to the believers, with depictions of saints who intercede for their salvation and are their ideal models. The representations in the upper parts of the building, the dome or the vaults, which correspond to the celestial sphere, normally depict Christ Pantocrator (Ruler of All) flanked by prophets and angelic hosts, or other eschatological subjects.

From the second half of the eleventh century the settlement of the Seljuk Turks in the territories of Asia Minor established a new *status quo* in the eastern borders of the empire. Of profound importance to the West were the worsening relations between the Patriarchate of Constantinople and the Papal See in Rome. The gradual alienation of the two sides, which had commenced in the eighth century and revolved around doctrinal issues as well as the matter of the primacies, was finalised by the Schism of 1054. This breach, which was concomitant with the different political history of the two major religious centres of Christendom, was in reality never healed. The Schism led to deep mutual distrust, even to enmity, on

both sides, which regarded each other as heretics. At a different level, the Byzantine contact with Genoa and Venice was put on a firm footing when Emperor Alexios Komnenos (1081-1118) granted privileges to these great Italian mercantile cities, and a large community of Genoese and Venetians was established in Constantinople. Contacts with the West acquired a different form in the twelfth century with the growth of the Crusader movement, which led the Latin militants of the faith to the East, set on liberating the Holy Land. The Crusader armies passed through the territories of Byzantium and ended up founding the Crusader states and settling Westerners in the Near East. The Byzantines' dealings and coexistence with the Italian merchants and the Crusaders on the one hand, and with the Muslim states of the region on the other, is clearly reflected in the artefacts of the age. Pottery, jewellery and silverwork attest to the formation of a common artistic language and to aesthetic preferences that are in each case rooted in the Late Antique heritage, which was shared equally by the peoples of the region (see cat no. 95).

The military weakening of Byzantium and the dynastic rivalries in the late twelfth century, in conjunction with the dynamic military presence of the Crusaders, culminated tragically when the Fourth Crusade turned its sights towards Constantinople. In 1204 the Crusaders captured and sacked the capital, and the territories of Byzantium were shared out between their rulers. Although Emperor Michael VIII Palaiologos (1259-1282) won back Constantinople in 1261, Byzantium was now an empire in name only, a peripheral power confined to the western littoral of Asia Minor, northern Greece and part of the Peloponnese, diminishing continually until its final conquest by the Ottoman Turks. Large parts of its erstwhile lands remained under Latin or Venetian rule or an autonomous regime. As the Ottoman Turkish threat was looming ever larger, the emperors of the Palaiologan Dynasty (1261-1453) sought assistance from the Latin West, offering in exchange, in successive negotiations, the highly controversial union of the Orthodox with the Catholic Church. But memories of the Latin conquest were still fresh, and the emperors' efforts to confront the state's tragic position through this course split Byzantine society into two warring factions, the Unionists and the Anti-Unionists. In the same period, the position of the Orthodox Church was strengthened in relation to the waning imperial power and religious authority was enhanced as a principal rallying point, since Byzantium was suffering the throes of civil strife and popular revolts in the urban centres.

Very few luxury objects are known from the Late Byzantine period, even though the literary sources recount the impressive private wealth of powerful political personalities of Constantinople (see cat no. 97). Characteristic is the information on the sumptuous splendour of Theodore Metochites, leading political figure – prime minister – man of letters and patron of the arts in the early fourteenth century. Even though at the end of his life he was put in prison and his enormous property was confiscated, Metochites left behind him one of the most renowned Byzantine monuments to have survived unchanged to this day, the famous Chora Monastery at Constantinople (1316-1321), which was renovated at his expense. The mosaics and the wall-paintings which decorate the interior of the monastery are in many ways the epitome of Palaiologan art. Deeply imbued with humanism and classicism, they are the best expression of the inquiries of Late Byzantine painting, revealing why many scholars dub the art of the period a Palaiologan Renaissance (see cat no. 102). This style coexists with an expressionistic current, which never ceased to thrive alongside the classicistic trend in Byzantine art and aimed mainly at enhancing the expressive power rather than the beauty and harmony in the composition.

On the eve of the fall of Constantinople to the Ottoman Turks, literati and artists fled the capital, seeking more promising conditions in which to live and work. The walled town of Mystras in the Peloponnese, for a brief period (see cat no. 92), Russia, Italy and especially Venetian-held Crete were such destinations. Through their influx into and settlement in these regions, the torch of Constantinopolitan art was passed on, kindling the development of the main schools of post-Byzantine art.

On 29 May 1453, after a siege lasting 23 days, the armies of the Ottoman Sultan Mohamed II (1451-1481) captured and plundered Constantinople. The conquest was crowned by Mohamed's victory parade, which terminated at the symbol of Byzantium, the church of Hagia Sophia, which was subsequently converted into a mosque. The Fall of Constantinople, an event of global impact for the age, was linked with a host of traditions, laments and legends. It shook, and shocked, the Hellenic world and had tremendous repercussions in the West, which had looked on with detachment at the inevitable, almost preordained fall. Not long afterwards, the last parts of the once glorious Byzantine Empire, as well as the rest of the Balkan states, were subjugated to the Ottoman Turks. ■

ILLUSTRATIONS

Window shutters or cupboard doors

Cat no. 60
5th–7th c.
From Egypt
Wood, carved in relief, painted
49 (h) x 43 (w) cm
Inv. no. 9083

The two leaves are decorated at the centre with asymmetrical woodcarvings of confronted birds, framed above and below by rosettes. At the junction of the leaves is a colonnette with schematic vegetal decoration and heart-shaped motifs terminating above in a capital with acanthus leaves. The carved decoration is superbly enhanced by the addition of colour: the background is black, the frame green, the intertwined 'pearl-studded' bands surrounding the subjects are yellow, while the birds combine green, pink and red with details picked out in black.

There is a virtually identical wooden window, also of Egyptian provenance, in the Walters Art Gallery, Baltimore. It is worth noting that a second possible use of the two leaves was as doors closing a cupboard within a house. The manner in which the birds' features are represented, such as the large round eyes formed by concentric circles, is typical of Coptic artworks.

Subjects are rendered in a similar style not only in wood-carvings but also on Egyptian painted pottery and textiles of this period.

The arid climate of Egypt favoured the preservation of works in perishable materials, such as cloth and wood, which have not survived in other regions of the Byzantine world. Thus, through Egyptian finds we are able to study aspects of the material culture that are otherwise known of only from literary sources. Even though these works express the singular artistic idiom of Egypt, they undoubtedly reflect the dominant trends developed in the major metropolitan centres of Byzantium, from where they diffused to the provinces. Objects such as the window discussed here provide valuable information on the domestic equipment of modest households and show how subjects prominent in the formal art of the period were transferred to cheaper materials.
AD

Published: *Everyday life in Byzantium* 2002, 271, no 268 (A Drandaki). For the window in the Walters Art Gallery see: *Beyond the Pharaohs* 1989, 234, no 147. On the iconography, cf a painted vase with birds of the sixth–seventh century: Gonosovà, Kondoleon 1994, 288–291, no 101.

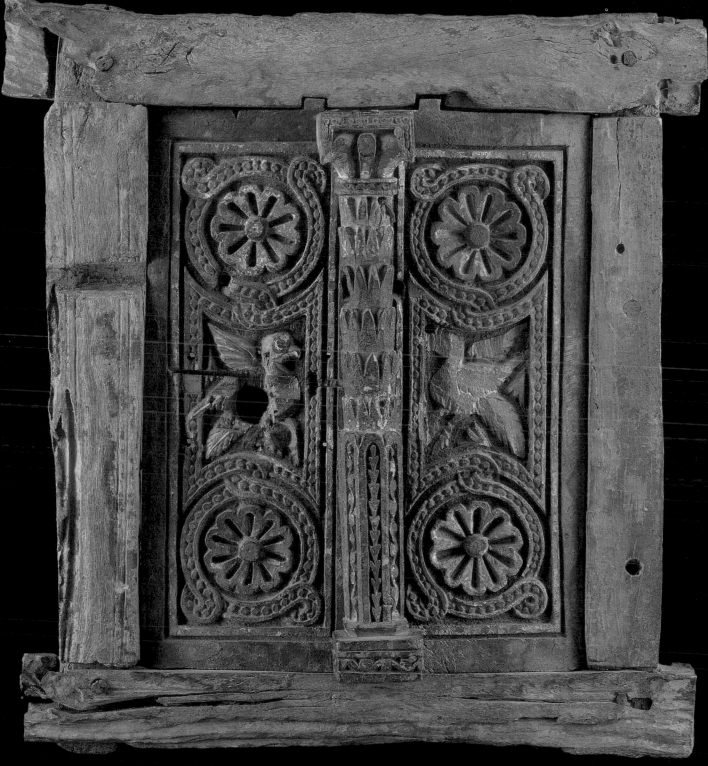

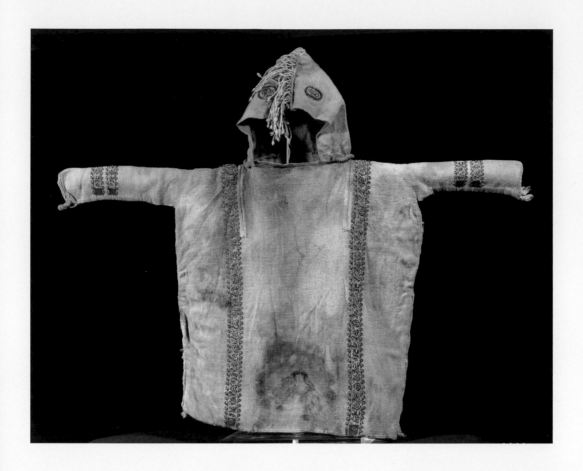

Child's tunic with hood

Cat no. 61
8th–9th c.
From Egypt
Wool warp and weft, loom-
shaped in cruciform, weft-faced
tabby with interwoven tapestry
ornaments
Tunic 45 (l) x 45 (w) cm; loom 90
(w) cm; sleeve 20.5 (l) cm; hood
20 x 30 cm
Inv. no. 7160

The all-wool, beige garment
woven in one piece, is in its
original state. It is decorated with
two vertical stripes (*clavi*) running
the length of the tunic, from back
hem to front hem, and with
double sleeve bands in tapestry
weave. The design, in purple
wool on light ground, is
essentially the same on the *clavi*
and the sleeve bands, consisting
of a row of stylised birds and fish
in profile, bordered by wave-
crested bands. The garment is
sewn at the sides with woollen

thread in running stitch. The
sleeves are double-folded and
sewn but left open at the armpits.
The pointed hood was made
separately from a single rectangle
of cloth and sewn to the tunic.
It is decorated with fringing and
two roundels with a stylised lion.
The technical traits of the
garment attest to the high
standards of Egyptian weaving
in this period.

Tunics were the standard
garment since Roman times,
worn by men, women and
children alike. They were made
as a rule of linen or cotton, but
also of wool and more rarely of
silk. The quality of the cloth,
the colour, the length and the
decoration of the garment were
also indicative of the wearer's
social status. The *clavi*, the
commonest form of decoration,
derive from Roman insignia of
office, which gradually lost their
significance.

Most of the surviving hooded
tunics belong to children.
An example in the Musée du
Louvre, with almost identical
tapestry pattern and technical
features, is so similar to the
Benaki Museum piece that they
are possibly products of the
same workshop. AD

Published: *Byzantium: an oecumenical
empire* 2002, 286, no 151
(Cortopassi, Tsourinaki); Tsourinaki
2002, 29–36; Cortopassi, Tsourinaki
(forthcoming), with extensive
bibliography.

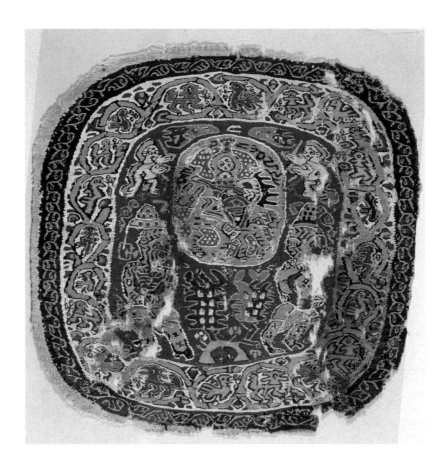

Large tapestry roundel

Cat no. 62
7th–8th c.
From Egypt
Woven, wool warp
34.5 (h) x 33.5 (w) cm
Inv. no. 7109

The large tapestry-weave roundel was originally an ornament on a garment. Its wide double border comprises an outer band decorated with yellow scrolls on a black ground and an inner one with beige ground, against which a scroll forms medallions enclosing stylised animals. In the upper part of the central medallion is a sky-blue roundel, in which is a haloed figure with confused features, mounted on a quadruped. To the right is a pseudo-inscription, following the circumference of the roundel; a symmetrical one would have existed to the left, on the now damaged part of the composition.

On the red ground above the medallion are two vegetal motifs, beneath which two naked figures with cloaks fluttering from their backs turn respectfully with outstretched hands towards the central figure. Below the roundel, two stylised plants are flanked by two figures in larger scale, which walk outwards but turn their heads behind to face each other. Their attire is typically eastern, with Phrygian cap, richly decorated tunic and leggings with cross motifs.

The unusual arrangement of the decoration complicates interpretation of the iconography. According to some scholars, two New Testament scenes are depicted: the Virgin and Child on a donkey (the Flight into Egypt) in the medallion, and below this, two of the Magi homeward bound.

Although these identifications are appealing, there are several problematic iconographic details. In representations of the Flight into Egypt the faces of Mary and Jesus are always clearly shown, one next to the other, unlike here. Furthermore, the naked figures beside the medallion are more reminiscent of pagan *putti* than Christian angels. Concerning the identification of the figures in oriental dress as two of the Magi, it has to be noted that no other textiles are known with representation of their return journey, whereas they are depicted regularly in the scene of the Adoration. It is possible that the weaver of the Benaki Museum roundel used only part of a much larger representation as a model, which could explain the peculiar arrangement and obscure character of the decoration. A roundel in the Musée des Tissus in Lyon is very similar in style and composition to the present example.

Roundels and squares, the *segmenta*, were the usual decoration of tunics, along with vertical *clavi* (see cat no. 61). *Segmenta* could be placed on the upper arm of the garment or over the knee area in front. In several cases they were integral parts of the garment, woven directly into its fabric, while in others, as here, they were woven separately as appliqués and sewn in place. AD

Published: Apostolaki 1954, 157–161; De Chaves 1994. For discussion of the iconography see: Cortopassi, Tsourinaki (forthcoming).

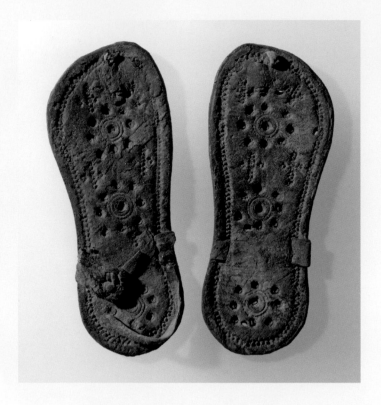

Pair of child's sandals

Cat no. 63
5th–7th c.
From Egypt
Leather, stamped
12.8 (l) x 5.1 (w) cm
Inv. no. 21859

The leather sandals are decorated with stamped concentric circles and crosses. The soles are worn, verifying that the footwear had been used, in contrast to other examples of shoddier workmanship which was made exclusively for funerary use. Numerous items of footwear have been found in graves in Egypt, where the arid climate favoured the preservation of organic materials such as textiles, wood and leather. Leather sandals for an adult, made in the same way but with simpler decoration, have been found in Upper Egypt, while more elaborate examples have been recovered from Fayum.

The stamped motifs on the Benaki Museum sandals seem to have been commonly used to decorate footwear. Comparable motifs are repeated on the sole of a bronze lamp which realistically reproduces a left foot in a sandal, also in the Benaki Museum. Concentric circles were a very popular and widespread motif on all manner of works in late antiquity. They occur on jewellery, combs, bone carvings and metal vessels, and their diffusion is perhaps linked with an apotropaic nuance to the subject. This view is reinforced by the presence of concentric circles on amulets as well as on the entrances to fortifications, such as the Justinian walls of the monastery of St Catherine at Sinai in Egypt. AD

Published: *Everyday life in Byzantium* 2002, 112, no 105 (A Drandaki). For parallels see: *Ancient faces* 1997, nos 327–329; *L' art copte* 2000, no 129 (F Calament-Demerger); Bowman 1986, 115, fig 68. For the bronze lamp in the form of a sandalled foot see: Delivorrias, Fotopoulos 1997, 184, fig 313. On the significance of the motifs see: *Art and holy powers* 1989, 5–7.

Toy horse and sistrum

Cat nos 64, 65
5th–7th c.
From Egypt
Bone, carved in relief
Horse: 7 (h) x 9 (l) cm; sistrum:
17.7 (h) x 3 (w) cm
Inv. nos 10392, 10388

The body of the bone horse has been stained with red pigment. The ears are carved in relief, while details such as the eyes and mane are incised. Only the two front wheels have survived, but the axle for a similar pair would have passed through the hole in the hind legs of the horse. The wheels in the natural colour of the bone create a pleasant contrast with the red body of the animal. A small hole in the horse's head was for affixing the string with which the child pulled the toy.

The wheeled horse is one of the most widespread toys, in a host of cultures, and in all periods, to this day. The diffusion of this toy in Egypt, provenance of the Benaki Museum example, is documented by the existence of numerous comparable horses in child graves, although these are, as a rule, carved in wood. The expensive material of this particular horse classes it among the more luxurious toys to have survived. The careful carving and incising is equal to the quality of the raw material, whereas in wooden toys of this kind the representation of the equine is elementary.

The bone sistrum, a percussion instrument, most probably belongs in the same class of luxury objects for children's use.

It comprises a long handle with serrated, forked finial. Affixed to its end are two rectangular plaques which produce sounds when the instrument is shaken. The sistrum is decorated with simple geometric incisions. There is a similar object in the Institute of Egyptology at the University of Heidelberg. Comparable examples, of smaller size and less careful construction, have been found at Fayum in Egypt, along with children's toys, indicating that they were possibly used as rattles. AD

Published: *Everyday life in Byzantium* 2002, 205, 493, nos 230, 674 (A Drandaki). For parallels see: Bowman 1986, 152, fig 90; Rutschowscaya 1986, nos 290, 291, 293–299; *L'art copte* 2000, nos 270 (M-H Rutschowscaya), 284 (C Nauerth).

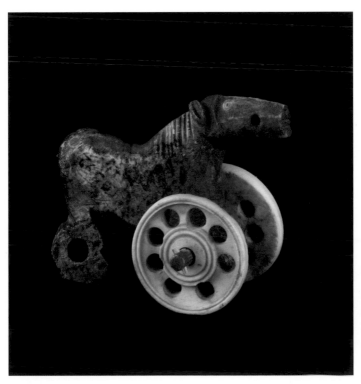
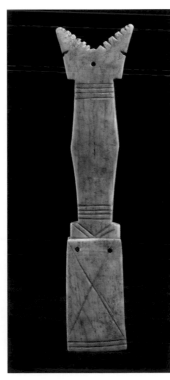

Small amphora

Cat no. 66
5th c.
From Egypt
Copper alloy, cast, chased, punched
22.2 (h) x 8.5 (side of base) cm
Inv. no. 11602

The small pointed-bottomed amphora is set in a tripod decorated with punched concentric circles and relief animal protomes. The handles are in the form of felines, while on the lid an eagle, with a cross on its head, perches on a highly schematic bull's head. The neck of the amphora is decorated with herringbone pattern, and the belly with an incised vine and a band of geometric motifs, while the pointed end forms a multi-lobed calyx. There is a small amphora vessel with the same decoration and identical finial in the Hermitage Museum, St Petersburg.

This vase, like the numerous corresponding examples, may have been used as a perfume flask. The decorative elements – eagle with cross, feline, vine and concentric circles – recur regularly on all manner of objects from the Late Roman period. Not only do they embellish the vessels but also, as protective symbols, shield their owners from malevolent daemons and hostile forces.

The shape and the decoration of the vessel are at the same time characteristic of Egyptian metalwork. The strong Graeco-Roman tradition in Egypt was imbued with Christian elements, elaborating a distinctive artistic language which is detected in all manifestations of so-called Coptic art – woodcarvings, textiles and bone objects. With regard to metalworking in particular, Egypt developed during late antiquity into a major centre of production and circulation of bronze and also of silver vessels. Their discovery at archaeological sites throughout the Mediterranean basin and in territories of western Europe, as far as eastern England, testifies to their wide distribution and Egypt's thriving commercial contacts with these regions. AD

Published: *Everyday life in Byzantium* 2002, 469–470, no 642 (A Drandaki). For parallels see: *L' art copte* 2000, no 263 (O Ocharina); *Everyday life in Byzantium* 2002, 469, no 641 (A Drandaki). On the symbolic meaning of the decoration see: *Art and holy powers* 1989, 1–33.

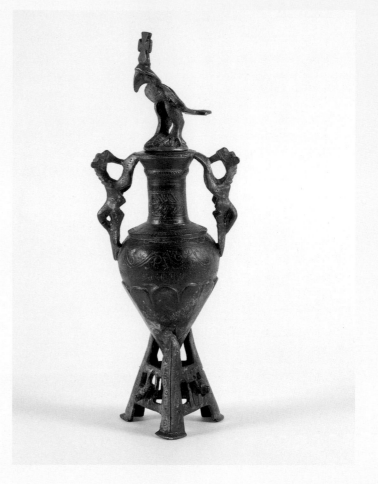

Bowl with handle

Cat no. 67
4th–5th c.
From Egypt
Copper alloy, cast
19.9 (l) x 11.5 (bowl diam) cm
Inv. no. 11599

The body of the shallow bowl is of truncated conical shape. A single row of 'pearls' encircles the wide, flat rim which is raised at the ends. Traces of working on a lathe are visible on the inside and outside of the bowl, both at the central point of stabilising the vessel and on the incised concentric circles decorating the bottom, the walls and the rim. The handle has been cast separately and attached to the bowl. Its forked finial is united with a third cast piece, a wide ring from which the vessel was hung.

This type of bowl, also known by its Latin name, *patera*, was very common in Roman times and throughout the Early Christian period. It was used for water, which is why the more luxurious examples are frequently decorated with marine motifs, both realistic and mythological. It is possible that the bifurcated finial of the handle on the Benaki Museum bowl, which is reminiscent of a fish, is inspired by analogous decoration. Several examples have a dolphin-shaped handle ending in a tail of this kind, such as a silver patera in the Musée du Louvre, and two simpler ones in bronze in the same museum and in the Royal Ontario Museum, Canada. There are another two bowls in the Benaki Museum and similar ones are known in many collections and museums. Vessels of this kind, securely dated to the fifth century, have also been found in excavations in Nubia.

Bowls, sometimes with shallow and more commonly with deep body, were associated with both domestic and religious context. In everyday life they were used for washing hands and were part of the tableware. In the religious milieu they were intended for libations and were adopted, as is to be expected, as liturgical vessels in Christian rites. It is characteristic that a patera is depicted along with other liturgical vessels in front of the altar table in a representation of the Communion of the Apostles, which decorates a sixth-century silver paten from the Riha Treasure, now in the Dumbarton Oaks Collection, Washington DC. The absence of decoration from the patera discussed here points clearly to its use in a domestic environment. AD

Unpublished. For parallels see:
Wealth of the Roman world 1977, no 107; Hayes 1984, 124, no 196; Emery, Kirwan 1938, vol 2, pl 82, no B9–11; *Isskustvo Bizantii* 1977, vol 1, no 384; Bénazeth 1992, 79–83, with further examples.

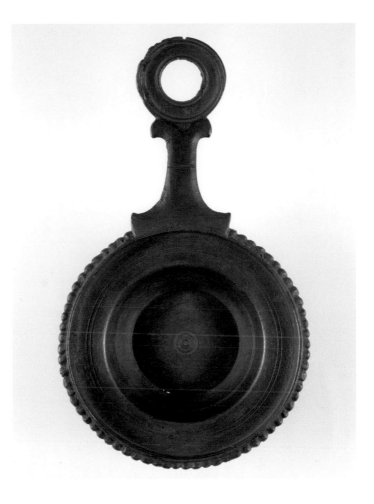

Two-wick lamp

Cat no. 68
5th c.
From Egypt
Copper alloy, cast, engraved
13.5 (h) x 22.5 (l) x 8 (w) cm
Inv. no. 11547

The lamp is in the form of a two-headed dolphin, with a raised tail ending in a lily-shaped calyx which is also the mouth for filling the vessel with oil. The twisted lid is broken but one small Latin cross is still preserved, which stands on the front petal of the lily-mouth. The dorsal fins of the dolphin's heads have also been broken and the cylindrical base of the lamp has sunk into its body.

Dolphins are among the most popular subjects of the period, featuring frequently on silver and bronze lamps and *polykandela* (see cat no. 88). Lamps of this particular shape occur commonly from the first century onward, the earlier examples displaying greater plasticity and more naturalistic characteristics. The closest parallels for the lamp discussed here come from tombs in Nubia, securely dated to the fifth century. The cross does not necessarily point to an ecclesiastical use of the vessel, since, as the Christian symbol of protection *par excellence*, it is encountered on all manner of utilitarian objects in the Early Christian period. Apotropaic symbols often featured on vessels for lighting, because they underlined and reinforced the protective function of light.

In morphology and decoration, this lamp and the following one, cat no. 69, are characteristic of coeval types of lighting vessels, with many parallels in collections and museums, most of which are also of verified Egyptian provenance. They are typical examples of Egyptian bronze-working, which flourished in this period. As is known from the sources, they covered not only the needs of the local clientele but were also exported, via maritime trade, to the wider Mediterranean world. AD

Published: *Greece and the sea* 1987, 244, no 147 (L Bouras); *Everyday life in Byzantium* 2002, 154, no 168 (M Xanthopoulou). For parallels see: Bailey 1996, no Q3590–3591, pl 17; Emery, Kirwan 1938, figs 98–100, 102; Hayes 1984, 138, no 214; Bénazeth 1992, 144–150. On the symbolic meaning of the decoration see: *Art and holy powers* 1989, 9–10, 57–59. On the dating of the Nubian tombs see: Török 1988, 154, pl 1. On the commercial activity of the period see: Mundell-Mango 2001.

Lamp on a lampstand

Cat no. 69
5th–6th c.
From Egypt
Copper alloy, cast
Lamp: 13.7 (h) x 16.8 (l) x 8.8 (w) cm; lampstand: 22.5 (h) cm
Inv. no. 11545

The lamp has a folding reflector in the form of a cockleshell to amplify the luminosity of the flame. On the back of the reflector is the loop-shaped handle of the lamp. The body is elongated, with a truncated conical foot. On the upper part is the filling-hole with a rotating lid in the form of a schematic male mask in relief. The lamp is set in a lampstand, which has a circular tray to catch drops of oil. The stem of the stand, formed from successive cast spirals and mouldings, terminates below in a calyx-shaped base which stands on three feline paws.

There are another four identical lamps in the Benaki Museum and very similar examples are known from other museum collections in Cairo, Ontario, Berlin and the Musée du Louvre. All are of Egyptian provenance. The shape of the body points to the dating of the group in the period from the fifth to the seventh century. None of these lamps bears a Christian symbol, however. The apotropaic character of the male mask, which can be identified with a satyr or with the Egyptian deity Bes, rather indicates a pagan milieu.

Whereas other contemporary lamps have loops for their suspension from chains, the example discussed here was intended exclusively for placing on a lampstand. The type of lampstand with zoomorphic feet was widely diffused in Roman times and continued to be used, with ever-increasing schematisation, until at least the seventh century. The more luxurious examples to have survived are wrought of silver and were often part of church treasures. Their use in a domestic context is documented by archaeological finds, as well as by representations such as the famous silver wedding casket of Projecta in the British Museum, on which a lamp on a lampstand is depicted, among other vessels, in the scene of the procession to the bath. AD

Published: *Greece and the sea* 1987, 244, no 146 (L Bouras); *Everyday life in Byzantium* 2002, 291, no 307 (M Xanthopoulou). For parallels see: Strzygowski 1904, 286, nos 9124–9125; Hayes 1984, 141, 146–147, nos 218, 226–228; Bénazeth 1992, 116 (with further examples); Bailey 1996, 76, no Q3821, pl 87. On the Projecta casket see: Elsner 2003 (with earlier bibliography).

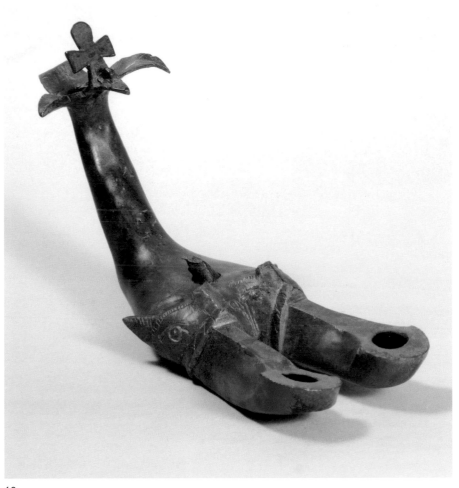

68

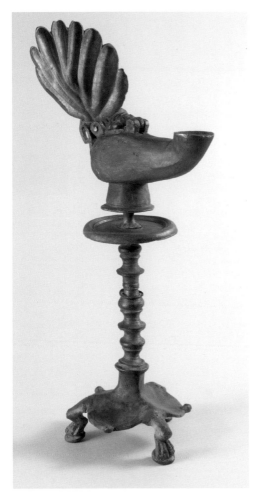

69

107

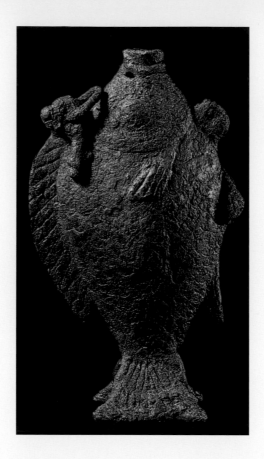

Fish-shaped perfume flask

Cat no. 70
5th–6th c.
From Egypt
Copper alloy, cast, engraved
14.8 (h) x 8.4 (max w) cm
Inv. no. 11528

The tail of the fish forms a quadrilateral base on which the vessel stands upright; the fish's mouth is also the mouth of the vessel. The surface of the body is imbricated, realistically rendering the overlapping scales of the fish. The loops on the upper side of the fins were presumably used for affixing a chain by which the vase was hung.

Fish-shaped vessels are known from antiquity but became particularly popular in Late Roman times. There is an almost identical bronze flask in the Staatliche Museen, Berlin and another one in the Metropolitan Museum of Art, New York. Comparable examples in clay or glass document their wide dissemination in this period. Among the most interesting objects in the shape of a fish are some lamps and a delightful mirror.

The Benaki Museum perfume flask or *unguentarium* comes from Egypt and displays technical and stylistic traits of Coptic bronze-working, in which there was an obvious preference for marine and Nilotic subjects. The fish, a much-loved motif throughout Christendom, is among the earliest and commonest Christian symbols and is encountered in a wide variety of objects. Its diffusion in the framework of the dynamically developing Christian religion was due to the fact that the Greek word for fish, ΙΧΘΥΣ (*ichthys*), is an acrostic of the phrase Ιησούς Χριστός Θεού Υιός Σωτήρ (Jesus Christ Son of God Saviour). Its significance as a symbol must also have been reinforced by the numerous references to fish in the Gospels and primarily to two of Christ's miracles: the multiplication of the loaves and fishes (Matthew 14:17–21) and the great catch of fish in Lake Galilee (Luke 5:1–7). AD

Published: *Greece and the sea* 1987, 246, no 149 (L Bouras); *Everyday life in Byzantium* 2002, 155, no 169 (A Drandaki). For archaic vessels of the same shape see: *Master bronzes* 1968, no 62 (G M A Haufmann). For the Berlin example see: *Bronzen von der Antike* 1983, no 15. On the symbolic meaning of the fish see: Galavaris 1970, 57–58; *Art and holy powers* 1989, 22–23. For other types of vessels in a fish shape see: *Cradle of Christianity* 2000, 123.

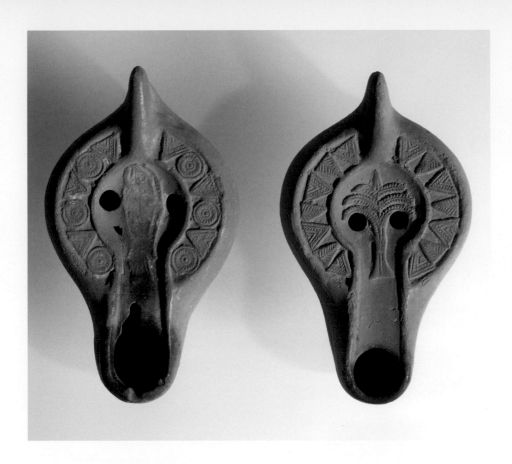

Two lamps

North African workshop
Cat nos 71, 72
5th c.
From Egypt
Clay, red with slip, mould-made
Lamp no. 71: 11.5 (h) x 7 (w) cm;
lamp no. 72: 11.5 (h) x 7.2 (w) cm
Gifts of Loukas Benakis (11840, 11843)

The two lamps are identical in shape and dimensions. They have a long, channelled nozzle and a circular disc surrounded by a broad flat band. The shoulders curve to end at a flat bottom set upon a ring base. A simple stump-handle projects behind the body. The disc of one lamp is decorated at the centre with a fish, beside which are two filling-holes. Around the circumference is a band of triangles alternating with concentric circles, filled with decorative incisions and dots. The disc of the other lamp is decorated with a seven-branched palm tree, on either side of which is a filling-hole. The broad band around its circumference is covered by alternating schematic palm leaves and triangles with geometric embellishments.

Both lamps are mould-made and belong to a very widely disseminated type of which several hundred intact or fragmentary examples are known. The fine red clay with glossy slip is the same as that encountered in vessels of African red-slip ware and classes these lamps as products of North African workshops (see also cat nos 73 and 74). Triangular motifs and concentric circles identical to those on the lamps are also encountered on *terra sigillata* vases. The fish and the palm leaf are among the symbolic subjects adopted by Christian iconography. The Christian significance of the fish derives from its close association with episodes and miracles in the New Testament (see cat no. 70), while the palm tree and the palm leaf, ancient symbols of victory, allude to the triumph of Christ over death and simultaneously symbolise eternal life. For this reason they feature frequently on Christian funerary monuments. AD

Unpublished. For parallels see: Hayes 1972, 310–311; Ennabli 1976, no 757, pl XL; Bailey 1988, 201, no Q1832, pl 27; Hayes 1980, 68, no 288; *Di terra in terra* 1991, 173–174, figs 298–300, 304–307 (C Greco); Pavolini 1982, 147, pl 6, type XA1a. For plaster moulds used for the production of lamps cf: Hayes 1980, 140–141.

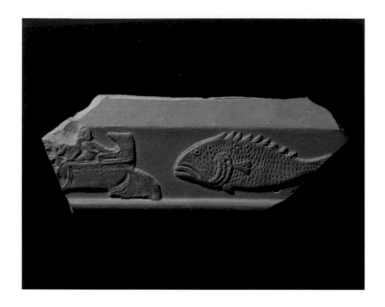

Rim fragment from a clay tray

North African workshop
Cat no. 73
c. 360–430
From Egypt
Clay, red, fine, with thin slip
15.6 (l) x 6 (h) cm
Gift of Loukas Benakis (12407)

The fragment is from the rim of a shallow rectangular tray. The clay is of fine fabric with the shiny red slip distinctive of good quality pottery of the Late Roman period. The marine scene decorating the fragment includes, left, part of ship with two figures casting nets, and right, an over-size fish. Despite the unreal scale of the representation – the fish is larger than the ship – the rendering of details, such as the parts of the vessel and the scales and fins of the fish, is realistic.

The colour and the quality of the clay class this tray among the characteristic examples of African red-slip ware. As finds from excavations document, the various *terra sigillata* vessels produced by North African workshops dominated the Mediterranean market in the fourth and the first half of the fifth century. Specifically, the manufacture of rectangular trays of this type is dated to the years between 360 and 430. They reproduce faithfully the shape and very often the iconography of their counterparts in silver. Silver rectangular trays (the *lances quadratae* of Latin sources) were part of luxurious household chattels in late antiquity and were most probably used for display, as perhaps were their cheaper imitations in clay. On the clay trays, the main body was made in limestone moulds – examples of which are preserved in private and museum collections – while the relief motifs on the rim were stamped with a die or made separately in a mould and then stuck to the damp clay. This technique permitted mass production of these vessels, a fact confirmed by the host of extant examples.

Although very few intact *terra sigillata* trays have survived, the numerous fragments found attest to the variety of subjects used in their decoration. Some derive from the iconography of Graeco-Roman mythology and others from the new Christian repertoire. The first category includes scenes from the cycles of Achilles, the Dioskouroi and Pegasus. A favourite theme in the second category is the representation of the chief apostles Peter and Paul at the centre, framed by sea scenes from the Old Testament story of Jonah. The Benaki Museum rim fragment is very possibly from such a tray. The story of Jonah was very popular in Early Christian times, because it was seen by the Church fathers as an allegory for the salvation of mankind. AD

Published: Loverdou 1969, 242, 0pl 102b; Hayes 1972, 89; Salomonson 1973, 19, figs 10–11; *Greece and the sea* 1987, 248–249, no 153 (K Loverdou-Tsigaridas). For the type and parallels see: Hayes 1972, 83–91, 284–285, 292–293; Poulou-Papadimitriou 1994. For limestone moulds cf: *Rom und Byzanz* 1999, 129, no 139 (M Mackensen), with further bibliography.

Bowl

North African workshop
Cat no. 74
490–540
From Egypt
Clay, red with slip
20.6 (diam) cm
Gift of Loukas Benakis (12517)

The bowl stands on a tapering foot and has a rather shallow body with broad, slightly downturned rim. At the centre of the bottom is a medallion with the Greek monogram of Christ, also known as the Christogram, bearing the pendent inverted letters Alpha (A) and Omega (Ω). The vase is coated with thick, lustrous red slip.

The bowl is of a characteristic class of vessels from North African workshops, the activity of which is located at Oudna in Tunisia, most probably in the early sixth century. As is the case with most pottery, the model for the shape of the bowl is to be found in analogous silver vessels with an equally broad rim, usually decorated with pearl motifs. In the Benaki Museum bowl the rim has been decorated with a roulette as the pot was turning on the wheel, while the central Christogram was made by pressing a stamp into the damp clay. Stamps of this kind have survived, such as one in a private collection in Munich.

The Christogram is a combination of the letters Chi (X) and Rho (P), initials of the name of Christ in Greek; in several cases, such as this example, the Rho is combined with a cross. The two motifs, the Christogram and the cross, are the symbols of Christ *par excellence* and appear in all manner of domestic objects during the Early Christian period. They not only declare the faith of the object's owner but also function as potent protective symbols. Equally rich in content is the presence of the first and last letters of the Greek alphabet, Alpha (A) and Omega (Ω), which correspond to Christ's saying: 'I am the Alpha and the Omega, the Beginning and the End' (Revelation 1:8, 22:13). AD

Published: Hayes 1972, 149–150; *Greece and the sea* 1987, 248, no 152 (K Loverdou-Tsigaridas). For the stamps see: *Rom und Byzanz* 1999, 125, no 131 (M Mackensen), with further bibliography.

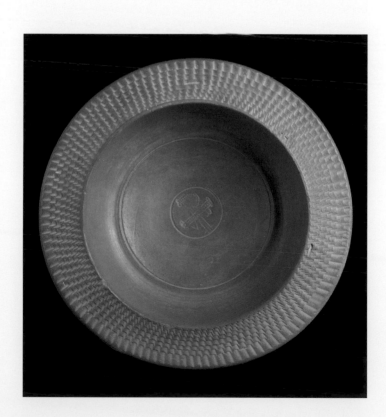

Two pilgrim flasks of St Menas

Cat nos 75, 76
6th–7th c.
From the Monastery of St Menas,
Abu Mina, Egypt
Clay, red
Flask no. 75: 10.2 (h) x 8.2 (w) cm;
flask no. 76: 13 (h) x 12 (w) cm
Gifts of Loukas Benakis (13716,
12538)

The two flasks, although of different dimensions, are identical in shape and iconography. They have a round body with long neck ending in a narrow mouth, and two handles rising from the body to just below the mouth. The larger example (cat no. 76) is broken above the root of the neck and both its handles are missing. The same decoration is repeated on front and back of the vases. Represented in the middle is the standing figure of the soldier-saint and martyr, in short tunic, high boots and long mantle fastened on the shoulder. He stretches his hands out in a gesture of intercession and is flanked by two sitting camels. On the larger flask the figure is identified by an inscription around it: Ο ΑΓΙΟϹ ΜΗΝΑϹ (Saint Menas). On the smaller flask there are crosses in place of the inscription. The representation is encircled by hemispherical bosses in high relief. This iconography refers to the *Vita* (Life) of St Menas, according to which the camels bearing his body stopped of their own volition at a point in the desert, where a monastery to the saint was subsequently built.

The shape and iconography of these vases are repeated on hundreds of comparable examples, all sharing the same place of origin, the monastery of St Menas in Egypt, one of the best-known pilgrim shrines in the early centuries of Christianity. These flasks (*ampullae*), made of local clay and mass-produced from the fifth to the seventh century, were filled with holy water or, more likely, myrrh from the saint's tomb. The numerous pilgrims brought them back home as a souvenir of their presence in the sanctified place and at the same time as a blessing of the saint through his myrrh, which they believed had miraculous properties. It is significant that the Greek name of these flasks is *eulogia*, which means blessing. The iconography on vessels or mementoes of this kind is always summary and easily understood. The same iconographic types are reproduced virtually unchanged for centuries, since, for the recipients of the objects, originality or artistic merit was not as important as the easy identification of the memento with the sacred place from which it came.

The tradition of journeys of pilgrimage goes back to the early centuries of Christianity. In addition to the Holy Land, the great monastic centres in the wilderness, such as that of St Menas in the Maryut Desert, southeast of Alexandria, were equally significant poles of attraction for these travellers. The fact that ampullae from St Menas have been found all over the Mediterranean area attests to the great importance of this pilgrim shrine. AD

Unpublished. For this type of flask see: Metzger 1981; Kiss 1989; Vikan 1991; Vikan 1998; *Everyday life in Byzantium* 2002, nos 193 (E Meramveliotaki), 197 (Th. Archondopoulos), with earlier bibliography.

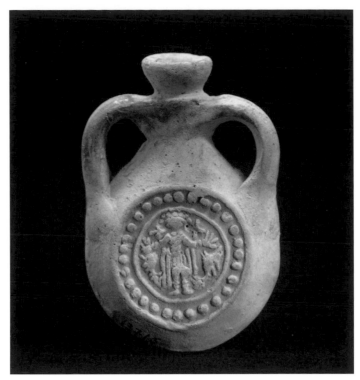

75

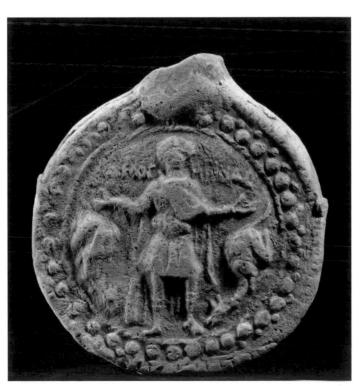

76

Appliqué ornament

Cat no. 77
5th c.
Probably from Syria
Gold sheet, pierced-work, glass paste
4 (diam) cm
Inv. no. 1749

The ornament is formed from a thin pierced-work gold disc, with a white glass-paste gem at the centre and eight green ones in circular arrangement set in mounts. The pierced-work decoration consists of rows of palmettes and a rosette framing the central gem.
The circumference of the disc is bordered by a band with two rows of beaded wire. On the back are gold strips to secure the stones and four loops for sewing the ornament onto a textile.

The precision of the design and the balanced geometric arrangement of the decoration link the Benaki Museum ornament with some of the highest-quality pieces of jewellery of the fifth century, such as a necklace from Egypt now in the Staatliche Museen, Berlin. Comparable characteristics are observed in later jewellery-making, until the seventh century. However, the technical details in the execution of the pierced work point to the dating of this piece among the earlier examples of the type.

There are gold appliqué ornaments of analogous form and decoration in the British Museum and in the former Forrer Collection, the latter known to be of Syrian provenance. Appliqués were a basic accessory of dress in late antiquity, used for fastening garments as well as purely for adornment, as borne out by the depiction of such pieces on painted Egyptian funerary portraits and their woven representation on Coptic tunics. The luxurious extant examples, like the one discussed here, are of gold, but there are also appliqués of copper alloy, which copy the fashion in cheaper material for a less affluent clientele. Characteristic examples of the latter are two bronze medallions with female portraits, in the Benaki Museum. AD

Published: Segall 1938, 132–133, no 201, pl 32; *Benaki Museum Greek Jewellery* 1999, 299, no 108, fig 215 (A Yeroulanou); Yeroulanou 1999, 51, 118, 232, no 161 (with earlier bibliography and further examples). On painted and woven representations of appliqué medallions see: *Ancient faces* 1997, 157–158, no 176; Bruhn 1993, 33–34.

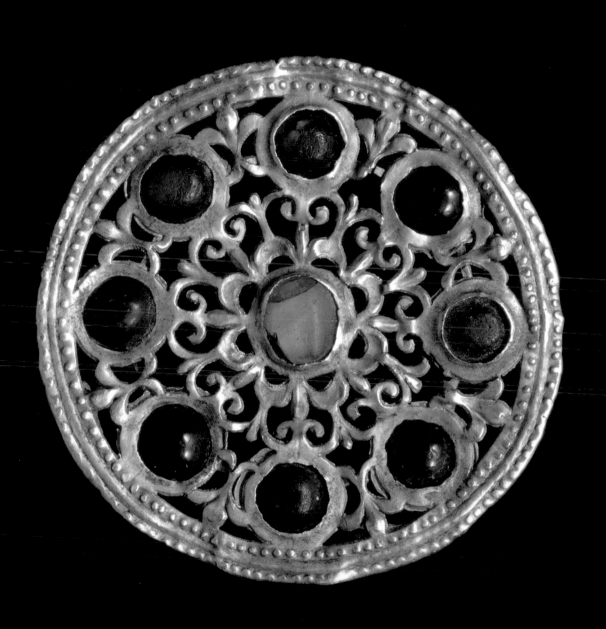

Earrings

Cat no. 78
7th c.
Provenance unknown
Gold sheet, pierced-work,
chased, stippled
4.4 (h) cm
Inv. no. 10810

At the centre of the pierced-work lunate earrings is a circle divided horizontally in two. The upper semicircle encloses two confronted birds with united beaks, perched on a nest represented in the lower semicircle. The circle is flanked by two stippled leaves with biconcave finial, each enclosing a five-leafed palmette. Around the perimeter of the earrings are a notched wire and five soldered globules, one of which is missing on one earring.

Lunate pierced-work earrings are among the most characteristic pieces of jewellery of the Early Christian period. The most elaborate examples are decorated with peacocks, eagles or other birds, in a great variety of compositions; the simpler ones are usually filled with vegetal or linear motifs. The representation of birds combined with stems or scrolls is encountered not only in jewellery but also on textiles, mosaics and sculptures of the same period. This composition, while a decorative subject in vogue, was nevertheless endowed with Christian messages as a symbolic rendering of a paradisial landscape.

In contrast to the early ornaments, on which the birds retain naturalistic features that often permit the identification of the species, on later ones, such as the earrings discussed here, the treatment of the subject is more schematic and generic. The rather late dating of these earrings, in the seventh century, is corroborated by technical traits of their decoration, such as the stippled framing of the motifs and the deep chasing on the palmettes and the nests. Analogous characteristics are observed on pieces of jewellery from the Mytilene Treasure found in Greece and the Pantalica Treasure discovered in Sicily, dated to the sixth–seventh century and to the late seventh century respectively. AD

Published: Segall 1938, 155–156, no 243; Baldini 1991, 87, no 33, fig 5; Delivorrias, Fotopoulos 1997, 213, fig 370; *Benaki Museum Greek Jewellery* 1999, 323, no 121, fig 243 (A Yeroulanou); Yeroulanou 1999, 181, 294, no 582 (with further examples).

Earrings

Cat no. 79
4th c.
Provenance unknown
Gold wire and sheet, pierced-work, chased, emerald plasma, garnets
4.2 (h) cm
Inv. no. 1672

The intricate earrings consist of a quadrilateral mount set with emerald plasma, to which is affixed the hook for inserting it in the earlobe. Around the mount is a soldered frame formed from continuous palmettes. The lower part of the earrings is formed from a central vine leaf flanked by two curving stems terminating in ivy leaves. At the tips of the leaves are three mounts set with garnets, linked together with gold-wire volutes, from which sprout elements set with emerald plasma. Two garnets are missing from one earring, while the emerald plasma is preserved only on the middle element of both earrings.

The palmette frame around the quadrilateral mounts is a characteristic feature of Late Roman jewellery of the third and fourth centuries. It occurs on numerous earrings as well as on the mounts of coins of the period (see cat no. 54), which were widely used as ornaments. On the earrings discussed here, as on many others, the palmette band is not executed in true pierced work, the triangular voids having been cut out prior to the soldering to give the impression of a pierced-work ornament. Pierced-work technique was the 'trademark' of jewellery in this period. Known from the Latin sources as *opus interrasile*, it attests to the skill of the craftsman as well as to the aesthetics of the age. Equally loved in Late Antique jewellery was polychromy, which is achieved on the Benaki Museum earrings by combining green emerald plasma with red garnets.

The vine leaves and the ivy leaves are popular decorative motifs on jewellery of the third and primarily the fourth century. Vine leaves in particular, a basic element of the Dionysiac iconography in pagan antiquity, were incorporated in the Christian thematic repertoire as a symbol inspired by the Gospel passage in which Christ declares 'I am the vine …'(John 15:1–8). Characteristic in this respect is the example of a pair of gold pierced-work necklace plaques, formerly in a private collection in London, on one of which are vine leaves and on the other the Chi-Rho monogram of Christ. This observation does not rule out a similar symbolic content for the decoration on the Benaki Museum earrings. AD

Published: Delivorrias, Fotopoulos 1997, 212, fig 367; *Benaki Museum Greek Jewellery* 1999, 296, no 107, fig 213 (A Yeroulanou); Yeroulanou 1999, 278, no 466 (with further examples and earlier bibliography).

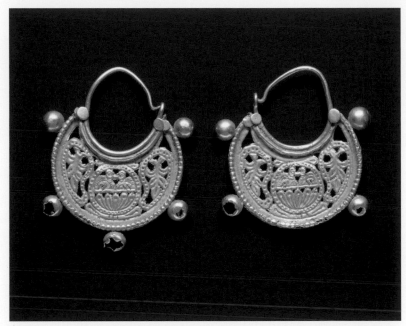

78

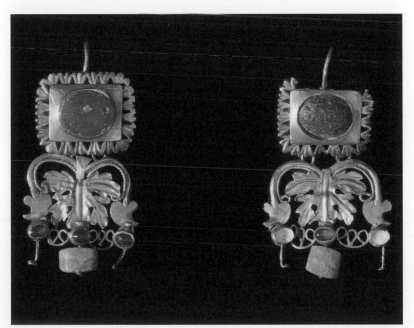

79

Pectoral cross

Cat no. 80
First half 7th c.
Provenance unknown
Gold sheet, granulation
3 (h) cm
Inv. no. 1849

The conical arms of the cross are formed from gold sheet. Placed at the point of their intersection is a decorative quatrefoil rosette with globule at the centre. Soldered to the finial of the upper arm is the wide suspension loop, decorated with grooves, between which is a single row of granulation.

Pectoral crosses, made in a wide range of materials, are the commonest type of jewellery-amulet from the early centuries of Christianity to the present day. Similar crosses with conical arms and decoration at their intersection are frequently found in seventh-century treasures, confirming the dating of the Benaki Museum example to the same period. Comparable are analogous examples from the Mersine Treasure discovered in Cilicia, Asia Minor, and from another find, possibly of Constantinopolitan provenance, which is now in the Dumbarton Oaks Collection, Washington DC.

The most usual decoration at the crossing of the arms was a mount set with a stone. On some examples there is a cruciform opening at the centre, which may have been intended to receive a holy relic. However, the tradition of reliquary-crosses in which the victory-giving, protective power of the cross is reinforced by the presence of sanctified relics was to enjoy very wide dissemination in the period after Iconoclasm, mainly from the ninth to the twelfth century (see cat no. 85). Rosettes such as the one adorning the present cross, trefoil or quatrefoil with globule at the centre, are popular in Early Christian jewellery. They are encountered on various pieces, such as two bracelets in the Dumbarton Oaks Collection with mounted gold coins and rosettes set between them. These bracelets are of Constantinopolitan or Egyptian provenance and are dated between 610 and 641, thus furnishing a secure chronological parallel for the Benaki Museum cross. AD

Published: Segall 1938, no 273, pl 52; *Benaki Museum Greek Jewellery* 1999, 326, no 122, fig 245 (A Yeroulanou), with further bibliography; Delivorrias, Fotopoulos 1997, 215, fig 376. For parallels see: *Rom und Byzanz* 1999, nos 274-276, 279, 284, 287, 289 (C Schmidt); *Everyday life in Byzantium* 2002, 404, no 508 (N Saraga).

Finger ring

Cat no. 81
6th-7th c.
Provenance unknown
Gold
2.9 (h) cm
Inv. no. 1826

The heavy ring has a solid hoop of semicircular section with flaring shoulders, on which a high, calyx-shaped bezel is attached. At the top of the bezel is an opening in the form of a quatrefoil cross, which may well have been intended, as on comparable examples, for the insertion of a holy relic or a glass-paste gem, now lost. It is equally possible, however, that the ring was left unfinished.

The high bezel attachment links the Benaki Museum jewel with a group of rings from seventh-century treasures, such as those discovered in Mytilene, Greece and in Mersine, Cilicia in Asia Minor. It is also comparable with analogous examples in the Dumbarton Oaks Collection, Washington DC. In contrast to those pieces, in which the bezel in the form of an elaborate flower is of purely decorative character, the design of the Benaki Museum ring explicitly evokes the shape of the cross, endowing it with an amuletic character. This character would have been further reinforced if the opening in the bezel did indeed contain relics, as suggested above.

The same amuletic function is apparent in many pieces of jewellery in this period, in which the possessor's desire for adornment seems to have gone hand in hand with that for a protective shield against hostile forces and malevolent daemons. For this purpose, the decoration of their jewellery was enriched with potent Christian symbols, such as the cross, or with religious representations and verses from the psalms. AD

Published: Segall 1938, no 257, pl 50; Delivorrias, Fotopoulos 1997, 213, fig 369; *Benaki Museum Greek Jewellery* 1999, 315, no 116, fig 231 (A Yeroulanou) with further bibliography. On rings with calyx bezels see: Yeroulanou 1994. On the prophylactic character of early Christian jewellery see: Vikan 1984; *Art and holy powers* 1989, 159-160.

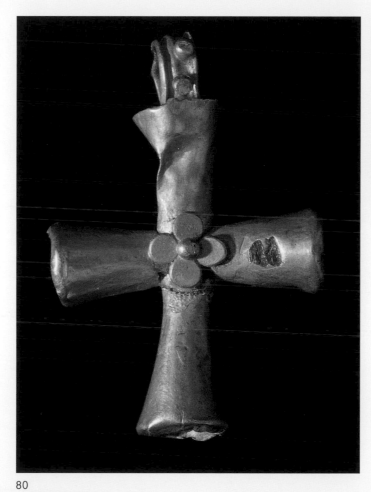

80

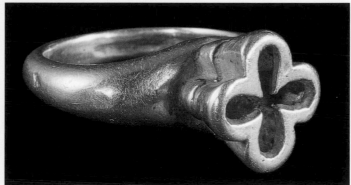

81

Stone relief with soldier-saints

Cat no. 82
13th c.
From Amaseia, Asia Minor
Limestone, carved in relief,
traces of red and black pigment
33 (h) x 44 (w) x 5 cm
Acquired with the contribution
of Ergasias Bank (33630)

The stone plaque bears a relief representation of two soldier-saints on horseback, spearing an enemy. They are shown confronted, with their steeds rearing and trampling with the forefeet the recumbent foe. The two saints and the enemy have common features, with round bearded faces and large bulbous eyes – those of the foe are closed, indicating that he is dead – and similar attire. They wear an overgarment with short sleeves, crossed over on the chest and belted at the waist. Below this is a sleeved tunic with low neck, under which is a second inner garment that reaches to just below the knee. On the feet are boots. Strangely, behind the equestrian figures flutter schematic edges of mantles, although these are not among their clothing. The basic difference in the garb of the three figures is the elaborate headdress of the dead enemy, unlike the headdress of the mounted warriors, and the addition of a folded collar to his overgarment. Incised beside the head of each saint are graffiti,

very possibly later, that identify them as Theodore (left) and George (right). On the ground of the plaque are traces of red and black pigment.

The iconography is consistent with the Byzantine schema of representing pairs of confronted soldier-saints slaying a dragon or an adversary, according to the hagiographical tradition accompanying each. Analogous representations are particularly frequent in wall-painting ensembles of Cappadocia in Asia Minor, but even more closely akin to the plaque discussed here are two stone relief plaques from Kiev, of the eleventh–twelfth century. Plaques of this type were incorporated in the façades of churches, where their function was not only decorative but also potently apotropaic. A similar use on secular buildings, possibly for military purpose, cannot be ruled out. After all, soldier-saints, as warriors of Christ, fought not only the human enemy but also evil forces or daemons in general which threatened man in his daily life. For this reason, soldier-saints were much loved among the ranks of the military as well as by priests and women.

In comparison with the Kiev plaques, the Benaki Museum relief differs essentially in the figures' attire, which is not identified with the traditional military uniform of Byzantine

soldier-saints, who wear a breastplate, short tunic and mantle fastened on the shoulder. The type of overgarment and the boots of the three figures here refer to clothing of Eastern type. Comparable costumes are encountered not only in numerous Islamic works of art but also in the Armenian sculptures of Aght'amar (915-929) – an island in Lake Van – in later Armenian stone reliefs, such as the donor plaque in the Haridch monastery (1201), and in fourteenth-century Armenian manuscripts, usually in the raiment of the Magi who come from the East.

More specific evidence for dating the Benaki Museum stone relief is provided by certain details of the execution, such as the full, round faces and, mainly, the combination of the stippled dots on the haloes and the edges of the garments, with the concentric circles that abound as decorative element of the representation. Similar ornaments occur also in metal objects of the thirteenth century which come from the eastern margins of the Byzantine world, such as the well-known silver-gilt revetment of the Virgin of Tenderness from Zarzma in Georgia, which has been dated recently to this period.

The presence of iconographic elements from both Byzantine and Oriental tradition in this stone relief at once accords with

and reflects the historical circumstances prevailing in the region of its provenance, Amaseia in central Asia Minor, where Greeks, Armenians and Seljuk Turks moved with equal ease in the thirteenth century. AD

Published: Delivorrias, Fotopoulos 1997, 244, fig 429. For parallels see: Grabar 1976, no 77c-d, pl LXII; Der Nercessian 1977, figs 53, 54, 58, 59, 147; *Roma-Armenia* 1999, 148. On the iconography of military saints see: Walter 2003a, 269 and *passim*; Walter 2003b. On the Zarzma icon revetment see: Djavakhichvili, Abramichvili 1986, figs on pp 136–145; and on its correct dating see: Velmans 2002, 317–323, 341–376, fig 261.

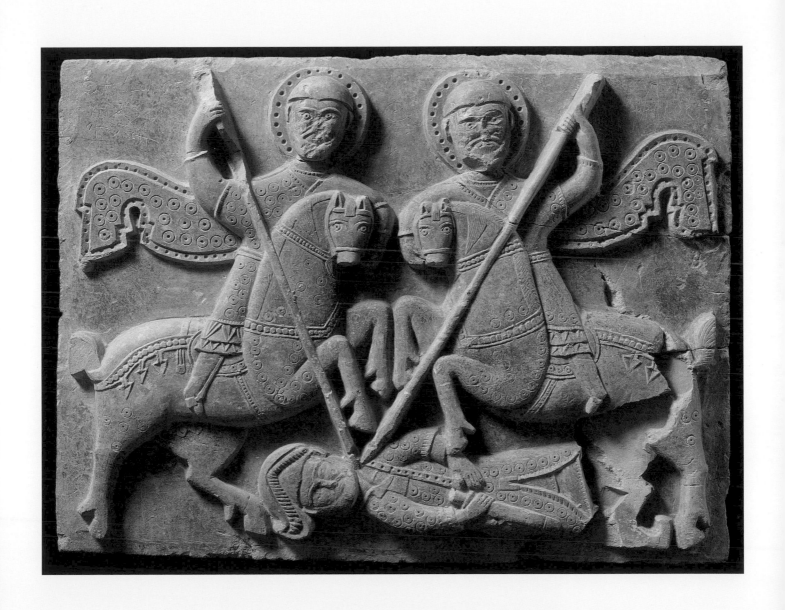

Standing censer

Cat no. 83
14th–15th c.
Provenance unknown
Copper alloy, cast, openwork
15 (h) x 19.5 (l) x 11.8 (w) cm
Gift of Helen Stathatos (21502)

The standing censer or *katzion* is made of four cast pieces: the shallow bowl to which is soldered the rim with the integral handle, the prismatic base and the conical lid. The bowl bears traces of working on a lathe. The handle, the foot and the lid are in openwork technique, with schematic vegetal motifs and birds. The decoration is complemented by tiny hammered circles, which also denote the birds' eyes.

The first mention of the type of standing censer with long, wide handle by the term *katzion* or *katsion* is in Byzantine monastic inventories of the eleventh century. These vessels possibly had a special use in funerary services of the Church, because they are frequently depicted in painted representations of the Dormition of the Virgin, or of other saints, and appear too in scenes of litanies of icons. The

katzion in the Benaki Museum is one of the best preserved of a series of cast standing censers, one of which was found in the excavation of a grave in Mystras, in the Peloponnese, and is dated to the second half of the fourteenth or the fifteenth century. Other examples are to be found in the Simonopetra monastery on Mt Athos and the Great Meteora monastery in central Greece, in museum collections in Belgrade and in the British Museum. Some of these are of exactly the same dimensions and have identical decoration with birds, which indicates that they were made in the same mould. Others, such as the example in the British Museum, have different decoration, with representations of running animals instead of birds.

The openwork technique and the decorative themes link these censers with Late Byzantine lighting devices such as monastic chandeliers, a candelabrum in the Dečani monastery in Kosovo and a multiple hanging lamp in the Averoff Collection in Metsovo, in central Greece. Workshops producing cast objects for wider consumption existed

in the mining regions of Serbia and, as the evidence indicates, in major urban centres such as Constantinople, Thessaloniki, and perhaps Serres in northern Greece.

The tradition of making openwork chandeliers and lamps goes back to the Early Christian period, but the thematic repertoire of animals and birds recalls thirteenth-century Islamic works in metal and ceramics. The reciprocal influences between Byzantine and Islamic art are to be expected in this period, during which Asia Minor, although recently conquered by the Seljuk Turks, continued to be inhabited by Christian populations that coexisted with the newly-settled Muslims. AB

Published: Bouras 1981, 65, 69–70; *Oi pyles tou mysteriou* 1994, 266, no 90 (A Drandaki); Delivorrias, Fotopoulos 1997, 221, fig 394. For Late Byzantine lighting devices see: *Byzantium* 1994, 201, no 217 (M Mango); *Byzantium: Faith and Power* 2004, 123–124, figs 5.7–5.8, 125, no 60 (A Ballian).

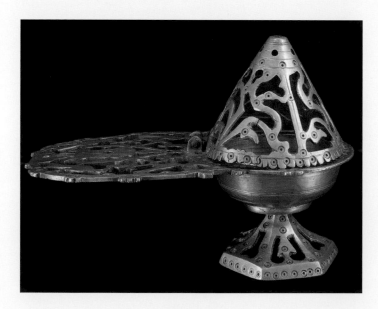

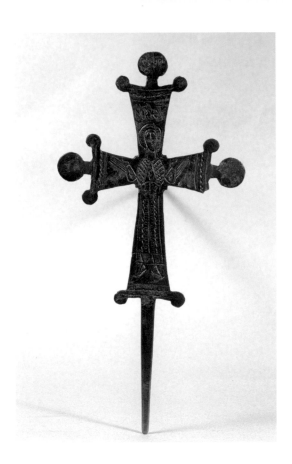

Processional cross

Cat no. 84
11th–12th c.
Provenance unknown
Copper alloy, cast, engraved
28.2 (h) x 13.8 (w) x 0.3 cm
Gift of Stephen and Francis
Vagliano (30259)

The cross is covered with a dark green patina. Represented on the obverse is the Virgin, standing, full-bodied, with her hands in a gesture of intercession (*orans*). The figure is schematically rendered with the disproportionately large, open hands underlining the role of the Virgin as mediator with Christ for the salvation of mankind. Above her head, on the arm of the cross, is the usual abbreviated inscription: ΜΗ(ΤΗ)Ρ Θ(ΕΟ)Υ (Mother of God). The flaring ends of the arms of the cross are decorated with incised motifs and terminate in discs framed by smaller discs. Incised in the disc on the upper arm is the inscription: Ο Α(ΓΙΟΣ) ΑΝΔΡΕΑC

(St Andrew). The integral long shaft from the lower part of the vertical arm was for inserting the cross in a pole for carrying it in procession. The back of the cross is undecorated.

Processional crosses were an essential element of public religious rituals in the ecclesiastical life of Byzantium from Early Christian times, and their use continues to this day. Among the extant examples are several precious silver-gilt processional crosses of the Middle Byzantine period, with lavish decoration and rich iconography. They are often accompanied by dedicatory inscriptions recording their affluent donor. However, alongside the high quality works are several crosses of humbler materials, with summary decoration which copies the iconography of the more sumptuous models, as in the example here. The representation of the Virgin *orans* appears with

considerable frequency, since intercession for the salvation of the faithful is a constant subject in the iconography of processional crosses. On other analogous examples the Virgin has been replaced by other saints. It cannot be ruled out that these figures of suppliant saints corresponded to homonymous churches in which the crosses were dedicated.

In terms of workmanship, the decoration of the cross is linked closely with a large group of portable copper alloy reliquary crosses, (see cat no. 85), which enjoyed very wide dissemination throughout the Byzantine realm after Iconoclasm, primarily during the eleventh and twelfth centuries. AD

Unpublished. For parallels see: *Early Christian and Byzantine art* 1990, 102, no 67; Cotsonis 1994, 102, no 12. On the iconography and style see: Pitarakis 1996, *passim*; *Mother of God* 2000, no 25 (B Pitarakis), no 41 (A Drandaki).

Reliquary cross

Cat no. 85
11th–12th c.
From Constantinople
Copper alloy, cast, engraved
8.2 (h) x 5 (w) cm
Gift of Prodromos Mellon (35553)

The cross consists of two parts, front and back, connected by a hinge and forming between them a case to receive a holy relic. Engraved on the obverse is a full-bodied figure rendered in a highly schematic manner. Although represented in frontal pose, the feet are turned left. The head is surrounded by a cross-inscribed halo, a form of halo exclusive to Christ. This identification is confirmed by the inscription either side of his shoulders: HC XC (Greek abbreviation of Jesus Christ). The Lord wears a long garment, the *colobium*, with decorative bands on the girdle and the hem, and raises his right hand in a gesture of blessing, while with the left he holds a Gospel book or a casket. On his right is a flabellum, identified by the misspelled inscription ΕΞΑΤΕΡΥΓΟ. On the corresponding left arm of the cross is an object suspended from chains, which can be identified as a hanging lamp or, more probably, a censer. The upper arm of the cross is decorated with a triple figure-eight motif.

Engraved on the reverse of the cross is a simple geometric ornament framing a circular cavity at the intersection of the arms, which would have been filled with glass paste, now lost. The arms of the cross on both faces terminate in discs, decorated with concentric circles.

This cross belongs to a very large category of similar objects, of which almost one thousand examples are known. Reliquary crosses were widely disseminated after Iconoclasm, mainly between the tenth and twelfth centuries, all over the Balkans and Asia Minor, where they have been found in houses, graves and churches. Only a few luxury examples in gold have survived, such as the one from Pliska in Bulgaria, and more in silver, such as two specimens in the Benaki Museum. As is to be expected, these crosses have carefully executed decoration, enriched with niello, and a complex iconography. The huge number of copper alloy reliquary crosses, on the other hand, bear either relief decoration cast in a mould or, as in the example here, summary engraved representations. The engraved examples are often so schematic that if there were no inscriptions it would be impossible to identify the saints depicted.

Christ features frequently on reliquary crosses, as a rule in the scene of the Crucifixion, but the representation on the example discussed here displays peculiarities. Although the square object Christ holds could be interpreted as a Gospel book – the identifying trait *par excellence* of the Pantocrator (Ruler of All) – the flabellum and the censer(?) flanking him endow the representation with a liturgical character. Christ's attire, which differs from the simple chiton and himation, and perhaps reproduces liturgical vestments, can be considered as pointing in the same direction. If this interpretation of the iconography is correct, then the cross can be dated fairly confidently to the eleventh or the twelfth century, a period in which the influence of the liturgy on Byzantine iconography acquired ever-increasing significance. AD

Unpublished. For parallels see: *Mother of God*, 308–312, nos 23–26, (B Pitarakis) with further bibliography.

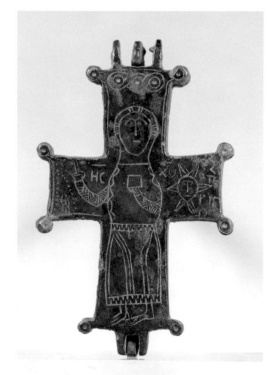

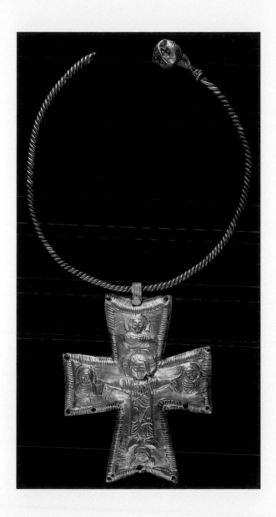

Silver cross with necklet

Cat no. 86
7th c.
From Egypt
Silver, repoussé, incised
21.3 (overall h) cm;
cross 10 (h) cm
Inv. no. 11423

The cross is formed from two thin silver sheets joined at the edges. The obverse is decorated in repoussé, with a representation of the crucified Christ occupying most of the surface. The Lord, who wears a long garment (*colobium*), has disproportionately large hands and a cross-inscribed halo. At the ends of the arms of the cross, which flare slightly, are four busts of saints swathed in himations. Around the edge of the cross runs a band decorated with parallel incisions, interrupted by small holes which were probably set with stones. Affixed to the middle of the upper arm is the suspension loop, which is passed onto a twisted wire necklet. Only one terminal of the necklet survives, with its button-shaped fastening.

The decoration is rather crudely executed, both in the drapery of the garments and the rendering of the figures. Since the four busts framing Christ display no personalised features and are not accompanied by inscriptions, it is only possible to identify them through parallel examples. In all likelihood they are the four Evangelists, who occur in the same arrangement on other pectoral crosses.

The human figure is treated in analogous manner on numerous pieces of jewellery and silverwork of the sixth or seventh century. The closest comparison for the Benaki Museum ornament in both iconography and style is a gold cross in the Dumbarton Oaks Collection in Washington DC, which has been dated to the first half of the seventh century. Although of more careful craftsmanship in every detail and of more luxurious material, this has exactly the same iconography as the silver cross discussed here. The figures have comparable full faces and round eyes. The representation of Christ is also identical, with the enlarged palms turned downwards as if showing the viewer the marks from the nails, rather than depicting the actual event of the Crucifixion, which the Evangelists surrounding him had written down. The Dumbarton Oaks cross likewise lacks inscriptions, but an attempt has been made to differentiate the portrait features of the Evangelists.

Necklets were very widespread in Late Antique jewellery and were worn equally by women and men. The small diameter of the necklet of the Benaki Museum cross indicates most probably that this jewel-amulet belonged to a woman or a child. AD

Published: Delivorrias, Fotopoulos 1997, 191, fig 322. For parallels see: *Age of spirituality* 1979, nos 296, 301 (K Reynolds Brown).

Censer

Cat no. 87
8th–9th c.
Provenance unknown
Copper alloy, cast
9.5 (h) x 8.5 (rim diam) cm
Inv. no. 11526

The censer is shaped as a goblet with truncated conical foot. It would have originally hung from chains, now lost, fixed in the holes visible below the rim. The bowl is decorated in relief with five scenes from the life of Christ, developed in a continuous frieze: the Annunciation, the Nativity, the Baptism, the Crucifixion and the Women at the Tomb. The cast figures are rendered in a very summary manner, evidently without any refinement to enhance details. Inside the hollow base, which was visible when the vessel was suspended, is a representation of Christ in the manger.

The Benaki Museum censer belongs to a large group of similar vessels – about one hundred examples of this type are known – which were apparently already widespread from as early as the sixth century and continued to be produced in the following centuries. Their manufacture by casting confirms their mass production. All have a common thematic repertoire and comparable technical traits, but they differ in the number of gospel scenes represented, the most elaborate example being a censer with two zones of decoration that includes twelve scenes. On some censers the workmanship is more refined, with additional engraved details and decorative bands on the rim and the foot.

Certain iconographic details associate these censers with the decoration on pilgrim souvenirs from the Holy Land, such as the Monza and Bobbio ampullae, and the finger-rings with the Women at the Tomb. This fact, in conjunction with the very wide dispersal of these vessels, indicates that their centre of production may well have been in the same geographical region and that the censers may also have been mementoes from the major Christian pilgrim shrines in Jerusalem. It may be significant in this aspect that a large number of such censers has been found in Syria and Palestine. AD

Published: Bouras 1981; Richter-Siebels 1990, no 1. For parallels see: *Isskustvo Bizantii* 1977, vol 2, no 442; Effenberger, Severin 1992, nos 114–115; *Rom und Byzanz* 1999, 44, no 30 (J Paula).

Multiple hanging lamp

Cat no. 88
9th–11th c.
Provenance unknown
Copper alloy, cast
72 (h) x 24 (disc diam) x 15.5 (inscribed disc diam) cm
Acquired with the contribution of Aristeidis and Themistoklis Alafouzos (32651)

The multiple hanging lamp, known as *polykandelo*, consists of cast parts which have been assembled with hinges and hooks. The central hoop has six circular holes, in which the glass lampions were set, and is decorated with openwork patterns including rosettes, heart-shaped motifs and schematic vegetal stems. From three integral loops, which are linked with corresponding plain metal strips, hangs the central suspension device, set with a smaller disc. Its openwork decoration is organised in two concentric circles. At the centre is a large Greek cross with four smaller crosses in the segments between the arms. Around the outer zone runs the dedicatory inscription prefaced by a cross: +ΜΑΡΗΑΝΟΥ Α΄СΠΑΘΑΡΙΟΥ (of Marianos Protospatharios).

Polykandela were, from Early Christian times, the basic means of lighting large private halls and churches. Some luxurious examples in silver are included in ecclesiastical treasures, but most of the surviving vessels are made of copper alloy, like the one discussed here. Although the basic design of these objects remained the same for centuries, Middle Byzantine polykandela are, as a rule, decorated with heart-shaped motifs and schematic vegetal stems, subjects characteristic of the repertoire and the decoration of the period. There is a very closely related example in the Averoff Collection in Metsovo, in central Greece, while another seven pieces, virtually identical to the Benaki Museum polykandelo, were found as an ensemble at Ovaakçe in the vicinity of Bursa, Turkey. It is very possible that the piece in the Benaki Museum belonged originally to the same group. Therefore, we are dealing with a set of similar objects which were commissioned by the Protospatharios Marianos, who most probably dedicated them to a church, thus offering the lighting equipment so essential for its operation.

Of particular interest in this group of lighting vessels is the inscription on their disc, which records the identity of the commissioner. The title Protospatharios, given to officers in the Byzantine army, is encountered after 718 and with greater frequency from the ninth century onward, thus providing a further strong piece of evidence for dating the objects. The same name, Marianos, is repeated on an openwork medallion from another polykandelo, now in the Byzantine Collection of Princeton University. Although different in execution, it probably dates from the same period. AD

Published: Xanthopoulou 1997, II, 367, III, pl 256; Delivorrias, Fotopoulos 1997, fig 394. For parallels see: Firatli 1969, 181, figs 16–17; *Anatolian civilisations* 1983, 167, no C.37; *Sylloges Evangelou Averoff*, no 151 (V Papadopoulou); Bouras 1982; *Splendeur de Byzance* 1982, 177, no Br 20 (L Bouras); Effenberger, Severin 1992, 127, no 46.

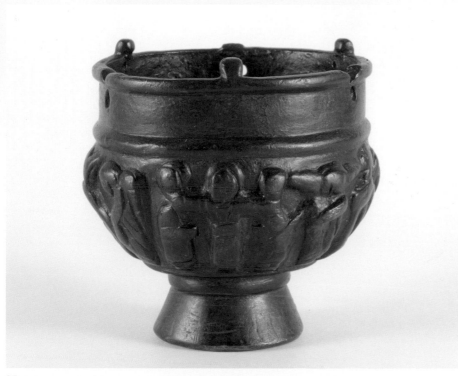

87

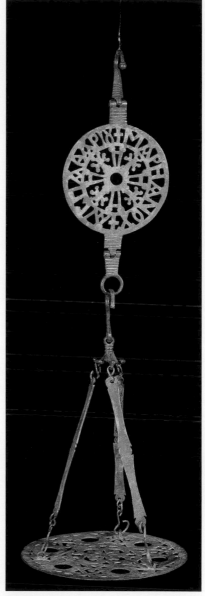

88

Manuscript of the Four Gospels

Cat no. 89
12th c.
Provenance unknown
Parchment, 129 folios
200 x 140 mm
Benaki 2

The manuscript is without title and incomplete. The first folio is torn and only a small part survives, on which traces of the illumination are visible. Executed in gold and colours, the illumination comprised the headpiece with the miniature of the Evangelist Matthew and the initial capital B of the opening word of the first Gospel (i.e. the Greek word for book, *Biblos*). The scribe is unknown, as is the provenance of the manuscript, which is preserved in good condition although not bound.

The codex is made up of quartos, the numbering of which is not legible. The text is in one column of 32 or 33 lines, penned in rounded, upright, careful script. Black ink has been used, with rubrics on the inscriptions of the Gospels and the initial capitals of the text, which are also covered with gold. Of the miniatures of the Evangelists at the beginning of each Gospel, only one is preserved, on folio 77r, in an elaborate headpiece including a bust of the Evangelist Luke. The Evangelist is depicted within a roundel, turned slightly right, blessing with his right hand and holding a closed codex in his left. The title, 'The Holy Gospel According to Luke', is in gold lettering with calligraphic initial E (of the Greek word for gospel, *Evangelion*). This type of introductory illumination of manuscripts dates back to the eleventh-twelfth century and is a condensed and more economical solution for the iconography.

The codex includes 'The Holy Gospel According to Matthew', folios 1-44v, text untitled and incomplete (both beginning and end missing); 'The Holy Gospel According to St Mark', folios 45-75r, also untitled and incomplete on some folios, and last, 'The Holy Gospel According to St Luke', folios 77-129v, incomplete on some folios.

On folio 76v, a later scribe in the eighteenth century wrote two misspelled *synaxaria* (brief hagiographical notices incorporated in the Church month calendar of fixed days). On folio 90v is a note written in the eighteenth–nineteenth century by a hieromonk (a monk ordained as a priest). PT

Published: Aland 1963, 196, no 2557; Tselikas 1977, 23, no 11; Lappa-Zizica, Rizou-Couroupou 1991, 18, no 2.

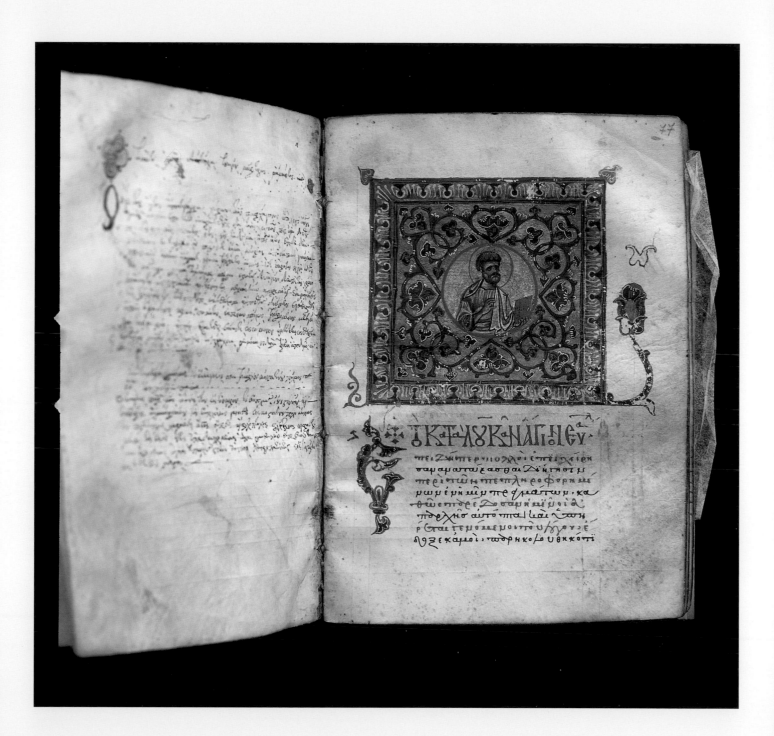

Manuscript lectionary

Cat no. 90
1300
From Caesarea, Asia Minor
Parchment, 337 folios, leather
binding, gold-tooled
350 x 245 mm
Inv. no. TA 318

This lectionary, one of a small group of Palaiologan manuscripts in the Benaki Museum collection, is outstanding for the quality of both its script and its illumination. Although it does not include full-page miniatures, its large dimensions, generous use of parchment and careful presentation attest to the intention of producing a special and impressive codex.

It comprises 43 quartos, numbered with letters of the Greek alphabet. The number of each quarto is marked bottom right on the recto of the first folio and bottom left on the verso of the last. Only the first quarto is unnumbered. Between quartos 19 and 20 there is a double folio also unnumbered. The verso of folio 151 is blank.

The text is in two columns of 21 to 25 lines. The scribe is unknown. The script is upright, rounded and very fluent. Black ink is used and many gold embellishments on the chapter titles and the indications of readings. There are ornate illuminations in gold and colours on the 258 initial capitals and the 14 headpieces of the text. Folio 248 has been completed by a later scribe in the eighteenth century.

The date of the manuscript is noted on the last folio, 337. The scribe had penned in gold three letters of the Greek alphabet, which stand for the year 6808 since the Creation of the World (*Anno Mundi*) and correspond to AD 1300, according to the Byzantine chronological system, the starting point of which is the year 5509/5510 BC. Over time, however, the first letter-digit was erased, and as a result the two letters left represented the date 808. A later scribe over-wrote the notation 808 in red ink and a second scribe repeated below, in black lettering, the same

indication. This perhaps misled readers of the codex into recognising the date 808 as the year of its production. Modern research confirms the original indication of the date 1300 and accepts its provenance from Caesarea in Cappadocia, Asia Minor.

The contents are in the following sequence: on folios 1-248v is an *evangeliary*, the Byzantine Gospel lectionary, used chiefly at Eucharist and containing only those Gospel passages that are actually read (folios 1-77v John; folios 78-111v Matthew; folios 112-151 Luke; folios 152-170r fasts; folios 170v-248v Holy Week). On folios 249-331v is a brief *menologion* – a collection of *vitae* arranged according to the date of each saint's celebration in the Church calendar, 1 September-31 August – and on folios 331v-337 are Gospel passages for the Resurrection.

The codex is preserved in excellent condition, with a precious binding in Western style. The wooden boards are covered in red leather and rich gold-tooled decoration.

On the front, within a frame of floral ornaments, is the Resurrection and in the four corners are the Evangelists. On the back, the central representation is the Crucifixion and in the corners again are the Evangelists. The spine is elaborately gold-tooled. The two clasps are intact. PT

Published: Levidis 1907, 272–273, no 2; Aland 1969, 31; Lappa-Zizica, Rizou-Couroupou 1991, 222–223, no 109.

ΕΚΤΟΥ ΚΑΤΑ ΙΩΑΝΝΗΝ ⁖

μας χη ην
ο λ̅ς· και
ο λογος ην π̅
τον θ̅ν· και
θ̅ς ην ο λο·
ουτος ην
δι αρχη προς
τον θ̅ν· παν
τα δι αυτ
εγενετο· ς
χωρις αυτ

φ ερ γετοο
ο δ γ̅ ο λ̅ο
ρ γ̅ν· υμα
τω ζωη ην
και η ζωη ην
το φως τω
α̅ν̅ων· και
το φως εν
τη σκοτια
φαινει· και
η σκοτια

Loose leaf of a psalter
Constantinopolitan scriptorium

Cat no. 91
c. 1084
Parchment
160 x 110 mm
From codex 49 of the Pantokrator
monastery on Mt Athos, now in
the Dumbarton Oaks Collection,
Washington DC, no 3
Benaki 66

The loose leaf is from a codex
which, until 1941 at least,
belonged to the Pantokrator
monastery on Mt Athos, with
the number 49. At some time
it found its way onto the market
and the main body of the
manuscript was subsequently
purchased, in 1962, by the
Dumbarton Oaks Center for
Byzantine Studies. The loose leaf
discussed here had been removed
and was acquired by the Benaki
Museum in 1936. The codex
consists of 364 folios and includes
the psalms, canticles and the New
Testament, as well as texts giving
spiritual and liturgical instructions
to the faithful. Particularly
valuable are the Paschal tables,
showing the date of Easter for
the years from 1084 to 1101.
This element documents precisely
the date of the copying of the
manuscript c. 1084.

The Benaki Museum folio is
78r–v of the codex. The text
is from the Canticle of Jonah
(Jonah 2:3–10). The recto is
decorated with an almost full-
page miniature illustrating the
text. Depicted in the lower left
corner is the sea with Jonah
projecting from the mouth of
the whale. A little behind is a
half-naked but now effaced figure
holding a trident, who is, according
to the accompanying inscription,
the personification of the Abyss.
Further right, Jonah appears
again, full-bodied, standing and
offering a prayer of gratitude
to God for his deliverance.
In the background of the rocky,
mountainous landscape in which
the figure stands is a small building
in the antique style, possibly
representing the gate of Nineveh.
The text continues on the verso,
but the miniature in the lower
half of the page belongs to the
following Canticle of the Three
Hebrews, the text of which is
developed on folios 79–80. The
three boys, in the Persian attire
of traditional iconography, are
represented inside the fiery furnace.
The middle figure is in frontal
pose with palms on the chest,
while the two figures flanking
him raise their head in prayer
toward the angel who protects
them and points his lance at the
terrified Chaldean servants.

The codex from which the Benaki
Museum loose folio comes belongs
to the category of Byzantine
aristocratic psalters. Among the
distinctive traits of the exquisite
miniatures are the rich,
bold palette, the balanced
composition, the elegant
refinement of the figures and
the uncontrived incorporation
of classicistic elements, such
as the personifications and the
archaised building reminiscent
of a Roman villa. The
illumination displays close
affinities with manuscripts
by renowned scribes from
the famous scriptoria of
Constantinople, of the late
eleventh century, which confirms
an analogous provenance for
this codex. AD

Published: Der Nercessian 1965;
Cutler 1984, 91–98 (with extensive
bibliography); Lappa-Zizica, Rizou-
Kouroupou 1991, 55, no 31 and
363–364 (S Papadaki Oekland);
Delivorrias, Fotopoulos 1997,
235–236, figs 417–418.

Κ ἀπὸ τοῦ προβλήματος μαι ἐξ ὀφθαλμῶν σου· ἄρα τὰ ῥοσθήσω
τοῦ ἔτι μὲ ἐπιμεῖναι πρὸς ναὸν ἅγιόν σου· περιεχύθη
μοι ὕδωρ ἕως ψυχῆς μου· ἄβυσσος ἐκύκλωσέ με ἐσχά-
τη· ἔδυ ἡ κεφαλή μου εἰς σχισμὰς ὀρέων· καὶ ὑπημεῖσο
γῆν· ἧς οἱ μοχλοὶ αὐτῆς· καὶ ἀπὸ χρόνιοι· καὶ ἀνα-
βήτω ἐκ φθορᾶς ἡ ζωή μου· πρὸς σὲ κε ὁ θς μου·
ἐν τῷ ἐκλείπεσθρὸς ἐξ ἐμοῦ τὴν ψυχήν μου· τοῦ κυ̅ ἐμνήσθην·
ὁ θη̅ρ· καὶ ἔλθοι πρὸς σὲ ἡ προσευχή μου· πρὸς ναὸν τὸ
ἅγιόν σου· φυλασσόμενοι μάταια καὶ ψευδῆ· ἔλεος αὑτῶν
τὸν ἐγκαταλιπεῖν· ἐγὼ δὲ μετὰ φωνῆς αἰνέσεως
καὶ ἐξομολογήσεως θύσω σοι· ὅσα ηὐξάμην ἀποδώσω
σοι εἰς σωτηρίαν μου τῷ κω̅·

εἰκ. 18

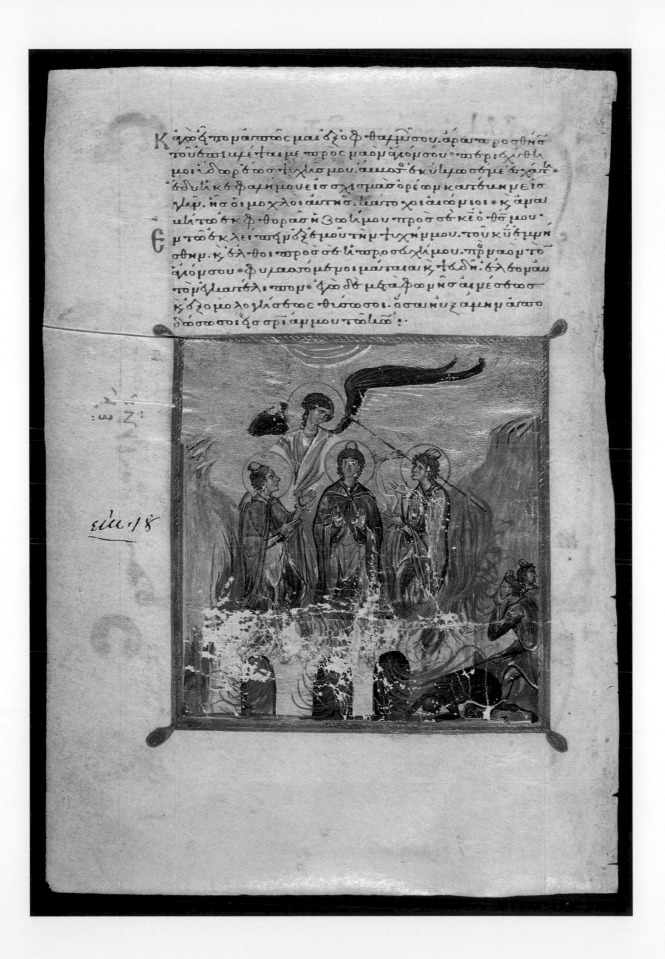

133

Argyrobull decree of Demetrios Palaiologos

Cat no. 92
1456
Provenance unknown
Vellum
300 x 360 mm
Benaki 67

This is one of the few extant original argyrobull decrees. Argyrobulls are official documents sealed with a silver bulla. Their issuing was an exclusive privilege of the Imperial family and of those who bore the title of despot, whereas chrysobulls were issued solely by the emperor.

The text is of considerable interest, not only because it provides useful information on the fiscal organisation and political situation in the time of its issue, but also because the document itself had a chequered history, since it was the victim of forgery. According to the text, the Despot of Mystras, Demetrios Palaiologos (1448-1460), grants privileges to his nephew Ioannis Xanthopoulos and his siblings in exchange for the significant financial support they had offered him in difficult hours. But the name Xanthopoulos has been added to the document after the erasure of the real name of Palaiologos' nephew. The forgery was made recently, in the late nineteenth or the early twentieth century, presumably so that the Xanthopoulos family could claim a title of nobility or property. The true recipients of the document are revealed further on in the text itself, where it is mentioned that the sons of Frangopoulina, that is, the Frangopoulos brothers, are those for whose sake the decree was discharged.

The family name Frangopoulos, common in Byzantium from the eleventh century, is closely connected with the history of Mystras and the Peloponnese in the turbulent fifteenth century. As is well known, the Protostrator (highest official) Ioannis Frangopoulos was donor of the Pantanassa monastery, one of the most important monuments at Mystras (1428). In all probability the same Frangopoulos family of the Peloponnese is referred to in a document of Mohammed the Conqueror, of 1454, securing the possessions of the Byzantine feudatories of the same name. AD

Published: Vranousi 1977, 509, pl VI.2; Vranousi 1980; Lappa-Zizika, Rizou-Kouroupou 1991, 55–56, no 30, fig 41; *Oi pyles tou mysteriou* 1994, 254, no 74 (A Drandaki); *Byzantium: an oecumenical empire* 2002, 147, no 54 (A Drandaki). On the Frangopoulos family see *PLP* I / 12, 144– 147, nos 30077–30100.

Manuscript lectionary with cover

Cat no. 93
Codex 11th c.; metal fittings
15th–16th c.
From Ince-Su, region of Caesarea, Asia Minor
Parchment, leather binding over paper boards, fittings of silver, copper alloy, traces of gilding
24 (h) x 19 (w) cm
Inv. no. 34180

Lectionaries contain lections intended for reading in liturgical services. This particular example is dated to the eleventh century and is of parchment, with carefully penned script in brown ink, illuminated headpieces and initials painted in gold and bright colours. The later leather binding has gold lettering on the spine and metal fittings, probably from earlier codex covers, nailed on the front. At the centre is a large silver crucifix, at the corners are gilded round bosses (*boules*), and in the spaces between the arms of the cross are four almond-shaped bosses (*amygdalia*) of different sizes but with a similar 'pearl' border.

The shape of the cross, with the trefoil finials on the arms, the rectangular projections at the corners and the splaying of the lower end of the vertical arm, follows Late Gothic, possibly Italian, models. Of similar provenance is the iconography, in which the crucified Christ wears a loincloth down to the knees, inclines his head to the right and has his feet crossed and driven through with one nail upon the support for

the feet. A vellum scroll at the top of the vertical arm of the cross bears the abbreviated inscription IN(B)I (Jesus of Nazareth King of the Jews). Depicted on the finials of the arms of the cross are the four symbols of the Evangelists, not the Evangelists themselves, as is more usual in Byzantine iconography. This iconographic trait points to Italian silver processional or wooden painted crosses of the fifteenth–sixteenth century, which enjoyed very wide dissemination in Late Byzantine times, as well as after the Fall of Constantinople (1453). A 'pearl' border frames the outline of the cross.

Metal crosses were a common decorative element on the covers of Byzantine lectionaries and corresponded to the crosses painted on the frontispieces of manuscripts. The terminology of boules and amygdalia, as well as their combination with the crosses, comes from Byzantine monastic inventories that are preserved from the eleventh century onwards. Entered in these inventories is the property of the monasteries, such as sacred vessels and codices with descriptions of their covers. Because codices were stored horizontally, the projecting *boules* and *amygdalia* were of practical use, protecting the faces from friction and wear. AB

Unpublished. For the manuscript see: Lappa-Zizica, Rizou-Couroupou 1991, 221–222, no 108.

Miniature icon of the Archangel Michael

Cat no. 94
Second half 13th c.
Provenance unknown (former Collection of Contesse de Béarn)
Steatite, carved in relief
6.5 (h) x 5 (w) x 0.7 cm
Inv. no. 13507

Steatite, a soft, pale green stone, was widely used during the Byzantine period for fashioning minor sculptural works. The icon has been rubbed with oil, which has altered the original shade of the stone, imparting a brownish hue. This was possibly part of the production process.

The Archangel is represented in half-body, turned slightly to the right, in military attire, brandishing his sword in his right hand and holding the scabbard in the left. He is framed by an arch that rests on twisted columns. On the ground are the ligatures (abbreviations) that identify the figure as Archangel Michael: ΑΡΧ(άγγελος) ΜΙΧ(αήλ).

The icon combines the techniques of high relief with medium relief on the face and hands, and low relief on the halo and wings. The prominent areas are highly polished and there is a loss of details of the carving, due to the object's use over many years. The combination of varying degrees of relief attests to the creator's endeavour to impart a three-dimensional quality to the work. The representation of the Archangel in military attire and brandishing his sword, poised for battle, occurs in Byzantine iconography from the eleventh century and enjoyed wide popularity in the subsequent centuries. The combination of the subject with the technical characteristics of the relief points to a date in the second half of the thirteenth century and to the attribution of the icon to a workshop in a major metropolitan centre, perhaps even Constantinople.

Miniature icons of this type, the most luxurious made of ivory or steatite, and others made of cheaper stone, were rather common items for personal devotions among the Byzantines. Because of their small size, they were easy to carry and many examples are pierced with suspension holes, indicating that they were worn as pectoral amulets. Miniature icons with soldier-saints or archangels in military dress possibly belonged to members of the army, who invoked the aid and protection of the 'heavenly' soldiers in their martial ventures. This possibility is strengthened by the existence of such icons bearing inscriptions beseeching the soldier-saint to provide his protection for the icon's owner in the hour of battle. AD

Published: Kalavrezou-Maxeiner 1985, 186, no 105; *Byzantine Art* 1986, 208–209, no 234 (L Bouras); *Oi pyles tou mysteriou* 1994, 256, no 77 (A Drandaki); *Everyday life in Byzantium* 2002, 510–511, no 700 (Y Varalis).

Bracelet

Cat no. 95
11th c.
Provenance unknown
Silver, repoussé, chased, partial gilding, niello
3.3 (h) x 5.5 (diam) cm
Inv. no. 11457

The wide cylindrical bracelet or *perikarpion* is made up of two sections of equal size, joined by a hinge. Each section is divided into three rectangular panels with a repoussé medallion at the centre, framed by four almond-shaped motifs. Smaller medallions are linked to the larger ones, creating a horizontal axis and balancing the arrangement of the panels. Each medallion is decorated with a fine layer of niello, forming a banded cross consisting of four scrolled palmettes.

Similar scrolled crosses are typical of Middle Byzantine reliefs, while the interconnected medallions recall the repeated roundels, the so-called *rotae sericae*, which were a typical layout of precious Medieval textiles. The type of bracelet with rectangular decorative panels seems to represent a simplified form of Late Antique bracelets, such as those which are observed on the sculptures of Palmyra in Syria and are embellished with almond-shaped leaves.

The best-known examples of perikarpia are an enamelled pair found in Thessaloniki and dated to the ninth–tenth century. Closer to the Benaki Museum bracelet is a group of gold or silver perikarpia, with scroll decoration and medallions enclosing real or imaginary animals, which are preserved in the Canellopoulos Museum in Athens, the Dumbarton Oaks Collection in Washington DC, the Museum of Fine Arts in Boston, the Walters Art Gallery in Baltimore, the Musée du Louvre and the Hermitage Museum in St Petersburg. The bracelets in the last two museums are from hoards found at Sayram Su in central Asia and Izgirli in Bulgaria, and are works in a mixed Byzantine-Islamic style. The same features occur on one other intact bracelet and on two sections of bracelets in the Benaki Museum, decorated with griffins and pseudo-Arabic inscriptions in angular Kufic script.

Fantastic creatures and pseudo-Kufic inscriptions belong to the repertoire of Byzantine decoration, which in the eleventh–twelfth century especially displays influences from Islamic art. Principal bearers of this influence were the moveable luxury products of the Muslim world, such as textiles, ceramics and metalwork objects, which were traded in the Eastern Mediterranean and were commercial and collectible items in high demand, as much in Byzantium and the Crusader East as in Western Europe. AB

Published: *Byzantine Art* 1986, 190–191, no 201 (L Bouras); *Greek Jewellery* 1997, 213, no 283; *Benaki Museum Greek Jewellery* 1999, 334–337, no 126 (A Ballian); *Everyday life in Byzantium* 2002, 413, no 520 (A Drandaki). For the Louvre bracelets see: *Byzance* 1992, 338–339, no 253 (J Durrand). For the Izgirli hoard see: Ballian, Drandaki 2003, 47–80.

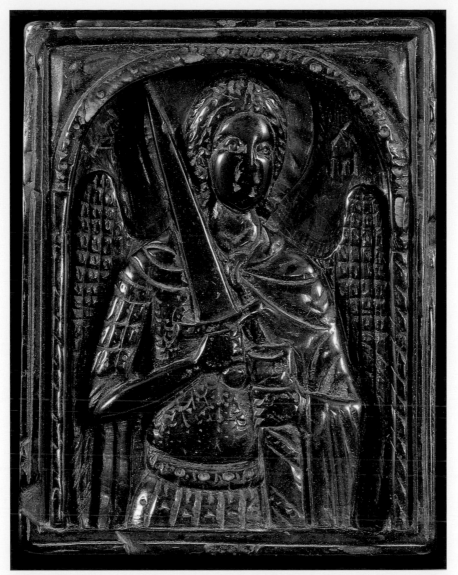

94

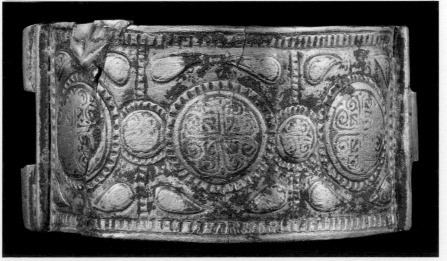

95

Appliqué roundels

Cat no. 96
12th–14th c.
Provenance unknown
Gold sheet, repoussé
3.8 (diam) cm
Inv. no. 1841

The two circular appliqués are made of thin gold sheet worked in repoussé. The decoration consists of hemispherical motifs of differing size, forming a Greek cross with large boss at the intersection of the arms, which is also the centre of each ornament. Four bosses of equal size, encircled by smaller pearl motifs, are placed between the arms of the cross. Around the circumference of the appliqués runs a double pearled edging. Small holes on the surface of the roundels were for sewing them to fabric.

Appliqués were commonly used as decoration on garments from Late Roman times and throughout the Byzantine period, documented by surviving examples, as well as by depictions of such ornaments in Egyptian funerary portraits of the third and fourth centuries AD. Of gold, silver-gilt or even copper alloy, appliqués enriched the appearance of the textile, endowing it with opulence and variety. The simple type of decoration on the Benaki Museum appliqués, which is restricted to hemispheres of alternating size, is usual on ornaments of the Middle and Late Byzantine periods. A characteristic example is a pair of gold earrings in the Canellopoulos Museum in Athens, on which the central figure of the Virgin in intercession (*orans*) is framed by hemispherical bosses. Even closer in decorative conception to the Benaki Museum appliqués are some silver and silver-gilt ornaments discovered in excavations in the Balkans, such as in tombs at Hadjučka Vodenica in Serbia. These are rectangular and were sewn onto cloth, to be used sometimes as bracelets and sometimes as diadems. Ornaments of comparable workmanship have come to light in other cemeteries along the Danube and in Bulgaria, at Brestovik, Brza Palanka and Kaliakra, some of which were found together with coins of the Serb Tsar Dušan (1346-1355).

AD

Published: Segall 1938, 173, no 271, pl 48. For parallels see *Greek Jewellery* 1997, 229, no 281 (N Saraga); Ercegović Pavlović 1986, 107, pl VI.

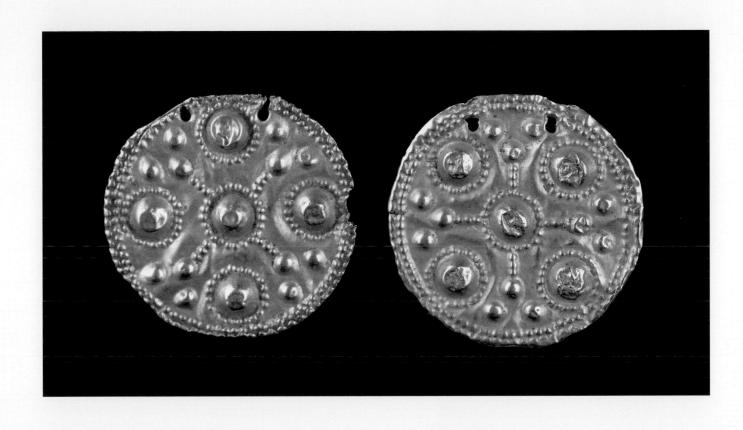

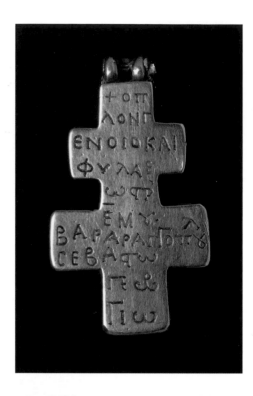

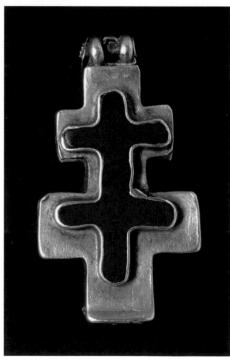

Pectoral cross

Cat no. 97
13th– 14th c.
Provenance unknown
Gold, lapis lazuli
4 (h) x 0.7 (th) cm
Inv. no. 1853

The small cross is of the Resurrection type – with two horizontal bars – and hangs from a double suspension loop. Inset on the front, and projecting from it, is a cross of lapis lazuli held in place by a strip of gold. The weight and the thickness of the cross are due to the lapis lazuli, which is deeply set in a protective case.

The pectoral cross is reminiscent of portable reliquaries containing fragments of the True Cross, which were widespread during the Middle Byzantine period. The way in which the lapis lazuli is inlaid refers to the cruciform openings of reliquaries, through which the sacred relic they contained could be seen.

Lapis lazuli was particularly popular in jewellery because of the striking contrast between the semi-precious stone's deep blue colour and the shining gold. According to the Roman author Pliny the Elder (*Natural History* XXXVIII, 119–20), lapis lazuli contained streaks of gold, and thus resembled the star-spangled sky.

Engraved on the reverse of the cross is an inscription underlining its protective power and mentioning its owner:
+ΟΠΛΟΝ ΓΕΝΟΙΟ ΚΑΙ
ΦΥΛΑΞ Ω ϹΤ(ΑΥ)ΡΕ ΜΟΥ /
ΒΑΡΑ<ΡΑ> ΓΓΟΠΟΥΛ(Ω)
ϹΕΒΑϹΤΩ ΓΕΩΡΓΙΩ (O my

Cross, become thou a weapon and guardian for Georgios Varangopoulos Sebastos). The title Sebastos, which derives from the Greek translation of the Roman imperial title Augustus, reappeared in Byzantium in the eleventh century when, in the context of efforts to strengthen the position of the reigning dynasty, it began to be awarded mainly to kinsmen of the Komnenos lineage as well as to foreign princes. From the late twelfth century, however, the title was demoted and began to be granted to lower-ranking officials and to leaders of the ethnic groups settled in the Byzantine realm. The name Varangopoulos possibly declares the origin of the owner from the Varangians, the Scandinavian people who played an important role in the military and political history of Byzantium, primarily as mercenaries in the emperor's bodyguard. An Alexios Varangopoulos is recorded as lord of the island of Kos as early as 1258, and another member of the family is mentioned in a document of 1400 as the proprietor of a bath-house opposite the monastery of the Hodegon in Constantinople. AB

Published: Segall 1938, 174, no 277; *Byzantine Art* 1986, 195, no 214 (L Bouras); *Oi pyles tou mysteriou* 1994, 258, no 80 (A Drandaki); *Benaki Museum Greek Jewellery* 1999, 354– 355, no 132 (A Ballian).

Pectoral plaque

Cat no. 98
10th–11th c.
Provenance unknown
Gold, cloisonné enamel
2.99 (h) x 2.64 (w) cm
Inv. no. 8837

The oval plaque, with a double suspension loop at the top, was probably intended to be joined to a second plaque, now lost, to form a case in which relics were possibly placed. The plaque is decorated in cloisonné enamel, now considerably eroded. At the centre is a foliate, 'jewelled' cross. The ground is of blue enamel, which is ornamented with oval and square cloisons, filled with brick-red and light green enamel respectively. The flaring arms of the cross terminate in large discs, flanked by two smaller roundel finials at the outer corners. The four discs and the circle at the intersection of the arms of the cross are decorated with a palmette. From the lower disc spring two symmetrical, upright half-palmettes filled with brick-red enamel. The spiral strips covering the ground of the plaque were coated with translucent green enamel, now badly destroyed. Despite the extensive damage, the pendant retains the vivid polychrome effect of the original decoration.

The type of foliate cross that decorates the pectoral is encountered in works of the late tenth and the eleventh century, and is the commonest ornament on the reverse of contemporary reliquaries or metal icons. The closest examples have been identified on a silver cross of 960–963, in the Dumbarton Oaks Collection in Washington DC, and on the reverse of three silver reliquaries of the True Cross of the late tenth or the eleventh century, kept in San Marco in Venice, the Hermitage Museum in St Petersburg and the Museo della Cathedrale of Monopoli in Italy. The presence of the motif on numerous reliquaries reinforces the possibility that the Benaki Museum pectoral served the same purpose.

Byzantine cloisonné enamelling, which spread from the ninth century, was among the most renowned techniques of decorating luxury objects. Enamels were offered as diplomatic gifts by the Byzantine emperors to foreign rulers in East and West, and were also highly praised export products. AD

Published: *Byzantine art* 1986, 188, no 196 (L Bouras); *Benaki Museum Greek Jewellery* 1999, 346, no 129, fig 261 (D Buckton); *Greek Jewellery* 1997, 227, no 278 (A Drandaki). For parallels see: *Glory of Byzantium* 1997, 79, no 37 (J C Anderson), 79–80, no 38 (D Katsarelias), 162–163, no 110 (W D Wixom). On Byzantine enamels see: Wessel 1967; Buckton 1988; Hetherington 1988.

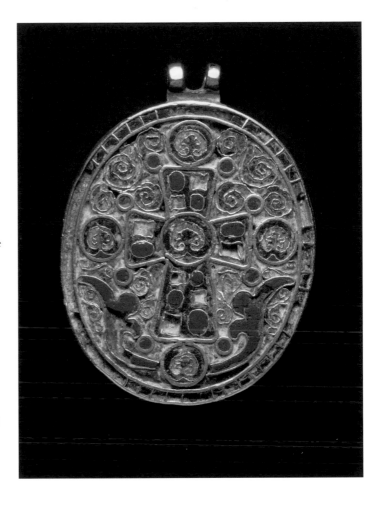

Footed pyxis

Cat no. 99
Late 12th c.
From Constantinople (former
Macridy Collection)
Clay, red, yellow glaze
11.5 (h) x 18 (rim diam) cm
Inv. no. 13592

The pyxis stands on a conical foot with flattened base. The rim of the bowl is formed so as to receive a lid, now lost. Lightly incised on the bottom of the bowl is sgraffito decoration of a bird with talons surrounded by numerous forked motifs. The vessel is of red clay, with a thick coat of good quality yellow glaze inside and a thinner layer outside.

The Benaki Museum pyxis is the sole known vase of this shape. Its decoration assigns it to a large class of open vases featuring birds with comparable characteristics. In addition to examples in the Benaki Museum, numerous vessels with similar birds have been recovered from excavations

in Corinth and from the Kastellorizo shipwreck. It has been argued persuasively that both the Benaki Museum vessels and those from Corinth are linked with the workshop or workshops from which the vases on the Kastellorizo shipwreck were commissioned. This decoration also occurs on another large category of Middle Byzantine vases known as Aegean Ware.

In terms of decorative technique, the pyxis is an example of so-called incised sgraffito vases on which the subjects were executed with a gouge. On this piece the subject is worked entirely in incised sgraffito, but in many other cases this is combined with fine sgraffito for variety or for rendering details. On the basis of excavation data, incised sgraffito vases are dated to the late twelfth–early thirteenth century. AD

Published: Bakirtzis, Papanikola-Bakirtzi, Mavrikiou 1999, 85–86, 95, no 185. For parellels see: *Corinth* XI, pl LIh–j; Philotheou, Michailidou 1986; Philothéou, Michailidou 1989; Megaw 1975; Papanikola-Bakirtzi 1999, 143–157; Sanders 1999.

Bowl
Cypriot workshop

Cat no. 100
14th c.
Possibly from Constantinople
(former Macridy Collection)
Clay, brown, yellow glaze
9.5 (h) x 14.5 (rim diam) cm
Inv. no. 13681

The bowl has a slightly raised base
with flattened ring and a straight
rim arising from the carination
of the body. It is coated inside
and outside, to the base, with
white slip. The dense decoration
is incised, organised in zones, in
which lattice hatching alternates
with rinceaux. On the outside, a
band of horizontal lines intersects
with a zigzag line. The sgraffito
decoration is enhanced by
brownish yellow and green paint,
and the whole is coated with
good quality yellow glaze.

Although the provenance of the
bowl is recorded as Constantinople,
both its shape and decoration are
characteristic of the products of

Cypriot workshops. The dense
linear motifs and the utilisation
of colour contrasts are distinctive
of fourteenth-century vases.

Cypriot ceramics enjoyed
considerable development from
the thirteenth to the sixteenth
century, with distinctive local
characteristics relating to the
historical course of the island,
which from 1191 until 1572
was under initially Frankish and
subsequently Venetian sovereignty.
The fourteenth century, in
particular, was the heyday for
Cypriot glazed earthenware; after
the Venetian conquest in 1489,
the output waned, possibly due to
the mass importation to the island
of majolica tableware from Italy.
AD

Published: Bakirtzis, Papanikola-
Bakirtzi, Mavrikiou 1999, 160–161,
167, no 344. For parallels see:
Papanikola-Bakirtzi 1996, with earlier
bibliography; Papanikola-Bakirtzi
1999, 23–24.

Bowl

Paphos workshop, Cyprus

Cat no. 101
13th c.
Possibly from Constantinople
Clay, red, pale green glaze
7.4 (h) x 15 (rim diam) cm
Gift of Theodoros Macridy
(13609)

The bowl has a slightly raised base and a shallow body with slanting walls. The rim is partly restored. The inside is coated with white slip. The decoration, executed in fine and incised sgraffito, represents a full-bodied female figure in dance pose, with the head full-face and the body turned left, holding in her hands a kind of castanets. The eyes are large and wide open, the face is round and the hair curly. In the field right is a cross-hatched disc. The sgraffito decoration is enlivened by streaks of brownish yellow and green.

The fabric of the clay and the style of decoration link the vase with the Paphos ceramic workshop and its products in the thirteenth century. The shape, and the combination of sgraffito with the two distinctive colours – brownish yellow and green – are further characteristics of the period.

The bowl is of particular interest primarily because of the charming iconographic subject. The dancing girl is depicted in a schematic manner, yet details such as the lunate castanets, which can be identified with the *phengia* mentioned in Byzantine sources, are shown with relative realism. Human figures are encountered frequently in Byzantine ceramics, represented in realistic scenes as couples, dancers, musicians or falconers, as well as fantastic subjects which drew on contemporary narratives and songs that enjoyed wide

currency. The most popular motif from this last iconographic unit is the imaginary scene of dragon-slaying, inspired by the epic of Digenes Akritas, incarnation of the ideal of the Byzantine hero and invincible warrior. AD

Published: *Byzantine Art* 1964, no 633; *Splendeur de Byzance,* 233, no C8 (L Bouras); Papanikola-Bakirtzi 1984; Papanikola-Bakirtzi 1996; Delivorrias, Fotopoulos 1997, 245; Bakirtzis, Papanikola-Bakirtzi, Mavrikiou 1999, 161, no 335; *Everyday life in Byzantium* 2002, 203–204, no 227 (D Papanikola-Bakirtzi).

Icon of St Paraskevi
Attributed to a Macedonian
workshop

Cat no. 102
First half 14th c.
Provenance unknown
Wood, egg tempera
83 (h) x 47.5 (w) cm
Gift of Stephen and Francis
Vagliano (30261)

The icon is painted on gesso
priming without linen, on a single
sturdy plank of wood, which has
not been trimmed as a proper
rectangle so that the right vertical
side is shorter. The paint surface
is destroyed down to the wood
over the entire lower part of the
image, while the right side has
suffered extensive damage.
The figure is painted against a
silver ground, traces of which
are discernible around it. No
inscription with the saint's name
has survived, but on the basis
of the iconography she can be
identified as St Paraskevi.

The saint wears a blue monastic
habit and a brown chiton. Faintly
visible beneath the cowl is the
wimple in tones of greyish white.
In her right hand she holds a thin
red cross of martyrdom, while
the left hand, now lost, would
have been raised in the typical
gesture with the palm outwards.
The saint's face is modelled on
an olive-green underlayer and
the volumes are highlighted with
ochre; the transitions from
illumined to shadowed areas are
soft. The features are fine, with
discreet drawing and emphasis
on the painterly quality. The eyes
are melancholy, the nose long and
narrow, and the mouth pursed.

The iconographic type of the
elegant female figure and the
stylistic treatment of the work
recall two icons of the Virgin
Hodegetria, one in Thessaloniki,
dated to the first decade of the
fourteenth century, and the other
in the church of Christ in Veroia,
which has been ascribed to
Georgios Kalliergis, one of the
most important painters of the
period, and dated to the first
quarter of the same century.
An additional characteristic in
common with the Veroia icon is
the use of silver instead of gold
for the ground, a practice observed
on other icons from Macedonia.

The models for the lovely saint –
notwithstanding the damage –
in the Benaki Museum icon can
be located in aristocratic
Constantinopolitan creations
of the early decades of the
fourteenth century, such as the
wall-paintings in the Chora
monastery, but also in the
mosaics in the Church of the
Holy Apostles at Thessaloniki.
Despite the lack of specific
information as to its provenance,
the icon could be attributed to a
workshop in Macedonia. AD

Published: *Oi pyles tou mysteriou* 1994,
221, no 42 (A Drandaki). For parallels
see Weitzmann et al 1982, fig on p 179;
Holy image holy space 1988, no 16A
(Th. Papazotos); Underwood 1966, II,
68–69, pl 51; Papazotos 1995,
pls 21, 23.

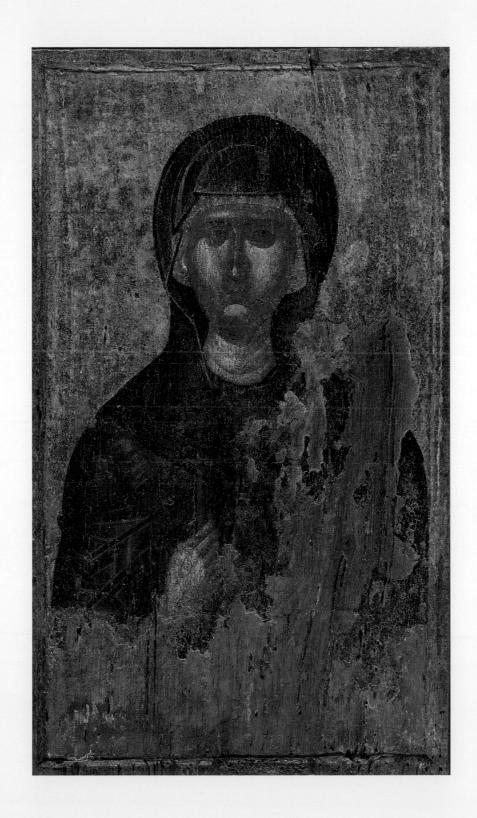

The Virgin and Child with St George and St Nicholas

Cat no. 103
Early 15th c.
Provenance unknown
Wood, egg tempera,
gesso on textile
31 (h) x 28.2 (w) x 2.8 (th) cm
Gift of Marinos Kalligas (2975)

The Virgin stands upon a low dais at the centre of the panel, holding the Christ Child in front of her chest. His figure is rendered as if sitting on an invisible throne in front of his mother, who simply rests her left hand on his shoulder and her right on his knee, without actually supporting him. On the left, St George, in courtly raiment, holds a martyr's cross and raises his left hand in a gesture of intercession. On the right, St Nicholas, in prelatic vestments appropriate to his status, blesses with his right hand. All the figures have incised haloes with double outline, without additional decoration, and are accompanied by easily legible red-lettered inscriptions. The only exception is the Christ Child, who has a cross-inscribed halo, now considerably effaced. Damage is discernible in other parts of the work which are covered by gold striations, as on Christ's garment and St Nicholas'

vestments. The sides and back of the icon are primed with red pigment.

The figures are rendered in a particularly painterly manner, with confident brushstrokes modelling the flesh in earth tones, with abundant use of rose pink on a brown underlayer. A few freely-applied white highlights impart a plasticity to the volumes, and pure red pigment is used sparingly on the noses, the lips and the ears. A striking feature is the bright eyes with black pupils, which enliven the faces and heighten the intensity of expression. An analogous freedom is observed in the treatment of the drapery of the garments, which follow the curvature of the limbs and the movement of the bodies with remarkable naturalism.

The work reproduces an iconographic schema known from a considerable number of Byzantine portable icons, in which the Virgin and Child are framed by two or more saints. Among these, Saints George and Nicholas, who are portrayed in the Benaki Museum icon, are the most popular. There are several iconographic parallels in the monastery of St Catherine on Mt Sinai, in Egypt, which possesses the world's richest

collection of Byzantine icons. In terms of style, an analogous modelling of figures is encountered in icons dated to the second half of the fourteenth–early fifteenth century. Typical examples are the icons commissioned by Maria Palaiologina (+ 1394) – wife of the Despot of Epirus, Thomas Preljubović(1366/7-1384) – and which are now in the monastery of the Transfiguration at Meteora in central Greece (c. 1367-1384) and in the cathedral of Cuenca in Spain (c. 1382-1384), the icon of Prophet Daniel in the Byzantine and Christian Museum, Athens (mid-fourteenth century) and that of the Restoration of the Icons in the British Museum (c. 1400). A comparable style is distinctive of wall-painting ensembles of the same period.

The stylistic and iconographic traits of the Benaki Museum icon, such as the attire of St George with the double tunic, were to become gradually standardised in icon painting of the Post-Byzantine period.
AD

Published: Xyngopoulos 1936, 7-9, no 4, pl 7a. For parallels see: Sotiriou 1956-58, II, pls 155, 163, 164, 177, 197; Acheimastou-Potamianou 1998, 54-55, no 13; *Byzantium: Faith and Power* 2004, nos 24a-c, 78 (A-M Weyl Carr). On the garments of St George see: *Byzantium: Faith and Power* 2004, no 110 (Y Piatnisky).

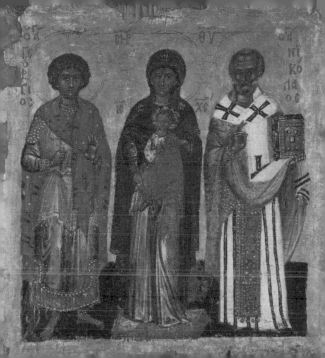

POST–BYZANTINE PERIOD
15TH – 18TH CENTURY

BETWEEN EAST AND WEST: GREEK CHURCH AND COMMUNITY LIFE UNDER FOREIGN RULE

Anna Ballian and
Kate Synodinou

From the mid-fifteenth century, the Greek world lost its political independence and was shared under the sovereignty of the Ottoman Turks, who captured the Byzantine capital, Constantinople, in 1453, and the Venetians, who had long been established in Crete and in various islands and coastal areas of the Aegean and Ionian seas. The Genoese were established on Chios and the Knights of St John of Jerusalem occupied Rhodes. Ottoman expansionism continued, gradually breaking up the Latin possessions, with principal milestones being the conquest of Rhodes (1522), Cyprus (1571) and finally Crete (1669), after the 21-year siege (1648-1669) of its capital Candia (mod. Herakleion). Sole exception was the Ionian Islands, which remained under Venetian rule until 1797 and then under British protection until 1864. The Greek world was thus shared within different spheres of influence, which had a direct impact on all sectors of socio-economic development as well as artistic creation.

Religious painting in Venetian-held Crete

The presence of the Venetians in Greece was more permanent in character than the other Frankish overlords, with long-term effects on the cultural life and art of the subject populations. Under the threat of Ottoman expansionism, the Serenissima Republic of Venice adopted policies favourable to the peaceful coexistence of the Catholic and Orthodox populations in her possessions, and promoted the development of trade and shipping. This brought economic prosperity, liberating new social forces and paving the way for the development of a flourishing bourgeois society. In Crete, the Venetians' most important possession in the eastern Mediterranean, prevailing economic and social conditions were comparable to those in western European cities during the Renaissance – particularly in the last two hundred years of Venetian rule, until 1669 – and had a direct impact on the island's artistic output. The flourishing of Cretan literature, theatre and the visual arts is known conventionally as the 'Cretan Renaissance'.

The artistic activity of Crete was concentrated in the urban centres, Candia, Rethymnon, Chania and Siteia. The numerous artists were bourgeois professionals and their clientele mainly burghers and nobles of Venetian or Greek origin. The burgeoning of artistic production is documented not only by the surviving works, but also by the invaluable archives of the Duke of Crete and notarial documents that were taken to Venice after the fall of Candia. These sources furnish a host of information on social organisation, commercial activity and the guilds of artists and artisans, such as painters, goldsmiths,

stonemasons, sculptors, woodcarvers, who executed commissions for public, private or ecclesiastical buildings. Numerous among the extant artworks are the portable icons of the fifteenth to the seventeenth century, which were not only dedicated in churches but also adorned the residences of patrons alongside artworks imported from western Europe.

The religious painting of the so-called Cretan School is the great bequest of Cretan art. Its beginnings are linked with the arrival on the island of artists from Constantinople in the late fourteenth century, seeking more propitious conditions in which to live and create. The economic development of the urban centres, the relative tolerance of the Venetian authorities and the affluence of the Cretan nobles, who had the means as well as the desire to commission painted works, with which they promoted their religious beliefs and social status, were definitive factors for this fertile move.

A significant artistic figure in the first half of the fifteenth century is Angelos Akotantos, who established important iconographic types of Cretan painting by grafting the Palaiologan tradition with Late Gothic elements (cat no. 104). His hand-written will, drawn up in 1436 before he left on a journey to Constantinople, reveals that he was a prosperous bourgeois professional with a workshop in Candia, who was travelling to the Byzantine capital to keep abreast of developments in his art. In the icons from late fifteenth-century workshops the traits of mature Cretan painting are fully elaborated (cat nos 105, 106). The Palaiologan models, assimilated in iconography and style, are crystallised in schemas which impress with their theological content, balanced composition and excellent technique. The relative standardisation of iconographic subjects is explained by the mass demand for Cretan icons, as documented in the sources, as well as possibly by a sense of security these familiar images offered to the Orthodox populations under foreign rule (cat no. 107). Nevertheless, the clientele of the Cretan workshops included not only Greek Orthodox but also Catholic patrons, from Crete as well as abroad, for whom the highly competent painters produced works in both the *maniera greca*, following Byzantine tradition, and the *maniera latina*, in accordance with Late Gothic models.

In the second half of the sixteenth century Crete enjoyed an economic heyday with a concurrent flourishing of arts and letters. The optimistic climate was further boosted after the naval battle of Lepanto (Nafpaktos, 7 October 1571), in which the allied European forces, with a strong Cretan participation, destroyed the Ottoman fleet.

Innovative tendencies in the painting of the period are expressed in the incorporation of contemporary Western models, with overt influences from Italian Mannerism. Georgios Klontzas, Michael Damaskenos and Domenikos Theotokopoulos (El Greco), in the first phase of his career, are among the artists who painted icons in this spirit.

From the early seventeenth century a conservative turn is observed in Cretan painting, which perhaps reflects the difficult circumstances on the island as Venice lost ground to the Ottoman advance, culminating in the fall of Candia in 1669. Many Cretans, including artists, left in search of a better fate, settling mainly in Venice and the Venetian-held Ionian Islands. In this last period, the final efforts to renew late Cretan painting were made in their new hospitable homelands by icon painters such as Emmanuel Tzanes and Theodoros Poulakis (cat nos 110, 111).

Church, community life and art under Ottoman rule

Despite the sufferings caused by the conquest, the Greek world under Ottoman domination regained the unity and cohesion it had lost since 1204 with the fragmentation of Byzantium into Venetian colonies and various Orthodox and Frankish principalities. Unity was imposed by the central political authority, while cohesion was achieved through the

Orthodox Church and local communities, which were the main mechanisms of integration of conquered Christian population in the Ottoman Empire, as well as the only form of self-government. Within this institutional framework, the cultural heritage and in particular the Greek language were kept alive, while artistic activity, closely linked with the Church, developed thanks to the patronage of prelates and community leaders.

The position of the Greeks in the Ottoman Empire was defined by the Muslim political theory that conceded freedom of religious observance to Christians and other 'People of the Book', in return for the payment of head tax. Immediately after the Fall of Constantinople, the Orthodox Christian community was acknowledged in the figure of its leader, the patriarch, who was appointed by the sultan and was responsible for the management of the Church. The so-called privileges granted to the Church essentially describe the process of its inclusion in the administrative machinery of the Ottoman Empire. The Church is truly the only Byzantine institution which survived after the Ottoman conquest, maintaining its hierarchical structure, bureaucratic network and economic robustness, as well as extending its geographical jurisdiction and ecumenical significance. Until the founding of the national Churches in the nineteenth

century, the Orthodox Bulgarians, Vlachs and, for a shorter period, Serbs, were all subject to the religious authority of the Patriarch of Constantinople. An important role in reconstituting the Patriarchate was played by eminent Greeks in the service of the sultan – frequently scions of Byzantine families – who served the Ottoman state, either as lessees of tax incomes (tax-farming system) or as officials in the administration, thus initiating the dependence of the Church on these magnates.

From the late sixteenth and particularly the seventeenth century, the dissolution of the Ottoman military-administrative machine and the consequent weakening of central authority brought important changes in the social and economic status of the Orthodox community. In Constantinople these changes steadily reinforced the role of Christian laymen in the higher echelons of the Ottoman administration and the economic life of the capital. The class of Greek nobles, the so-called Phanariots, was enhanced and from the early eighteenth century its eminent members were appointed by the Sublime Porte as princes of Wallachia and Moldavia (cat no. 114). Concurrently, the 'most noble purveyors', the leaders of the manufacturing and commercial guilds in the capital, such as grocers and furriers, acquired significant economic power.

Both the Phanariots and the leaders of the guilds were actively involved with the administration of the Patriarchate.

At the level of the parish, village, town or province, changes took place in the framework of the communities, an informal institution of self-government, the basic function of which was fiscal, allocating and collecting the taxes levied on the non-Muslim populations. The notables or primates in the communities – the nature of which differs according to geographical regions and periods – together with the local ecclesiastical authority and, in the cases mainly of urban centres, with the heads of the guilds, were the representatives who mediated between the Christians and the Ottoman administration and supervised works beneficial to the Christian community, such as renovating and equipping churches, maintaining schools and, especially in the nineteenth century, founding hospitals and charitable institutions for the needy.

Greek artistic activity in the first two centuries of Ottoman rule is documented almost entirely by ecclesiastical works, since most secular works have been lost. By the mid-sixteenth century, period of zenith for the Ottoman Empire, Church property had been consolidated and in many cases increased. In mainland Greece, and particularly in the monastic

154

communities of Meteora and Mount Athos, there was a building boom, which included the founding or re-founding of monasteries and the renovation and decoration with wall-paintings of their main churches. The development of the monastic centres in Greece coincided with the flourishing of the so-called School of Mainland Greece in religious painting, chief representatives of which are Frangos Katelanos and the Kontaris brothers. In their high-quality works of urban character they continue the tradition of an expressionistic, anticlassical trend of Palaiologan painting, which they enrich with innovative elements borrowed both from Ottoman decoration and Western engravings. The local painting tradition was influenced decisively by Cretan painters such as Euphrosynos and Theophanes, who were invited to execute wall-paintings and icons for the affluent monasteries of Meteora and Mount Athos in the mid-sixteenth century. The Cretan works, with their classicist stylistic traits and crystallised iconographic types, left a lasting legacy in the major Orthodox religious centres. The inviting of Cretan painters to monasteries in the mainland not only reveals that boundaries were fluid between the Ottoman-held and Venetian-held regions of the Greek world, but also points to the high level of patronage, which included distinguished figures in the Church hierarchy and the patriarchal court, in monastic circles and in the court milieu of the Danubian principalities of Wallachia and Moldavia, and mainly the Orthodox Romanian princes themselves.

Ottoman decentralisation favoured local initiatives and the involvement of the communities in the founding or re-founding, the decorating and equipping of churches. The result depended on the economic standing and social status of the community and the patrons, as well as on the artists. Characteristic are the painters in rural regions, such as those from Linotopi in Epirus, who from the late sixteenth century, for about eighty years, created wall-paintings and portable icons over a wide geographical area, from Epirus and Macedonia as far as central Greece, usually commissions from local primates, priests and monks or the inhabitants collectively of a village. Their works, closely affined to those by other seventeenth-century painters in the southern Balkans, enjoyed great popularity, expressing the aesthetic preferences of the mainly rural populations of the region (cat no. 109).

However, whether of rural or urban communities, or of mountain or island settlements, the artistic output of this time is characterised by two basic constants: devotion to the bequests of Post-Byzantine iconography and desire for innovation through the currents of contemporary Ottoman or western European secular art. Changes are obvious mainly in silverwork and gold embroidery, arts which served both ecclesiastical and secular purposes. In the sixteenth and seventeenth centuries, with the incorporation of the decorative vocabulary of Ottoman art, floral arabesques, tulips and lotus blossoms appear, while from the second half of the seventeenth and in the eighteenth century, large Baroque flowers, Mannerist scrolls and Rococo shells gradually predominate (cat no. 117). The channels of penetration of Western art were established early on in the capital, where European craftsmen settled and introduced luxurious products. The Christian workshops in Constantinople, in which oriental and occidental elements were combined, supplied the local communities with ecclesiastical silverware and liturgical textiles (cat nos 112, 119), which in their turn were copied and imitated by local craftsmen.

Contacts between subject Christians and the semi-independent regions of Wallachia and Moldavia, as well as with the flourishing Greek communities in western Europe, principally in Venice, played a decisive role in shaping the aesthetic of the age. At Jassy and Bucharest, where Greek men of letters, nobles and clerics were domiciled, a climate of protecting

the Orthodox Church was cultivated. The church plate dedicated by Romanian princes in the major monastic and other ecclesiastical centres was made by silversmiths in Transylvania, who adapted the Orthodox iconography to central European Baroque models (cat no. 113). Venice continued to export luxury commodities to the East until the eighteenth century, and the influence of its silverwork is evident not only in the Venetian-held but also in the Ottoman-held Greek lands. From the sixteenth century, the thriving Greek community in Venice became involved with printing Greek books, mainly ecclesiastical. Illustrated with Venetian engravings and vignettes, these reached even the most remote Christian communities, offering the local Greek craftsmen models for reproduction and modification.

International conjunctures in the eighteenth century favoured the subsequent course of subject Greeks. Important military events opened the way for the political and economic penetration of the European powers into the Ottoman state, while commercial activities passed increasingly into Christian hands. With the treaties of Carlowitz in 1669 and Passarowitz in 1718, the Austro-Hungarian Empire emerged as hegemonic power in the northern Balkans and opened the routes of overland trade.

Greek and other Orthodox merchants – the 'conquering Orthodox Balkan merchant', according to the classic article by the historian Troian Stoianovich – thus moved freely from the mountainous massif of Pindos and the southern Balkans as far as Vienna and central Europe, creating flourishing trading enclaves. Correspondingly, the Russo-Turkish treaty of Kutchuk Kainardji in 1774 was an impetus to the development of Greek island shipping. Greek vessels were allowed to sail under the Russian flag, thus opening up the hitherto closed Ottoman Black Sea to shipping, trade and the establishment of Greek merchant houses in the ports of southern Russia and Romania. The result was a true economic heyday that improved living conditions in Greek lands and facilitated the import of liberal ideas from the West, accelerating the formation of what is termed the Neohellenic Enlightenment.

Evidence of secular artistic production proliferates from the eighteenth century, particularly from regions of Greece which enjoyed a privileged community organisation in the Ottoman Empire or experienced a boom in mercantile and maritime activities, such as Macedonia, Epirus and the Aegean islands. The creations of secular art are significant in both quantity and quality. However,

social conditions and the diminishing of public life did not favour monumental manifestations, and aesthetic needs were mainly expressed in the domestic sphere of the house – in architecture, stonecarving, woodcarving (cat no. 144), painting (cat no. 130), pottery, embroidery (cat nos 120-124) – and in personal adornment – costume (cat nos 141-143) and jewellery (cat nos 125-129, 131-140).

Prominent among the parameters which shaped Neohellenic secular art is the deeply ingrained Byzantine tradition, which bequeathed forms and formats, together with a penchant for structured composition and austere grandeur. However, the centuries of coexistence of Greeks with Turks are also evident in the pronounced decorative character and love of the floral world, typical of Ottoman aesthetics. Secular art reflects too the spirit of European movements, particularly late Baroque and Rococo, disseminated to Greek lands via Constantinople, Italy, especially Venice, and central Europe. From the mid-eighteenth century, through the fertile assimilation of these diverse elements, the trends of a new aesthetic orientation were crystallised, and the Neohellenic idiom had acquired established forms.

Artistic production displays clear affinities with that of the neighbouring peoples of the Balkans. Contributory factors to this phenomenon were the continuous communication facilitated by the absence of frontiers, as well as the movement of itinerant Greek craftsmen, who were much in demand and travelled all over the Ottoman Empire, bringing the same techniques and the same aesthetic and decorative canons. Even so, the distinctive 'personality' of Greek works is immediately apparent and differentiates the aesthetic preferences and artistic expression of the Greek people from the particular characteristics of the art of its neighbours.

Throughout the Greek world, from Cyprus and Crete, and from the Ionian Islands to the Greek areas of Asia Minor and the Pontos lands – notwithstanding local peculiarities in style, a single aesthetic orientation prevailed. Nevertheless, apart from the general divisions of artistic production into island and mainland, mountain and plain, countryside and urban centre, a remarkable variety of forms exists from island to island, village to village, town to town.

Among the principal constituents of Neohellenic secular art are collective expression, magical-religious symbolism and, except in outstanding cases, the anonymity of its creators. Above all, this art reveals a particular love of man and of efflorescence as a symbolic expression of fertility. An overt anthropocentricism runs through the whole gamut of artistic expression, in which the human figure plays a decisive role, whether rendered in an abstract-geometric or a more realistic, painterly manner. Thus Greek art of the period of foreign rule is a hymn of praise to man's potential and personal freedom, which no power imposed from above can suppress. ∎

ILLUSTRATIONS

Icon of St George
Cretan workshop

Cat no. 104
Second half 15th c.
Provenance unknown
Wood, egg tempera,
gesso on textile
37.7 (h) x 28.4 (w) x 1.6 (th) cm
Gift of Panayiotis Lidorikis (3737)

St George is depicted full-bodied in slight *contrapposto*. He is clad in military uniform, with gold-embellished cuirass, a sword on his belt and a round shield held on his left arm. His lower limbs are covered by cloth leggings, with decorative motifs below the knees, and on his feet are soft cloth boots. He steps upon the dragon, which he has impaled in the mouth with his spear. The scene is set in a rocky landscape with sketchy representation of the natural environment and a gold ground, as is the norm in Byzantine iconography. In the top right corner of the panel is the segment of heaven (*segmentum coeli*) from which projects the hand of God (*manus Dei*) blessing the saint. The painter has placed particular emphasis on the decorative details of the composition. The saint's halo is delicately punched with a vegetal motif of Renaissance type, while the realistic elements such as the straps of the epaulettes, the hilt of the sword and the arm straps of the shield are executed with great care. The palette is rich and balanced, dominated by the red of the mantle, which surrounds the heroic figure of the youthful dragon-slayer saint like a mandorla.

Among the distinctive traits of the icon are the soft, gentle modelling, which is based on the translucence of the pigments, and the elegance of the figure, which alludes directly to the International Gothic style. This combination of Late Gothic style with traditional Byzantine iconography, with which it is in keeping, is a hallmark of many fifteenth-century Cretan works. Perhaps the most fertile coexistence of these elements is to be found in the numerous icons of soldier-saints painted by the renowned Cretan artist Angelos Akotantos (+ pre-1457), in the first half of the fifteenth century, and by Cretan painters in the following decades who continued to worthily serve the same idiom. The icon discussed here is associated directly with the saints painted by Angelos, both in the assiduous attention to the realistic details and the choice of colours, and in the rendering of the figure of the dragon. Characteristic are the correspondences between this icon and works signed by Angelos or ascribed to him, such as the icon of St Phanourios in the collection of the Church of St Catherine of the Sinaites, in Herakleion, Crete, of St Theodore in the Byzantine and Christian Museum, Athens, and of St Demetrios in the Andreadis Collection, Athens.

The representation of the standing, dragon-slaying St George displays even closer affinity with an icon of St George and St Mercurios, by an unknown painter, which is presently in the Latsis Collection, Athens, and was once part of a polyptych. The polyptych, together with the creations by Angelos, express in the best possible way the floruit and eclecticism of Cretan painting in the first half of the fifteenth century. In comparison with the aforesaid works, however, the Benaki Museum icon is distinguished by a certain schematisation in its execution, even though it follows the same trend and the same models. It should be attributed to one of Angelos' successors, who continued in the same current in the second half of the fifteenth century.

The episode of the slaying of the dragon is narrated in the Life (*Vita*) of St George, which enjoyed wide popularity in Byzantium from the eleventh–twelfth century. The representation of this episode is included in Byzantine icons depicting scenes from the *Vita* of the saint, such as the thirteenth-century icon of St George in the monastery of St Catherine at Sinai, in Egypt. At the same time it was a much-loved subject in its own right, represented on portable icons primarily of the Post-Byzantine period. AD

Published: Chatzidakis 1985, pl 204c; Chatzidakis (Th.) 1982, no 14; Chatzidakis (N) 1983, no 14; *Oi pyles tou mysteriou* 1994, no 48 (M Vassilaki). For parallels see: Acheimastou-Potamianou 1998, 112, no 30; Drandaki 2002, 36–41, no 5; Kazanaki-Lappa 2000. On the iconography of St George see: Walter 1995, 320–322.

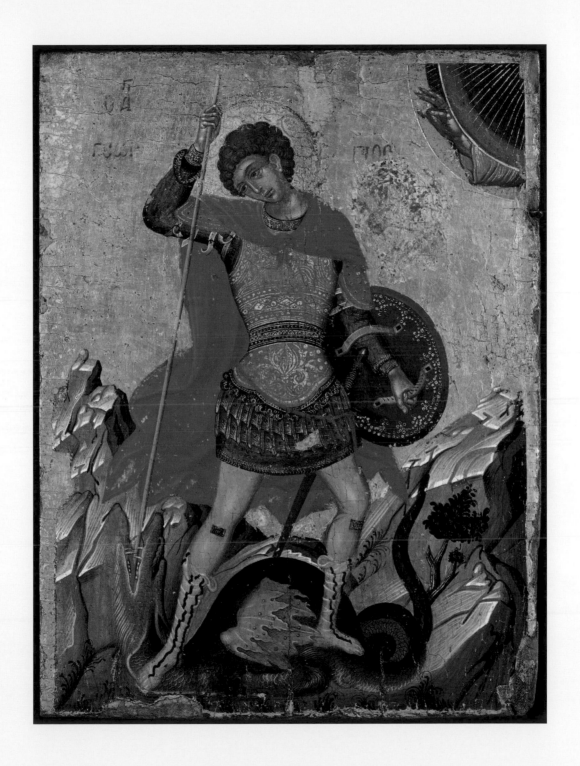

Triptych
Cretan workshop, attributed to
Andreas Ritzos or his workshop

Cat no. 105
Late 15th c.
Provenance unknown
Wood, egg tempera
20.7 (h) x 42.8 (w)
x 2.8 (th) cm (open)
Inv. no. 29537

Depicted on the central leaf of the triptych are the Virgin and Child, seated on a marble throne with footstool. Higher up, in the corners of the frame, are the archangels Michael and Gabriel, rendered in miniature inside red medallions. On the side leaves are trios of saints: right, the apostles Peter, John the Theologian and Paul; left, the Saints Anthony, Nicholas and Savvas. On the back of the left leaf are the soldier-saints George, Demetrios and Theodore. The back of the right leaf – which also formed the outer side of the triptych when closed – is coated with red pigment imitating leather and decorated with a gold cross on a stepped base, which symbolises the hill of Calvary (*Golgotha*) and encloses the schematic Adam's skull. The cross is framed by the symbols of the Passion:

the lance, the sponge and the crown of thorns. Around can be read the ciphers I(HCOY) C X(PICTO)C N(I)K(A), T(ОПOC) K(PANIOY) П(APAΔEICOC) Γ(ЕГONEN) (Jesus Christ Conquers, Place of Skulls Has Become Paradise).

In terms of iconography and style, the triptych is typical of the products of late fifteenth-century Cretan workshops. The flesh, modelled on an olive-green underlayer, graduates from ochre to rose, and the prominent features are emphasised by fine white highlights. The bodies have balanced proportions and are depicted in a variety of poses, which relieves their linear arrangement, particularly in the trios on the side-leaves. The Virgin and the Christ Child on the central leaf are rendered on a slightly larger scale, with elongated bodies, small heads and gentle gestures. Among the characteristics of the work are the precision of the drawing, the delicacy of the execution and the richness of the well-balanced palette.

The iconographic models of the figures as well as of the individual elements, such as the marble throne

in the central representation, are to be found in early fifteenth-century Cretan works which, in their turn, have roots in the Palaiologan tradition. The closest similarities are found mainly in the creations of Angelos Akotantos, a paramount artistic personality in Candia (mod. Herakleion) in the first half of the fifteenth century (+ pre-1457), who established the iconography and the style of Cretan painting (see also cat no. 104). Thus, Peter and Paul reproduce representations of these saints by Angelos, St Nicholas follows the analogous signed icon by Angelos in a private collection in Corfu, and the marble throne of the Virgin and Child copies the corresponding throne of the Pantocrator, again by Angelos, now in the Zakynthos Museum.

The painter of the Benaki Museum triptych is distinguished by his excellent technique and exceptional skill in handling the models and the artistic means available to him. The high quality of the piece and the specific stylistic features link it with the most important workshop in Candia in the second half of the fifteenth

century, that of Andreas Ritzos (1421–pre-1502) and his son Nikolaos (1452–pre-1507). At least another two triptychs, comparable in dimensions, workmanship and iconography, have been attributed to the same workshop. One is in a private collection, the other in the Hermitage Museum in St Petersburg. The presence of very similar works documents the output of a series of triptychs of this type, which is consistent with the fact that the painting of icons on Crete in this period assumed the character of mass production in response to the great international demand. The triptychs were undoubtedly intended for private devotions and the variety in the iconography permitted their use by a diverse clientele, which could have ranged from monks to laymen and soldiers. AD

Published: Bouras 1992, 401–406; *Oi pyles tou mysteriou* 1994, 235, no 56 (M Vassilaki). For parallels see: Chatzidakis (N) 1983, 44–45, no 38; *Sinai Byzantium Russia* 2000, 177–178, no B-154 (Y Piatnisky). On Angelos Akotantos see: Vassilaki-Mavrakaki 1981; Vassilaki 1994a. On the production of triptychs attributed to the workshop of Ritzos see Vassilaki 1994b; Drandaki 2002, 48–51, no 7.

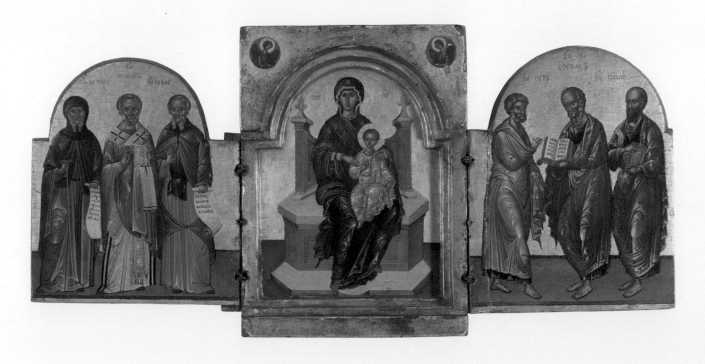

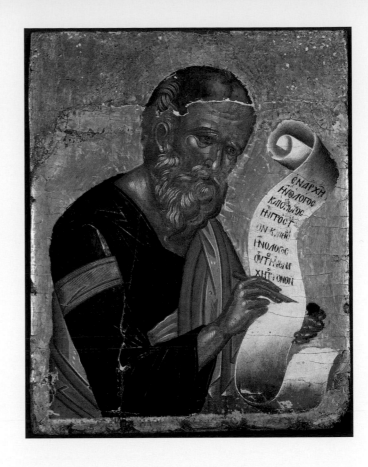

St John the Theologian

Cretan workshop, attributed
to Andreas Ritzos

Cat no. 106
Second half 15th c.
Provenance unknown
Wood, egg tempera, gesso
on textile
29.8 (h) x 23.4 (w) cm
Inv. no. 28110

St John is depicted in half-body,
in three-quarter pose to the right,
clad in a deep green chiton with
gold decorative band on the
sleeve and a rose-coloured
himation. He holds a stylus with
which he writes the text of his
Gospel in an open scroll with
majuscule script, in which the
beginning of the book is clearly
legible: *In the beginning was the
Word* ... The portrait type is of
an old man, as is established in
Byzantine iconography for St
John as scribe of the Revelation,
in contrast to his younger
appearance in Gospel scenes.
The flesh is modelled with
exceptional refinement in ochre
tones on the olive-green underlayer,
with delicate rougeing and dense
white highlights, alternating

thicker and thinner, on the
volumes, the hair and the beard.
The saint's gaze, turned towards
the scroll, imparts a sense of
profound introspection befitting
the author of the Revelation.
The upper part of the icon
and part of the saint's head
have been destroyed and are
now over-painted.

In the lower part of the icon
are traces of a badly effaced
inscription, in red pigment,
which reads: Χ(ΕΙΡ ΜΙΧΑ)ΗΛ
ΔΑΜΑCΚΗ(ΝΟΥ) ΤΟΥ
ΚΡΗΤΟC (…) (Hand of
Michael Damaskenos the Cretan
...). This identifies the painter of
the icon as Michael Damaskenos
(*c.* 1532–1592/93), one of the
most important Cretan painters
of the second half of the fifteenth
century. However, careful study
of the inscription has shown that
it is much later than the painting,
since the letters are written over
the previously damaged surface.
Furthermore, the style of the
icon points to a date considerably
earlier than the time of
Damaskenos. The meticulous
treatment of the figure and the

drapery link St John with the
creations of Andreas Ritzos
(1421-pre-1502), who was active
in Candia (mod. Herakleion)
during the second half of the
fifteenth century (see also cat
no. 105). In known works signed
by or attributed to this artist,
the same iconographic type of
St John is encountered, with the
prominent cheekbones, the strong
nose and very similar expression.
The most characteristic parallels
are the depictions of the saint in
the triple icon in the Basilica di
San Nicola in Bari, on the door
of the sanctuary in the icon
of Christ Pantocrator enthroned
in the monastery of St John the
Theologian on Patmos, and in
the composite icon with the
enthroned Virgin and Child and
saints in the Benaki Museum.
The work discussed here differs
from the examples cited in the
presence of the scroll, instead
of the open codex which St John
the Evangelist usually holds.

Beyond the stylistic and
iconographic affinities between
the Benaki Museum icon and
the creations of Ritzos, there

is an additional connection,
which is the subject itself. As
mentioned above, there are
signed icons by Ritzos in the
Patmos monastery of St John
the Theologian. The Cretan
artist seems to have worked in
this leading monastic centre and
to have kept a special relationship
with it, since apart from the
major commissions he also
painted a series of triptychs with
'Patmian' iconography, dedicated
to the life of St John.

AD

Published: *Oi pyles tou mysteriou*
1994, no 52 (M Vassilaki). For
parallels see: Chatzidakis 1985,
58–62, nos 9, 11; *Icone di puglia
e basilicata* 1988, 138–139, no 43;
Oi pyles tou mysteriou 1994, no 53
(M Vassilaki); Vassilaki 1994b. On
Andreas Ritzos see also: Cattapan
1968, 42–44; Cattapan 1973;
Chatzidakis, Dracopoulou 1997,
324–332.

Virgin of Tenderness
Cretan workshop

Cat no. 107
Icon 16th c.; later frame
Provenance unknown
Wood, egg tempera,
gesso on textile; later frame
decorated with bone plaques
and tortoiseshell
65 (h) x 54 (w) cm
Gift of Maria Vellini-Koelling
(37714)

The icon has suffered considerable damage, due to an earlier harsh cleaning intervention followed by retouching of the painting. The Virgin holds the Christ Child in her left arm and her cheek rests tenderly on her son's. She wears the traditional dark red garment covering the head and shoulders (*maphorion*), which is decorated with long gold fringing and tiny flowers on its edges, now largely destroyed. Her kerchief and her undergarment are deep green. Christ is clad in a greyish chiton, extensively over-painted, and an orange himation, which was

originally embellished lavishly with gold striations. He raises his head to touch the face of his mother, on whom he turns his gaze. He holds a rolled scroll in his hands and his left calf is bared. Inscribed on the gold ground of the representation is the appellation of the Virgin: Η ΑΜΟΛΥΝΤΟC (The Immaculate). The flesh is modelled on an olive-green underlayer, in the characteristic technique of Cretan painters, in warm ochre tones with a roseate tinge and fine white highlights emphasising the volumes.

Despite the extensive damage to the work, which alters its aspect, revealing the underlayer over large areas, the icon can be classed stylistically among typical Cretan creations of the sixteenth century. Its iconography reproduces one of the best known and most widely diffused versions of the Virgin of Tenderness, which was particularly popular among the clients of Cretan

painters, as attested by the numerous examples of the type produced in Cretan workshops in the fifteenth and sixteenth centuries. This iconographic type, already crystallised in the Middle Byzantine period, is among the most human and affectionate depictions of the Virgin and Child, at the same time being charged with profound theological symbolism and allusions to the future Passion of Christ.

The tender contact between mother and child foreshadows the lamenting Virgin's tragic embrace of the Lord's lifeless body before its burial. This interpretation, as analysed in theological texts and sermons, is underlined by iconographic details in the composition. Particularly characteristic is the prominence of Christ's bare calf, which links him with the Lamb that will be sacrificed for the salvation of mankind. Christ is portrayed in analogous manner

in scenes of his Presentation in the Temple, in which references to his impending Passion are more overt, through Simeon's prophecy to the Virgin: 'Yes, a sword will pierce through your own soul also' (Luke 2:35). He is depicted in exactly the same manner, in Simeon's embrace, in a lovely fifteenth-century Cretan icon now in the church of the Taxiarchs on Siphnos, which can be considered as a condensed, emblematic representation of the Presentation in the Temple. This theological content of the Mother-Son embrace is emphasised even more by the Virgin's appellation, 'The Immaculate', which as a rule accompanies the Virgin of the Passion, who is flanked by angels holding the symbols of the Crucifixion. AD

Unpublished. For parallels see:
Eikones Kritikis technis 1993, nos 3, 6 (Y Piatnisky), no 135 (M Borboudakis); Baltoyanni 1994, 17–40, pls 2–32; Chatzidakis (N) 2003.

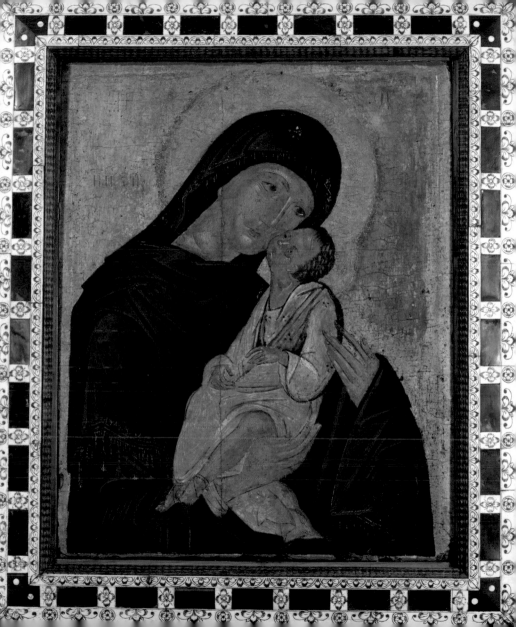

The Restoration of Icons
Cretan workshop

Cat no. 108
Third quarter 16th c.
Provenance unknown
Wood, egg tempera, priming
on linen
51.2 (h) x 40.7 (w) x 2.4 (th) cm
Gift of Helen Stathatos (21170)

The icon, which once bore the forged signature of Emmanuel Tzanfournaris (a seventeenth-century painter) is developed in two registers. The figures are arranged symmetrically around the vertical axis at the centre of the image, which is defined by the depiction of two icons, placed one above the other, the Virgin Hodegetria above and the Christ Great High Priest below.

In the upper register, the dominant Hodegetria icon is placed on an icon-stand and supported by two young deacons in long white tunic with sleeves (*sticharion*) and the stole (*orarion*) appropriate to their rank. Presiding at the ceremony beside them are Empress Theodora (842-856) and Patriarch Methodios (843-847), holders of supreme temporal and spiritual office respectively, who were the protagonists in the final Restoration of the Holy Icons in 843. Methodios is attended by a priest and two monks, while next to Theodora is her young son Michael (842-867), with three ladies-in-waiting behind them.

In the lower register, two serried rows of figures are grouped around the icon of Christ Great High Priest and King of Kings. The first row consists of the Church Fathers, three of whom hold scrolls with texts from the *Synodikon* of Orthodoxy (a liturgical document first produced after 843) and a *kanon* chanted on the Sunday of Orthodoxy. Behind them is a dense crowd of monks and laymen, including three cantors.

The stylistic traits of the icon display affinities with works of the Cretan School, of the mid- and the third quarter of the sixteenth century, such as the wall-paintings and portable icons by Theophanis (+1559), and other anonymous contemporary works.

The Restoration of the Icons is a subject encountered on only one surviving Byzantine icon, now in the British Museum, which dates from the late fourteenth century and probably comes from a Constantinopolitan workshop. The historic event of the Restoration of the Holy Icons in 843, marking the end of Iconoclasm, does not seem to have resulted in the immediate creation of a specific iconographic type to crystallise iconolatry in pictorial form. However, the British Museum icon attests that it was in existence by the Palaiologan era. In the same period a similar composition showing public ceremonies – of veneration and procession – in honour of the Virgin Hodegetria made its appearance in cycles of the Akathistos Hymn depicted in wall-paintings and illuminated manuscripts. It is not impossible that in the troubled clime of the fourteenth century, when Byzantium was torn apart by dynastic strife and ecclesiastical disputes involving the reassessment of the content of Orthodoxy and the role of the Church, this image of the Restoration of the Icons was created to embody the anticipated restoration of tranquillity within Church and State, with the hoped-for reconciliation of the two interdependent axes of power, Patriarch and Emperor, so prominent in the upper register of this representation.

The Cretan artist of the icon in the Benaki Museum faithfully follows the iconography of that in the British Museum, while making certain interesting variations to the details. Among these is the insertion of subjects that were widely diffused and particularly popular in sixteenth-century Cretan iconography, such as the portrayal of Christ as Great High Priest and King of Kings. The addition of the inscribed scrolls, which are not present in the Palaiologan work, both emphasises the content of the scene and endows the work with a didactic character found in other Cretan icons, mainly dating from the second half of the sixteenth century. Finally, the inclusion of additional figures – especially in the densely populated second row in the lower register – imparts an air of animation which is lacking from the hieratic Palaiologan work. AD

Published: Xyngopoulos 1951, 8–10, no 6, pl 6; Drandaki 2001 (with extensive bibliography). For parallels see: *Mother of God* 2000, 340–341, no 32 (R Cormack); Chatzidakis 1962, 96, no 63; Chatzidakis (N) 1997, 86–91, no 5.

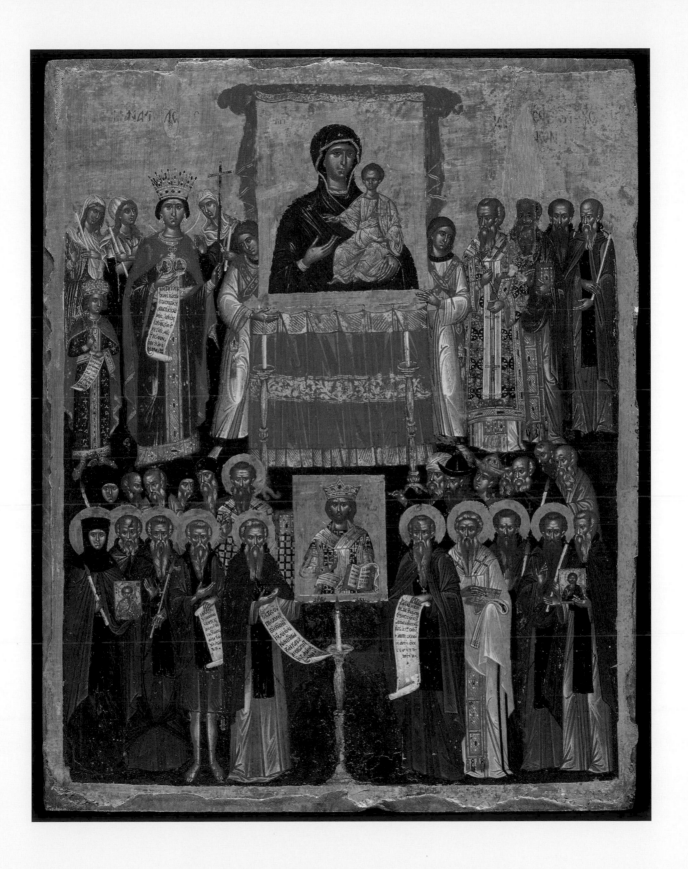

Icon of St George
Macedonian workshop

Cat no. 109
Second half 16th c.
Provenance unknown
Wood, egg tempera
19.2 (h) x 20.3 (w) x 2.8 (th) cm
Inv. no. 27934

St George is depicted on horseback slaying the dragon. His steed rears in impetuous movement towards the right, as the saint plunges his spear into the mouth of the dragon, which coils its tail around the horse's hind legs. On the horse's haunches, behind the saint, sits a young figure in smaller scale, holding glass vessels, a bowl and a cup. This is the youth from Mytilene who, according to hagiographic tradition, had been sold into slavery and was rescued from this fate by the miraculous intervention of the saint. The figure of the youth appears in numerous thirteenth-century representations and is reproduced consistently in the iconography of the equestrian saint in Post-Byzantine painting. In the top right corner of the icon is the segment of heaven (*segmentum coeli*), the rays from which beam upon the saint. The nominative inscription is painted freehand in red majuscule letters, without the use of guidelines.

The faces are modelled on a deep brown underlayer with ochre flesh tones, light rougeing on the cheeks and a few white highlights on the prominent features. The execution of the icon overall has the deft painterly character reminiscent of wall-painting. Emphasis is placed on conveying the vitality of the representation rather than on its calligraphic design. This is particularly obvious in the impulsive steed, as well as in details of the vigorous drapery, in which the few highlights render summarily yet successfully the movement of the figures.

In addition, characteristic of the style of the work, as well as indicative of its provenance, is the total absence of gold from both the ground and the decorative details. The ground is blue, again bringing the icon closer to wall-paintings in which a similar colour is used, while the saint's halo is ochre. These characteristics refer to a workshop in Macedonia where comparable traits are encountered in numerous works. Analogous lively treatment of the figures, use of a coloured ground and substitution of ochre for gold are observed on icons from Veroia and Kastoria, in Macedonia. The simple palette, based on alternating tones of reds and blues, and certain constructional details, such as the thick, sunken wooden panel, lead to the same region.

The episode of the slaying of the dragon is included in the Life of this popular saint, which was disseminated in the Byzantine world during the eleventh and twelfth centuries. According to the narrative, St George saved a princess from the monster, thus delivering her city from constant danger and converting its inhabitants to Christianity. The dragon-slaying is depicted in iconographic cycles of St George such as the well-known early thirteenth-century icon depicting scenes from the *Vita* of the saint in the monastery of St Catherine on Mt Sinai, in Egypt, but also occurs as a representation in its own right. In the Benaki Museum icon, as on numerous other examples, the narrative elements, the depiction of the city and of the princess, are omitted, so endowing the image with a more emblematic and symbolic character. AD

Published: Delivorrias, Fotopoulos 1997, 259, fig 449. For icons from Veroia see: Papazotos 1995, cf 69, pls 102–104.

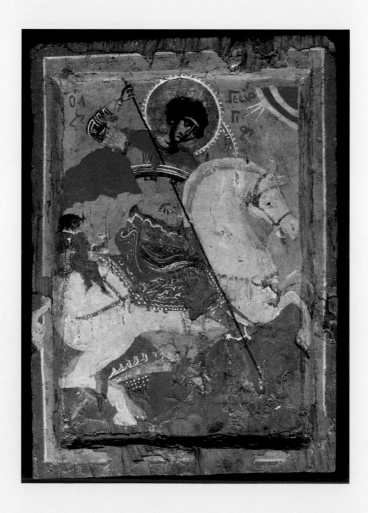

Icon of St Demetrios
Signed by Emmanuel Tzanes

Cat no. 110
1672
Provenance unknown
Wood, egg tempera
40.2 (h) x 32.6 (w) x 2.1 (th) cm
Inv. no. 3000

St Demetrios is shown in military attire, mounted on a horse moving left. In his right hand he holds a spear, steadied on his shoulder, and in his left he pulls at the reins of his chestnut steed, which rears and turns its head towards the viewer. The horse's harness and saddle are carefully drawn with gold-embellished ornaments. Emphasis on the decorative is evident too in the halo, which is covered by a rinceau on a punched dotted field.

The scene is set in a rocky landscape with a walled city in the background, bottom right. Although the landscape is not rendered in perspective, the painter has endeavoured to convey a sense of volume and depth by differentiating chromatically the superimposed planes of the rock and using light and shade for the relief of the terrain. The sky is covered by the conventional gold ground of Byzantine painting and in the top left corner is the segment of heaven (*segmentum coeli*). The flesh is modelled most assiduously and the contours of the face are rendered by fine white linear highlights. The colour scale is rich and balanced, with red predominant, in tones ranging from rose to the brownish red of the steed. The painter's signature can be seen bottom left: ΧΕΙΡ ΕΜΜΑΝΟΥΗΛ ΙΕΡΕΩΣ ΤΟΥ ΤΖΑ(ΝΕ) αχοβ (Hand of Emmanuel Tzanes priest, 1672).

There are another two icons of St Demetrios, bearing the signature of Emmanuel Tzanes, in Athenian collections. One of these bears the same date as that of the Benaki Museum icon and has common iconographic elements, particularly the pose of the saint, who is shown proceeding with his horse in parade step, with the spear resting on his shoulder. The same characteristics are repeated in a pricked cartoon (*anthivolo*), also in the Benaki Museum, which is associated directly with the output of Tzanes.

Emmanuel Tzanes (1610-1690), an eminent and prolific painter from Rethymnon, on Crete, must have abandoned his native island when the city was captured by the Ottoman Turks in 1646, and moved to Corfu. His presence there played an important role in passing on the torch of Cretan painting to the Ionian Islands, and the popularity of his work is documented by the many later imitators of his art in this region. He served for several years as vicar in the church of St George of the Greeks in Venice, where he was buried. Tzanes is without doubt one of the best representatives of late Cretan painting. His work is characterised by excellent technique, balanced synthesis and pronounced eclecticism. Following the dictates of the day, he sought to renew the vocabulary of Cretan painting by enriching it with elements from Western art, for which his main source was the Flemish engravings that circulated widely in this period. Nevertheless, although the work of the priest and man of letters Tzanes incorporates innovative elements, it is distinguished always by respect for the theological content of the scenes and submission to the Byzantine ethos of the composition as a whole. AD

Published: Sicilianos 1935, 212; Xyngopoulos 1936, 43, no 29, pl 21b. For the *anthivola* see: *From Byzantium to El Greco* 1987, 54–56, nos 72–73 (L Bouras); Bouras 1994; Vassilaki 1995. On Tzanes see: Drandakis 1962, *passim*; Drandakis 1974; Chatzidakis, Drakopoulou 1997, 408–425.

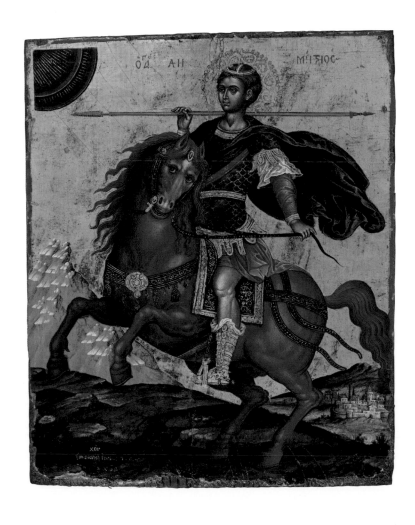

Icon of St Theodore Stratelates

Ionian Island workshop, possibly in Cephalonia

Cat no. 111
1733
Provenance unknown
Wood, egg tempera, gold leaf, gesso on linen
49.5 (h) x 41.3 (w) x 2.5 (th) cm
Gift of Eleni Eukleidi (32556)

Against the gold ground and upon the green foreground, St Theodore is depicted mounted on a horse, facing right. In the top left corner is the calligraphic nominative inscription:
Ο ΑΓΙΟΣ ΘΕΟΔΩΡΟΣ Ο ΣΤΡΑΤΗΛΑΤΗΣ
(St Theodore Stratelates, the army commander). In the right corner, on a smaller scale, is an angel crowning him with the wreath of martyrdom. The figure reproduces the usual iconographic type of the saint, with dark brown hair and short beard. His face is modelled with care and all the details are rendered with a decorative flourish characteristic of the image as a whole. The grey steed rears up in vigorous movement and turns its human gaze towards the viewer. The painter has lavished special attention on the horse's execution. The mane and tail are luxuriant, while the gold-embellished trappings

and the saddle are ornamented with diverse motifs, conveying an impression of conspicuous opulence.

An interesting decorative subject repeated on the saint's armour, his greaves and the horse's trappings, is the anthropomorphic or zoomorphic masks. This element was widespread in the iconographic vocabulary of the Western Renaissance, being consistent with the preference for ancient or archaised subjects. Although not unknown in Late Byzantine art, these decorative elements return more prominently in Post-Byzantine painting of the sixteenth century. The principal medium of their dissemination was Western European engravings, which circulated widely in Greece and particularly in Venetian-held regions such as Crete. Analogous subjects are encountered even more frequently in the works of later Cretan painters, such as Emmanuel Tzanes (see cat no. 110) and Theodoros Poulakis (c. 1620-1692). These two important Cretan painters, who were active in the Ionian Islands in the late seventeenth century, played a decisive role in passing on the torch of late Cretan art to this region. The icon of St Theodore belongs in this artistic current, of so-called Cretan-Ionian painting, which developed

in the Ionian Islands after the influx of learned refugees from Crete escaping the conquering advance of the Ottoman Turks.

Perhaps even more notable than the artistic quality of the icon is the three-line inscription beneath the horse's legs, in the bottom right corner, which reads: Άγιε μεγαλομάρτυς Θεόδωρε γενού πρέσβης και βοηθός/ του δούλου σου Φιοροβάντε Κρασσά ρήτορος ιατρού/ συν παντί τω οίκω αυτού α ψ λ γ
(O Saint Theodore great martyr become intercessor and helper / of thy servant Fiorovante Krassas orator and physician / and of all his family 1733). This informs us of the identity of the dedicator and the year in which the icon was painted. According to extant documents, the nobleman Fiorovante was a pupil in the College of St Athanasios in Rome, from 1697 until 1704, and went on to study medicine and philosophy in Padua – which studies he proudly mentions in the inscription. As a result of systematic proselytising by the Catholics in the College of St Athanasios, Fiorovante was converted to Catholicism.

The testimony of the inscription, in conjunction with historical evidence collected from the literary sources, is particularly

precious, not only because it enables us to connect historically a work of art with its commissioner – very rare for an icon – but also because it permits us to draw interesting conclusions on the artistic taste of an eminent, erudite member of Cephalonian society. We can ascertain that Fiorovante Krassas, who had studied in Italy, had direct perceptions of Italian art and was indeed a Catholic by faith, chose for his icon a painter who was a devoted exponent of the Post-Byzantine tradition. AD

Published: Drandaki 1996. On mask motifs in Palaiologan painting see: Mouriki 1980-1981. On the use of Flemish engravings see: Constantoudaki-Kitromilides 1991, 271, note 1; Drandakis 1962, 156-158. On Fiorovante Krassas see: Polychronopoulou 1987, 307, note 27 and p 338; Tsitselis 1904, 130-131, note 4.

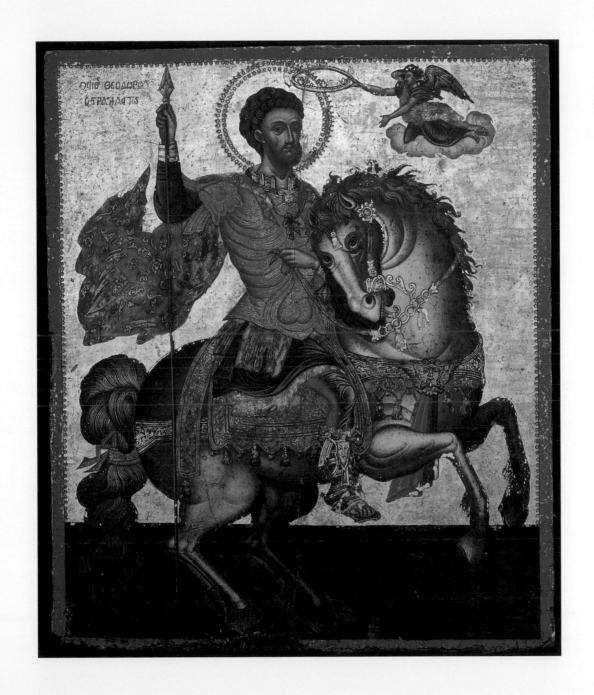

Pair of flabella

Cat no. 112
1755
Possibly from Constantinople
Silver parcel gilt, hammered,
pierced, repoussé, engraved
48 (h) cm; discs 30.5 (diam) cm
Inv. no. 34575

The pierced-work disc of the flabella is decorated with an engraved floral arabesque and applied medallions attached with rivets. The central medallion is upheld by two full-bodied winged angels, vested as deacons. Represented in half-length on one side of the medallion is Christ blessing, and on the other the crowned Virgin in intercession, with Christ on her bosom. Ranged around them are six medallions with the same representations on both sides. The two on the vertical axis feature six-winged seraphim and the other four, placed diagonally, the symbols of the Evangelists: the angel of Matthew, the lion of Mark, the ox of Luke and the eagle of John.

The medallions and the full-bodied angels were probably made by pressing in a mould. Similar medallions, with minor differences, exist on two pairs of seventeenth-century flabella in the Panachrantos monastery and the Hagias monastery, both on the Cycladic island of Andros. The latter, with a dedication of

Patriarch Dionysios Vardalis (1662-1665) and undoubtedly of Constantinopolitan provenance, suggests the attribution of the Benaki Museum flabella to Constantinople. This view is corroborated by the style of the pierced-work decoration, with the large open flowers and the reticulated stamen, a stylistic trait of European Baroque ornament, which from the seventeenth century influenced the art of the Ottoman capital and was used equally by both Muslim and Christian goldsmiths.

The hollow conical handles of the flabella are decorated with spiralling grooves and affixed in the discs by a forked shaft that penetrates the spherical knob and reaches their centre. The dedicatory inscriptions on the grooves attest that for each flabellum two separate donors collaborated, thus sharing the cost of their making and the anticipated reciprocal gift of God's blessing. They read, on Flabellum I: + ΔΕΗϹΙϹ ΤΩΝ ΤΟΥ ΘΕΟΥ ΣΤΕΦΑΝΙ ΚΑΙ ΜΟΓΙϹΙ 1755 (+ Prayer of the [servants] of God Stephanos and Moses 1755); and on Flabellum II: + (ΔΕΗ)ϹΙϹ ΤΟΝ ΔΟΥΛΟΝ ΤΟΥ ΘΕΟΥ ΘΕΟΦΙΛΟΥ ΠΡΟϹΚΙΝΗΤΟΥ ΚΑΙ ΚΑΤΕΡΙΝΑϹ ΡΟΓΙΛΙ ΠΡΟϹΚΙΝΙΤΟΥ ΥΟΒΑΝΙ 1755 (+ Prayer of the servants of God Theophilos pilgrim and Katerina Rogili pilgrim [of] Yovani 1755).

The handles, medallions and discs are stamped with the *tuğra* (monogram) of Sultan Osman III (1754-1757) and bear a zigzag assay mark, proving that the pieces have been checked for the purity of silver by the Ottoman authorities.

Flabella are the 'banners' of ecclesiastical ritual, symbolising the six-winged seraphim and the four-headed cherubim, the heavenly creatures who, according to the visions of Old Testament prophets, praise and protect the enthroned God. They originate from the Early Christian fans made of peacock feathers, fine leather or textile, with which the deacons wafted away the insects from the sacraments of the Eucharist. By the Middle Byzantine period, under the influence of imperial ceremonial, flabella acquired the form of imperial banners; they were processed before the Crucifix in litanies, just as imperial banners preceded the emperor in court ceremonies.

AB

Unpublished. For the inscription see: Chatzidaki 1959, 13, no 48. For the flabella of Andros see: Paschalis 1961, 39; Iconomaki-Papadopoulos 1980, 15, fig 20.

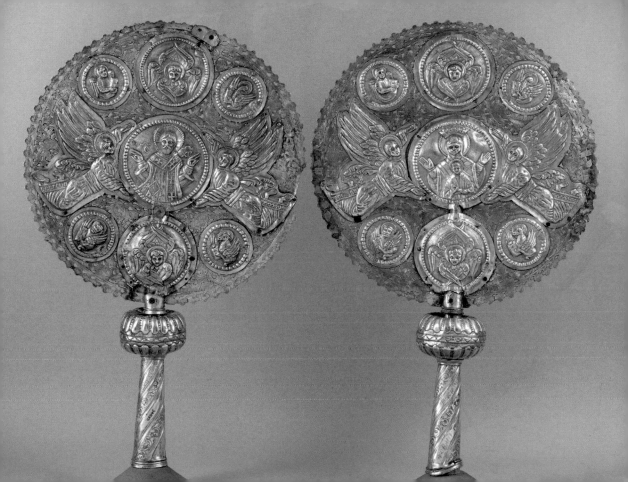

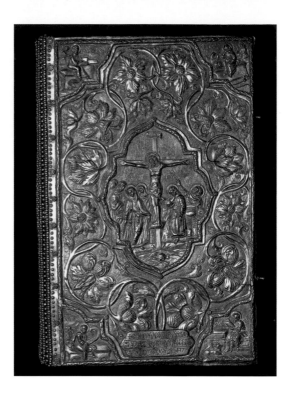

Printed Gospelbook
with silver cover

Cat no. 113
Publication 1697; cover 1721
From the church of St Demetrios,
Adrianople, Eastern Thrace
Paper, wooden boards, velvet,
revetment of silver sheet,
repoussé, niello
37.5 (h) x 25 (w) cm
Inv. no. 34144

The Gospelbook was printed in
Venice in 1697 at the press of
N Saros. The later cover has
silver revetment, affixed to
wooden boards covered with
green velvet. The decoration
on both front and back includes
a central lobed medallion and
triangular corner pieces, framed
by relief acanthus, while in the
field is a rinceau with large open
flowers. On the front are
represented the Crucifixion, in
the central medallion, and the
four Evangelists, with their
symbols, in the corner pieces.
On the back, correspondingly,
are the Resurrection – depicted
in the Byzantine manner of the
Descent into Hell – and the
prophets Moses, Isaiah, David
and Elijah holding scrolls.

The iconography and the Baroque
blossoms of the decoration reveal
the influence of the silversmith's
art of Transylvania, now a province
of Romania. Part of the Austro-
Hungarian Empire at that time,
it was an immediate neighbour
of the semi-autonomous
Danubian principalities of
Wallachia and Moldavia, which
were vassals of the Ottoman
Empire. The renowned workshops
of Braşov and Sibiu in Transylvania
followed the artistic currents of
Central European silverwork,
forming a branch of it. At the
same time they served the
Orthodox Christian clientele
of the principalities of Wallachia
and Moldavia, fashioning church
plate adapted to the needs of
Orthodox liturgy and iconography.
The rulers of the Danubian
principalities played a dynamic
role in the politics of the
Patriarchate of Constantinople
and acted as protectors and
donors of the important church
institutions under Ottoman rule.
Their donations comprised,
among other things, luxurious
silver objects, which survive to
this day in the major monastic
centres of the Orthodox East.

The iconography of the central
scenes on the cover, as well
as their relief frame with
acanthus, faithfully reproduces
Transylvanian models such as
the Gospelbook cover of 1681,
wrought by master-craftsman
'CV' for the Prince of Wallachia,
Serban Bassaraba, or the
Gospelbook cover of 1677,
in the Simonopetra monastery
on Mt Athos. Similar medallions
and corner pieces are frequently
encountered as single fittings
nailed to leather bindings of
Gospelbooks, revealing the
diffusion of the type to local
ecclesiastical silverworking.
In the Benaki Museum example,
the miniaturist rendering of the
religious scenes is at variance
with the large scale of the
open flowers in the decoration.
Blossoms of this size occur more
frequently on secular objects
whose shapes lend themselves
to a circular arrangement of
decorative motifs, such as salvers
or cups, produced in both
German and Transylvanian
silversmiths' workshops.

According to the dedicatory
inscription, written in niello on
a separate plaque nailed to the

front cover after it was completed,
this was a gift supervised by the
wardens of the church of St
Demetrios, with the financial
contribution of those mentioned
by name, among them a woman
and two tradesmen, a clockmaker
and an olive-oil merchant. The
inscription reads: +
ΕΠΗΜΕΛΕΙΑC ΤΕ ΚΑΙ
CΗΝΔΡΟΜΗ ΤΩΝ
ΕΠΙΤΡΟΠΩΝ ΤΟΥ ΑΓΙΟΥ
ΔΗΜΙΤΡΗΟΥ ΔΙΜΗΤΡΑ
ΚΑΙ ΟΡΟΛΟΓΑC
ΑΝΑCΤΑCΙC ΓΗΑΓΤΖΙC
ΧΑCΤΑΔΙΜΟC ΕΝ Ε(τει)
1721 (+ With the care and
contribution of the wardens of
the [church] of St Demetrios,
Demetra and clockmaker
Anastasis and oil-merchant
Hastadimos, in the year 1721).
AB

Unpublished. For the church of
St Demetrios at Adrianople see:
Saraphoglou 1929, 73. For the
inscription and dedicatory
inscriptions in general on church
silver see: Ballian 2001, 96,
100, fig 8.
For the Simonopetra Gospelbook
cover see: Iconomaki-Papadopoulos
1991, 166, pls 85–86. For silverwork
of Transylvania see: Nicolescu 1968.

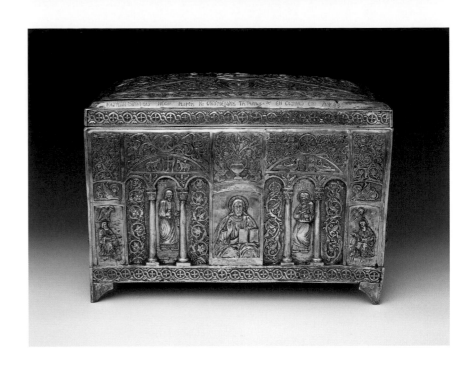

Ciborium

Cat no. 114
1766
Provenance unknown
Silver, hammered, repoussé,
chased, engraved
20 (h) x 28.6 (l) x 15.7 (w) cm
Inv. no. 13975

The elaborately decorated
ciborium, which stands on four
small triangular legs, alludes in
shape to a rectangular church,
with trilobe openings on each
side and a slightly vaulted roof.
At the midpoint of the long sides
are small icons, made as separate
plaques, depicting on the front
Christ enthroned and on the
back the Virgin and Child. These
are framed by arched openings
resting on slender colonnettes
and flanked by pilasters with the
Evangelists and their symbols.
Separate plaques fill the recesses
of the trilobe arches, with
representations in the central
lobe on the front of the apostles
Peter and Paul, and on the back
the Saints Barbara and Anastasia.
On the two short sides is a similar
arched arrangement with the
Saints Nicholas and John, and
prophets shown on the pilasters.
The decoration on the lid includes
a central oval medallion enclosing

an archangel at the intersection
of two diagonal lines, and four
circular medallions with
representations of seraphim.

The church-shaped construction
of ciboria was established in the
Byzantine period. The icons,
made of separate plaques on this
particular example, refer to the
doors of the church, while the
decoration of the lid recalls the
architectural arrangement of
cross-vaults. Ciboria of this type
were placed at the centre of the
Altar Table and usually used as
containers for the sanctified
bread of the sacrament.

The decoration of this ciborium
is extremely lavish, with floral
compositions and animals: the
sides are defined by a cross-
bearing guilloche, in the spandrels
are confronted sphinxes, harpies,
peacocks, lambs and deer, and in
the lateral lobes of the trilobe
arches are vine scrolls and pine
cones. Dominant above the
arches are medallions with the
Chi-Rho (X-P) monogram of
Christ, framed by vine scrolls or
acanthus. Correspondingly, above
the pilasters are sitting sphinxes,
lions, bear cubs and a scrolling
vine, populated by birds, hares
and other animals. Last, above

the central plaques, with Christ
enthroned and the Virgin and
Child, sphinxes flank a krater
from which sprouts a riotous plant.

The vegetal decoration of the
ciborium has an intensely hybrid,
Neo-Byzantine style which
derives from manuscript
illuminations. Characteristic are
the conical pine cones sprouting
from the stems, which allude to
corresponding ornaments in
illuminated manuscripts of the
School of Luke of Buzău and
of Matthew of Myra. These
manuscripts, created in the
Danubian principality of
Wallachia in the early seventeenth
century, circulated to the libraries
of the major Orthodox Christian
religious centres. Their decoration
with pine cones imitates the
engraved vignettes in printed
religious books.

The dedicatory inscription
incised on the edge of the lid
reads: + ΑΦΙΕΡΩΜΑ
ΣΑΜΟΥΗΛ ΧΑΝΖΕΡΗ
ΕΛΕΩ Θ(ΕΟ)Υ
ΑΡΧΙΕΠΙΣΚΟΠΟΥ
ΚΩΝ[Σ]ΤΑΝΤΙΝΟΥΠΟΛΕΩΣ
ΝΕΑΣ ΡΩΜΗΣ ΚΑΙ
ΟΙΚΟΥΜΕΝΙΚΟΥ
ΠΑΤΡΙΑΡΧΟΥ + ΕΝ
ΣΩΤΗΡΙΩ ΕΤΕΙ ΑΨΞΣΤ

ΚΟΠΟΣ ΔΑΜΙΑΝΟΥ
ΡΟΔΙΟΥ (+ Dedication
of Samuel Chanzeris by the
Grace of God Archbishop of
Constantinople, New Rome
and Ecumenical Patriarch +
in the year of the Lord 1766
toil of Damianos Rhodios).
The inscription leads us to
Constantinople and specifically
to the Phanari (Fener) quarter,
home to wealthy Christians and
seat of the Ecumenical Patriarchate.
The dedicator is Patriarch
Samuel Chantzeris (1763-1768,
1773-1774), who was a kinsman
of the eminent aristocratic
Skarlatos family, scions of
which were elevated to high
office by the Ottomans, including
a Dragoman of the Fleet and
a series of Greek princes of
Wallachia and Moldavia. AB

Published: *Oi pyles tou mysteriou*
1994, 280, no 115 (A Ballian). For the
manuscripts of Mathew of Myra see:
Gratziou 1982. For the Patriarch
Samuel Chantzeris see: Gedeon
1885-90, 657-660, 663-664.

Communion chalice

Cat no. 115
1740
From Cappadocia, Asia Minor
Silver, hammered, pierced,
repoussé, chased, gilded bowl
22 (h) cm
Inv. no. 34486

The chalice comprises a pierced-work calyx which served as receptacle for the deep, narrow bowl, a tall stem with integral knob and a lobed, stepped foot. The calyx is decorated with heads of cherubim with open wings, alternating with floral rinceaux. The bowl and the stem are ornamented with multi-petalled roses and acanthus leaves, while the foot is divided into seven lobes, in each of which is a six-winged seraphim. The two tiers of the foot, one in pierced work with scrolls and the other chased with leaves and shells, terminate in a circular inscribed base.

The chalice combines styles and characteristics of varied origin. The use of the calyx to hold the bowl, and the peculiar formation of the lobed and tiered foot, are features deriving from Late Gothic chalices, the influence of which is obvious in Byzantine ecclesiastical vessels from as early as Palaiologan times. The sanctified use of the vessels for the Holy Eucharist brought the crystallisation of their form, which was reproduced for centuries in both the Orthodox and the Catholic Churches. The gradual changes observed are confined to the decoration and the shape of the bowl, which in this particular piece has the same deep shape as cups for secular use in the eighteenth century. Elements from the Baroque – acanthus and scrolling stems with open flowers – coexist harmoniously in the decoration with stylistic traits of the Rococo – multi-petalled roses and shells – while the only feature that refers to Orthodox iconography is the six-winged seraphim.

Chalices of similar type exist in church sacristies throughout the wider Greek and Balkan lands. The most likely centre of diffusion of the type, however, is Constantinople. The sultan's monogram (*tuğra*) stamped on the base indicates that the silver has been assayed for purity by the Ottoman authorities.

The chalice comes from the Church of the Virgin in the little village of Vexe, near Caesarea, a region inhabited by Karamanlis, native Christians of the former Byzantine province of Cappadocia. The Christian population of this region is the oldest section of Byzantine Hellenism, conquered by the Seljuk Turks four centuries before the Fall of Constantinople in 1453 and surviving for nine hundred years until the compulsory uprooting with the Exchange of Populations in 1922. Over the centuries, the Christians of Cappadocia or Karamania, as the region was named from the fourteenth century, progressively lost their language and became Turcophone. In the urban centres Turkish almost universally prevailed, but in isolated mountainous areas a form of Medieval Greek, with Turkish admixtures, lived on. The phenomenon that best reveals the persistent and lengthy process of adaptation of the native Christians among the majority Muslim population is the writing of the mixed Turkish and Greek language using Greek characters, the so-called Karamanli script, which appears in the dedicatory inscription on the base of the chalice. This reads: ΧΑΤΖΗ ΜΗΧΑΛ ΒΑΚΟΥΦ ΕΤΗ ΠΑΝΑΓΗΑ ΚΛΗCΕCΗΝΗ 1740 ΒΕΞΕ (Dedication of Hadji Michalis to the Church of the Virgin at Vexe, 1740). AB

Published: *Arte y culto despues de Bizancio* 1995, 47, no 27 (A Ballian).

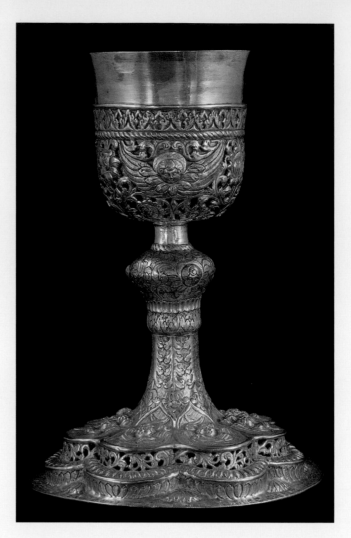

Standing censer

Cat no. 116
1810
Cappadocia, Asia Minor
Silver, hammered, pierced-work,
repoussé, chased, cast elements
26.1 (h) x 26.4 (l) cm
Inv. no. 34097

The censer or *katzion* reproduces
the type of contemporary
hanging censers, but instead of
suspension chains it has a broad
handle that rests on a cylindrical
shaft which can be used as an
extra handle (cf cat no. 83).
The vessel comprises a footed
hemispherical bowl and a lid
with turrets, vaults, pierced-work
openings and at the top a dome
on which is screwed a cast cross
inscribed within a laurel wreath.
The architectural form of the lid
is of Late Gothic provenance,
while in the hemispherical bowl
the Rococo shells, lattices and
acanthus leaves reveal the
influence of Western European
art. Represented on the broad
leaf-shaped handle is the scene of
the Presentation of Christ in the
Temple, following the established
iconography of Post-Byzantine
painting: on one side is a group
of three figures with the Virgin
and Joseph holding the doves
in his hands, and on the other
Simeon holding Jesus in his
hands, in front of a hemispherical
baldachin. The scene takes place
in the interior of the temple,
suggested by the paved floor and
the large lamp suspended from
the ceiling. Screwed to the end
of the handle is a cast protome
of a winged dragon with small
pendent bells. Three similar bells
hang below the foot of the bowl.

On the foot of the bowl is a
dedicatory inscription in Karamanli
script (see cat no. 115), which
reads: ΤΑΞΗΑΡΧΟΥ
ΜΙΧΑΗΛ ΚΑΙ ΓΡΙΓΟΡΙ
Χ(ατζή) ΤΑΝΙΗΛ 1810
(Of Taxiarch Michael and
Grigoris Hadji Taniil 1810).
The spelling 'Taniil' instead
of the correct 'Daniil' (Daniel)
reveals a common pronunciation
difficulty of the Karamanlis,
who originated from central
Asia Minor. The katzion perhaps
comes from the monastery of
the Taxiarchs, in the village
of Taxiarchis in the district
of Caesarea, which under the
abbacy of Anthimos from
Kermir (1798–1840) was
renovated and most probably
equipped with new sacred vessels.

The ecclesiastical silverware from
Cappadocia, the Pontos and
eastern Thrace forms part of the
refugee heirlooms brought to
Greece with the Exchange of
Populations. In 1922, the Treaty
of Lausanne between Greece
and Turkey imposed the
compulsory exchange of the
Greek Orthodox Christian
populations of Asia Minor and
eastern Thrace with the Muslim
populations of mainland and
island Greece. A special term
of the treaty made provision for
these groups to transport their
moveable community property.
This legal framework permitted
those refugees who abandoned
their ancestral hearths peacefully
to take with them the treasures
of their churches. These treasures,
now in Greek museums, are a
reminder and a testimony of the
thriving Christian communities
within the Ottoman Empire. AB

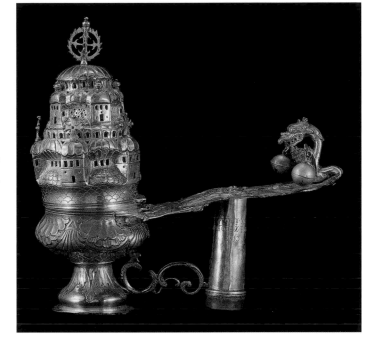

Published: Ikonomaki-Papadopoulos
1980, 20, fig 35; *Byzantine Art* 1986,
203, no 229 (A Ballian); *Ceremony
and Faith* 1999, 154, no 30 (A Ballian).

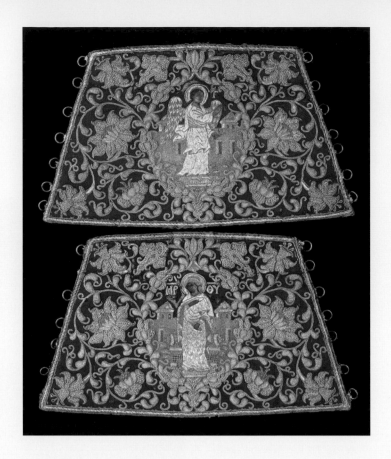

Embroidered maniples

Cat no. 117
18th–19th c.
Provenance unknown
Silk, gold and silver thread
15 (h) x 25 (w) cm
Inv. no. 9400

A typical subject for the decoration of maniples (detachable liturgical cuffs) in the Post-Byzantine period is the Annunciation, with the Archangel Gabriel represented on one and the Virgin on the other. On this pair the Archangel and the Virgin are depicted within a floral oblong medallion, against a background of architectural structures, consistent with the iconographic models of the Annunciation. They are inscribed accordingly: Γ(αβριὴλ) (Gabriel) and Μ(ήτη)Ρ Θ(ε)ΟΥ (Mother of God). The dense relief decoration with flowers and scrolling stems derives from European ornamentation prevailing in the eighteenth century, in both embroidery and metalworking. The excellence of the needlework bespeaks a specialist craftsperson and possibly an urban gold-embroidery workshop.

Maniples (*epimanika*) are worn by officiating clerics of all ranks in the Orthodox Church to cover the lower part of the sleeves of the long tunic (*sticharion*). They are trapezoidal, with loops on two sides, through which pass the laces or straps used to tie them to the wrists and which are considered to symbolise the chains with which Christ's hands were shackled when he was led before Pontius Pilate. As is the case with other sacerdotal vestments, maniples probably originated from secular attire. In fact, prelatic vestments preserve sartorial forms of late antiquity and were enriched over time with elements deriving from ecclesiastical and temporal art. The earliest mention of maniples as part of episcopal dress is in 1054 and it seems that they were first used in the mystery of baptism, for practical reasons. By the fifteenth century they were also worn by priests, and after the Fall of Constantinople (1453) by deacons as well. AB

Published: Vei-Chatzidaki 1953, 66, no 123; *Ceremony and Faith* 1999, 193, no 41 (A Ballian).

Liturgical veil

Cat no. 118
1776
Provenance unknown
Silk, gold and silver thread,
pearls, glass-paste gems
50 (h) x 76 (w) cm
Inv. no. 33726

The liturgical veil, *epitaphios*, depicts the dead Christ in a sarcophagus, covered by a shroud, beneath a canopy resting on four short columns. The vault of the canopy is adorned by a cross, while beneath its arches hang lamps and ovoid pendants. On high are two cherubim and two stellar rosettes. The liturgical character of the representation is heightened by the presence of the venerating Archangels, Michael and Gabriel, who flank the sarcophagus with the lifeless Christ. They are vested as deacons and wear the stole (*orarion*) crossed over on the chest, exactly as at the administration of Holy Communion. The inscription above reads: Ο ΕΠΙΤΑΦΙΟC Ο ΘΡΗΝΟC (The Lamentation at the Bier). Below are the initials of the archangels, Μ (Michael), Γ (Gabriel), and the abbreviated inscription Ι(ησοῦ)C Χ(ριστό)C NIKA (Jesus Christ Conquers).

The epitaphios is the liturgical veil which is used as an icon of the Lamentation during the Good Friday procession and which covers the altar table for celebrating the Divine Liturgy from the end of the matins service (*orthros*) on Easter Saturday until Ascension Day. A creation of the Late Byzantine period, the epitaphios is a development of the great *aer*, a liturgical veil with which the Sacraments, the chalice and the paten were covered. On the aer the dead Christ is represented as a lamb, indeed frequently as an infant inside a paten borne up by angelic hosts. It seems from the literary sources and depictions in wall-paintings that the epitaphios – great aer was also used as a litany veil during the procession of the Great Entrance (in the Mass), symbolizing Christ's triumphal Entry into Jerusalem. During the Post-Byzantine period the use of the epitaphios was limited to the service for Good Friday, as a consequence of which its iconography gradually acquired a narrative character, depicting all the persons in the Lamentation.

Below the representations on the epitaphios discussed here is the dedicatory inscription: ΕΤΟΥC 1776 Ο ΠΑΡΟΝ ΕΠΗΤΑΦΙΟC ΗΚΟΔΟΜΙΘΗ ΕΚ ΧΙΡΟC ΤΟΥ ΚΑΜΟΥ ΕΠΤΡΟΠΟΥ ΔΗΜΙΤΡΑΚΗ CΤΟΙΟΥΤΖΑC ΚΕ ΤΗ CΙΒΙΑC A[υτ]ΟΥ ΤΗC ΠΑΝΟΡΙΑC ΔΙΑ ΧΙΡΟC ΤΗC ΕΤΕΛΙΟΘΗ (In the year 1776 the present epitaphios was constructed at the hand of the warden Dimitrakis Stoioutzas and his wife Panoria through whose hand it was finished). This indicates that the donors were the church warden Dimitrakis Stoioutzas and his wife Panoria who, according to the inscription, embroidered it with her own hands. Of particular interest is the fact that Panoria appears to copy earlier models, combining the iconography of the aeres with that of the epitaphioi and emphasising the symbolic content of the representation. It is characteristic that the two venerating archangels are depicted in the same way as those of a great aer of 1613/4 in the Iviron monastery on Mt Athos, even though due to an error in design their right hands are omitted. AB

Published: Vei-Chatzidaki 1953, 50, no 63; *Ceremony and Faith* 1999, 198, no 47 (A Ballian). For the *aer* of the Iviron Monastery see: Vlachopoulou-Karabina 1998, 29, fig 10.

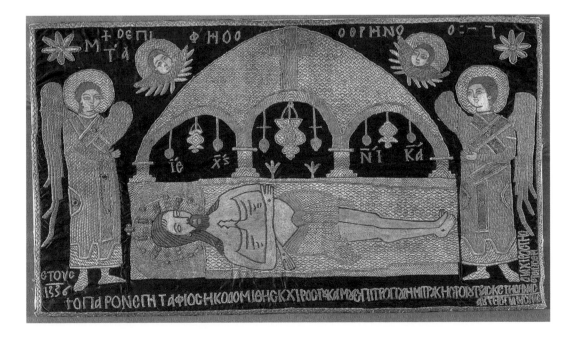

Embroidered genual
Constantinopolitan workshop

Cat no. 119
1696
Provenance unknown
Silk, gold wire
48 (h) x 48 (w) cm
Inv. no. 9357

Represented on the genual is the Adoration of the Magi, with the Virgin seated on the right holding the Christ-Child in her lap, and the three Magi advancing in line towards her. The Virgin and Child are sheltered by a wooden roof, and in the background is the cave with the animals and the manger. The first two Magi kneel in veneration, their crowns on the ground, and between them, in threes, boy servants bear the gifts. The third Magus, the dark-skinned Ethiopian, standing, still wears his crown. The star-spangled sky is dotted with semicircular clouds, within which fly little angels.

The iconographic models of the scene are Western, the most obvious features being the wooden shelter and the black king, which derive from Italian Mannerist painting of the sixteenth century. Absent, however, are the vigorous movement of Italian works and the crowding of figures. The combination of cave with shelter and the strict alignment of the figures reveal a desired merging with Byzantine models. The floral designs in each of the four corners are an adaptation of Baroque decoration to ecclesiastical gold embroidery.

The genual (*epigonation*) derives from the hand-cloth (*encheirion*) which hung from the belt of a secular lord and was originally worn in the same way by Orthodox bishops, who used it to wipe their hands. The term epigonation holds sway from the twelfth century to define the square piece of cloth which, mounted on stiff backing, hangs by one corner – and is therefore lozenge-shaped – from the belt of bishops. From the fifteenth century on, its use was extended to clerics of all ranks.

The Benaki Museum genual is a work of the renowned Constantinopolitan embroiderer Despoineta or Despoina (1682-1723) from the Diplokionio neighbourhood (mod. Beşiktaş). It is inscribed and signed by the embroiderer herself: +ΚΑΙ ΕΛΘΟΝΤΕC ΟΙ ΜΑΓΟΙ ΕΙC ΤΗΝ ΟΙΚΙΑΝ ΕΙΔΟΝ ΤΟ ΠΑΙΔΙΟΝ ΜΕΤΑ ΜΑΡΙΑC ΤΗC ΜΗΤΡΟC ΑΥΤΟΥ ΚΑΙ ΠΕCΟΝΤΕC ΠΡΟCΕΚΗΝΗCΑΝ ΑΥΤΩ ΚΑΙ ΠΡΟCΗΝΕΓΚΑΝ ΑΥΤΩ ΔΩΡΑ ΧΡΥCΟΝ ΚΑΙ ΛΙΒΑΝΟΝ Κ(αι) ΣΜΥΡΝΑΝ ΑΧϤCΤ. ΧΕΙΡ ΔΕCΠΟΙΝΕΤ(ας) (And the Magi entering into this house saw the child with Maria his mother and falling to their knees adored him and offered him gifts of gold, frankincense and myrrh. 1696. Hand of Despoineta).

Despoineta's workshop is attested by the considerable number of gold embroideries signed by her or her apprentices, while its fame is documented by the dispersal of her works throughout the Orthodox world, from Ankara, Kastoria in Macedonia and Aigio in the Peloponnese to Cyprus, the St Catherine monastery at Sinai in Egypt, and Wallachia. The Armenian community of Constantinople evidently also held her art in high regard. There is a slightly smaller genual with an identical representation of the Adoration of the Magi, with an Armenian inscription and the date 1713, in the Holy Etchmiadzin monastery in Armenia. AB

Published: Vei-Chatzidaki 1953, 30, no 40; Johnstone 1967, pl 55; *Ikonen Bilder in Gold* 1993, no 133; *Oi pyles tou mysteriou* 1994, 293, no 133 (A Ballian); *Vestments of the Eastern Orthodox Church* 1999, no 44. For Holy Etchmiadzin monastery in Armenia see: *Treasures of Armenian Church* 2000, 80–81, no 54.

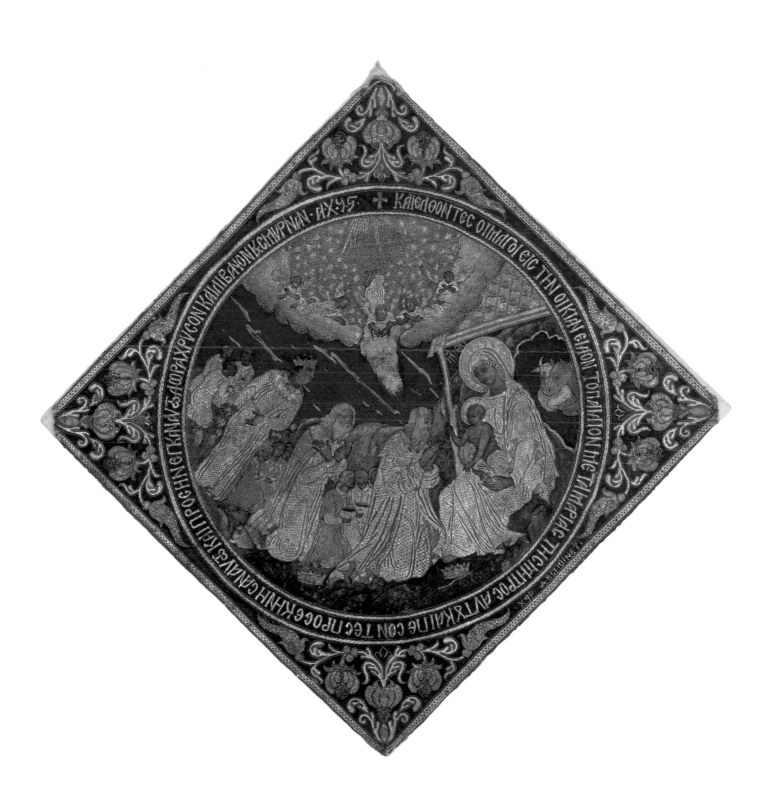

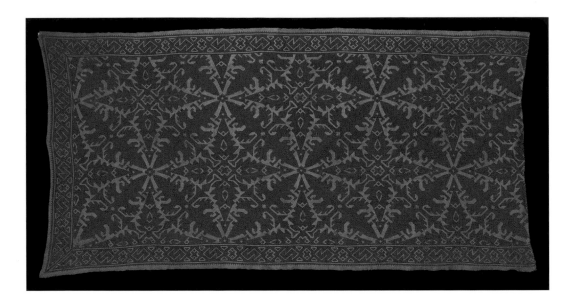

Part of a panel from a bedspread

Cat no. 120
Late 17th-early 18th c.
From Naxos, Cyclades
Linen textile, brick-red silk
thread; darning stitch
87 (l) x 44 (w) cm
Gift of Irini and Aimilia P Kalliga
(11299)

The surface of the linen fabric is covered by a repeating pattern of a geometric leaf and a four-rayed star, embroidered in brick-red silk. The outlines are left unworked in white. A narrow zone of geometric motifs runs round three sides. The fourth side has been cut off.

This is a typical example of the embroideries of Naxos. The overwhelming majority are in monochrome red, enlivened sometimes by intrusions of blue, green and, more rarely, honey-beige. Their main pattern is usually a repeated geometric leaf, set within a diagonal trellis forming large, faceted, quasi-circular shapes, in a vast variety. Their beauty derives from the complexity of the basic forms, which allows the 'reading' of the pattern in diverse ways. This is accentuated by the fact that the untwisted floss silk is laid in two directions – both horizontal and vertical – so that light is reflected to create the impression of two different shades of red.

The embroideries of Naxos are counted among the masterpieces of Cycladic needlework. They are imbued with a European air, since Naxos – as indeed the whole of the Cycladic Archipelago – was in direct contact with Italy, principally with Venice. According to textual sources, the nuns of the Ursuline Order, who settled on the island in 1639, taught embroidery and European lace-making to the women of Naxos, who were 'very skilled in these tasks', as Father Blezeau of the Jesuit Community remarked.

Testimonies of embroideries dating from the period of Venetian rule and kept in the houses of the Catholic community are recorded by travellers and visitors to the island, while there are sporadic references to red-embroidered cushion covers in dowry contracts and wills from the early seventeenth to the mid-nineteenth century. The English traveller Theodore Bent, who came to the island in 1884, writes that he saw a large number of red embroideries in the village of Apeiranthos, from where they most probably originate. KS

Published: Delivorrias 1992, 296, 337, fig 95. For red embroideries of Naxos see: Bent 1885, 340, 357; Taylor 1998, 46–53 and cf fig on p 48 (lower left).

Cushion cover

Cat no. 121
18th c.
From Skyros, Sporades
Linen textile, multi-coloured
silk threads; back and double
running stitches
90 (l) x 45 (w) cm
Inv. no. 6395

Along the two narrow sides of
the cushion cover, within a floral
field, is a repeat composition
of a male figure in long luxurious
attire and trilobed crown,
flanked heraldically by two
anthropomorphic felines. Depicted
at the centre are two frontal
mermaids, clothed on the torso
and with leaf-shaped fishtail with
floral finials, linked by a stem
topped by a flower. The remaining
surface of the fabric is filled with
tulips, fantastical flowers and
cockerels. The cushion cover is
bordered by a garland of blossoms
and birds. Many of the motifs
have dark-coloured outlines.

There are difficulties in
interpreting the composition with
the male figure, which is known
locally as 'the *kadi* with the lion
cubs'. The identification of the
figure as the kadi, an important
Ottoman official with judicial
and administrative duties, is
doubtful, given that in the Skyros
thematic repertoire human
figures are characterised
frequently by Hellenised names
of foreign provenance which
have yet to be decoded. Amuletic
properties could be ascribed to
the anthropomorphic felines, for
which there are no parallels in
the needlework of other islands,
while the mermaid, a popular
subject in Neohellenic traditional
art, is one of the most widely
disseminated motifs in embroidery,
particularly on Skyros and Crete
(see cat no.122).

Embroidered cushion covers of
this type, which are called
proskephalades (pillows) on Skyros
and are so mentioned in dowry
contracts, were intended mainly
for adorning the bridal bed. It is
possible that they were also made
for the ornamentation of the
house on various festive occasions,
such as baptism or launching a
ship. The lavish vegetal
decoration of this embroidery
alludes to the generative character
of blossoming and justifies its
nuptial association.

Skyros embroideries are
distinguished by the quality of
their technique, the variety of
designs and the delicacy of the
colours. Their subjects reveal
Western and Ottoman influences,
which refer to the island's long
period of foreign occupation,
first by the Venetians (1453-1538)
and subsequently the Ottomans
(1540-1830). The assimilated
thematic elements from West and
East, in conjunction with the rich
repertoire of subjects from the
imaginary world of indigenous
Hellenic tradition, are rendered
in a distinctive local style that
imparts a peculiarly merry and
expressive vitality to the motifs,
which is the hallmark of Skyros
embroidery. KS

Published: Chatzimichali 1936, 117,
fig 10; Petrakis 1977, 30;
Polychroniadis 1980, 37, fig 7. For
further information on Skyros
embroideries see: Taylor 1998, 87–99.

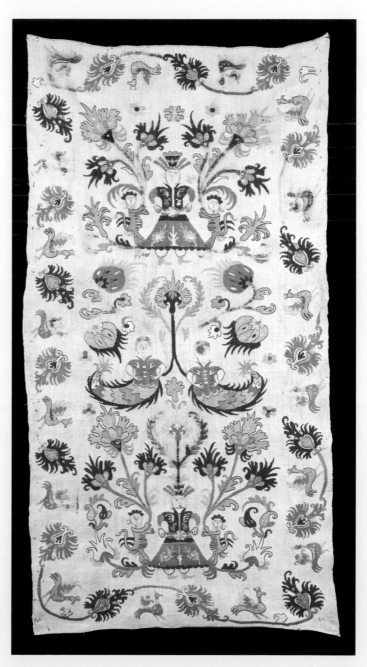

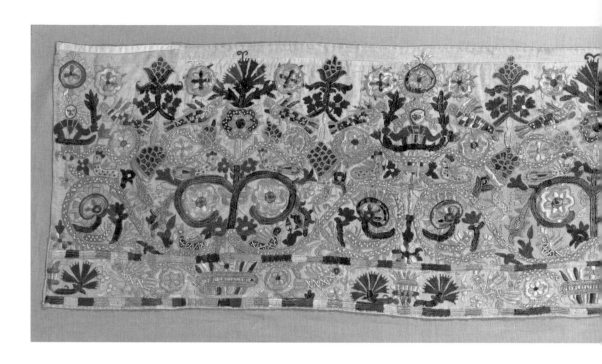

Part of a hem from a female dress

Cat no. 122
18th c.
From Crete
Linen textile, multi-coloured silk threads; Byzantine, pseudo-Byzantine, stem, herringbone, feather, chain, brick and French knots stitches
138 (l) x 31.5 (w) cm
Gift of Demetrios Sisilianos (EE3389)

The hem is embroidered with patterns traced freely on the cloth, though with a clear tendency towards symmetry in the overall arrangement. The surface is covered by dense, complex compositions of vegetal and floral volutes enclosing flowers and rosettes. Some of them terminate above in a carnation and others frame the central symbolic-amuletic motif of the mermaid holding in both hands her forked fishtail with floral finials. Represented in the narrow border zone are two variations of the plant-pot, from which sprout volutes, rosettes, carnations and confronted birds. The intervening spaces are filled with a wide variety of confronted and addorsed birds, small animals – perhaps dogs – pine-cones and blossoms.

One of the most characteristic subjects of Cretan needlework is the mermaid holding her forked tail in both hands. The theme of a female figure with one or two fishtails originates from the type of ancient Scylla, which was widespread up until Early Christian times. The first known occurrence of this iconographic motif linked to the myth of the Siren is in an eleventh-century Latin manuscript on monsters, the *Liber monstrorum*, which copies an unknown text of the seventh or eighth century that was widely disseminated in Medieval Europe. The type of the Italian Siren reached Venetian-held Crete through its incorporation in emblems on Italian coats of arms, and subsequently spread to Greek territories, at first as an ornamental motif with no underlying symbolism or meaning. It is not known precisely how and when the Western Siren was transformed into the mermaid of recent Greek tradition and associated with the familiar legend of Alexander the Great, in which his sister appears metamorphosed into a fish from the waist downwards. Over time, the mermaid in Cretan embroidery lost her marine character and came to be depicted more as a woman-flower than as a woman-fish, as in this particular example, or changed into a regular female figure with dress, floral crown and flowers in her hands.

In contrast to the other Aegean islands, there are very few extant examples of household embroideries from Crete, where needlework for domestic use was rare, such needs being covered by hand-woven textiles. The island's embroidery is known mainly

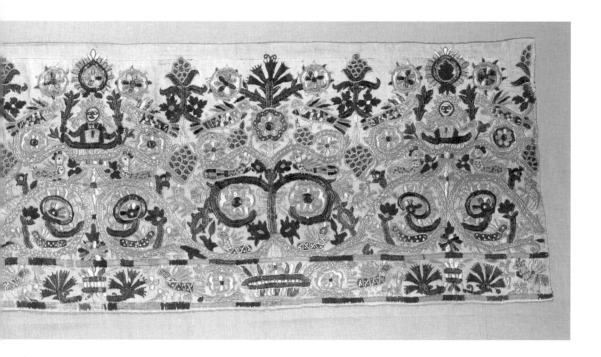

from the hems of the multi-pleated dresses of a costume whose type has been lost. The dresses, a very few examples of which have survived intact, have a wide, five-panelled, pleated skirt which hangs by straps from the shoulders and ends in a broad embroidered hem. This type of dress, with Renaissance roots, is also encountered in other islands of the Archipelago during the period of Latin rule (cf. cat nos. 141, 143).

Cretan hems, among the earliest examples of Greek needlework, sometimes preserved the date and the name of the embroiderer. In the Metropolitan Museum of Art in New York there are two examples, dated 1697 and 1726, and in the Victoria and Albert Museum in London there are three, dated 1733, 1752 and 1762, the first two of which bear the name of the embroiderer.
KS

Unpublished. For Cretan embroideries in general and other examples see: Johnstone 1972, 28–30, figs 121–128; Polychroniadis 1980, 20–21, figs 38–45; *Aegean Crossroads* 1983, 28–29, pl 21: no 57; Taylor 1998, 107–117.
For the mermaid see: Zora 1960, 331–365, esp 345–346.

Cushion cover

Cat no. 123
17th c.
From Ioannina, Epirus
Linen textile, multi-coloured silk
and silver metal threads; darning,
chain and stem stitches
138 (l) x 41 (w) cm
Gift of Helen Stathatos (21173)

The cushion cover depicts a scene of a wedding procession. Portrayed at the centre of the densely embroidered decoration are the bride and her parents, flanked by two ewers filled with flowers, upon which perch two anthropomorphic birds. At the edges of the embroidery, symmetrically rendered, are two galloping horsemen holding a pole with the *flambouro*, the wedding banner. The riders are accompanied by small animals, perhaps dogs. The whole of the remaining surface is filled with floral compositions of tulips, carnations and hyacinths. The figures are attired in opulent Epirot costume with a high cap. The bride and her parents wear the characteristic gold-embroidered overgarment of the urban costume of Ioannina, from which protrude the embroidered sleeves of the chemise. The bride wears a precious diadem of a type which lived on in the costume of the Pogoni region of northern Epirus until the nineteenth century.

The nuptial content of the representation is heightened by the symbolism of the decorative motifs. The generative character of the riotous floral decoration is combined with the references to the cycle of life, to which the flower-vases also allude, and with the apotropaic properties of the two anthropomorphic birds, here transmuted into the 'fairies' of Greek tradition, protective symbol of newlyweds.

The Ioannina cushion covers for the bridal bed, with their subject of the nuptial procession – in several variants – form a separate category of Epirot needlework. Embroidered with designs traced freely on the cloth, they are distinguished by their narrative character, which is enhanced by the horizontal arrangement of the subjects – as if in a mural – and are outstanding for the painterly rendering of the embroidered representations.

The embroideries of Epirus reflect prosperity and luxury. Ioannina, the region's capital, developed between the seventeenth and the nineteenth century into one of the most important centres of trade and manufacturing as well as the main node of routes linking East and West. KS

Published: Chatzimichali 1936, 101, fig 1; Wace 1957, 94, pl XXXVIII: no 172; Delivorrias, Fotopoulos 1997, 444–445, fig 768. See a parallel example in: *Aegean Crossroads* 1983, 103, fig 18. For embroideries from Epirus in general see: Taylor 1998, 127–145.

Part of a cushion cover

Cat no. 124
Early 18th c.
From Lefkada, Ionian Islands
Linen textile, silk threads;
split stitch
60.5 (l) x 45.5 (w) cm
Inv. no. 6263

The polychrome decoration of schematic heraldic animals is embroidered on a cream drawn-threadwork (*fil-tiré*) ground. The outlines of the motifs and the details are emphasised in another colour. At the centre of the embroidery are a large deer and four lions with one leg raised, in cruciform arrangement, and in the four corners are double-headed eagles with outspread wings. The bodies of the creatures and the surface of the textile overall are densely filled with deer, peacocks and birds on a smaller scale. The represent-ation is surrounded on three sides by an embroidered frame; on the fourth side, which has been cut, parts of the continuous motifs are preserved.

The embroidery comes from a long, narrow cushion cover on which the same composition was repeated thrice, as is inferred from two intact examples from the Ionian Islands with comparable motifs in a similar arrangement – one in the Victoria and Albert Museum, London, and the other in the Textile Museum, Washington DC.

Cushion covers embroidered in this style, encountered in Europe in the sixteenth and seventeenth centuries and probably reflecting Venetian influence, are either square or oblong. The former are usually embroidered with a finite subject, whereas on the latter the decoration is formed by the triple repetition of the same subject, as on the example here. The subjects of the decoration are either geometric patterns or schematic animals, or a combination of the two, while human figures occur more rarely.

In the animal repertoire of the cushion, motifs found on Italian embroideries of the fifteenth and sixteenth centuries coexist with those drawing on Byzantine tradition, such as the double-headed eagle. The heraldic lion recalls the lion of St Mark, the emblem of Venice, which stood sentinel over the gateway of the castle of Lefkada (Santa Maura), declaring that the island was a Venetian possession (1684-1797).

A typical trait of Lefkadian embroidery, apart from the polychromy, is the inclusion of smaller subjects in a larger one. The style of the needlework, with the densely filled surface, recalls Venetian gold-brocaded silks and velvets of the sixteenth and seventeenth centuries, yet with an overt Eastern influence. KS

Published: Polychroniadis 1980, 20, fig 31; Taylor 1998, fig on p 122. For similar types of cushion covers see: Johnstone 1972, 91, fig 108; *Aegean Crossroads* 1983, 34–36, 81, pl 1.

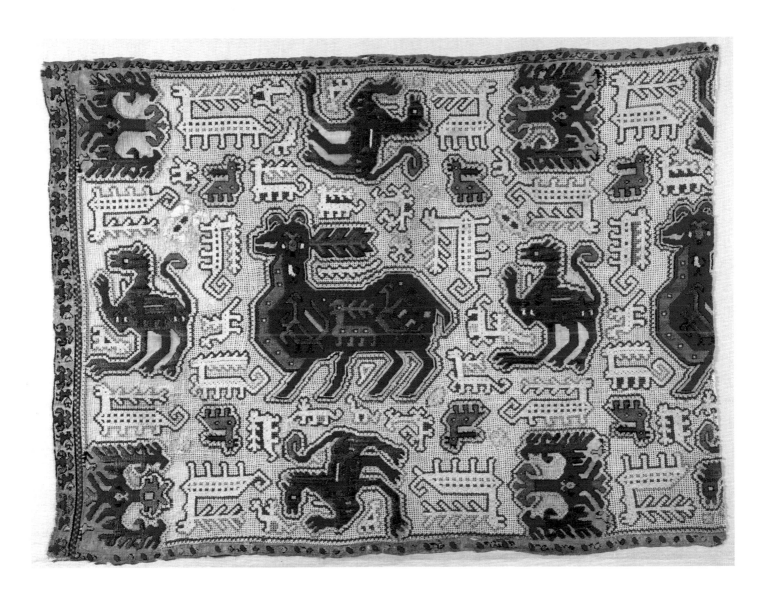

Earring pendants

Cat no. 125
17th–18th c.
From the Aegean Islands
Gold sheet, filigree, cloisonné
enamel, pearls
5 (h) cm
Inv. nos 1995, 1996

The miniature three-masted caravels impress with their superb craftsmanship and refined details. The vessels have a deep blue enamel hull, green prow and white keel and sails, the last stippled with gold dots and tiny stars. The masts and rigging are of twisted gold wire. The gold dots on the sides of the ship indicate gun emplacements. From the keel hangs a dove in flight with outspread wings, of white enamel with dark coloured and pink dots, framed by pendent Baroque pearls. The link at the top indicates that the ships hung from a decorative element now lost, most probably a bow, judging from analogous examples.

Ornaments in the form of sailing ships, as pendants for necklaces or earrings, enjoyed wide dissemination during the seventeenth and eighteenth centuries in the Mediterranean, particularly in Italy and along the Adriatic coast, as well as in the Greek islands, mainly the Dodecanese and the Cyclades. The Westernised style of these pieces of jewellery prompted the formerly widely-held view that they were made in workshops in Venice from where, together with other luxury commodities, they were imported to Greek lands, or made in some unknown provincial Italian centre on the Adriatic coast. This view is not corroborated by the archival testimonies, however, or documented by the essentially different style of contemporary Italian jewellery.

Despite the difficulty of attributing these pieces to a particular local workshop, there are several indications that they are of Greek origin: their striking distribution in the Greek islands, the correlating of the family names on inscribed examples with archival sources, the traces of their influences on later families of insular jewellery of indisputably local origin.

The above indications lead to the quest for their provenance in workshops in some urban insular milieu, perhaps in flourishing Candia (mod. Herakleion), capital of Crete, where the use of the ship motif on precious vessels from the fourteenth century, as well as the use of enamel in the early seventeenth century – which certainly reflects an existing tradition – are documented by archival sources.

The dove, one of the most popular Christian symbols, occurs frequently in Neohellenic art. Symbol of peace, harmony and hope when depicted with an olive branch in its beak, it expresses by its presence here, in combination with the caravel, the wish for a good voyage and a safe return of the sailors to their homes. KS

Published: Segall 1938, 203, no 365; *Greece and the sea* 1987, 311–312, no 215 (A Delivorrias); *Greek Jewellery* 1997, 256, no 305 (K Synodinou). For pendants in the form of sailing ships from the Aegean Islands see: *Benaki Museum Greek Jewellery* 1999, 363, fig 270, 373, fig 274, 375–376, figs 275, 276.

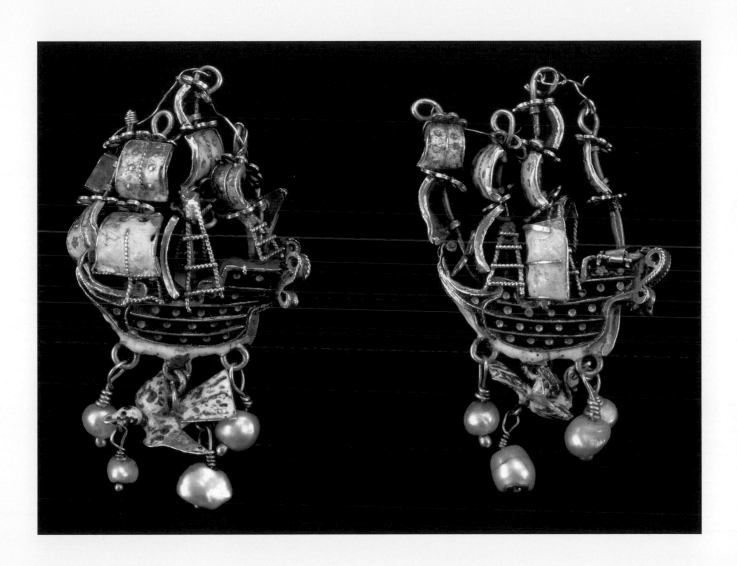

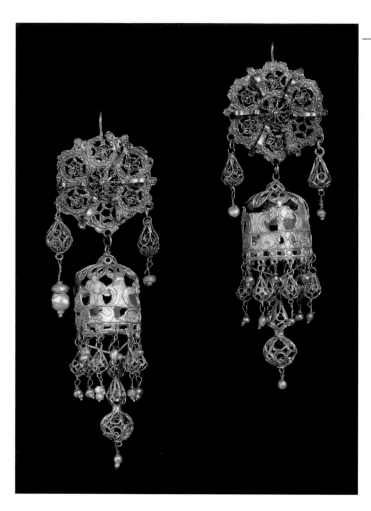

Earrings

Cat no. 126
Mid-18th c.
From Kos, the Dodecanese
Gold sheet, pierced-work,
filigree, pearls
11.5 (h) cm
Gift of Helen Stathatos (7667)

The earrings are composed of a series of interconnected pendent elements: a six-petalled rosette with a flower attached at the centre, a 'bell', and drop-shaped and spherical pendants with tassels of seed pearls. The ornaments are distinguished by the finely worked filigree, elegant shape and skilful articulation of the individual elements.

The filigree decoration of the earrings is mostly soldered to pierced-work cut-outs of gold sheet, consistent with the older tradition of Dodecanesian enamelled jewellery. The absence of colour from the gold surface is compensated for by the exquisite delicacy of the filigree floral decoration. From the mid-eighteenth century on the use of enamel in Greek jewellery gradually declined until it disappeared completely.
On the combined evidence of the absence of enamel and the technique used here, which is derived directly from the older tradition, the earrings may be dated to the mid-eighteenth century.

There are another three pairs of earrings of the same type, with Kos as their recorded provenance, in the collections of the Benaki Museum. The earrings are known as *kambanes* (bells), after the characteristic shape of their central element and are encountered by this name in other Dodecanesian islands, as well as in the Cyclades.

The kambanes must have accompanied a type of frontlet, now lost, as may be deduced from an analogous system of decoration of the forehead, variations of which are known from all over Greek lands. Like all earrings of comparable length, the kambanes were hooked on at some point above the ears and framed the face, dangling to the level of the neck and so forming an ensemble with the frontlet. The whole system of adornment obeys forms and shapes deeply rooted in Byzantine tradition and is reminiscent of Byzantine *prependulia*, which hung from the imperial diadems, as attested by literary sources and by depictions of imperial figures in various works of art, the best known being the representation of the Empress Theodora and her retinue, in the sixth-century mosaic in San Vitale, Ravenna.
KS

Published: *Greek Jewellery* 1997, 262, no 311 (K Synodinou). For an analogous pair of earrings from Kos in the Benaki Museum see: *Benaki Museum Greek Jewellery* 1999, 383–384, no 138 (E Georgoula). See mosaic of Ravenna with the Empress Theodora in: Grabar 1966, fig 172.

Earrings

Cat no. 127
Second half 18th c.
From the Aegean Islands
Gold sheet, pierced-work,
filigree, enamel, pearls
8 (h) cm
Inv. no. 7285

The hooks of the earrings are attached to arched pierced-work elements from which hang filigree bows with enamelled details and drop-shaped pendants with tassels of seed pearls. Despite their simplicity, these earrings are directly related stylistically to kambanes (cat no. 126) and would have completed an analogous system of head adornment. The execution of the filigree decoration, which creates a more direct impression of lace, and the simpler aesthetic of the earrings, suggest a later date.

The bow device, which possibly derives from a ribbon bow that was tied to the upper part of the ornament to keep it in place, is one of the most popular decorative motifs in European jewellery. It is depicted in European portraits from the mid-seventeenth century and holds sway from the mid-eighteenth. In Greece it is

encountered mainly in Crete (see cat no. 129), the Aegean Islands and the Ionian Islands (see cat no. 131), which had direct contact with Italy, primarily Venice.

The examples of gold jewellery from the Aegean Islands are distinguished by the perfection of the filigree details of the decoration, the added drop-shaped pendants and the systems of seed pearls which very often hang like bunches of grapes, and, until the mid-eighteenth century, by the polychrome enamelling. Their quantity and exquisite quality confirm that these pieces of jewellery circulated during a period of economic prosperity, which is reflected also in the impressive furnishing of the houses and the luxurious costumes. The Aegean Islands enjoyed two periods of affluence: the period of Venetian rule, from the mid-sixteenth to the mid-seventeenth century, and the years from the mid-eighteenth to the early nineteenth century, to which these particular earrings are assigned. KS

Unpublished. For jewellery from the Aegean Islands in general see: Delivorrias 1992, 289–293 (with extensive bibliography). For the bow see: Scarisbrick 1984, 22–23.

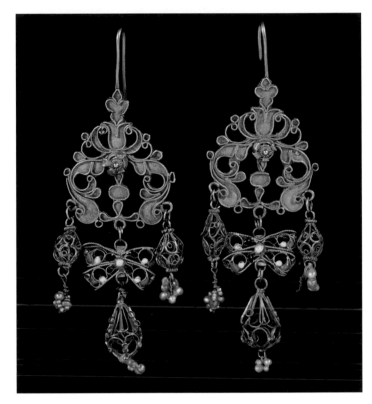

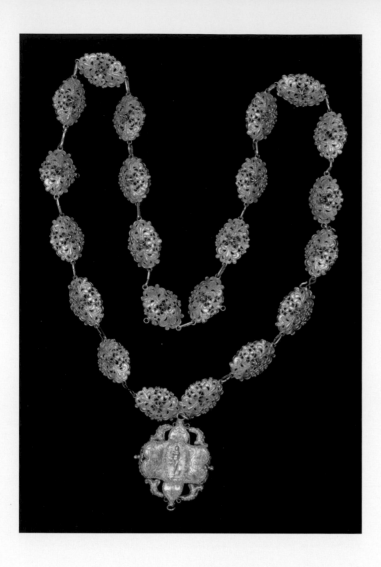

Necklace with pendant

Cat no. 128
Late 18th c.
From the Dodecanese
Gold sheet, pierced-work,
filigree, repoussé
Necklace 90 (l) cm;
pendant 5.5 (h) x 5 (w) cm
Gift of Yro Vyza (38202)

The necklace comprises 22 lozenge-shaped elements of pierced-work gold sheet with lacy edge and appliqué filigree floral decoration around a central rosette, connected by elongated links. The pendant, formed from two joined gold sheets, is embellished with soldered filigree foliate motifs and miniature repoussé representations at the centre, within an oval frame. Depicted on one side is a male figure of ancient mien, holding a snake, and on the other a female figure with shield, perhaps alluding to the deities Asklepios and Athena respectively.

The necklace, known by its local Dodecanesian name as *alyssos* (chain), is apparently not preserved in its original dimensions. It is deduced from examples surviving in the Dodecanese in the inter-war years that these pectoral ornaments were initially much longer, so that successive rows of them covered virtually the whole bosom, down to the waist. The fact that they are today preserved fragmented is due to the traditional custom whereby mothers would share out the family jewellery and heirlooms equally among their daughters.

Necklaces of this type, which frequently terminated in precious pectoral ornaments – such as caravels, crosses and variform pendants – must have been widely disseminated not only in the Dodecanese but also the Cyclades. Pendants of similar morphology, with lacy filigree decoration, but usually with representations of saints on both sides, complement an analogous pectoral adornment in the Ionian Islands.

According to information given by the donor, this piece of jewellery was a patriarchal gift to her grandfather Demosthenes Evgenides (+ 1912), who was resident in Constantinople in the late nineteenth century. KS

Unpublished. For necklaces of this type see: *Benaki Museum Greek Jewellery* 1999, 378, no 136 (A Delivorrias) and cf examples on 361, fig 269, 389, fig 283, 402, fig 292.

Part of a necklace with cross

Cat no. 129
19th c.
From Crete
Silver gilt, filigree, turquoise,
coral, glass gems
Necklace 50 (l) cm;
cross 10.3 (h) x 5.5 (w) cm
Inv. no. Eα470

The necklace comprises 27 biconical beads of hexagonal section, with arched sides and very fine, soldered filigree decoration. A pendent filigree cross with stylised bow, enlivened with coloured glass gems and turquoise, hangs from the necklace. From the ends of the bow, and from the arms and foot of the cross hang tiny filigree crosses.

Beads of this type, known as *botonia* or *botonakia*, were evidently used initially as buttons on sleeves, rather like cufflinks, and when fashions changed were worn strung together on a thread as necklaces. The earliest type of necklace with botonia dates from at least the second half of the sixteenth century, according to testimony in a Cretan will of 1611. Characteristically of great length, they were worn wound several times around the neck, but rarely survive in original form today because of inheritance practices (see cat no. 128). Judging by the large number of extant comparable examples – from the Dodecanese, the Cyclades, Cyprus – it seems that variations of this type of necklace, with crosses or other pendants, were worn in all the Greek islands from the eighteenth century onward.

The cross is one of the most frequently encountered ornaments in jewellery. Apart from its protective property, the symbol of the cross and the religious representations adorning Greek jewellery in general during the period of Ottoman rule are also declaratory of national identity.
KS

Published: Delivorrias 1992, 292, 331, fig 79. For a similar cross-pendant from Crete see: Delivorrias 1980, fig 29. For a parallel necklace see: *Greek Jewellery* 1997, 370, no 424 (Y Kaplani). For necklaces with botonia see: *Benaki Museum Greek Jewellery* 1999, 392–393, nos 141–142 (A Delivorrias). Cf analogous jewellery from Cyprus; *ibid,* 394, fig 286.

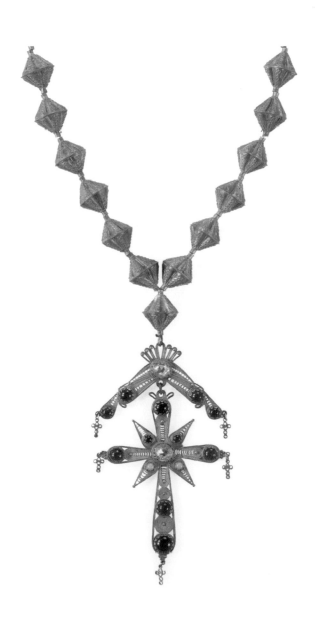

Fragments of a painted chest

Cat no. 130
18th c.
From Mytilene
Wood, egg tempera
27.5 (h) x 11.5 (w) cm
Inv. nos 8908, 8909

The two fragments come from the inner face of the lid of a painted chest. The female figures are shown in three-quarter pose, one turned right and the other left. They stand on a paved floor, at the far end of which is a low balustrade. They are luxuriously attired in long gold-brocaded dresses and overgarments, silk kerchiefs tied at the waist and elaborate headdresses. One holds a glass in her hand in a gesture of proposing a toast, the other a flower.

The two women were probably part of a larger painted composition depicting a reception on the veranda of an aristocratic villa. A mural from a mansion in Mytilene, of 1833, with a scene of noblewomen standing on the balcony of an extensive architectural complex, could

be used as a guide in the hypothetical restoration of the representation. However, some differences in the sartorial elements, as well as the exceptional miniaturist quality of the design in the Benaki Museum fragments, advocate an earlier date for the chest.

The thematic content and the style of the works are characteristic of the painting tradition of Mytilene and point toward a local artist. Dominant among the thematic preferences of this tradition are compositions featuring persons in imaginary gardens, in the countryside, in fantastical architectural complexes, august buildings or noble villas. The idealised terrestrial space is rendered with a romantic and naturalistic disposition.

Most of the few pieces of wooden furniture in the island house, primarily chests, were painted with representations in egg tempera. These are characteristic examples of secular painting, which enjoyed a heyday in the

eighteenth century when the practice of adorning the interiors of houses, especially mansions, with painted decoration began to spread throughout central and northern Greece and the eastern Aegean islands. By assimilating the artistic trends of Western Europe, as well as formats and motifs from the decorative arts of Ottoman tradition, the anonymous local painters gave painting a new dimension, thanks to their apprenticeship in Byzantine art.
KS

Published: Delivorrias 1992, 302, 347, fig 117; Rizopoulou-Egoumenidou 1996, 126 fig 117; Delivorrias, Fotopoulos 1997, 422, fig 728; Delivorrias 2003, 58, 59, fig 61. For a painted chest with analogous female figures see: Chatzimichali 1925, 170, fig 210. On the secular painting of the eighteenth and nineteenth centuries in general see: Delivorrias 1992, 300–305; Garidis 1996 (*passim*).

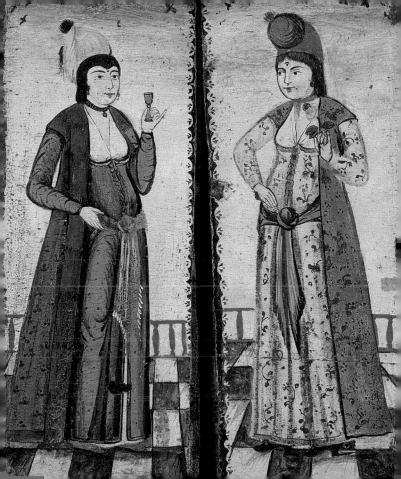

Earrings

Cat no. 131
Late 18th–early 19th c.
From Lefkada, Ionian Islands
Gold sheet, pierced-work, filigree, pearls
5 (h) cm
Inv. no. Εχρ612

The earrings consist of a schematic bow with pierced-work and soldered filigree decoration and a gondola-shaped boat with cabin. From the bow and the boat hang tassels of seed pearls. This pair and another single earring in the Benaki Museum are recorded with Lefkada as provenance. In dowry contracts and property inventories of Lefkada there are specific references to pieces of ship-shaped jewellery. In a dowry contract of 1823, for example, is recorded a 'gold galleon with pearls'. However, their stylistic affinity to the jewellery from the Aegean Islands (see cat nos 125-128) is obvious, despite the schematisation of forms, primarily of the gondola pendants, which can be justified by their later date. Identical little boats occur on another pair of earrings in a private collection, perhaps from the Cycladic island of Pholegandros, whose inhabitants originated from Candia (mod. Herakleion) on Crete.

Common technical characteristics link the earrings with a group of Cretan necklaces, providing additional indications of the common provenance of all the pieces of jewellery in the Greek islands, with Crete the most likely candidate. After the Ottomans captured Candia in 1669, the local goldsmiths seem to have joined the stream of refugees to the Ionian Islands and the Aegean Islands, transplanting their art to these places in just the same way as their coeval icon-painters. The settling of a large number of Cretan artists and intellectuals in the Ionian Islands helped stimulate the more general cultural awakening there and the flourishing of art and literature.

The ship, one of the most popular subjects in Neohellenic art, is encountered on a large number of items of jewellery from the Greek islands, denoting the Greeks' close relationship with the sea and the islanders' maritime mercantile activities.
KS

Published: Delivorrias 1992, 292, 333, fig. 87; *Greek Jewellery* 1997, 345, no 396 (K Synodinou). See identical earrings in: Chatzidakis 1957, 76, no 101/2, pl XII; Delivorrias *ibid*, 333, fig 86 (from Pholegandros).

Necklace

Cat no. 132
19th c.
From Cyprus
Silver gilt, cast, filigree, granulation, enamel
23 (l) x 8 (max. h) cm
Inv. no. Εα444

The necklace comprises twenty articulated S-shaped elements strung on a fine leather strap, a central plaque in the shape of a double-headed eagle with crown, and leaf-shaped pendants. It is decorated with granulation and enamelling. At the ends are hooks (one now lost) for affixing it to the garment at the height of the neck.

Many examples of this type of necklace, known from Cypriot descriptions of properties as *kertanes*, are preserved in museums and private collections in Cyprus and are illustrated accompanying local costumes in nineteenth-century photographs. The Benaki Museum possesses a series of analogous necklaces, some recorded as of Cypriot provenance and others as of Epirot. Their similarity is so striking that they may be considered products of the same workshop. A comparable type of ornament is encountered on Telos in the Dodecanese and in Asia Minor, while an identical necklace is an accessory of the costume of Sille at Ikonion (mod. Konya) in central Asia Minor.

Silver-working enjoyed a heyday in Cyprus from the seventeenth to the nineteenth century, with Nicosia (Lefkosia) as chief centre of production. Cypriot craftsmen traded their creations, mainly enamelled jewellery, throughout the Balkans and in the markets of the East, thus transporting their art from one place to another.

The influence of Byzantine tradition is pronounced in their decorative motifs, as are elements indicative of the island's link with the wider Ottoman domain. The similarities in technique and design between the jewellery of Cyprus and that of mainland and insular Greece, as well as of the Balkans generally, confirms the existence of a single artistic tradition – with local variations – in all these regions in which Hellenism flourished. This was the result of both ethnic unity and common historical fate.
KS

Unpublished. For parallels see: Rizopoulou-Egoumenidou 1996, 194-197, figs 179-180. For silverwork in Cyprus see: Pieridou 1980, 153-159; Papademetriou 2000, 72-75, 98-105.

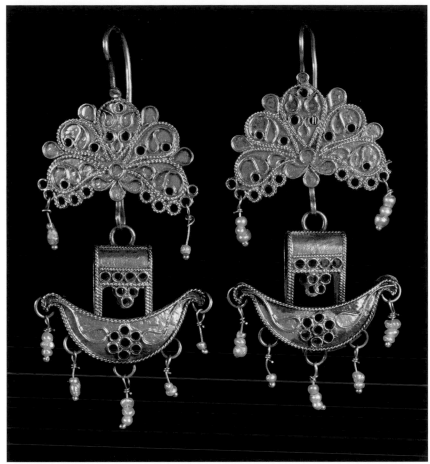

131

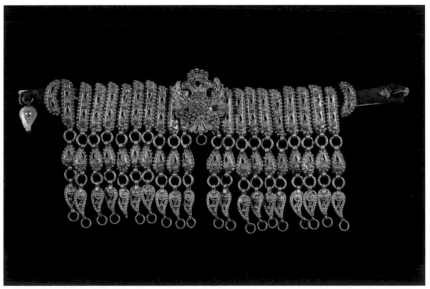

132

Belt with buckle

Cat no. 133
Late 18th–early 19th c.
From Saframpolis (Safranbolu),
Asia Minor
Silver, partly gilt, cast, filigree,
granulation, enamel, corals
Belt 91 (l) x 7 (w) cm; buckle
9 (diam) cm
Inv. no. Eα172

The belt is made up of cast, articulated, oblong plaques with granulation, passed onto a leather strap and giving an imbricated appearance. At the terminals of the belt is an impressive buckle formed of two semicircular plaques followed by disc-shaped sections and a central device, like a schematic rosette, which masks the hook-and-eye fastening. The appliqué decoration on the buckle is composed of filigree vegetal motifs picked out with green enamel, attached rosettes and ribbed, almond-shaped corals.

The characteristic decoration with the profusion of ribbed coral is typical of a large group of jewellery considered to originate from Saframpolis in Asia Minor. This attribution is based exclusively on oral tradition, and has yet to be documented by written evidence. Nevertheless, its production could be correlated with the flourishing silver mines at neighbouring Argyroupolis in the Pontos region, as well as with the relative economic affluence of the Greek communities in the areas around Trebizond, until 1922, when the Greek population was forced to abandon the lands that had been their home since antiquity.

The fact that many items of jewellery with the same stylistic unity were deposited in the Benaki Museum, together with the heirlooms brought by the Greek refugees, advocates their provenance in Asia Minor. One of these treasures is a comparable buckle, more complex but lacking the belt, which is confirmed as coming from the community of Kermira in the region of Caesarea. The date 1837, incised numerically on the back of the buckle, rebuts views on the Ottoman origin of these pieces of jewellery.

The presence and use of the belt and buckle as accessories of the Greek costume are continuous from antiquity to this day. In addition to serving needs both practical and decorative, they have symbolic–magical connotations and in more recent times are linked with customs associated with marriage and childbirth. KS

Unpublished. For the origin of this type of jewellery from Saframpolis and their dating see: *Benaki Museum Greek Jewellery* 1999, 472–475, no 166 (A Delivorrias).

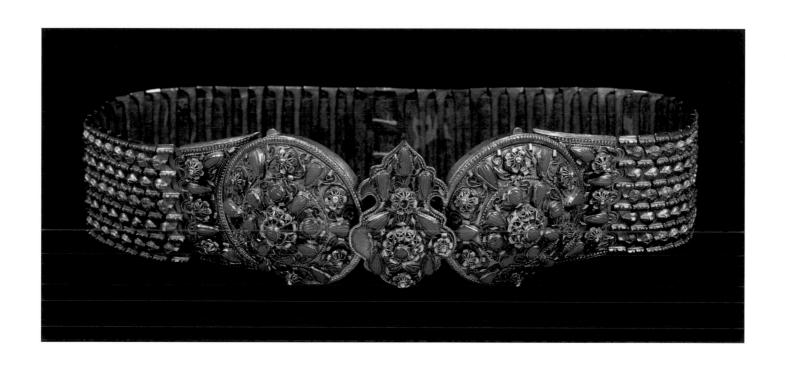

Pectoral ornament with chains

Cat no. 134
Second quarter 19th c.
From Saframpolis (Safranbolu),
Asia Minor
Silver, gilt details, filigree,
corals, glass gems, coins
50 (l) cm
Inv. no. Eα949

The ornament comprises six silver chains of differing length, held together by two large gilded plaques, with appliqué filigree vegetal patterns and attached rosettes at the centre, embellished with gold and red glass-paste gems. The decoration is highlighted by large, ribbed, almond-shaped corals and small, glistening polyhedral metal studs. From the plaques hang coral tassels, and from the four longer chains hang silver Ottoman florins with *tuğra* (sultan's monograms), ranging in date between AH 1143 and 1233 (1730–1817).

The chain pectoral is associated morphologically with analogous pieces of jewellery from mainland Greece (see cat no. 135). In general, however, the unity of jewellery of Saframpolis – which preserves the total of individual elements of the female parure – despite its stylistic singularity and distinct aesthetic personality, recomposes a system of adornment common in all families of Neohellenic jewellery, deriving from the same basic components and the same formal characteristics.

Judging by the range of distribution of these pieces in the Balkans, the jewellery of Saframpolis must have been worn widely during the eighteenth and nineteenth centuries. After the mid-nineteenth century it began to be replaced by presumably European creations and by around 1900 had ceased to be worn in urban areas, as is deduced from the absence of such pieces in photographs of that time.

The pectoral cannot be dated much later than the mid-nineteenth century, when the gradual ousting of Safranbolu jewellery commenced, with the invasion of European fashion, while the pendent Ottoman coins provide the year 1817 as the earliest date for the piece. The fact that most of the coins are dated to about this period suggests that they belonged to the ready cash of the person who ordered the pectoral and supplied the coins – possibly as a means of saving – to be used as ornaments.
KS

Published: Delivorrias 1980, 53, fig 89. See examples from the unity of jewellery from Saframpolis in: *Benaki Museum Greek Jewellery* 1999, 365, fig 271, 477–479, figs 341–343.

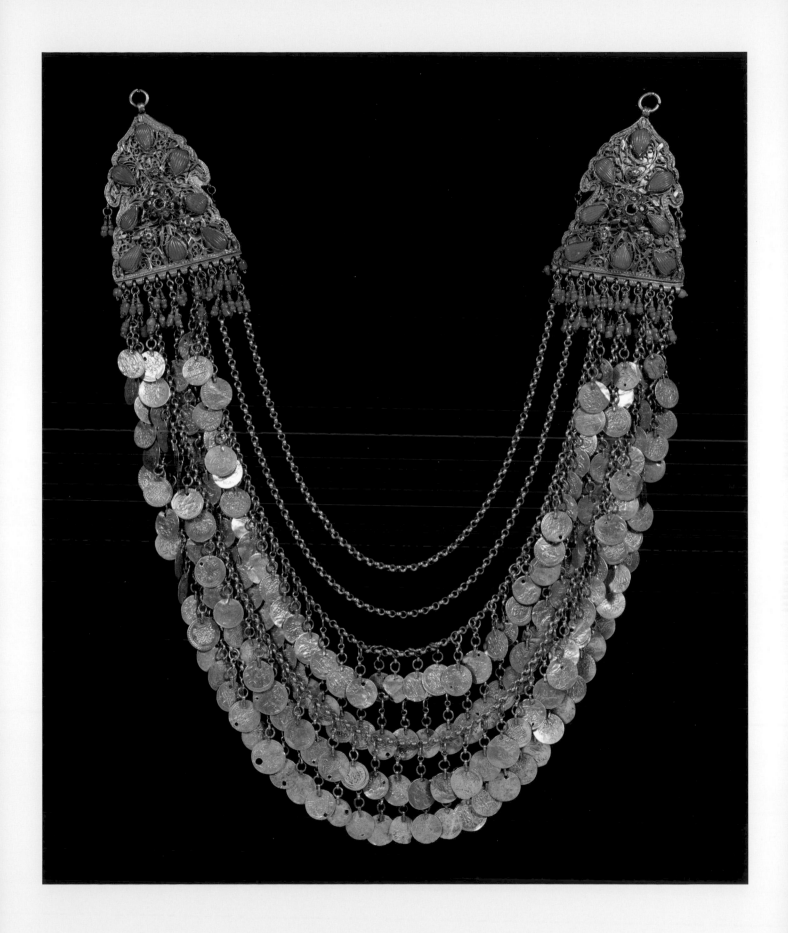

Pectoral ornament with chains

Cat no. 135
Second half 19th c.
From Attica
Silver gilt, cast details, filigree,
repoussé, turquoise, glass gems
55 (l) cm
Inv. no. Eα982

The ornament is composed of seven successive silver chains of differing length, held in place by two triangular gilded plaques each with an apotropaic head at their apex, which ends in a hook. The plaques bear a repoussé representation of a double-headed eagle with crown. In the middle of each chain is a gilt filigree pendant – in the form of a rosette on the first three and the last two, ovoid on the fourth and lozenge-shaped on the fifth – decorated with scrolls and lozenges, inset glass-paste gems in various colours and shapes, and pendent leaf-shaped strips below. The rosettes on the first two chains are set with a turquoise at the centre. The ornament was hooked onto the garment at the height of the shoulders, so that the lowest rosettes covered the belt, reaching several centimetres below the waist.

The filigree pendants of the pectoral are made by mould-casting, a technique which gradually replaced the toilsome craftsmanship of working filigree ornaments by hand with very fine wire, as in the older jewellery of the islands (see cat nos 126-129). The use of the mould, which facilitated mass production in answer to the ever-increasing demand, became more generalised from the mid-nineteenth century onwards, both on the mainland and in the islands.

This type of pectoral ornament, known as *kordoni*, was an accessory of the bridal costume of the villages of Attica and the rural population of Athens (see cat no. 142). According to foreign travellers' accounts and other written sources, the kordoni as accessory of the bridal costume seems to have appeared in the early decades of the nineteenth century. The size and value of the kordoni bore witness to the economic standing and social status of the bride and of the groom, whose gift it was to her. The relatives filled the chains of the ornament with coins, which made up the greater part of the bride's dowry, as is attested by dowry contracts which specified the precise value of each coin. In the years after the Greek War of Independence, however, when money began to be used in a more productive manner, real coins were replaced by imitations or by rosettes, as in this instance. It can be seen from early photographs that this particular type of pectoral ornament with rosettes was already fully developed in 1878 and coexisted with a mixed type in which the rosettes were combined with coins. On the basis of its morphological features, the Benaki Museum kordoni can be dated to the third quarter of the nineteenth century. EG

Unpublished. For similar pectoral ornaments with chains from Attica see: *Greek Jewellery* 1997, 335, no 386 (K Synodinou); Kaplani 1997, 19, 40, fig on p 76 (left); *Benaki Museum Greek Jewellery* 1999, 367, fig 272 and 495–498, no 172 (E Georgoula), with extensive earlier bibliography.

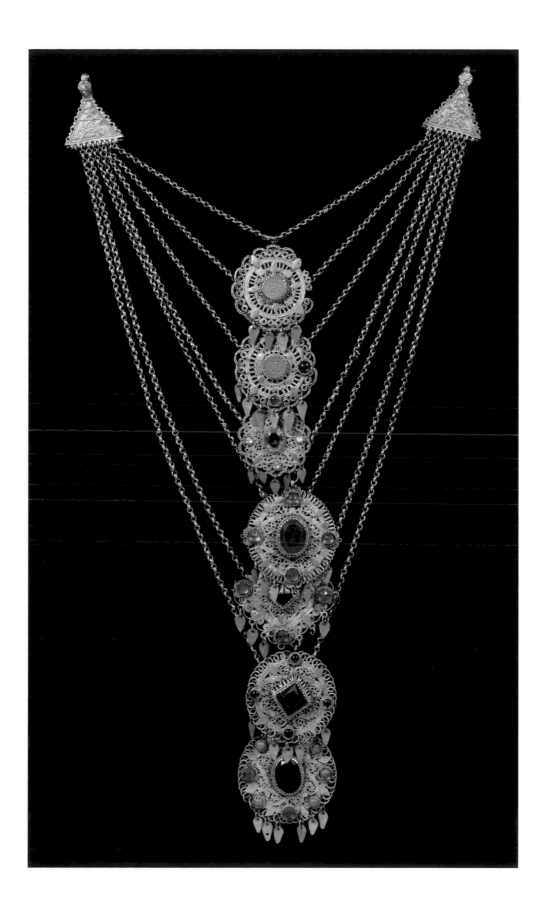

Necklace

Cat no. 136
Second half 19th c.
From Attica
Silver gilt, cast details, filigree,
glass gems
Necklace: 27.5 (l) x 4.5 (h) cm;
cross 6.3 (h) x 4.5 (w) cm
Inv. no. Eα1098

The necklace comprises a row
of eleven filigree elements, affixed
to a strip of silk, which terminate
above in a ten-petalled semi-
circular flower. From the central
element hangs a filigree cross.
The decoration of scrolls and
lozenges is complemented by
inset glass-paste gems in diverse
colours and shapes, and pendent
imitations of Ottoman florins.

This type of ornament, known
as *yordani*, belongs to a class of
necklaces which prevailed in
Attica and the whole of central
Greece, and which are worked
in various versions of filigree
technique. They were worn

at the height of the neck and
hooked onto the collar of the
garment.

As is evident from several other
examples, the coin was a basic
component of Neohellenic
jewellery. The use of coins in
jewellery can be traced back to
Roman times (see cat no. 54).
During the Byzantine period
coins were worn as amulets, the
commonest of which are known
to this day as *constantinata* (coins
of Constantine). In the years of
the Ottoman occupation, the
magical and metaphysical aspects
of the habit were transformed
into expediency, since coins
were an easy means of saving,
protecting and transporting
property in times of compulsory
migration due to Turkish
persecutions. After the liberation
of Greece, the use of coins in
jewellery continued, despite the
fact that they no longer served
the same need, assuming the
character of conspicuous display

of wealth and economic
robustness, to be transformed
gradually into simple decorative
practice with the substitution
of real coins by false ones.

Filigree jewellery enjoyed wide
distribution in Attica, an
important production centre in
mainland Greece. Characterised
by a common stylistic and
aesthetic conception, these are
among the few jewellery
ensembles whose geographical
provenance can be verified.
Together with the jewellery of
Saframpolis (see cat nos 133,
134) they constitute the two sole
stylistic unities which preserve
the totality of individual elements
of the female parure. KS

Unpublished. See examples of the
family of Attica jewellery in:
Delivorrias, Fotopoulos 1997, 476–
478, figs 839–841 and 842; *Benaki
Museum Greek Jewellery* 1999, 367,
fig 272.

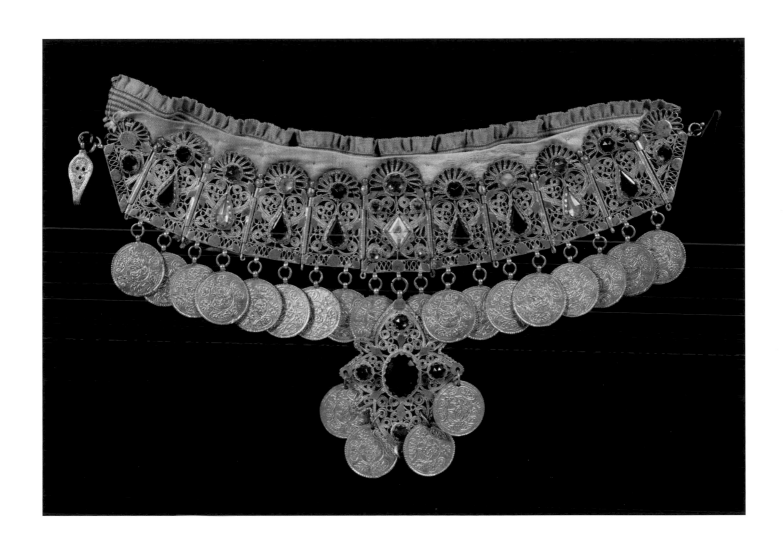

Neckband and earrings with pendent chains

Cat nos 137, 138
Second quarter 18th c.
From Epirus
Silver, cast and gilt details, turquoise, glass gems
Neckband: 21.5 (l) (34 with chain) x 10 (h) cm; earrings 19 (h) cm
Inv. nos. Eα747, Eα576

The neckband and the earrings, which originated from Epirus, were not acquired together, as is evident from their inventory numbers, but are presented here as a set because they undoubtedly belong to the same family of jewellery.

Both consist of a row of interdependent articulated and repeated cast elements, and dangling chain pendants. Small rectangular plaques, set at the centre with glass-paste gems and turquoise, and crowned by schematic double-headed eagles, are joined by hinge-pins terminating in schematic cherubim with open wings.

The plaques hold in place a chain of pendants with globules and tiny rosettes between the links, ending in pierced-work foliate finials. The two hooks with the chains hanging from the terminals of the neckband were used for affixing it to the garment at the level of the neck.

All the individual repeated elements of these ornaments were mould-cast, which facilitated their mass production, resulting in the diffusion and longevity of the particular types. The uniformity of the cast elements is counterbalanced by the finishing of the details by hand with a fine chisel, while partial gilding of certain components enlivens the overall impression of colour.

Double-headed eagles and cherubim alternate in the decoration of the items. The double-headed eagle is a ubiquitous motif in Neohellenic jewellery. Symbol of the lost Byzantine Empire and of the resurrection of the Greek nation, even when conventionalised as a simple decorative motif, it embodies a deep belief in its apotropaic power and conscious references to the illustrious past and the vision of liberty. The symmetrical presence of cherubim, encountered only on Epirot jewellery, strengthens the protective character of the pieces.

The ensemble with the extremely long earrings emanates an imperial majesty. As mentioned with reference to the long earrings (cat no. 126), they were fastened to the headdress at the height of the ears and always worn together with a frontlet, forming an integrated system of adornment of the head with incontrovertible Byzantine roots. KS

Unpublished. For parallel examples of earrings and neckbands see: Hatzimichali 1984, 163, fig 171; *Benaki Museum Greek Jewellery* 1999, 450–455, nos 160 and 161 (A Delivorrias).

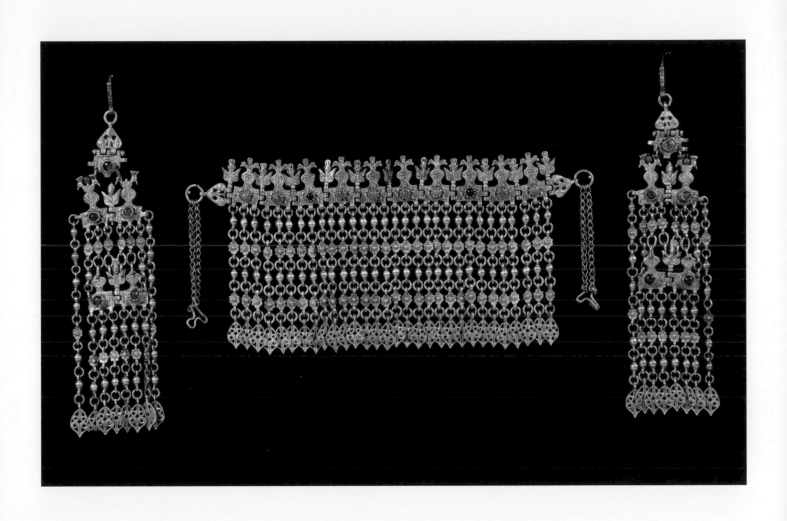

Belt buckle

Cat no. 139
Mid-18th c.
From Epirus
Silver gilt, cast details, chased,
hammered, pierced-work,
agates, niello
13 (h) x 26 (w) cm
Inv. no. Eα1374

The impressively large buckle is distinguished by the variety of materials and the diversity of techniques employed. The two rectangular, slightly concave side-pieces, with pointed ends, are adorned with hammered and locally pierced-work floral designs around a cast boss-shaped rosette. On the band bordering the side-pieces are chased and niello lozenges and the typical Neohellenic motif of the flowerpot, from which sprout symmetrically wavy stems with tulips. A small oblong plaque with projecting pointed ends, placed vertically at the centre to mask the hook of the fastening, is embellished with four soldered boss-shaped rosettes and six large agates in pairs.

Niello (savati) was one of the most widespread techniques used in decorating Neohellenic jewellery, executed in accordance with the traditional Byzantine technique by melting silver, copper, lead and sulphurous wax, and with this mixture filling the design incised on the surface of the metal. Niello was used mainly on pieces of silver jewellery, sometimes as the sole means of executing the decoration and sometimes in combination with other techniques for the painterly rendering of decorative details, as on this particular buckle.

Buckles and belts, as accessories of the costume, worn every day and subject to wear and tear, are by far the most numerous items of jewellery produced. The remarkably wide variety of designs often makes it impossible to classify them according to distinctive stylistic features and attribute them to a specific family of jewellery. Despite the absence of evidence on the provenance of the present buckle, the pronounced Baroque air of its decoration and the large agates associate it with the family of jewellery from Epirus. Moreover, the subject of the tulip, which from Ottoman art passed initially into Post-Byzantine ecclesiastical embroideries and silk textiles, and later into secular silverwork and embroidery, occurs particularly frequently in Epirus, in jewellery and, primarily, household embroideries.

Buckles of analogous shape, framed by a band, with decoration picked out in niello and tulips and rinceaux as predominant motifs, are encountered in neighbouring Serbia. The boss-shaped rosette, conspicuous among the decorative subjects of the buckle, is characteristic of a large number of pieces of jewellery primarily in mainland Greece, Serbia and Bulgaria, bearing witness to the common artistic tradition of the Balkan Peninsula and at the same time confirming the movement of itinerant goldsmiths to different regions during the Ottoman period.

The buckle would have been attached to a cloth belt and, judging by its opulence, would have belonged to a formal costume. EG

Published: Zora 1994, 238, no 160, fig on p 147; Delivorrias, Fotopoulos 1997, 487, fig 864; *Benaki Museum Greek Jewellery* 1999, 456–460, no 162 (E Georgoula) with earlier bibliography. For an analogous buckle from Macedonia see: *Greek Jewellery* 1997, 278, no 327 (Y Kaplani).

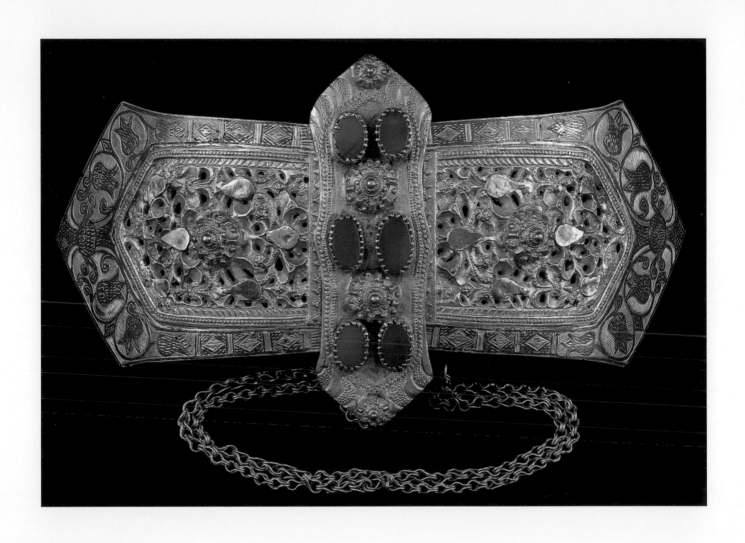

Pectoral ornament with chains

Cat no. 140
19th c.
From Thessaly
Silver, cast and gilt details,
filigree, glass gems
55 x 55 cm
Gift of Dorothea L Mela (Eα 1834)

The pectoral ornament comprises groups of silver chains forming a large intact cross and interconnected by five gilt plaques – a large one in the shape of a Maltese cross at the centre and four smaller triangular ones at the terminals – with multi-petalled filigree rosettes riveted to them. The lavish filigree scroll decoration is combined with soldered cast globules and lozenges, and embellished with inset coloured glass gems. A double-headed eagle with crown masks the hook at the apex of each triangular plaque. The ornament was worn in an X-shaped arrangement, covering the entire chest.

It belongs to a peculiar class of Greek jewellery items known as *kioustekia*, which are the only ones worn by both women and men, mainly by the females of the Sarakatsani, transhumant pastoralists of Greek origin, the Karagounides, autochthonous agriculturalists of the Thessalian plain, and the chieftains of the Greek War of Independence in Epirus and Missolonghi.

Kioustekia, heavy, composite pieces of jewellery articulated from groups of silver chains and connecting plaques worked in virtually all the techniques, are distinguished into various types, depending on the shape and the way in which they were worn on the chest or the waist. The crossed kioustekia on the chest, like this particular example, were attributed with protective properties, often reinforced by the presence of religious represent- ations on the central plaque. KS

Unpublished. For similar ornaments see: Hatzimichali 1979, 337, fig 355; Delivorrias 1980, 37, fig 50; Zora 1994, 28, 166, fig 192, 243, no 192.

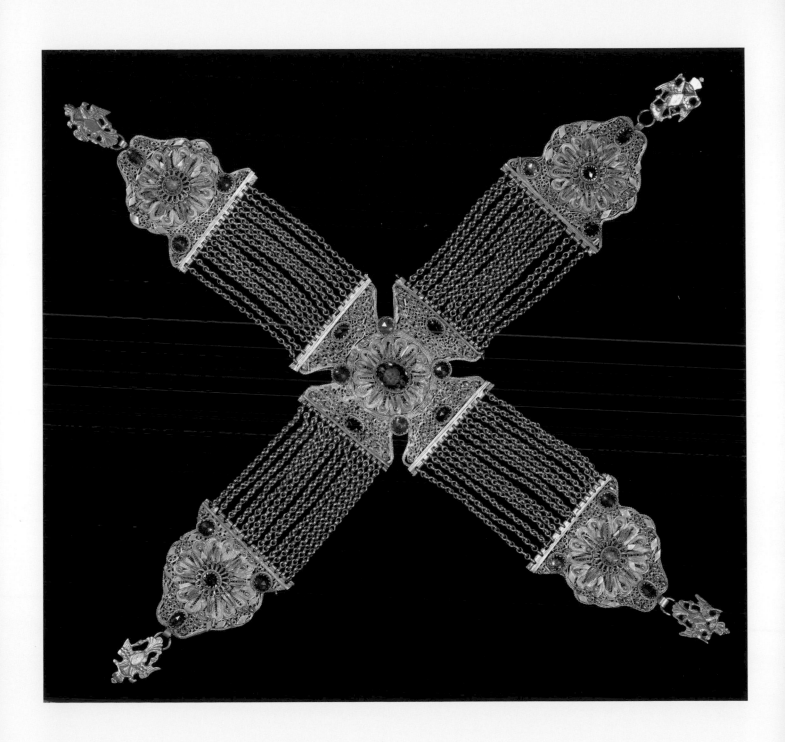

Bridal costume of Astypalaia

Cat no. 141
18th–19th c.
From Astypalaia, the Dodecanese
Ensemble of 11 pieces (garments,
accessories and jewellery)
Gift of the family of King
Constantine I of the Hellenes
(costume no. 156)

The bridal costume of the island
of Astypalaia, an amalgam of
Byzantine and Renaissance
influences, impresses by the
wealth of its embroideries, the
luxury of its materials and its
imposing appearance.

The green silk-satin dress of
Western type, with straps, folds
at the waist and a large pleat
on the skirt, shows off the lavish
embroideries on the wide sleeves
and the hem of the cotton
chemise worn beneath. This type
of dress with Renaissance traits
bears the indelible stamp of the
Venetians, who ruled the island
as part of the Duchy of Naxos
from 1207 until 1537.

On the brightly coloured
embroidery of the hem, ships
with human figures alternate
with animals – perhaps camels –
with imaginative inventiveness,
while in the trichrome
embroidery on the sleeves,

vegetal motifs of geometric
conception are repeated. Each
of the embroideries, of different
style and colouration, has its own
aesthetic substance, which is
incorporated in the exuberant
whole. The needlework has
the dense texture distinctive
of Dodecanesian embroidery
in general.

The headdress, deriving from
a diadem, with its long silk
veils and cap of crimson velvet
encrusted with pearls and
embroidered with gold wire,
in Byzantine technique,
emanates a sense of imperial
majesty. Pearl-studded pins
hold the veils in place and
gold hoops with gold beads
and pearls adorn the ears.

A host of ornaments – silver
breloques sewn to the back
of the dress, silver belts with
pendants such as mermaids,
little fish and so on, as well
as artificial flowers (now lost) –
completed the costume.
The red hose and the velvet
slippers are gold-embroidered.

Sources of the textiles were
Constantinople, Smyrna,
Alexandria, as well as the
surrounding islands, given that
Astypalaia was a port of call on

the sea route between Cyprus,
Rhodes, Kos and the rest of
Greece, as well as an important
node of commerce linking
West and East.

Of particular importance for the
study of the evolution of Greek
costumes are the testimonies of
foreign travellers, who from the
mid-sixteenth century also
recorded their impressions in
drawings. In contrast to the other
islands in the Archipelago, there
are only scant testimonies for the
costume of Astypalaia, since the
island does not seem to have
been included in the itineraries
that travellers usually followed.
The costume was first studied
in the early 1930s, at which time
abundant material still existed,
by Marica Monte Santo.
Authorised by the Italian
Ministry of Colonies, she
undertook, as part of the series
of studies on the colonies, to tour
the Dodecanese, which were then
under Italian rule (1912-1948),
and to record her impressions.

The costume of Astypalaia is one
of the sartorial ensembles that
survived until the early twentieth
century. The example in the
Benaki Museum was donated in
1938 by the family of King

Constantine I of the Hellenes
(1913-1917, 1920-1922).
According to the testimony
of the donors, it had been
purchased by his wife Queen
Sophia (1870-1932), presumably
as a collector's item, in the late
nineteenth century, which piece
of information is a clue to its age.
Despite the later components,
which undoubtedly prevailed
gradually with the reorientations
of fashion, the form in which the
costume was presented refers to
formats of earlier periods, the
roots of which are to be found
in the Byzantine East and the
Renaissance West. KS

Published: *Cosmèsis* 1984, 50, no 16,
fig on p 51. For the costume of
Astypalaia see: Montesanto (nd),
27–41; Tarsouli 1948, 329–332;
Hadzimichali 1954, 66, pl 80; Zaïri
2001, 53–76. For local costumes
in the Aegean in general see:
Papantoniou 1983-85, 29–44;
Delivorrias 1992, 284–288 and
cf 326, fig 69.

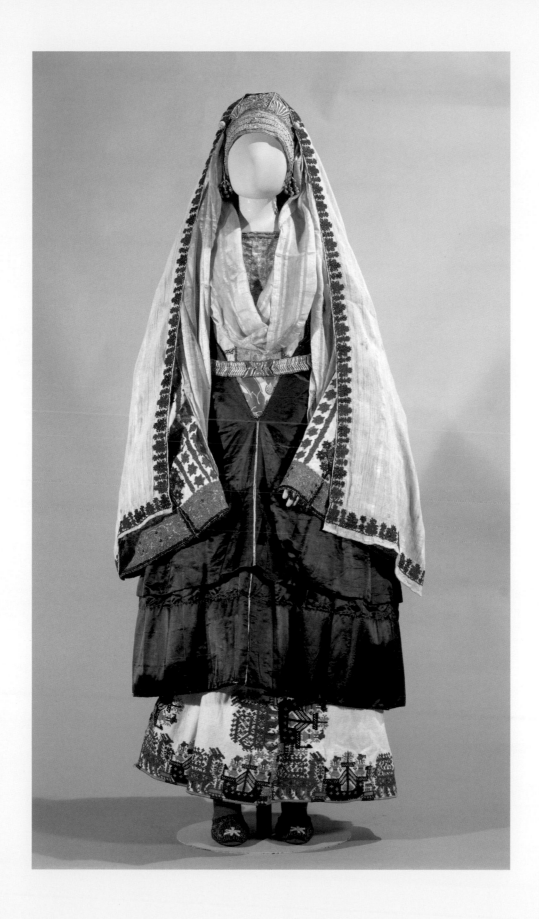

Bridal costume of Attica

Cat no. 142
Second half 19th c.
From Attica
Ensemble of 13 pieces
(garments, accessories
and jewellery)
Costume no. 21

The bridal costume of Attica is one of the richest and most representative in Greece. It belongs to a large family of female costumes, interrelated in cut and function, which hark back to a common ancestor widespread through the Balkans from Byzantine times.

The most characteristic garment in the costume is the long, sleeveless chemise with dense embroidery around the hem, often over 70 cm deep but varying according to the wearer's economic standing. Executed by professional embroiderers, in brightly coloured silk threads, with shades of red predominant, it gives the impression of a Byzantine mosaic created from polychrome tesserae. The decoration, arranged in zones, includes the same traditionally established patterns, with minor variations, formed from squares, triangles, tangential lozenges, meanders, vase motifs and so on.

Other typical garments are the small, tight-fitting cotton bodice with gold-embroidered sleeves and two sleeveless mantles, worn one over the other – the inner is longer – made of white woollen cloth and edged with bands of red felt. The mantles, gifts of the bridegroom to his betrothed, were woven and embroidered with gold cord by expert Athenian tailors.

The gossamer-silk veil draped around the head is edged with lace and fringes of gold thread. The opulence of the costume is heightened by the parure of gilded jewellery, with the pins for headdress and the frontlet, the necklace and the pectoral ornament of chains, the bracelets and the belt with buckle. These are wrought in filigree technique, enlivened with inlaid coloured glass-paste gems, cameos with miniatures and pendent imitation gold coins, consistent with the distinctive style and aesthetics of Attic jewellery (see also cat nos 135, 136). Down the back hangs an impressive ornament of red cord with silver plaques, pendent metal strips and tassels of silk threads, which is plaited into the hair.

This type of bridal costume was worn in all the villages of Attica by girls of the second social class. The more affluent brides wore the 'golden costume', on which the needlework on the hem of the chemise was executed in gold thread. The costumes of Attica reflect the social status and the economic standing of the bridegroom, whose gifts were all the gold jewellery and the ornaments, as well as that of the family of the bride, who in earlier times as part of her dowry hung actual gold coins on her jewellery.

The costumes of Attica are among the best known, since they attracted the attention of European travellers from early on. Among the earliest testimonies on the costume are a written account by R Chandler in 1764, and a gouache painting by J B Hilaire depicting a scene of an Athenian wedding in 1776. The costume was illustrated subsequently in album-publications by J Salomon Bartholdy, O M von Stackelberg, L Dupré, E Dodwell and others who visited Greece in the first two decades of the nineteenth century. It was still worn in Attic villages in the early twentieth century, as noted by the Greek folklore scholar Angeliki Hadjimichali for Marousi, in 1906, and the American traveller P S Marsden for Menidi, in 1907. The costume of Attica was the inspiration for the formal dress at the court of King George I of the Hellenes (1863-1913), which was established by Queen Olga (1851-1926) shortly after their marriage in 1867. KS

Unpublished. For the costume of Attica see: Hatzimichali 1979, 26–71, and for the formal dress of the court of King George I, 73–75; Weale-Badieritaki 1980, 90–94; Welters 1986 (passim); Bada-Tsomokou 1983 (passim). For the Athenian dress at the end of the 19th century see: Fotopoulos 1999 (passim).

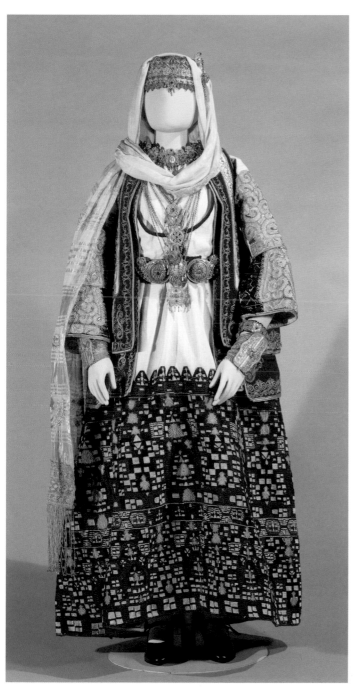
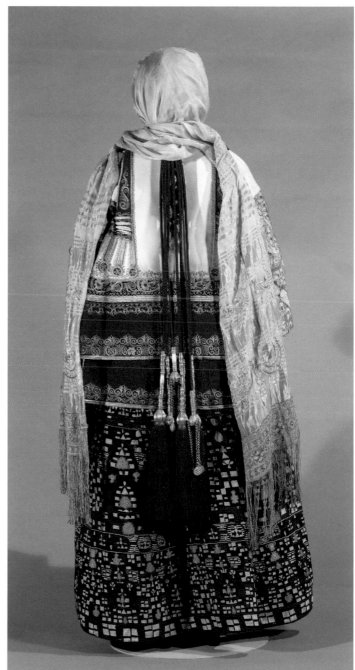

Bridal costume of Skopelos

Cat no. 143
19th c.
From Skopelos, Sporades
Ensemble of 8 pieces (garments, accessories and jewellery)
Gift of the Greek National Tourism Organization (costume no. 226)

The bridal costume of the island of Skopelos, one of the most spectacular and singular in Greece, is strongly influenced by Western European fashion.

Principal garment is the voluminous, pleated, sleeveless dress, which has no parallel in any other Greek costume. Made from 16 metres of black silk-satin, it stands like a bell, thanks to the many petticoats and a kind of crinoline – a stiff calico skirt with two straps and metal struts to hold out the dress. There is no doubt that this garment imitates European fashion of the eighteenth and nineteenth century, when richly voluminous dresses were much in vogue. Here the waist has been abolished entirely, however,

in contrast to European clothes where the waist was tightly cinched. The deep zone of embroidery on the hem, which features flowerpots from which sprout roses and leafy branches, executed in vividly coloured silk threads, has pronounced Rococo influences.

The, short, close-fitting, gold-embroidered bodice is of crimson velvet, the characteristic colour of the bridal costume, and is kept in place by a dickey (a kind of bib) in gold needlework. The bodice reveals the sleeves of the white silk chemise, embellished with gold lace and gold needlework. The slippers on the feet are gold embroidered too, frequently with the same motif as on the bodice. According to custom, after the wedding the dance of the *kontoura* (slipper) was performed, a circular dance with sedate movements, so that the bride's footwear did not slip off.

The white tulle kerchief, which forms a kind of canopy on the head, leaves visible the mesh of twisted black silk threads

imitating curled hair, and the decorative gold cords with sequins and pearls. Depending on the economic standing of the bride, her head and chest were adorned with jewellery.

The costume of Skopelos is associated also with the now-lost 'white costumes' of the Cyclades, known from drawings by eighteenth-century travellers. It belongs to the wider family of island female costumes with Western-type dress, as does the example from Astypalaia (cat no. 141). Most of the accessories of the bridal costume of Skopelos reveal influences from the fashion of Western Europe and it seems that some were brought from abroad by sailors from the island – in fact, some have Hellenised names of foreign provenance.

The costume appears to have acquired its final form in the eighteenth century, a period in which seafarers from Skopelos voyaged abroad and brought back from Western Europe and the Black Sea current fashions and textiles. From Taganrog in

southern Russia, where they went to work mainly as shipwrights, they brought black 'atlas' satin with woven coloured patterns, which the women of Skopelos pleated to make the bridal dress. Later, from the mid-nineteenth century, they began to copy the design and to embroider it with silk threads on the black cloth.

For all its impressive aspect, the costume does not enhance the wearer's femininity. This is true of Greek costumes in general, which do not enhance the beauty of the female figure but make an impact through their bold colours, their numerous ornaments and the imaginative manner in which their diverse accessories are worn and combined. KS

Published: *Cosmèsis* 1984, 62, no 58, fig on p 137. For the costume of Skopelos see: Sampson 1979, 95–123; Delivorrias 1992, 284–288, 325, fig 63; Papantoniou 1996, 140, pl on pp 40–41.

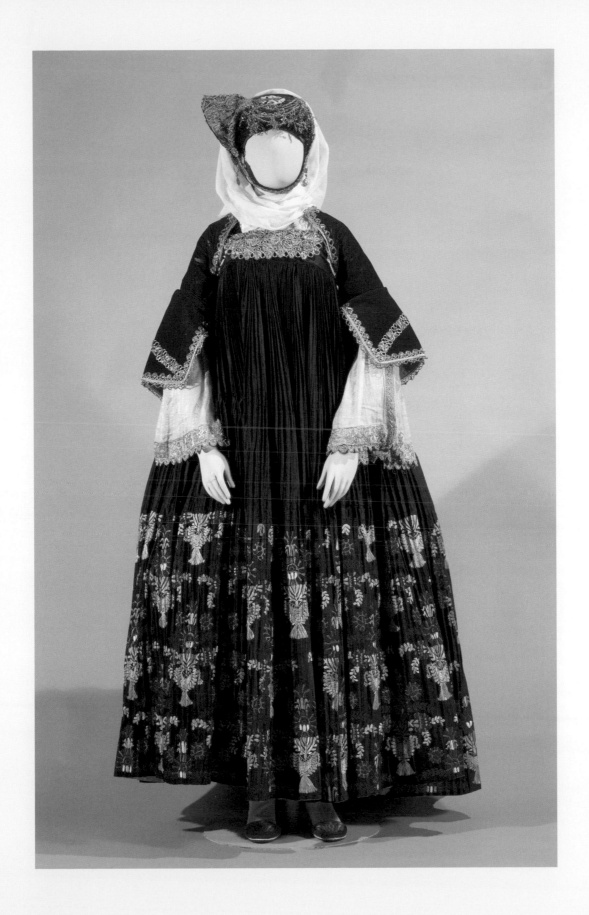

Front panel of a chest

Cat no. 144
18th c.
From the Peloponnese
Wood, of a conifer, perhaps
cypress, carved
39 (h) x 129 (l) cm
Gift of Helen Stathatos (21777)

The basic thematic nuclei of the representations appear in the midst of dense compositions of actual and fantastic vegetal and floral motifs. In the middle of the panel is an axially placed roundel with a double-headed eagle, crowned by two confronted birds. Dominating the left part is a heraldic complex of two lions rampant, with two likewise rearing confronted snakes behind the back of one and a flower-vase below them. Depicted on the right is an imaginary hunt, with a large male figure at the centre brandishing his sword, between a companion on a much smaller scale and a cypress tree with bird perched atop. A lion rampant at the same level and a hound below, chasing a hare, next to a flower-vase, complete the scene.

The symbolism of the ideas developed in the representation enhances the nuptial – bridal destination of the work. The heraldic complex of lions alludes to the custodians of the 'tree of life', while the reduced scale of the flower-vase complements conceptually the encoded message of the animal force they embody. The discreet presence of the birds guarantees the successful outcome of the subject's generative wish. The protective significance of the double-headed eagle is reinforced by the presence of the snake, guardian of the house. The implicit symbolism is completed by the scene of the hero-hunter, imposing in splendid garb amid the constituents of the narrative field, leaving no doubt as to the successful outcome of his contest with the animal force. His heroic dimension, in conjunction with the fertility symbolism of the other compositions, undoubtedly embodies the dream image of virility which girls must have created for their future spouse.

Although the thematic fields of the representation suffocate within a satiation of densely-packed filling elements, the structure of the composition is not marred. The decorative compositions are freely rendered with inventiveness and imagination, opposing the principles of symmetrical correspondence. The narrative flow of the representations does not follow the established direction of left to right, but begins from the right side, with the idealised figure of the groom, and culminates on the left side with the promises of fecundity for the future couple.

Chests were the essential – if not the sole – items of furniture in every traditional house and were used mainly for keeping household linen and clothes, and jewellery. Particularly well-made chests, like this example, were intended to hold the precious embroideries of the dowry.

Post-Byzantine woodcarving is known mainly from surviving monumental ecclesiastical creations, such as the superb iconostases (screens separating the sanctuary from the nave) in Orthodox churches. The secular output, without being represented by monumental works, also boasts spectacular creations, such as the carved, panelled (*boiserie*) interiors of eighteenth-century mansions, frequently gilded and painted.

The flourishing economy in the eighteenth century, due to the growth of Greek trade in response to favourable international circumstances, led to the creation of important centres of woodcarving, particularly in central and northern Greece (Epirus, western Macedonia, Thrace, Thessaly), but also in the Peloponnese and the Aegean Islands. Greek craftsmen were in great demand throughout the Balkans and in Asia Minor. Woodcarvers, like stonecarvers, were itinerant, and very often organised in guilds, who carried the same techniques and the same aesthetic canons everywhere within their ambit, with the result that their art displays a stylistic uniformity. KS

Published: Delivorrias, Fotopoulos 1997, 418, figs 714, 718; Delivorrias 2001, 115–116, fig 7.

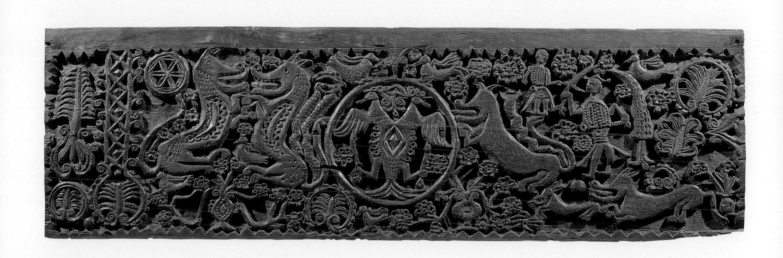

NEOHELLENIC PERIOD
19TH CENTURY

REORIENTATIONS AND CONFLICTS: INTELLECTUAL AWAKENING AND THE STRUGGLE FOR THE FORMATION OF THE GREEK NATION

Dimitris Arvanitakis

The Greeks' ten-year struggle for independence (1821-1830) commenced in the Danubian principalities early in 1821. Both the location of the outbreak and the agents of the movement are linked directly to the ideological context and the socio-economic causalities of the event.

The ideological underpinnings can be sought in the particular fomentations that had preceded the struggle, both in Greek lands and in lands which hosted the Greek diaspora. The tradition of Greek regions in insurrection in the long centuries of Ottoman domination began to acquire specific forms, greater mass participation and different demands during the eighteenth century. Contributory factors to this process were the two Russo-Turkish wars (1768-1774 and 1788-1792), in which Greek populations were implicated directly, since the theatre of hostilities encompassed Greek areas – the Peloponnese (popular uprising in the Orloff Incident) and the Greek seas ('buccaneering' activity of Lambros Katsonis) respectively. During the second half of the eighteenth century, the 'Eastern Policy' inaugurated by Peter the Great and continued by Catherine II acquired flesh and bones.

Of inestimable significance in forming ideology were, on the one hand, the French Revolution and its whole ideological armoury and, on the other, the presence of French revolutionaries in the Ionian Islands (1797-1799). The principle of nationality, which Napoleon's propaganda had artfully promoted, equipped the Greeks with a new ideological tool for effecting the transition from 'race' (*genos*) to 'nation' (*ethnos*) – basic component of the national consciousness being created at that time – and also convinced many that France would take an essential interest in the future of the subject Greeks.

The movement of the Neohellenic Enlightenment (1750-1821), particularly in its final and most radical phase (1800-1821), played its part in inculcating these new conceptions. The role of this movement, which has its beginnings in British thinking but which put down substantial roots in French vision of the eighteenth century, was decisive. The freethinking of Voltaire, the philosophy and practice of the Encyclopaedists, the movement of the Ideologues, but above all the French Revolution, had a catalytic influence on Greek men of letters, first and foremost those domiciled abroad.

Greek society in the eighteenth century was distinguished by a challenging of the doctrinal interpretations of the Church and a negation of traditional ideological structures, as well as by the linking of education with the prospect of national liberation, in order to create a state

founded on civil equality and democratic rights. These were characteristics of a current in Neohellenic thinking which may also explain the oppositions and conflicts that accompanied the phenomena of both the Neohellenic Enlightenment and the Greek Revolution.

The thinking of Adamantios Korais (1748-1833) and Rigas Velestinlis or Pherraios (*c*. 1757-1798) is indicative of the ways in which the French example was perceived and adapted to the needs of the Greeks. The great philologist and visionary Korais, resident in Paris from 1788, focused his efforts on compiling a corpus of Greek Letters and contributed decisively to the organisation of education, with the dream of national renaissance always uppermost in his mind. The more radical Rigas Velestinlis promoted the plan of revolutionary social change. Influenced by the French Constitution of 1793, he drafted the constitutional charter of the envisioned 'Balkan Federation': the *New Political Constitution of the Inhabitants of Roumeli, Asia Minor, the Islands of the Aegean and the Principalities of Moldavia and Wallachia* (1797). The new world foreseen by Rigas would have incorporated all the inhabitants of the Balkans, including Turks, while obviously keeping a privileged position for the Greeks in the future 'pluralistic' Balkan democracy. Rigas' plans did not have a fortunate end –

he was arrested by the Austrians, who handed him over to the Turks, and was executed in June 1798 – but the essence of his thinking passed into the ideology of the *Philiki Etaireia* (Friendly Society) and the strategy of Alexander Ypsilantis.

The development of the Neohellenic Enlightenment, the creation of schools and the publication of books would have been impossible without the gradual emergence of a class of bourgeois merchants inside and outside Greek territories. This class was radicalised in the second half of the eighteenth century, coming into contact with the rapid developments in Europe as well as confronting the structures of a backward, closed society, the anachronisms of which were heightened by insecurity and the terrorism exercised by the Ottoman master. The intellectual orientations in the turn of the nineteenth century, as attested by contemporary texts, showed a clear shift in the ideological axes: the role of the Church and of the Phanariots decreased gradually to the benefit of the more progressive views expressed by certain literati in a series of works.

At the time when insurrectionist plans were taking a more specific shape in the mind of several Greeks, a number of events, including the secessionist activity of Ali, Pasha of Ioannina, and of Pashvanoglu, Pasha of Vidino, dramatically

confirmed the dissolutionist phenomena inside the Ottoman Empire. Last, revolutionary movements in Europe in 1820-1821 (Spain, Italy) were living proof of popular dynamics that put to the test the *status quo* the Holy Alliance was seeking to re-establish after the fall of Napoleon (1814).

The credit as well as the responsibility for preparing the Greeks' uprising belongs to the *Philiki Etaireia* (Friendly Society), which was founded in Odessa, Russia, in 1814 by Emmanuel Xanthos, Athanasios Tsakaloff and Nikolaos Skoufas. In January 1820, the Friendly Society asked the Corfiot Ioannis Capodistria, minister of the tsar, to undertake its leadership. Although his refusal was undoubtedly a blow, his attitude of 'benign neutrality' encouraged Society members to turn towards Prince Alexander Ypsilantis, aide-de-camp to the tsar, who accepted their invitation (12 April 1820). Both proposals clearly reflected the hopes of its members, as well as of a large part of the Greek people, that fellow-Orthodox Russia would support the prospect of the Revolution.

On 22 February 1821, in agreement with the local populations on a common uprising, Alexander Ypsilantis crossed the River Prut and encamped at Jassy (mod. Iaşi), capital of Moldavia. His army included, apart from Greeks, Serbs,

Montenegrans, Bulgarians and Moldavians, the martyred 'Sacred Brigade', made up of Greek students from Odessa. On 24 February, he proclaimed the revolution at Jassy, concluding his exhortation with, 'Move, O friends, and you will see a mighty force defend our rights!', which attests to his hopes of a salvationary intervention by Russia and of creating *faits accomplis* at the diplomatic level. But all Ypsilantis' hopes were dashed: the Bulgarians refused to move and the Romanians had no intention of cooperating with Greek aims. At the same time, Russia's lukewarm stance allowed the sultan to crush the movement, wiping out the remnants of Ypsilantis' army in the battle of Dragatsani (7 June 1821).

News of the outbreak of the revolution reached the five Great Powers as they were in conference at Laibach (mod. Ljubliana in Slovenia), 11 January-25 February 1821, to deal with the uprisings in Spain and Naples (1820) and the Piedmont (1821). Ypsilantis' declaration put Tsar Alexander in a difficult diplomatic position with the rest of the Holy Alliance, while it neutralised politically the minister of the tsar and compatriot of the insurgents, Ioannis Capodistria. However, despite Ypsilantis' denunciation and dismissal from the Russian army, despite the

condemnation of the movement, Russia's stance at Laibach as well as afterwards allowed the Greeks to hope.

Capodistria aimed at a Russo-Turkish war that would serve the Greek cause and he tried slowly but surely to turn the hesitant Tsar Alexander in that direction. The suspicions of the Great Powers, primarily of the Austrian Chancellor Metternich, brought Capodistria into disfavour. Deprived of his credibility, he tendered his resignation to the tsar who, in a shrewd manoeuvre, did not accept it but granted his minister indefinite leave.

In the meantime the flame of revolution spread in the Greek Peninsula: on 23 March 1821 Grigorios Dikaios (Papaflessas), Petrobey Mavromichalis and Theodoros Kolokotronis liberated Kalamata; on 25 March the revolution was proclaimed in Patras; on 26 March the insurrectionists captured Kalavryta. Hearths of uprising flared in eastern Central Greece, with the freeing of a series of cities, and in Attica where, on 15 April, the Ottoman Turks were confined to the Acropolis. By this time several Aegean islands were caught up in the whirlwind of events and on 21 May revolution was declared officially in Crete. For various reasons, the rebellion broke with some delay in Thessaly, Chalkidiki, Epirus and western Central Greece.

By the end of the year the War of Independence was in full swing. On 23 September 1821 the freedom fighters captured Tripolitsa, capital of the Peloponnese, and on 14 January 1822 the strategic stronghold of Akrocorinth.

However, if military successes were essential for the viability of the revolution, the political cohesion of the revolutionaries and the diplomatic battle were of equally vital importance. The need for political cohesion, which would legitimise the revolution in the eyes of Europe and would be a precondition for the post-revolutionary developments in Greece, became obvious from the very outbreak of the Struggle. The revolutionaries managed to pass from the first local governments, which were formed in late 1821 in eastern and western Central Greece and the Peloponnese, to the convening of the First and Second National Assemblies at Epidauros (20 December 1821) and Astros, Kynouria (29 March 1823) respectively. Despite opposition and the deficient social representation, the two assemblies voted in two constitutions – 'Provisional Constitution of Greece', 1 January 1822, and 'Law of Epidauros', 13 April 1823, which amended secondary points of the first and abolished the local governments – of indisputably democratic and liberal character.

At the diplomatic level, the Greek Revolution can be safely regarded as the catalytic factor for the initial split and subsequent break-up of the Holy Alliance, the strong arm of the Restoration. The failure of the Greek delegates to appear at the Conference of the Holy Alliance in Verona (October 1822) brought new condemnation of the revolution, since the Great Powers, primarily Metternich's Austria, identified it with the *Carbonari* movements in Italy. But this was destined to be the last triumph of the coalition of 'Old Europe'. The views of the new British Foreign Secretary, George Canning, on his country's interests led to a restrained but significant neutrality on Britain's part. It is significant that on Canning's orders to the High Commissioner of the Ionian Islands, Sir Thomas Maitland, on 25 March 1823, the Greeks were recognized as a 'nation at war'. The change in British policy marked the beginning of the rivalry between Britain and Russia, which was to prove salvationary for the Greek Revolution: George Canning was aware that for all Tsar Alexander's indecision, Russia was intent on weakening the Ottoman Empire in order to gain easier access to the eastern Mediterranean. In the framework of these plans, Russia would have approved the creation of a Greek state of limited area and autonomy, under her indirect influence.

Canning began, behind the scenes, to favour rapprochement between the Greeks and Britain; the granting of two British loans at this time (1824-1825) can be easily interpreted as part of this policy. The moves of Britain and of Russia put before Europe, with ever-increasing clarity, the issue of a 'Greek Question'.

However, prior to the diplomatic moves of these governments, the Greek Struggle had won a proud victory in the hearts of the European people, generating that current which is called 'Philhellenism'. From the outset, but mainly from 1823, the creation and the activity of the 'philhellenic committees', the arrival in Greece of volunteers – about 1200, one-third of whom lost their lives – literary publications and artistic events in many European and North American cities supported the Revolution morally as well as materially. The publication of works by François Chateaubriand, François Pouqueville, Claude Fauriel, Victor Hugo and Lamartine, the paintings by Eugène Delacroix, the arrival of Lord Byron in Missolonghi and his death there (7 April 1824) contributed inestimably to the perception of the Greek Struggle abroad (cat nos 145, 152-157).

After the first surprise, the sultan put all his efforts into quashing the fires of revolt.

In 1822-1823, he tried repeatedly to carry out a combined attack by two infantry forces to relieve the beleaguered castles of mainland Greece. The attempt in 1822 proved futile, since the Ottoman forces were routed by the Greeks at Dervenakia (26 July 1822). Corresponding failure was experienced by Omer Vryoni and Mustafa Pasha of Skodra in their campaigns, in 1823. For these reasons, in conjunction with unfavourable diplomatic developments for the Ottoman Empire, in 1824 the sultan decided to seek the assistance of Mohamed Ali, Khedive of Egypt. In February and March 1825 Mohamed Ali's son, Ibrahim Pasha, after quashing the revolution on Kasos and on Crete, landed powerful forces – trained by French officers – in the Peloponnese, and the Struggle reached its most critical point.

The behind-the-scenes moves of the three Great Powers (Britain, France and Russia) to influence the Greeks, the diverse ideological approaches of the Greek political and military leaders, as well as their narrow-minded local interests, led to bitter disagreements and to a breach that verged on civil war, from summer 1824 until early 1825. The clashes and mistrusts within the revolutionaries' camp plunged the revolution into a crisis of planning and action, which culminated with the fateful exodus of the

Greeks from besieged Missolonghi (the night of 22 to 23 April 1826) and the fall of that town to the Ottomans.

In the meanwhile, the British policy began to bear specific fruit: the crisis that came in the wake of the civil strife and the deadly danger posed by Ibrahim's intervention coincided admirably with its aims. The pro-British revolutionaries – the core of what was known as the 'British party'– succeeded in persuading the government and chiefs of the armed corps to request that Britain undertake the exclusive protection of Greece (approved by the parliamentary plenum of 1 August 1825). Canning officially turned down the Greek proposal, since acceptance of it would have put British interests in jeopardy. But this move, known to history as the 'Act of Submission', was to strengthen Britain's position in the 'Greek Question' and to lead, in parallel, to the hardening of the cores of the other two 'parties' involved. Almost immediately (winter 1825-spring 1826), corresponding proposals were submitted by the other two 'parties': the pro-French group proposed the son of the Duke of Orleans, Louis-Charles, Duke of Nemours, as King of Greece, while the pro-Russian group promoted the election of Capodistria as governor.

The continuously growing involvement of Britain – and secondarily of France – in the Greek cause, in combination with the accession of the energetic Nicholas I to the throne of Russia on the death of Tsar Alexander on 1 December 1825, explains the rapid developments that led to the next phase of the issue. These three powers were now going to handle the problem exclusively, obeying their interests and promoting a solution which annulled *de facto* the policy of the Holy Alliance.

The Anglo-Russian Protocol of St Petersburg (4 April 1826) and mainly the Treaty of London (6 July 1827), signed by the three Powers, foresaw ways of imposing the truce between the warring sides. The reaction of the sultan and of Ibrahim Pasha led to the crucial naval battle of Navarino (20 October 1827), in which the Turkish-Egyptian navy was destroyed.

The death of Canning – shortly after his appointment as Prime Minister in April 1827 – and the retraction of British policy by the succeeding government of the Duke of Wellington, permitted Russia to adopt an even more aggressive policy. Replying to the *jihad* declared by the sultan and to the blame placed on Russian policy for the recent developments, Nicholas I opted for the solution that Capodistria and the Greeks had been wanting for years.

In April 1828 he declared war on the Ottoman Empire.

In Greece, the pressure of circumstances imposed agreement between the advocates of pro-Russian and pro-British policy, so that the Third National Assembly at Troizin (April 1827) decided to invite Ioannis Capodistria to take up the post of Governor (President) for a seven-year term. Obviously, the diplomatic developments and the naval battle of Navarino boosted the revolutionaries' morale. Furthermore, after the agreement of the Great Powers, French forces under General Nicolas-Joseph Maison disembarked in the Peloponnese (August 1828), intent on driving out the Egyptians, which they achieved following an agreement with Ibrahim.

The basic concern of Capodistria – he reached Nafplion, the first capital, on 30 January 1828 – was to organise the struggle in eastern and western Central Greece, since his chief aim, in contrast to British policy, was to secure extensive northern frontiers for the new state. The Governor's indefatigable efforts and his interventions in the council of ambassadors of the three Great Powers, on Poros, led to the signing of successive protocols on the degree of independence and the borders of the new state (16 November 1828 and

22 March 1829). But the factor which triggered developments was Russia's defeat of the Ottoman army. With the Treaty of Adrianople (14 September 1829), the terms of which were dictated by triumphant Russia, the Ottoman Empire agreed, among other things, to the intermediary role of the Great Powers and the frontier line running from Volos to Arta for the new, autonomous Greek state.

Once again Anglo-Russian rivalry favoured developments. Wellington, reacting to the Russian success and keen to avoid the creation of a petty state under indirect Russian control, surpassed even the most optimistic predictions by proposing the creation of an independent Greek state. On 3 February 1830 the delegates of the Great Powers signed the Protocol of Independence, which gave birth to the first independent Greek state, albeit of limited area. A new protocol (30 August 1832) finalised the territories included in the fledgling state: the Peloponnese, the Cyclades and Euboea, and part of Central Greece, as far north as the line between the Ambrakian and Pagasitic gulfs.

In the same interval, domestic political life was stamped by Governor Capodistria's arduous but unsuccessful endeavours to organise the central administration, education and the economy. The opposition of traditional local leaders, together with the accusations of absolutism and obscurantism made by liberal intellectuals such as A Korais, mainly after 1830, led to a political crisis. The tension served mainly British policy, which never hid its suspicion that Capodistria was a tool of Russia. The great statesman's career was terminated, together with his life, on 9 October 1831, when he was assassinated by the powerful Maniots, Georgios and Konstantinos Mavromichalis.

After the assassination of Capodistria and the previous abdication of Leopold of Saxe-Coburg, the Great Powers elected Otto (Otho), the seventeen-year-old son of King Ludwig of Bavaria, as King of Greece (7 May 1832). On 1 February 1833 the ships carrying King Otto, still a minor, along with the members of the Regency and 3500 Bavarian soldiers, dropped anchor at Nafplion. Otto was to reign in a land laid waste (cat nos 158-163), with a population of 750,000. Some 2 million Greeks were still living under British sovereignty in the Ionian Islands, and under Ottoman sovereignty in central and northern Greece, in the Aegean Islands (except the Cyclades) and in Crete. ∎

ILLUSTRATIONS

***The Dance of Zalongo, or
Women of Souli***
Claude Pinet

Cat no. 145
*c.*1855
Oil on canvas, 69 x 90 cm
Signed 'Claude Pinet'
Gift of Ioannis G Trikoglou (8997)

From the scant biographical
information available on the French
artist Claude Pinet, he is known
to have been a pupil of the
philhellene painter Jean-Claude
Bonnefond (1796-1860), who
was based in Lyon.

Philhellenism, the sentimental as
well as, primarily, physical solidarity
manifested in many European
countries, and in America, with
the Greeks who were fighting
for their independence, found
its ideal expression in France.
The ideas of the Greek War of
Independence had been hatched
by the same Enlightenment
sources as triggered the French
Revolution. The decade 1820–
1830 saw an ever-growing

demand by liberal intellectuals
for greater intervention on behalf
of the Greeks, in keeping with
the convictions of the liberal
opposition to the official pro-
Ottoman policy of the conservative
royalists. This current of sympathy
led to a wider philhellenic output
in literature and the visual arts.

One of the subjects of the Greek
Struggle which was an inexhaustible
source of inspiration was the
heroic resistance of the people
of Souli to the Ottoman governor
of Ioannina, Ali Pasha (1750-
1820). In the late eighteenth
century the Greeks organised
a strong military force in Souli,
an isolated village in the mountains
of Epirus, which was an obstacle
to the expansionist plans of Ali
Pasha. The Souliot struggle lasted
from 1789 until 1804. In the
course of the third campaign
against rebellious Souli (1800-
1804), the beleaguered Souliots,
without food and ammunition,
were forced to capitulate, on
the understanding that they
would be allowed to escape.

Ali Pasha, however, reneged
on the agreement and turned
against them. The women and
children sought refuge in the
village of Zalongo where,
tradition has it, they cast
themselves from a precipice
to avoid being taken captive.

The sacrifice of the Souliot
women, which passed into legend,
became known in France through
the narratives of authors such
as F L Pouqueville and A F
Villemain, while the eminent
Romantic writer Alfonse de
Lamartine commented: 'Here is
one of the prodigies of heroism
and misfortune ... and Europe
just looks on!' The subject was
a source of inspiration for well-
known French Romantic painters
such as Alexis-Nicolas Perignon
and Eugène Fromentin.

Claude Pinet moves within this
frame, his subject inspired by
the final and most tragic phase
of the siege of Souli. The painter
represents the Souliot women
who, on seeing their menfolk lost

in the unequal battle with the
Turks, have grabbed their
children in their arms and are
leaping into the abyss, preferring
death to the hardships of
captivity. The work is a
representative example of
'historical reportist' painting.
Despite the tragedy of the event,
the arrangement of the figures
with the rather stereotype
gestures and the melodramatic
pose of the protagonist-mother at
the centre endow the composition
with a theatrical character.
F-MT

Published: *La Grèce en révolte* 1996,
180– 181, no 62 (F-M Tsigakou). For
the impact of the theme 'the dance of
Zalongo' see: Athanassoglou-Kallmyer
1989, 104–107, 149, note 84. For the
works of A de Lamartine see: *ibid*,
149, note 87.

Cartridge pouch

Cat no. 146
c. 1830
Provenance unknown
Silver plate, punched,
chased, niello
13 (h) x 10 (w) cm
Inv. no. 6177

Represented in niello on the front of the pouch is a heraldic composition of Athena, with archaised helmet and urban dress, between two Greek flags whose poles stand on martial trophies. The goddess holds a spear in her right hand and a severed human head in her left. Palm branches topped by owls complete the representation. The finial of the lid is decorated in pierced-work technique with a palmette and birds pecking flowers at the centre, and a schematic vase with lid at the edges and the apex. Schematic foliate pattern surrounds the three sides of the back, and

nailed at the centre is the loop through which the belt passed.

The placement of these diverse symbols endows the composition with a glorifying and triumphal character. The palm branches, symbols of glory and victory, are crowned by the owl, Athena's companion bird, which symbolises wisdom. The victory of the goddess, who holds the conqueror's severed head as trophy, is sanctified by the small cross on her neck. An interesting point is the similarity between the goddess's striped dress and the Greek flag. The representation, conjugation of a Neoclassical subject and allegory, is of 'Liberty' in the type of the goddess Athena.

The armed female figure with archaised appearance, as both decorative subject and national symbol, had been established in Europe since the eighteenth

century. The portrayal of arms-bearing Athena as national symbol was adopted by the Greeks during the years of the War of Independence and became one of the most popular decorative subjects featured on cartridge pouches, as well as on accessories of Greek weaponry in general.

Cartridge or gunpowder pouches were an essential element of weaponry. They were usually made of silver or bronze, sometimes gilded, or of leather, often covered in embroidered textile. Freedom fighters hung their cartridge pouches from the back of their belt or from a separate leather girdle. KS

Unpublished. See a similar example in: Delivorrias, Fotopoulos 1997, 520, fig 919. For cartridge pouches and the representation of the goddess Athena see: Vassilatos 1989, 114–116.

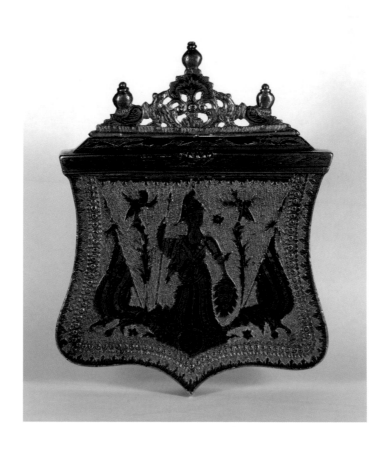

Cartridge pouch

Cat no.147
Mid-19th c.
Belonged to the Greek
freedom fighter Ilias Yatrakos
Silver plate, gilded details,
repoussé, chased
14 (h) x 10 (w) cm
Gift of King George II
of the Hellenes (6121)

On the front of the pouch is an emblematic composition of two addorsed lions with their heads turned towards each other, flanking a flower-vase with handles. The representation is surrounded by a decorative zone, with a flower in each of the four corners and a small shell at the bottom. The lid has a pierced-work finial with two lions in heraldic arrangement and a mask between them. Nailed to the centre of the back is a square loop with repoussé decoration, through which passed the belt.

The lion, king of beasts, with the symbolic meaning of guardian of the gate, the throne and the grave, features frequently in the art of pre-Christian times and lived on in many ways in the Christian Age, acquiring new symbolisms relating to the immortality of the soul and the resurrection of the dead. Because of its multiple symbolism, the lion as decorative subject had a particular emotive appeal for the Greek freedom fighters. Heraldic compositions occur frequently on cartridge pouches and are the principal ornamental device on flintlocks. The face-mask has most probably been used as an apotropaic element, since folk belief attributes protective properties to the frontal representation of the human face.

Greek cartridge pouches, with the pedimented finial on the lid and their singular shape, borrowed from eighteenth- and nineteenth-century European military pouches in leather, differ essentially from their Albanian and Turkish counterparts, which are square or rectangular.

According to the donor, King George II of the Hellenes (1922-1923, 1935-1941, 1946-1947), the cartridge pouch belonged to the freedom fighter Ilias Yatrakos (+ 1875), scion of an old leading family of the Mani in the Peloponnese which offered important services to the Greek Struggle for Independence. KS

Unpublished. See a similar example with addorsed lions in: Delivorrias, Fotopoulos 1997, 520, fig 920. For the symbolic meaning of the lion see: Chevalier, Gheerbrant 1982, sv lion, 575-577. For the face-mask on weapons see: Vassilatos 1989, 115-116, note 223.

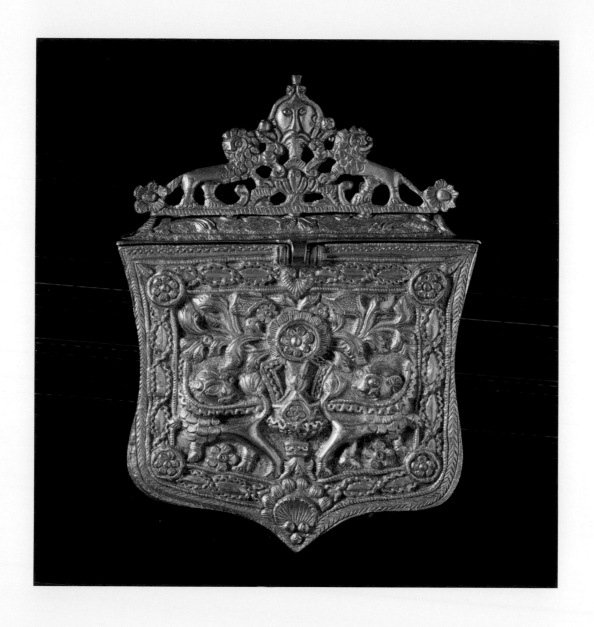

Pistols
Algerian workshop

Cat no. 148
Late 18th c.
Provenance unknown
Wood, silver, steel, coral
57 (l) cm
Inv. no. 5870/1-2

The pistols are front-loading with a flintlock firing mechanism. They are set all over with midribbed, almond-shaped corals, large on the back of the handgrip. The silver revetment on the wooden body is embellished with almond-shaped designs on the sides of the barrel and repoussé and engraved decoration of scroll and floral motifs on the rest of the weapon. Either side of the handle-grip, the silver is stamped, possibly with the name of the workshop in which the pistols were made, which has not yet been identified.

The luxurious pistols are almost certainly booty from a battle. Comparable morphological features, corresponding aesthetics and kindred craftsmanship are encountered on a pair of pistols from Algeria, of AH 1198/AD 1784, now in the Tareq Rajab Museum in Kuwait. Algeria was famous in the Christian world for its guns and its corsairs, who plagued the sea routes of the western Mediterranean, even raiding into the Atlantic as far as the British Isles. Dutch, British and French merchants established themselves in Algeria, engaging in commerce. Arguably the most prized guns from Algeria were those decorated with coral, which was very much a hallmark of the area. Coral also became fashionable at the Ottoman court in the eighteenth century. It was used extensively to decorate weapons and horse-trappings, in what was known in the Empire as Algerian work. Pistols with coral decoration in Algerian and Ottoman style were also made in France for export.

In Greek lands at that time the most widespread firearm was the rifle, usually of small bore and with long barrel. Possession of pistols was quite a rare phenomenon in mainland Greece before the War of Independence, the privilege of chieftains of armed irregulars, leading citizens and professional soldiers. The Greeks, like most peoples in the western Balkans, imported the principal elements of these weapons, the barrels and the mechanisms, from Italy, an important centre of pistol manufacturing. The word 'pistol' derives from the Italian city of Pistola, where these guns first appeared in the early sixteenth century. Later centres supplying firearms from the West were the Low Countries, Spain, France and England. KS

Unpublished. See a similar pair of pistols in: Delivorrias, Fotopoulos 1997, 569, fig 1000. For information on Algerian firearms and parallel examples see: Elgood 1995, 74–79, figs 40–42. For firearms used by Greeks in the eighteenth and nineteenth centuries see: Vassilatos 1989, 99–106.

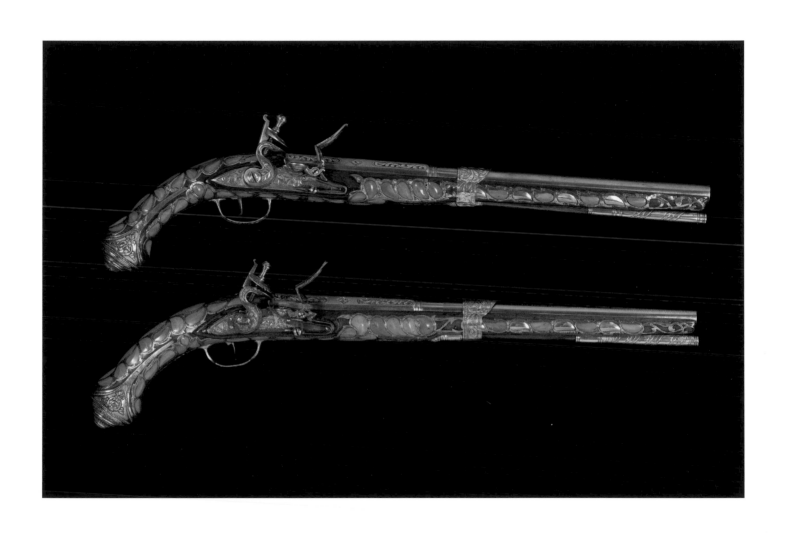

Yatagan with scabbard

Cat no. 149
Late 18th c.
Belonged to the Greek freedom fighter Photos Tzavellas
Steel, silver gilt, repoussé, punched, pierced, niello
72.5 (l) cm
Gift of Prince George (5759)

The wooden scabbard and the hilt are clad with silver-gilt sheets covered with repoussé decoration on a ring-punched ground. On either side of the scabbard, intersecting wavy lines form compartments filled with florets, birds, flower-vases, heraldic lions and trophies. There are three emblems on each side, with flowers and double-headed eagle executed in niello. On the mouth of the scabbard are two zones with pierced-work decoration of foliage, three bands of herringbone and small medallions with niello flowers. Represented on the hilt are flowers, banners and birds. The steel blade is embellished with inlaid arabesques in silver and an inscription in Arabic calligraphy (*Naski*) in gold, with lines from a poem and the name of the weapon-maker, Ishmael.

The *yatagan* or scimitar, a long knife of oriental provenance, appeared in the seventeenth century and spread throughout the Balkans, Turkey, the Middle East and North Africa. It was widely used during the Greek War of Independence, being an essential item in the weaponry of Greek and Ottoman alike. It was fixed to the *selachi*, a kind of pleated leather or cloth belt which was worn in front of the fighter's waist and was provided with holders for weapons. Yatagans had wooden scabbards, usually covered with leather. Those belonging to distinguished guerrilla leaders, such as the example here, were decorated with elaborate silver revetments.

According to the donor, Prince George (1869-1957), the yatagan belonged to Photos Tzavellas (*c.* 1770-1809), a leading figure in the legendary struggles of the Souliots against the Ottoman governor of Ioannina, Ali Pasha (see cat no. 145). The weapon was undoubtedly obtained as booty taken by Tzavellas from the Turks in a battle, with the scabbard and hilt subsequently fashioned by a Greek craftsman.

The intricate decoration of the yatagans, which the philhellenes took home from Greece as mementoes, impressed nineteenth-century European Orientalist painters, who depicted them in many pictures inspired by the Greek Struggle for Independence. KS

Published: Delivorrias, Fotopoulos 1997, 522-523, fig 926. For yatagans see: Vassilatos 1989, 97-98.

Sabre

Cat no. 150
Early 19th c.
Provenance unknown
Steel, horn, silver, punched, engraved, niello
86 (l) cm
Inv. no. 5832

The hilt is made of horn with a fringe of black silk. The cross-shaped guard is revetted in silver with decoration in niello on a ring-punched ground. Represented on one side is a bust of a freedom fighter in a frame, and on the other a panel with a schematic floral ornament. The curved steel blade is inlaid in gold with the initials Γ Μ Β and a schematic floral ornament. The silver scabbard has figural and floral decoration executed in niello on a ring-punched ground, and two ornate rings with loops to which the hanging cord was attached. On either side of the scabbard, intersecting wavy lines describe compartments filled with equestrian figures, animals attacking birds, buildings, churches, trophies and escutcheons. Outstanding among them on one side is the representation of a horseman with raised sabre, in the type of a triumphal St George, and the scene of a man wrestling with a lion, which alludes to a Labour of Herakles, and on the other side the representation of a Greek freedom fighter holding a severed head. A band of floral pattern runs around the edge of the scabbard, framing the scenes.

The subjects of the decoration are symbolic and allegorical. The conjugation of the two great heroes of antiquity and Orthodoxy, Herakles and St George, with the Greek freedom fighter, portends the successful outcome of the Greek Struggle for Independence from the Ottoman Turks.

The way in which the representations are worked – the craftsman first traced the outlines of the subjects and then executed the details with fine incisions, in which he applied niello, an alloy of silver, copper, lead and sulphur – as well as the overall style of the pictorial decoration, are reminiscent of engraving.

The sabre, the design of which is considered to be a cultural achievement of the Mongols, was spread by the Turks, via the steppes of Central Asia, to Greece and the Balkans in general. The Byzantines adopted it during the last century of their thousand-year empire. In nineteenth-century Greece, oriental sabres, mainly Ottoman, were widely used. The most widespread was the *pala*, with broad, curved blade, like the example discussed here. Together with the *kariofili*, a long-barrelled rifle, they were the inseparable companions of freedom fighters in the War of Independence and one of the weapons especially extolled in folk poetry. KS

Unpublished. For sabres see: Vassilatos 1989, 91-94. For weapons used by Greeks in the eighteenth and nineteenth centuries see: Minotos 2000, 210-231.

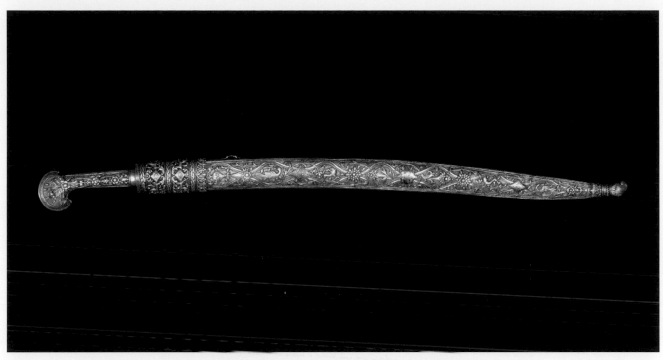

149

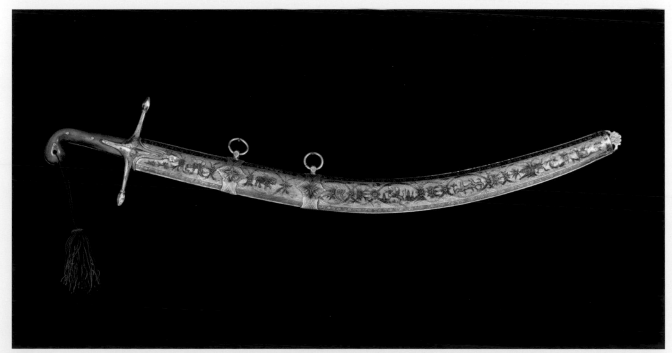

150

Plate
English manufacture

Cat no. 151
Third quarter of 19th c.
Probably from Syros, Cyclades
Clay, glazed
24 (diam) cm
Inv. no. 8511

At the centre of the plate, depicted in black on a white ground, is the bust of Rigas Pherraios, with his name ΡΗΓΑΣ ΦΕΡΡΑΙΟΣ and the date 1821 inscribed around him. Rigas (1757-1798), one of the most important figures of the Greek Enlightenment, endeavoured to underpin the uprising of the subjugated Greek nation by encouraging its intellectual and spiritual awakening and the collaboration of all peoples of the Balkans. His inspired activity was cut short by his arrest by the Austrian authorities, which handed him over to the Ottomans and a martyr's death.

On the rim of the plate are composite devices of helmets, shields and weapons, and four busts of heroes of the Greek War of Independence, with their names. These are Nikitaras (1787-1849), Odysseas (Androutsos) (1788/9-1825), (Petrobey) Mavromichalis (1765-1848) and (Athanasios) Diakos (1786-1821).

The plate belongs to a special class of ceramics of foreign provenance which made their appearance in Greece in the mid-nineteenth century, mainly after the arrival of King George I (1863). They were made in various European factories, commissioned by Greeks to cover the needs of the emergent social and economic bourgeoisie, primarily the merchants in the developing cities and urban centres. The increasing demands for a more comfortable lifestyle, expressed among other things by household furnishings and equipment, led to the ordering of large numbers of complete dinner services, as well as sets for sweetmeats and coffee. These ceramics came to be known as 'Syran', because of the strikingly large percentage of orders placed by the merchants of the Cycladic island of Syros, a major commercial centre and nodal port.

The preliminary designs for these ceramics were most probably drawn by Greek craftsmen, on the basis of photographs and prints that circulated widely, and were then sent to European factories for further processing and production, given that no ceramics factory yet existed in Greece. Their iconography renders events associated with the royal dynasty, personalities in contemporary public life, historic figures of antiquity, Byzantium and the Greek War of Independence (like the present example), mythological and allegorical scenes. The thematic repertoire of these ceramics reflects the political preferences of the middle class of merchants, shipowners, professionals and intellectuals, as well as their 'worship' of antiquity and their sensitivity regarding national issues. EG

Published: Korré-Zografou 1995, 256–262, fig 487. For a similar plate see: *The Kyriazopoulos Collection* 1975, 69, no 61, figs 50, 82.

Philhellenic plates
Montereau porcelain factory

Cat nos 152, 153
1826–1827
Provenance unknown
Porcelain
23.7 (diam) and 21.8 (diam) cm
Gifts of Marina Lappa-Diomidous
(8522, 8538)

The first plate, with inscription declaring CONSTANTIN CANARIS SUR UN BRULOT, depicts in black on a yellow ground Konstantinos Kanaris on his fireship. Kanaris (1790-1877) is famed for his daring nautical exploits, which contributed decisively to the successful outcome of the Greek Struggle for Independence.

The second plate, with a polychrome representation on a white ground, bears the inscription QUETE POUR LES GRECS and shows a scene of collecting contributions 'in support of the Greeks'. During the Greek War of Independence, many ladies of the French aristocracy collaborated with the philhellenic committees that had been set up in various cities in France by organising collections of this kind.

These plates are part of the philhellenic series produced by the French Montereau porcelain factory. In addition to the philhellenic subjects depicted at the centre of the plates, this series had a specially designed border, decorated with laurel wreaths, inscribed within which, in pairs, are the names of three philhellenes and three leaders of the Greek Revolution. The names of the French Colonel Charles-Nicolas Fabvier (1782-1855), the British Lord Byron (1778-1824) and the Swiss Jean-Gabriel Eynard (1775-1863) are combined respectively with those of Konstantinos Kanaris, Andreas Miaoulis (1769-1835), Commander of the Greek naval forces, and the Souliot freedom fighter Markos Botsaris (1790-

1823), one of the most charismatic figures of the Greek War of Independence. The banners between the wreaths bear the words LA CROIX (The Cross) and LIBERTE (Freedom). The back of the plate is incised with the stamp of the factory, LL & T AU.

The initiative of creating these objects was taken by the porcelain factory of the Paillart brothers at Choisy-le-Roi in France, who commissioned the French painter and lithographer Karl Loeillot (1798-1864) to create 16 lithographs in four units, entitled 'Greek Revolution' (November 1824-September 1825). The series of plates from the Choisy factory, with scenes of daily life of the insurgent Greeks, as well as scenes of battle, probably came onto the market in early 1826. Towards the end of that year, the Montereau porcelain factory also produced a philhellenic set of twelve plates, mainly of

historical content, which illustrate current subjects inspired by the struggles of the Greeks.

Since philhellenism was a movement of considerable popular appeal, the philhellenic thematic repertoire passed extensively into the applied arts. Episodes from the Greek War of Independence circulated on many utilitarian objects, such as clocks, fans, inkwells, etc., but primarily on tableware for everyday use. In an era when there were no illustrated newspapers, these coloured and black-and-white depictions on dinner services and tea services brought events in revolutionary Greece to a wider public. EG

Unpublished. For the Montereau factory and the series of philhellenic plates see: Amandry 1982, 36–41, 63, fig 96, 64, fig 120. For philhellenism in France in everyday life see: *La Grèce en révolte* 1996, 232–236, nos 101–105 (A Amandry).

The Oath of the Missolonghians
Louis-Benjamin-Marie Devouges
(1770–1842)

Cat no. 154
1826
Oil on canvas, 71 x 86 cm
Signed 'Devouges'
Inv. no. 8989

Louis-Benjamin-Marie Devouges, pupil of the pre-eminent Classicist painter Jean-Louis David and drawing master in the Lyon Lycée, regularly exhibited portraits in the Paris Salon from 1793 to 1839. He apparently took a particular interest in the Greek cause, since he is known to have offered to the Paris Greek Committee a work 'on behalf of the Greeks', entitled *Morning in Missolonghi*.

Missolonghi, whose tragic plight enhanced the town as a symbol of the Greek struggle, declared its participation in the War of Independence in May 1821. Strategically located on the Gulf of Patras, it became the centre of military operations in western Greece. The indomitable spirit of its inhabitants during the two sieges (October-December 1821, April 1825-April 1826), their unparalleled self-sacrifice and above all the epic exodus of the besieged on the night of 9-10 April 1826, shocked public opinion. A long series of literary works on this subject circulated in France at the time, while related paintings flooded exhibition halls. Devouges created other works inspired by the events of Missolonghi. In the Benaki Museum there is a small oil painting by the artist entitled *Defenders of Missolonghi* (40 x 31 cm). This is probably a copy of the work of the same title which Devouges exhibited in 1828 in the residence of the Duchesse du Berry (see *Journal des artistes*, 27 April 1828, 269).

The oil painting represents the moment that the Missolonghians, men and women, having just sworn the sacred oath, rush into battle at the behest of a venerable cleric. With fervour and resolve, the freedom fighters advance arm in arm. One fighter with his rifle on his shoulder marches beside a priest holding a cross, while banners with the symbol of the cross flutter above them. Fatherland and religion epitomise the ideals for which the Greeks fought in 1821. Religious symbols have been popular motifs in philhellenic iconography since the struggle of Christian Greeks against Muslim Turks assumed the character of the opposition between Cross and Cresent in the Crusades of the Byzantine Age. 'If our voice could be heard, the barbarians who are slaughtering the Greeks would have been wiped out and the banner of the Cross would wave above the rooftops of Constantinople and the Parthenon,' wrote the French newspaper *Constitutionnel* on 26 July 1821. Devouges sought through this work to extol the role of the Church in the liberation of Greece. The figures, which are rendered in a Classicist manner, are of monumental character, while the composition has a laudatory tone which nevertheless preserves the emotionalism and the sanctity of the moment. F-MT

Published: Athanassoglou-Kallmyer 1989, 68–69, fig 33; *La Grèce en révolte* 1996, 132–133, no 34 (F-M Tsigakou).

Lord Byron's Oath upon the Tomb of Marcos Botsaris at Missolonghi

Lodovico Lipparini (1800-1856)

Cat no. 155
1850
Tinted lithograph on paper,
65 x 75 cm
Inscribed in Greek and Italian:
'Lipparini invented and painted, Markovich drew, Cappello lithographed *The Oath of Lord Byron upon the Tomb of Marcos Botsaris at Missolonghi* – To His Royal Highness the King of Greece Otto I most respectfully offered – Franceso Boualdi – The original, length 3.5 metres and width 2.5 by Mr S. Giacomelli from Treviso D.D.D. – From the Lithography press of Kirckmayr Venice.'
Inv. no. 26318

The Italian painter Lodovico Lipparini is known for his historical subjects. His works are imbued with a Romantic spirit, with explicit allusions to the liberationist struggle being waged in the mid-nineteenth century in Italy against the absolutist Austrian regime. It is interesting that after 1835 the painter was preoccupied almost exclusively with themes inspired by the Greek War of Independence. For this reason King Otto (1833-1862) honoured him by appointing him a member of the newly-founded Fine Arts Society of Greece.

The leading British poet and philhellene George Gordon, Lord Byron (1788-1824) visited Greece, Asia Minor and Constantinople in 1809-1811. Towards the end of 1823 he returned to Greece, now in the throes of revolution, as representative of the London Greek Committee, for the purpose of gathering data for the possible granting of a loan to the Greek Struggle by banking circles in England. On 5 January 1824 he arrived in Missolonghi, where he was given a highly enthusiastic welcome by the beleaguered townsfolk. However, the hardships of the journey and the unwholesome climate of the area affected his health and on 7 April 1824 he died there.

Just as Byron's poetry supplied Romantic artists with fanciful subjects, the poet himself was the model of the Romantic hero. A liberal spirit and acerbic critic of contemporary society, Byron first came to Greece as a dreamy traveller to the land of ancient myths and oriental fairytales. When he returned, the exuberant youth had given way to a man of action. With the publication of *Childe Harold's pilgrimage* in 1812, the poet succeeded in interweaving the Classical and the Oriental elements of the Greek identity with contemporary reality, revealing moreover an alluring land with people worthy

of a better fate. Although Byron's energetic intervention in the Greek Struggle did not alter the course of historical developments, his death acquired the dimensions of a symbolic event, heightening the awareness of liberal consciences everywhere and rekindling the philhellenic movement.

The lithograph copies a large canvas in oils, painted by Lodovico Lipparini, and commissioned by – as the inscription records – Sante Giacomelli, a patron of the arts from Treviso, who later donated it to the Museo Civico of that town. The work depicts Lord Byron swearing an oath upon the tomb of Markos Botsaris, a popular freedom fighter from Souli, who fell at Karpenisi on 8-9 August and was buried at Missolonghi. Byron characterised Kapetan Markos Botsaris (1790-1823) as 'the perfect combination of brave soldier and honest man'. A charismatic leader, much loved by his comrades, Botsaris was the model Greek hero for the philhellenes and after his death was inscribed in the philhellene repertoire as 'young Leonidas'.

At the centre of the composition, Byron is represented taking the oath, with one hand upon Botsaris' tomb and the other on the Greek flag. Around him are representatives of the clergy and the laity, the men of Missolonghi with their womenfolk and

children, a motley crowd presented by the painter to convey more vividly to the beholder the pulse of the moment. Organised theatrically, the composition highlights Byron as symbol of freedom and self-sacrifice, as national hero surrounded by the faith and adoration of the Greeks. Together with the assiduous depiction of anecdotal details, the artist strives to give an idealistic exaltation of reality, aimed at moving and instructing the viewer. F-MT

Published: *Niccolò Tommaseo e il suo mondo* 2003, 141-143, 165-166, no 27 (F-M Tsigakou). For a similar oil painting by Lipparini see: *Through Romantic Eyes* 1991, 138-139, no 57 (F-M Tsigakou); Delivorrias, Fotopoulos 1997, 544, fig 956. For the Death of Marcos Botsaris theme see: *Risorgimento greco e filellenismo italiano* 1986, 297, no C27 (C Spetsieri-Beschi).

Young Greek Defending his Wounded Father

Ary Scheffer (1795-1858)

Cat no. 156
1827
Oil on canvas, 45 x 37 cm
Inv. no. 11177

The oil painting is unsigned but is identified on the basis of the homonymous lithograph created by the artist. The well-known Romantic painter Ary Scheffer was of Dutch origin but was active mainly in France. In 1826 he hung a portrait of Fabvier in the exhibition of works organised by the Paris Greek Committee in the Galerie Lebrun, the proceeds from the sale of which were disbursed to the Greek Cause.

The Greek War of Independence was coeval with the Romantic Movement. The Romantic creators turned to major moments in history to escape from the prosaic trivia of daily life. The Greek Struggle stimulated the forces of Romanticism and enriched European artistic inspiration with new and exciting themes. The presence of the ancient Greek tradition, embodied in the Greek Struggle, was a first-class thematic repertoire for the Romantic painters. Using allusively the Classical vocabulary, they strove to elevate particular persons and events to images of global import. Ancient ruins feature frequently in philhellenic representations, indicating the presence of the Classical past, which also fires the heroism of the protagonists.

In this painting Ary Scheffer, as authentic representative of Romanticism, is not inspired by a specific historical event. He presents upon the stage of history a Greek youth who is playing an active role in creating a historic moment. The historical event, interwoven with the personal drama, elevates to the sphere of the heroic a boy who, in the desperate moment when his wounded father dies, acquires the sense of duty and becomes a man in the hour of battle.

The work, a manifesto of patriotism and principles, proclaims the message that for the Greeks the struggle for parents and for liberty is the same. The artist suggests successfully, within a genuine dramatic atmosphere, the patriotic and didactic content of the painting. At the same time, by creating a composition in which the protagonists are portrayed with ancient Greek facial features and the father is shown dying in the pose of the famous ancient statue of the 'Dying Gaul', he alludes to the ancient Greek past which the fighting Greeks are defending. This is an allegorical representation which the painter, by removing every narrative element, elevates to a symbol of everlasting valour. Faithful to the principles of Romanticism, he hints at the role of the personal strength of the individual in shaping the common destiny, while simultaneously expressing the common emotion of the philhellene viewer. F-MT

Published: *Through Romantic Eyes* 1991, 154–155, no 65 (F-M Tsigakou); *La Grèce en révolte* 1996, 190–191, no 69 (F Ribemont); Delivorrias, Fotopoulos 1997, 531–532, fig 937.

A Greek Boy

Alexandre-Marie Colin
(1798-1873)

Cat no. 157
c. 1829-1830
Oil on canvas, 44 x 38 cm
Signed 'A. Colin'
Gift of Theodoros I Karallis
(21794)

The French painter Alexandre-Marie Colin served for a time as director of the School of Design of Nîmes. He took part in the exhibitions of the Paris Salon from 1819 until 1868, with scenes of war or scenes inspired by literature, drawing his inspiration from Romantic authors, while his engravings increased his popularity even more. In 1827 he exhibited in the Salon a work entitled *Massacre of the Greeks*.

News of the outcome of the Greek Struggle did not monopolise the philhellenic sentiments of the Europeans. What also touched philhellenic chords was the fate of the civilian population, of the women and children. In the major European centres philanthropic societies were founded with the aim of collecting money for the care of indigent families and paying ransom for prisoners of war. Ladies of the European aristocracy considered it an honour to take part in amateur theatrical performances 'on behalf of the Greeks' or in collections for sending food and clothes to the displaced people of Chios, Missolonghi and Parga. At the premiere of the philhellenic tragedy *Léonidas*, by Michel Pichat, produced in 1825 at the Théâtre Français in Paris, the audience emotionally applauded the sons of the Greek freedom fighters Miaoulis and Kanaris in the box of the Duke of Orleans. In this same period in Britain, ten Greek boys were studying under the auspices of the London Greek Committee. In the 'Panhellenion' boarding school in Munich, founded in 1827 by King Ludwig I of Bavaria expressly to take care of Greek orphans, the sons of some of the best-known freedom fighters in the War of Independence were educated.

Children occupied a special place in the philhellenic repertoire. The mythologising of the child in art and literature was a multi-faceted phenomenon in nineteenth-century Europe. Painters and poets sketched various images of child heroism, of moralistic-didactic character. The poem 'L'enfant' from Victor Hugo's collection *Les Orientales*, published in 1828, enriched the Romantic repertoire with a subject of heroic dimension, which evoked immediate emotion in the audience. Alexandre-Marie Colin, who is known to have belonged to the artistic coterie of Delacroix, must have had a child of this kind in mind.

In this work the Greek boy, who is painted with the demeanour and pose of the heroes in the struggle, is portrayed with idealised features and restrained expression, within a radiant Greek landscape. His 'best' costume is pristine, while the rifle and yatagan accompanying him are inordinately large for his stature, making him look like a toy soldier. The idealistic development of the subject denotes the artist's desire to endow the hero with symbolic connotations. Beautifully clad within a sun-drenched landscape, the Greek boy alludes to the hopes and optimism embodied by the fledgling Greek state. F-MT

Published: *Through Romantic Eyes* 1991, 156-157, no 66 (F-M Tsigakou); *La Grèce en révolte* 1996, 102-103, no 10 (F-M Tsigakou); Delivorrias, Fotopoulos 1997, 518-519, fig 918, 521, fig 923.

View of Athens from the Philopappus Hill

Richard Banks Harraden
(1778-1862)

Cat no. 158
c. 1820
Oil on canvas, 49 x 86 cm
Gift of Damianos Kyriazis (11192)

The work is unsigned but was identified thanks to an oil painting of the same dimensions in the possession of the Museum of the City of Athens, inscribed: 'R. B. Harraden pinxit Oxford 1830'.

The British landscape painter and engraver Richard Banks Harraden, known mainly for his views of the English and French countryside, lived in France for many years and toured southern Europe. There is no specific information on exactly when he visited Greece. During the nineteenth century, Greece was a favourite destination of British artist-travellers, whose interest in Greek locations had begun two centuries earlier. The number of landscapes with Greek subjects painted by British artists in this period is impressive (see also cat no. 159). The degree of reliability of the representations varies,

given that not many artists were concerned with recording current reality. Harraden's composition is important because it presents a credible picture of Athens in the early nineteenth century.

The view is drawn from the Hill of Philopappus or of the Muses, which overlooks the southwest slope of the Acropolis and offers the viewer an overall image of the monument as well as a panoramic view of the city. Visible in the left foreground is part of the funerary monument of Gaius Julius Antiochus Philopappus, benefactor of Athens, which was erected by the Athenians in his honour in AD 114-116.

The topographical and architectural elements of the composition furnish a reliable record of the city and the monuments. Athens during the Ottoman period, as in antiquity, was divided into two separate sections: the Acropolis, which was then called *Kastro* (castle), and the lower city. The Acropolis was no longer the sanctuary of the goddess Athena, but the seat of the Turkish governor. As the picture shows, its entire area was

covered by the barracks of the soldiers in the garrison. Inside the Parthenon stands the large mosque that was built after the destruction of the temple in the bombardment of the Acropolis by the Venetian army, under the command of F Morosini, in September 1687. The artist has depicted with archaeological assiduity the fortifications which the foreign conquerors constructed at the entrance to the Acropolis to turn it into a fortress. Discernible are the bastions on the west side, the tower put up by the Franks in the fifteenth century to fortify the Propylaia, as well as the so-called Serpentzes defensive wall on the south slope, in which was incorporated the Odeum of Herodes Atticus. The city was girdled by a wall built in 1778 by the Turkish governor (*voevod*), Hadji Ali Haseki. Conspicuous among the humble Athenian homes and the minarets of the mosques are the renowned ancient monuments of Athens, the Theseion (Temple of Hephaistos) on the left and the Olympieion (Temple of Olympian Zeus) on the right. F-MT

Published: *Through Romantic Eyes* 1991, 26–27, no 1 (F-M Tsigakou)

View of the Acropolis from the Pnyx

Thomas Miles Richardson
(1813–1890)

Cat no. 159
c. 1850
Watercolour on paper,
19 x 32 cm
Signed 'M. Richardson'
Inv. no. 23038

The British landscapist Thomas Miles Richardson, scion of a family of artists, toured southern Europe after 1840. He was a member of the Royal Academy of Watercolourists, where he regularly exhibited views inspired by his travels.

The school of British watercolour painters enjoyed a remarkable heyday in the late eighteenth and the early nineteenth century. The young British aristocrats of the eighteenth century, inaugurating the so-called 'Grand Tour', the 'pilgrimage' to antiquities in Europe and the Mediterranean, established the habit of gathering visual testimonies of the ancient sites they visited. These representations were either painted by themselves or by professional artists accompanying them, using watercolour as medium. Prior to the invention of the camera, watercolour served the artist-travellers admirably, since it was the ideal medium for quick and expressive recording of landscape features. The clarity and the descriptive potential of watercolour led to its wider acceptance by the artistic establishment, as well as to its direct association with the concurrent development of landscape painting. British landscape painting evolved during the first half of the nineteenth century into an independent genre, which not only competed with the genres considered 'high art', that is, portraiture and historical subjects, but also created enormous possibilities for personal expression.

This view is a representative example of the abilities of Richardson, a talented artist renowned for his lustrous palette. Apart from its chromatic quality, the work is of interest for the arrangement of the individual landscape elements, because it is indicative of the way in which foreign artist-travellers approached Athens. Most nineteenth-century Athenian views reflect the magnetism that the city of Pallas Athena held for cultivated Europeans, combined with the spirit of Romantic landscape painting. Following the dictates of current aesthetics, Richardson carefully selected the elements of his composition, contriving to heighten the emotive and evocative impact. The view of the Acropolis is taken from the Hill of the Pnyx, closely associated with the history of ancient Athenian democracy, where the People's Assembly (*ecclesia of the deme*), the most important representative body of the ancient city-state, held its sessions. In opting for this site, the painter endeavours to impart an allegorical dimension to the representation – in the eyes of the cultivated viewer, the dialogue between the Acropolis, symbol of Athens and of ancient Greek civilisation, and the Pnyx, symbol of democratic ideas, hints at the dialogue between art and politics which found their ideal manifestation in ancient Hellas. Thanks to the successful staging, the British artist created an Athenian image that affects the viewer and suggests an imagined recourse to the illustrious Greek past. F-MT

Unpublished.

View of Athens from the Ilissos River

Johann Michael Wittmer
(1802-1880)

Cat no. 160
1834
Watercolour on paper,
24.5 x 39.5 cm
Inv. no. 23995

The work is unsigned but has been identified thanks to a series of watercolours in the possession of the Museum of the City of Athens and ascribed to the same painter. Protegé of King Ludwig I of Bavaria (1786-1868), the German landscape painter Johann Michael Wittmer lived and worked in Rome between 1828 and 1843. In 1834 he visited Greece as a member of the retinue of Prince Maximilian of Bavaria, brother of King Otto (1833-1862) who had just assumed the kingship of the newly-founded Greek state.

At the time of Wittmer's journey, Athens was a small town of 3000 inhabitants, with humble dwellings alongside the heaped ruins of ancient and Byzantine monuments and more recent buildings that had been destroyed in the War of Independence. According to accounts of foreign artist-travellers, the young Greek capital offered countless scenic possibilities for those who adored the picturesque.

The visual angle selected by the painter for this view of Athens permits him to give a synoptic image of the city within the walls, with the Acropolis in the background, and to include well-known ancient monuments. Dominating the middle ground is the Olympieion, the Temple of Olympian Zeus, a colossal building which was completed in AD 131-132, in the reign of Emperor Hadrian and alternatively known as Hadrian's Palace. Foreign visitors were impressed by the sight of the gigantic columns still standing on an immense terrace. Discernible between them is the Arch of Hadrian, constructed in his honour in the second century AD and later incorporated in the Turkish fortification wall raised by Haseki (see cat no. 158), which was used as one of the main city gates and was known as Kamaroporta (the Arched Gate). In the foreground is the River Ilissos, known from antiquity, which by the nineteenth century had almost run dry, as can be seen in the work.

Wittmer, an acutely sensitive and highly talented draughtsman, captured in this view the special character of Athens at that time, the anarchical coexistence of monuments of different eras, which gave the city the aspect of a stage set. Here the viewer follows, between the columns of the Olympieion, a scenic panorama in which are imprinted the ancient and the later monuments, as if narrators of the city's long history. The limpidity of the atmosphere and the festival costumes of the figures in the foreground contribute to the joyous air of this representation. F-MT

Unpublished. For a similar painting by J M Wittmer see: *Through Romantic Eyes* 1991, 48–49, no 12 (F-M Tsigakou); Delivorrias, Fotopoulos 1997, 573, fig 1007.

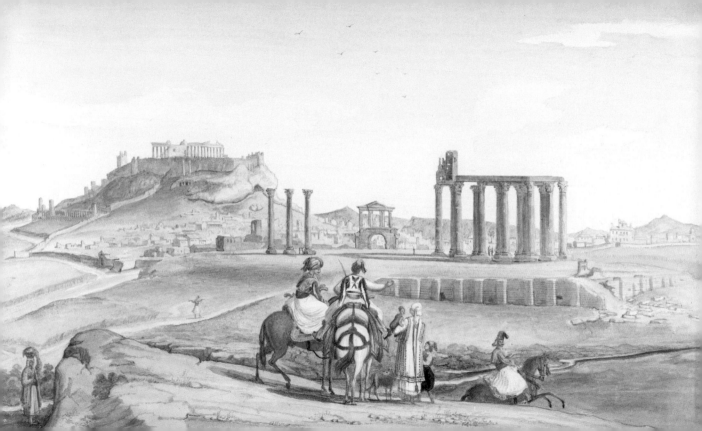

The Gate of the Roman Agora

Théodore Achille Louis, Vicomte du Moncel (1821-1884)

Cat no. 161
1845
Tinted lithograph on paper,
25 x 38 cm
Inv. no. 27882

The French antiquarian and inventor Théodore Achille Louis, Vicomte du Moncel toured Italy, Greece and Turkey in 1843 and 1845. During the period 1846–1849 he exhibited works with Greek subjects in the Paris Salon, while in 1843–1845 he published the impressions of his travels in three monumental illustrated tomes with the titles *De Venise à Constantinople à travers la Grèce* (Paris 1843), *Vues pittoresques des monuments d'Athènes* (Paris 1845) and *Excursion par terre d'Athènes à Nauplie* (Paris 1845).

The numerous European illustrated publications with Greek subjects that circulated during the reign of Otto (1833–1863) offer a panorama of the landscape, the environment and the inhabitants of Athens and of Attica, which are of exceptional significance for scholars of Neohellenic history. Since King Otto made efforts to transform immediately ruinous Athens into a European capital worthy of its erstwhile glory, around the mid-nineteenth century spectacular changes were made in the urban planning structure and morphology of the city. A reliable image of Athens at this time is given by Du Moncel in his book *Vues pittoresques des monuments d'Athènes*. This monumental album in folio format includes fourteen lithographic plates of the most important ancient and Byzantine monuments.

This particular representation of Athens is plate 7 from the album. The Roman Agora (Forum Romanum), natural continuation of the ancient Agora, was built c. 10 BC, according to the dated inscription over its imposing entrance, the Gate of Athena Archegetis, which is depicted here. In Ottoman times this Roman gate was known as the Pazaroporta (Bazaar Gate), because it was used as the entrance to the bazaar, the commercial centre of Athens, which occupied the area between the Roman Agora and the Library of Hadrian (see cat no. 162). The little Byzantine church to the right of the gate is that of Hagia Soteira (known as 'of the Pazaroporta'), of the seventeenth century, which was demolished before the end of the nineteenth century. In the left background is the hexagonal Tower of the Winds or Clock of Andronikos Kyrrhestou, a Roman monument of the first century BC, and adjacent to it, at the edge of the picture, stands the sixteenth-century Fethiye Cami or Mosque of the Grain Market, which was built in honour of Mohamed the Conqueror (1451-1481). F-MT

Published: *Athens* 1985, 80, no 205 (F-M Tsigakou). For further details on the painter see: Tsigakou 1981, 200–201.

The Library of Hadrian

Théodore Achille Louis, Vicomte du Moncel (1821-1884)

Cat no. 162
1845
Tinted lithograph on paper,
25 x 38 cm
Inv. no. 27884

The representation is plate 8 in Du Moncel's lithographic album (see cat no. 161), where it is entitled *Painted Stoa*, referring to the colonnade (stoa) with monumental columns depicted on the right side of the picture. Nineteenth-century visitors to Athens referred to this monument by various names, such as Painted Stoa or Stoa of Hadrian or Gymnasium, for its true identity was not discovered until after 1884, when systematic excavations commenced in the area of the Roman Agora (Forum Romanum). Recent archaeological investigation shows that this imposing colonnade is part of the propylon of the Library of Hadrian, a huge building constructed in AD 132, next to the Forum. Depicted at the edge of the propylon – incorporated in two columns – is a small Byzantine church. This is Hagioi Asomatoi sta Skalia (Incorporeal Saints at the Steps) of the eleventh century, which belonged to the noble Athenian Chalkokondylis family and was demolished before the end of the nineteenth century, falling victim to the antiquarian extremism of 'purifying archaeological sites'. The Ottoman building visible at the far end of the road is the Djisdaraki Cami or Mosque of the Lower Fountain, which was built in 1759 by the homonymous Turkish governor, as recorded by the surviving inscription. For its construction one of the columns of the Temple of Olympian Zeus was used to make lime.

This particular lithograph, with the small Byzantine church of the Incorporeal Saints, is a unique visual testimony for those who study Byzantine Athens. Well known is the zealous effort to restore the antiquities, which – unfortunately – downgraded care for the Byzantine monuments, many of which were pulled down or left to fall into dilapidation during the nineteenth century. The lack of interest in Byzantine monuments is not a uniquely Greek phenomenon, since interest in Byzantine studies in the West also came rather late. An exception is the French researcher A-N Didron, who in his book *Manuel d'iconographie chrétienne grecque et latine* (Paris 1845), exhorted King Otto to stop sacrificing the Byzantine monuments in order to enhance the antiquities.

In this representation the artist has brought to life a neighbourhood of Athens which was exceptionally popular because of its proximity to the Acropolis. People and architecture have been depicted with photographic perfection, the costumes creating a picturesque contrast with the ancient monuments. The works of the artist-travellers who flooded into Greece during the nineteenth century are tangible testimonies not only to the illustrious past, but also to the landscape. Similar scenes from the everyday life of the inhabitants enacted alongside the ancient ruins in a way established the modern Greeks in the consciousness of Europeans as the natural heirs to the ancient Hellenic world. F-MT

Unpublished. For further details on the painter see: Tsigakou 1981, 200–201.

A Greek Couple
John Linton

Cat no. 163
c. 1860
Oil on canvas, 22 x 30 cm
Signed 'John Linton'
Inv. no. 9006

John Linton, about whom no biographical details are known, following the dictates of the day endeavours to remodel a 'Greek' scene of everyday life. After the mid-nineteenth century a progressive shift of interest among foreign artist-travellers is observed, from presenting the ancient monuments to portraying scenes from Neohellenic daily life. The 'Greek' images painted by foreign artists were now addressed to a public with diminished archaeological interest, and fascinated mainly by the quaint contrasts of Greece, a land on the threshold of East and West, which had just emerged from four hundred years of foreign occupation.

John Linton's canvas represents a Greek couple, a young man playing a traditional Greek musical instrument, the shawm (*zournas*), and a young girl spinning wool. Painted with idealised features and in luxurious garments, they are shown sitting beside an ancient relief, while dispersed in the space between them are ancient ruins with the Acropolis in the background looming over all.

The work is perfectly attuned to the spirit of mid-nineteenth-century travel-painting and is addressed to viewers who are not so much interested in specific features of a landscape as in enjoying an attractive image of a popular destination. In this particular case the viewer is not invited to get to know Athens – a city in any case familiar from a host of images in the travel publications which circulated widely in that period – but mainly to escape to a setting with dazzling atmosphere, unique monuments and unaffected inhabitants. In a nutshell, to travel in imagination to a land considered an ideal destination of escape from the northern climate and grey, overcast skies.

The elements of local identity, such as the Acropolis and other antiquities, are rendered through a Romantic approach and a tendency to the picturesque, stereotypes encountered in a host of analogous works of the time. The composition is theatrical in character and alludes to eighteenth-century pastoral idylls of Arcadian inspiration. Nevertheless, thanks to the stylistic elegance of the composition and the warm colour tones, the artist succeeded in creating a 'Greek' genre scene with a lyrical disposition. F-MT

Published: Tsigakou 1981, 69; *Through Romantic Eyes* 1991, 84–85, no 30 (F-M Tsigakou).

ABBREVIATIONS OF PERIODICALS AND SERIES

AA	Archäologischer Anzeiger	BZ	Byzantinische Zeitschrift
ΑΔ	Αρχαιολογικόν Δελτίον	CVA	Corpus Vasorum Antiquorum
AE	Αρχαιολογική Εφημερίς	ΔΧΑΕ	Δελτίον της Χριστιανικής Αρχαιολογικής Εταιρείας
ΑΕΜΘ	Το Αρχαιολογικό Έργο στη Μακεδονία και στη Θράκη	DOP	Dumbarton Oaks Papers
AJA	American Journal of Archaeology	Hesperia	Hesperia, Journal of the American School of Classical Studies at Athens
AM	Mitteilungen des Deutschen Archäologischen Instituts. Athenische Abteilung	JbAC	Jahrbuch für Antike und Christentum
ASAtene	Annuario della Scuola Archeologica di Atene e delle Missioni italiane in Oriente	JÖB	Jahrbuch der Österreichischen Byzantinistik
ASOR	American Schools of Oriental Research	LIMC	Lexicon Iconographicum Mythologiae Classicae
BABesch	Bulletin Antieke Beschaving	OJA	Oxford Journal of Archaeology
BAR	British Archaeological Reports	PLP	Prosopographisches Lexikon der Palaiologenzeit
BCH	Bulletin de Correspondance Hellénique	RA	Revue Archéologique
BNJ	Byzantinisch Neugriechische Jahrbücher	REB	Revue des études byzantines
BSA	Annual of the British School at Athens	SIMA	Studies in Mediterranean Archaeology
Byz F	Byzantinische Forschungen		

BIBLIOGRAPHY

Books and periodicals

Acheimastou-Potamianou, M. *Icons of the Byzantine Museum of Athens*, Greek Ministry of Culture/Archaeological Receipts Fund, Athens, 1998

Adriani, A. 'Un motivo "Teocriteo" in un vaso alessandrino', in *Mélanges offerts à Kazimierz Michalowski*, Panstwowe Wydawnictwo Naukowe, Warsaw, 1966

Aland, K. *Kurzgefasste Liste der griechischen Handschriften des Neuen Testaments, I. Gesamtübersicht* (Arbeiten zur neutestamentlichen Textforschung 1), De Gruyter, Berlin, 1963

Aland, K. *Die griechischen Handschriften des Neuen Testaments, Materialien zur neutestamentlichen Handschriftenkunde* (Arbeiten zur neutestamentlichen Textforschung 3), De Gruyter, Berlin, 1969

Amandry, A. *L'indépendance grecque dans la faïence française du 19e siècle*, Fondation Ethnographique du Péloponnèse-Nafplion, Athens, 1982

Amandry, P. *Collection H Stathatos: Les bijoux antiques*, vol I, Institut Archéologique de l'Université de Strasbourg, Strasbourg, 1953

Amyx, D A. *Corinthian vase-painting of the Archaic period*, 3 vols, University of California Press, Berkeley/Los Angeles/London, 1988

Apostolaki, A. 'Δύο "σημεία" με θρησκευτικά θέματα εκ του Μουσείου Μπενάκη', *AE* (1953–54), 157–161

ARV²: Beazley, J D. *Attic red-figure vase-painters*, Oxford University Press, Oxford, 1963²

Aslanis, I. *Η προϊστορία της Μακεδονίας I: Η Νεολιθική εποχή*, Kardamitsa Editions, Athens, 1992

Athanassoglou-Kallmyer, N M. *French images from the Greek War of Independence, 1821–1830*, Yale University Press, New Haven/London, 1989

Aupert, P. 'Chronique des fouilles et découvertes archéologiques en Grèce en 1974', *BCH* 99 (1975), 589–694

Bada-Tsomokou, K. *Η αθηναϊκή γυναικεία φορεσιά κατά την περίοδο 1687–1834*, PhD diss, University of Ioannina, Ioannina, 1983

Bailey, D. *A catalogue of the lamps in the British Museum: Roman provincial lamps*, vol III, British Museum Press, London, 1988

Bailey, D. *A catalogue of the lamps in the British Museum: Lamps of metal and stone, and lampstands*, vol IV, British Museum Press, London, 1996

Bakirtzis, Ch, Papanikola-Bakirtzi, D and Mavrikiou, F. *Byzantine glazed pottery in the Benaki Museum*, Benaki Museum, Athens, 1999

Baldini, I. 'Gli orecchini a corpo semilunato: Classificazione tipologica', *Corsi di Cultura sull'arte Ravennate e Bizantina* 38 (1991), 67–101

Ballian, A. 'Dedications and donors of 17th to 19th century church silver', *Mouseio Benaki* 1 (2001), 87–110

Ballian, A and Drandaki, A. 'A middle Byzantine silver treasure', *Mouseio Benaki* 3 (2003), 47–80

Baltoyanni, Chr. *Icons: Mother of God*, ADAM Editions, Athens, 1994

Barber, R L N. 'The pottery of Phylakopi, first city, phase ii (I–ii)', in A MacGillivray and R L N Barber eds, *The prehistoric Cyclades: Contributions to a workshop on Cycladic chronology. In memoriam John Langdon Caskey (1908–1981)*, Department of Classical Archaeology, Edinburgh, 1984, 88–93

Barber, R L N. *The Cyclades in the Bronze Age*, Duckworth, London, 1987

Bénazeth, D. *L'art du métal au début de l'ère chrétienne*, Réunion des musées nationaux, Paris, 1992

Bent, Th. *The Cyclades*, Longmans, Green & Co, London, 1885

Benzi, M. *Ceramica micenea in Attica*, Istituto Editoriale Cisalpino-La Goliardica, Milan, 1975

Betancourt, Ph. P. *The history of Minoan pottery*, Princeton University Press, Princeton, 1985

Birtacha, K. 'Χρώματα και χρωματισμός κατά την Πρώιμη Εποχή του Χαλκού στις Κυκλάδες', in A Vlachopoulos and K Birtacha eds, *Argonautis: Volume in honor of Prof Christos G Doumas*, Kathimerini SA, Athens, 2003, 263–276

Bittel, K. *Prähistorische Forschung in Kleinasien*, Universum-Druckerei, Istanbul, 1934

Blegen, C et al. *Troy I: General introduction to first and second settlements*, Princeton University Press, Princeton, 1950

Boulotis, Chr. 'Η ελιά και το λάδι στις ανακτορικές κοινωνίες της Κρήτης και της μυκηναϊκής Ελλάδας: Όψεις και απόψεις', in *Ελιά και Λάδι. Τριήμερο εργασίας, Καλαμάτα, 7–9 Μαΐου 1993*, ETBA Cultural Foundation, Athens, 1996, 19–58

Bouras, L. 'Παλαιοχριστιανικά και βυζαντινά θυμιατήρια του Μουσείου Μπενάκη', *Αρχαιολογία* 1 (1981), 64–70

Bouras, L. 'Byzantine lighting devices', *JÖB* 32.3, *Akten XVI: Internationaler Byzantinistenkongress* (1982), 479–491

Bouras, L. 'Νέο τρίπτυχο Κρητικής σχολής του 15ου αιώνα στο Μουσείο Μπενάκη', in *Ευφρόσυνον: Αφιέρωμα στον Μανόλη Χατζηδάκη*, vol 2, Archaeological Receipts Fund, Athens, 1992, 401-406 (in Greek with English summary)

Bouras, L. 'Δύο εικόνες του Αγίου Δημητρίου του Εμμανουήλ Τζάνε και η σχέση τους με ανθίβολα του Μουσείου Μπενάκη', in *Αντίφωνον: Αφιέρωμα στον καθηγητή Ν Β Δρανδάκη*, P Pournaras Editions, Thessaloniki, 1994, 361–369, 635 (in Greek with English summary)

Bowman, A. *Egypt after the Pharaohs, 332 BC–AD 642*, British Museum Press, London, 1986

Brommer, F. 'Archäologische Funde von Herbst 1938 bis Frühjahr 1939. Griechenland', *AA* 54 (1939), 223–268

Bruhn, J A. *Coins and costume in late antiquity* (see Exhibition Catalogues)

Buckton, D. 'Byzantine enamel and the west', *Byz F* 13 (1988), 235–244

Burn, L and Higgins, R. *Catalogue of Greek terracottas in the British Museum*, vol III, British Museum Press, London, 2001

Cattapan, M. 'Nuovi documenti riguardanti pittori cretesi dal 1300 al 1500', in *Πεπραγμένα του Β΄ Διεθνούς Κρητολογικού Συνεδρίου, Γ΄ Τμήμα Μεσαιωνολογικόν*, Philological Society 'Chrisostomos', Athens, 1968, 29–46

Cattapan, M. 'I pittori Andrea e Nicola Rizo da Candia', *Θησαυρίσματα* 10 (1973), 238–282

Cauvin, J. 'La signification symbolique de l'obsidienne', in M-C Cauvin et al eds, *L'obsidienne au proche et moyen Orient: Du volcan à l'outil*, BAR 738 (1998), 379–383

Chatzidaki, E. 'Χριστιανικές επιγραφές Μικράς Ασίας και Πόντου', *Μικρασιατικά Χρονικά* 8 (1959), 1–27

Chatzidakis, M. 'Bijoux des XVIᵉ, XVIIᵉ et XVIIIᵉ siècles rehaussés d'émail et de pierreries', in *Collection H Stathatos: Les objets byzantins et post-byzantins*, vol II, n p, Limoges, 1957, 69–78

Chatzidakis, M. *Icônes de Saint Georges des Grecs et de la Collection de l'Institut*, Institut hellénique d'études byzantines et post-byzantines de Venise, Venice, 1962

Chatzidakis, M. *Icons of Patmos*, National Bank of Greece, Athens, 1985

Chatzidakis, M and Drakopoulou, E. *Έλληνες ζωγράφοι μετά την Άλωση (1450–1830)*, vol 2, Institute of Neohellenic Research, Athens, 1997

Chatzidakis, N. *Icons of the Cretan School* (see Exhibition Catalogues)

Chatzidakis, N. *Icons: The Velimezis Collection*, Benaki Museum, Athens, 1997

Chatzidakis, N. 'Άγνωστη εικόνα του αγίου Συμεών του Θεοδόχου στη Σίφνο', *ΔΧΑΕ* 24 (2003), 243–256 (in Greek with French summary)

Chatzidakis, Th. *L'art des icônes en Crète et dans les îles après Byzance* (see Exhibition Catalogues)

Chatzimichali, A. *Ελληνική λαϊκή τέχνη, Σκύρος*, P G Makris, Athens, 1925

Chatzimichali, A. 'Μεσογειακά και Εγγύς Ανατολής κεντήματα: Τα ελληνικά κεντήματα — Ήπειρος, Σκύρος', *BNJ* 12 (1936), 96–118

Cherry, J F and Torrence, R. 'The typology and chronology of chipped stone assemblages in the prehistoric Cyclades', in J A MacGillivray and R L N Barber eds, *The prehistoric Cyclades: Contributions to a workshop on Cycladic chronology. In memoriam John Langdon Caskey (1908–1981)*, Department of Classical Archaeology, Edinburgh, 1984, 12–25

Chevalier, J and Gheerbrant, A. *Dictionnaire des symboles*, Laffont, Paris, 1982²

Coldstream, J N. *Greek Geometric pottery: A survey of ten local styles and their chronology*, Methuen, London, 1968

Coldstream, J N. *Geometric Greece*, E Benn, London, 1977

Constantoudaki-Kitromilides, M. 'Ο Θεοφάνης, ο Marcantonio Raimondi, θέματα all' antica και grottesche', in *Ευφρόσυνον: Αφιέρωμα στον Μανόλη Χατζηδάκη*, vol 1, Archaeological Receipts Fund, Athens, 1991, 271–282 (in Greek with English summary)

Corinth XI: Morgan, Ch H. Corinth XI: *The Byzantine pottery*, Cambridge Massachusetts, 1942

Cortopassi, R and Tsourinaki, S. *Catalogue of the Coptic textiles in the Benaki Museum* (forthcoming)

Cotsonis, J. *Byzantine figural processional crosses* (see Exhibition Catalogues)

Csapo, E. 'Deep ambivalence: Notes on a Greek cockfight (Part I)', *Phoenix* 47 (1993), 1–28

Cutler, A. *The aristocratic psalters in Byzantium*, Picard, Paris, 1984

Davis, E. *The Vapheio cups and Aegean gold and silver ware*, Garland, London, 1977

De Chaves, L. '"La fuite en Égypte et le retour des Mages": Médaillon copte de la collection du Musée Benaki', *Bulletin de la Société d'Archéologie Copte* XXXIII (1994), 57–62

Delivorrias, A. *Benaki Museum: Greek traditional jewelry*, 'Melissa' Publishing House, Athens, 1980

Delivorrias, A. 'Traditional art on the Aegean islands', in *The Aegean: The epicenter of Greek civilization* (collective work), 'Melissa' Publishing House, Athens, 1992, 281–360

Delivorrias, A. 'Carved wooden chests from the Peloponnese: Questions of stylistic and thematic singularity', *Mouseio Benaki* 1 (2001), 111–125

Delivorrias, A. 'Decoration of houses', in D Philippides ed, *Aegean islands: Architecture*, 'Melissa' Publishing House, Athens, 2003, 50–67

Delivorrias, A and Fotopoulos, D. *Greece at the Benaki Museum*, Benaki Museum, Athens, 1997

Der Nercessian, S. 'A psalter and New Testament manuscript at Dumbarton Oaks', *DOP* 19 (1965), 153–183

Der Nercessian, S. *L'art arménien*, Arts et Métiers Graphiques, Paris, 1977

Despini, Aik. *Greek art: Ancient gold jewellery*, Ekdotike Athenon, Athens, 1996

Diehl, E. *Die Hydria: Formgeschichte und Verwendung im Kult des Altertums*,

Philipp von Zabern, Mainz on Rhine, 1964

Djavakhichvili, A and Abramichvili, G. *Orfèvrerie et toreutique des musées de la République de Géorgie*, Aurora Art Publishers, Leningrad, 1986

Drandaki, A. 'Εικόνα με τον Άγιο Θεόδωρο Στρατηλάτη από την κληρονομιά της Ελένης Ευκλείδη', *Τα Νέα των Φίλων του Μουσείου Μπενάκη* (1996), 41–48

Drandaki, A. 'Η Αναστήλωση των εικόνων: Παράδοση και ανανέωση στο έργο ενός Κρητικού ζωγράφου του 16ου αιώνα', *Mouseio Benaki* 1 (2001), 59–78 (in Greek with English summary)

Drandaki, A. *Greek icons, 14th–18th century: The Rena Andreadis Collection*, Skira, Milan, 2002

Drandakis, N B. *Ο Εμμανουήλ Τζάνε Μπουνιαλής, θεωρούμενος εξ εικόνων του σωζομένων κυρίως εν Βενετία*, Athens Archaeological Society, Athens, 1962

Drandakis, N B. 'Συμπληρωματικά εις τον Εμμανουήλ Τζάνε. Δύο άγνωστοι εικόνες του', *Θησαυρίσματα* 11 (1974), 36–72

Effenberger, A and Severin, H G. *Das Museum für Spätantike und Byzantinische Kunst*, Philipp von Zabern, Mainz on Rhine, 1992

Elgood, R. *Firearms of the Islamic world in the Tareq Rajab Museum, Kuwait*, Tauris, London/New York, 1995

Elsner, J. 'Visualising women in late antique Rome: The Projecta casket', in Chr. Entwistle ed, *Through a glass brightly: Studies in Byzantine and Medieval art and archaeology presented to David Buckton*, Oxbow Books, London, 2003, 22–36

Emery, W B and Kirwan, L P. *The royal tombs of Ballana and Qustul*, 2 vols, Service des Antiquités de l'Égypte, Cairo, 1938

Ennabli, A. *Lampes chrétiennes de Tunisie (Musées du Bardo et de Carthage)*, Editions CNRS, Paris, 1976

Ercegović Pavlović, S. *Les sites d'habitation et les necropolis médiévaux de Boljetin et de Hadjučka Vodenica*, Cahiers des Portes de Fer 1, Belgrade, 1986

Evans, J and Renfrew, C. *Excavations at Saliagos near Antiparos*, BSA suppl. 5 (1968)

Firatli, N. 'Müzemize yeni giren eserlerden birkaçi', *Instanbul Arkeoloji Müzeleri Yilliği* 15–16 (1969), 180–181

Fotopoulos, D. *Athenian fashions at the turn of the 19th century*, Hellenic Literary and Historical Archive, Athens, 1999

French, E. 'Development of Mycenaean terracotta figurines', *BSA* 66 (1971), 101–188

Galavaris, G. *Bread and the liturgy*, Wisconsin University Press, London/Wisconsin, 1970

Garidis, M. *Διακοσμητική ζωγραφική: Βαλκάνια — Μικρασία 18ος–19ος αιώνας*, 'Melissa' Publishing House, Athens, 1996

Gedeon, M. *Πατριαρχικοί πίνακες*, Lorenz & Keil, Constantinople, 1885–90

Getz-Gentle, P. *Stone vessels of the Cyclades in the Early Bronze Age*, Pennsylvania State University Press, Pennsylvania, 1996

Gonosovà, A and Kondoleon, Chr. *Art of late Rome and Byzantium in the Virginia Museum of Fine Arts*, Virginia Museum of Fine Arts, Richmond, 1994

Grabar, A. *L'âge d'or de Justinien*, Gallimard, Paris, 1966

Grabar, A. *Sculptures byzantines du moyen âge (XIe–XIVe siècle)*, vol II, Librairie Adrien-Maisonneuve, Paris, 1976

Gratziou, O. *Die dekorierten Handschriften der Schreibers Matthaios

von Myra (1526–1624)*, K Michalas Editions, Athens, 1982

Hadjisavvas, S. 'The production and diffusion of olive-oil in the Mediterranean, *ca* 1500–500 BC', in N Chr. Stampolidis and V Karageorghis eds, *Πλόες. Sea Routes: Interconnections in the Mediterranean 16th–6th c. BC. Proceedings of the International Symposium held at Rethymnon, Crete, Sept. 29–Oct. 2, 2002*, University of Crete/A G Leventis Foundation, Athens, 2003, 117–123

Hadzimichali, A. *Hellenic National Costumes*, (A E Benaki ed), vol II, Benaki Museum, Athens, 1954

Haskell, H. 'The origin of the Aegean stirrup jar and its earliest evolution and distribution (MB III–LB I)', *AJA* 89 (1985), 221–229

Hatzimichali, A. *Benaki Museum: The Greek folk costume* (T Ioannou-Yiannara ed), vol I, Benaki Museum/'Melissa' Publishing House, Athens, 1979

Hatzimichali, A. *Benaki Museum: The Greek folk costume* (T Ioannou-Yiannara ed), vol II, Benaki Museum/'Melissa' Publishing House, Athens, 1984

Hayes, J W. *Late Roman pottery*, British School at Rome, London, 1972

Hayes, J W. *Ancient lamps in the Royal Ontario Museum, I: Greek and Roman clay lamps, a catalogue*, Royal Ontario Museum, Toronto, 1980

Hayes, J W. *Roman and related metalware in the Royal Ontario Museum*, Royal Ontario Museum, Toronto, 1984

Herscher, E. 'The ceramics', in S Swiny et al eds, *Sotira-Kaminoudhia: An Early Bronze Age site in Cyprus, ASOR Archaeological Reports* 8 (2003), 145–204

Hetherington, P. 'Enamels in the Byzantine world: Ownership and distribution', *BZ* 81 (1988), 29–38

Higgins, R A. *Greek and Roman jewellery*, Methuen, London, 1961

Hoffmann, H. 'Hahnenkampf in Athen: Zur Ikonologie einer attischen Bildformel', *RA* (1974), 195–220

Hoffmann, H and Davidson, P. *Greek gold: Jewellery from the age of Alexander* (see Exhibition Catalogues)

Hood, S. *Excavations in Chios 1938–1955: Prehistoric Emporio and Ayio Gala*, vol I, *BSA* suppl. 15 (1981)

Iconomaki-Papadopoulos, G. *Εκκλησιαστικά αργυρά*, Apostoliki Diakonia of the Church of Greece, Athens, 1980

Iconomaki-Papadopoulos, G. 'Εκκλησιαστικά αργυρά', in S Papadopoulos ed, *Σιμωνόπετρα, Άγιο Όρος*, ETBA Bank, Athens, 1991

Jantzen, ,U. 'Geometrische Kannenverschlüsse', *AA* 68 (1953), 56–67

Johnstone, P. *Byzantine tradition in church embroidery*, Alec Tiranti, London, 1967

Johnstone, P. *A guide to Greek island embroidery*, Victoria and Albert Museum, London, 1972

Kalavrezou-Maxeiner, I. *Byzantine icons in steatite*, 2 vols, Byzantina Vindobonensia 15, Vienna, 1985

Kalogeropoulou, A. 'Δείγματα άγνωστου κεραμεικού εργαστηρίου στη Σκύρο του 7ου αι. π.Χ', in *Atti del Convegno Internazionale Grecia, Italia e Sicilia nell' VIII e VII sec. AC, Atene 15–20 ottobre 1979, ASAtene* 61, Nuova Serie 45 (1984), 137–152

Kaplani, Y. *Modern Greek silverware: From the collections of the Museum of Greek Folk Art*, Greek Ministry of Culture, Athens, 1997

Kazanaki-Lappa, M. 'Two fifteenth-century icons in a private collection', in E Haustein-Bartsch and N Chatzidakis eds, *Greek icons: Proceedings of the symposium in memory of Manolis Chatzidakis in Recklinghausen, 1998,*

Benaki Museum/Ikonen-Museum Recklinghausen, Athens, 2000, 29–38

Kiss, Z. *Les ampoules de Saint Ménas découvertes à Kôm el-Dikka (1961–1981), Alexandrie*, vol V, Editions scientifiques de Pologne, Warsaw, 1989

Knoll, K. *Alltag und Mythos: Griechische Gefäße der Skulpturensammlung. Staatliche Kunstsammlungen Dresden*, UniMedia, Leipzig, 1998

Korré-Zographou, K. *Τα κεραμεικά του ελληνικού χώρου*, 'Melissa' Publishing House, Athens, 1995

Kourou, N. *CVA*, Greece 8 (Athens, National Museum), Athens, 2002

Kübler, K. *Kerameikos VI: Die Nekropole des 10. bis 8. Jahrhundert*, Berlin, 1954

Kurtz, D C. *Athenian white lekythoi: Patterns and painters*, The Clarendon Press, Oxford, 1975

Laffineur, R. *Les vases en métal précieux à l'époque mycénienne*, P Aströms Förlag, Göteborg, 1977

Lamb, W. *Excavations at Thermi in Lesbos*, Cambridge University Press, Cambridge, 1936

Langdon, S. 'From monkey to man: The evolution of a geometric sculptural type', *AJA* 94 (1990), 407–424

Lappa-Zizica, E and Rizou-Kouroupou, M. *Κατάλογος ελληνικών χειρογράφων του Μουσείου Μπενάκη (10ος–16ος αι.)*, Benaki Museum, Athens, 1991

Lemerle, P. 'Chronique des fouilles et découvertes archéologiques en Grèce en 1938', *BCH* 62 (1938), 443–483

Lemos, I S and Hatcher, H. 'Protogeometric Skyros and Euboea', *OJA* 5 (3) (1986), 323–337

Levidis, Απόσπασμα εκ της περιγραφής της Καππαδοκίας: Περί των σωζομένων εν Καππαδοκία εν μεμβράναις χειρογράφων Ευαγγελίων', *Ξενοφάνης* 5 (1907)

Loverdou, K. 'Θραύσματα πήλινων πρωτοχριστιανικών δίσκων στο Μουσείο Μπενάκη', *ΔΧΑΕ* 5 (1969), 229–246 (in Greek with French summary)

Loverdou-Tsigaridas, K. *Οστέινα πλακίδια: Διακόσμηση ξύλινων κιβωτιδίων από τη χριστιανική Αίγυπτο*, Greek Ministry of Culture, Athens, 2000

Makridis, Th. 'Χαλκά Μακεδονικά του Μουσείου Μπενάκη', *AE* (1937), 512–521

Malagardis, N and Iozzo, M. 'Amasis et les autres: Nuovi documenti del pittore di Amasis', *AE* (1995), 185–208

Manakidou, E P. *Παραστάσεις με άρματα (8ος–5ος αι. π.Χ.): Παρατηρήσεις στην εικονογραφία τους*, Kardamitsa Editions, Thessaloniki, 1994

Marangou, L. *Bone carvings from Egypt*, Ernst Wasmuth, Tübingen, 1976

Marangou, L I. *Ancient Greek art: The N P Goulandris Collection*, N P Goulandris Foundation, Athens, 1996²

Mastrapas, A. *Η ανθρώπινη και οι ζωικές μορφές στην προϊστορική κεραμεική των Κυκλάδων*, Kapodistrian University of Athens/School of Philosophy, Athens, 1991

Mastrapas, A. 'Σύνθετο κεραμεικό σκεύος της Πρώιμης Χαλκοκρατίας από το Μουσείο Μπενάκη', *Annals of the Second Cycladological Congress, Thera 31 Aug.–3 Sept. 1995* (in press)

Megaw, A. 'An early thirteenth century Aegean glazed ware', in G Robertson and G Henderson eds, *Studies in memory of David Talbot Rice*, Edinburgh University Press, Edinburgh, 1975, 34–45

Metzger, C. *Les ampoules à eulogie du Musée du Louvre*, Réunion des musées nationaux, Paris, 1981

Minotos, D-A. ' Όπλα από τους απελευθερωτικούς αγώνες των Ελλήνων, 18ος-19ος αιώνας',

in *Sylloges Evangelou Averoff* (see Exhibition Catalogues), 210-231

Mollard-Besques, S. *Musée Nationale du Louvre: Catalogue raisonné des figurines et reliefs en terre-cuite grecs, étrusques et romains I. Époques préhellénique, géométrique, archaïque et classique*, Réunion des musées nationaux, Paris, 1954

Montesanto, M. *L'isola dei Gigli (Stampalia)*, Sindacato Italiano Arti Grafiche, Rome, nd

Mottier, Y. *Die deutschen Ausgrabungen auf der Otzaki-Magula in Thessalien, II. Das mittlere Neolithikum*, Habelt, Bonn, 1981

Mountjoy, P A. *Mycenaean decorated pottery: A guide to identification*, *SIMA* 73 (1986)

Mountjoy, P A. *Mycenaean Athens*, P Aströms Förlag, Jonsered, 1995

Mouriki, D. 'The mask motif in the wall paintings of Mistra: Cultural implications of a classical feature in late Byzantine painting', *ΔΧΑΕ* 10 (1980–1981), 307–338

Mouseio Benaki — Glyptiki: Ελληνική και ρωμαϊκή γλυπτική από τις συλλογές του Μουσείου Μπενάκη, St. Vlizos ed, Benaki Museum/'Melissa' Publishing House, Athens, 2004

Mundell-Mango, M. 'Beyond the amphora: Non-ceramic evidence for late antique industry and trade', in S Kingsley and M Decker eds, *Economy and exchange in the East Mediterranean during late antiquity. Proceedings of a conference at Somerville College, Oxford, 29 May 1999*, Oxbow Books, Oxford, 2001, 87–106

Mylonas, G. *Δυτικόν νεκροταφείον της Ελευσίνος*, vol B, Athens Archaeological Society, Athens, 1975

Nicolescu, C. *Argintăria laică și religiosă in Tarile Romăne (sec. XIV–XIX)*, n p, Bucharest, 1968

Oakley, J and Sinos, R. *The wedding in ancient Athens*, Wisconsin University Press, London/Wisconsin, 1993

Palmer, R. 'Trade in wine, perfumed oil and foodstuffs: The Linear B evidence and beyond', in N Chr. Stampolidis and V Karageorghis eds, *Πλόες. Sea Routes: Interconnections in the Mediterranean 16th–6th c. BC. Proceedings of the International Symposium held at Rethymnon, Crete, Sept. 29–Oct. 2, 2002*, University of Crete/A G Leventis Foundation, Athens, 2003, 125–140

Papademetriou, E. *Cypriot ethnography collections in British museums*, Cypriot Ministry of Education and Culture/Cultural Services, Nicosia, 2000

Papageorgiou, I. ῞Ενα μαρμάρινο κυκλαδικό ειδώλιο στο Μουσείο Μπενάκη', *Τα Νέα των Φίλων του Μουσείου Μπενάκη* (1996), 29–34

Papageorgiou, I. 'Μαρμάρινο νεολιθικό ειδώλιο-περίαπτο γυναικείας μορφής: Συμπεράσματα από ένα παλαιό εύρημα', *Mouseio Benaki* 2 (2002), 9–18

Papageorgiou, I. 'Eine reitende Kourotrophos Göttin geometrischer Zeit im Benaki Museum', *AM*, 2005 (in press)

Papanikola-Bakirtzi, D. 'Η ταυτότητα ενός αγγείου στο Μουσείο Μπενάκη', *Report of the Department of Antiquities, Cyprus* (1984), 351–353

Papanikola-Bakirtzi, D. *'Μεσαιωνική εφυαλωμένη κεραμική της Κύπρου: Τα εργαστήρια Πάφου και Λαπήθου'*, AG Leventis Foundation, Thassaloniki, 1996

Papanikola-Bakirtzi, D ed. *Βυζαντινά εφυαλωμένα κεραμικά, Η τέχνη των εγχαράκτων* (see Exhibition Catalogues)

Papantoniou, I. 'Οι τοπικές φορεσιές στο Αιγαίο από την Άλωση μέχρι την απελευθέρωση: Μια πρώτη προσέγγιση'', *Ethnographica* 4–5 (1983–85), 29–44 (in Greek with English summary)

Papantoniou, I. *Greek regional costumes*, Peloponnesian Folklore Foundation-Nafplion, Athens, 1996

Papazotos, Th. *Βυζαντινές εικόνες της Βέροιας,* Akritas Editions, Athens, 1995

Paralipomena: Beazley, J D. *Paralipomena: Additions to Attic black-figure vase-painters and to Attic red-figure vase-painters*, Oxford University Press, Oxford, 1971[2]

Paschalis, D P. 'Μονή της Ζωοδόχου Πηγής ή Αγίας', *Ανδριακά Χρονικά* 10 (1961), 17–172

Pavolini, C. 'Le lucerne in terra sigilata africanada esportazione: Proposta di una tipologia', in *Colloque sur la céramique antique, Carthage 23–24 juin 1980, Actes*, Centre d'études et de documentation archéologique de Carthage, Carthage Dossier 1, Tunis, 1982, 141–156

Pecorella, P E. *La cultura preistorica di Iasos in Caria*, G Bretschneider, Rome, 1984

Peege, Chr. *Die Terrakotten aus Böotien der archäologischen Sammlung der Universität Zürich*, Archäologisches Institut der Universität Zürich, Zurich, 1997

Petrakis, J. *The needle arts of Greece: Design and techniques*, Charles Scribner, New York, 1977

Philothéou, G and Michailidou, M. 'Βυζαντινά πινάκια από το φορτίο ναυαγισμένου πλοίου κοντά στο Καστελλόριζο'', *ΑΔ* 41 (1986), Μελέτες, 271–329

Philothéou, G and Michailidou, M. 'Plats byzantins provenant d'une épave près de Castellorizo', in V Déroche and J M Spieser eds, *Recherches sur la céramique byzantine: Actes du colloque organisé par l'École française d'Athènes et l'Université de Strasbourg II, BCH* suppl. XVIII (1989), 173–176

Pieridou, A G. *Κυπριακή λαϊκή τέχνη*, Cyprus Research Centre, Nicosia, 1980

Pingiatoglou, S. *Η κοροπλαστική της Αιγύπτου κατά τους*

ελληνιστικούς και ρωμαϊκούς χρόνους, Benaki Museum, Athens, 1993

Pipili, M. *CVA*, Greece 4 (Athens, National Museum), Athens, 1993

Pipili, M. 'A skyphos by the Affecter in Athens: Dispersed fragments reassembled', in O Palagia ed, *Greek offerings: Essays on Greek art in honour of J Boardman*, Oxbow Books, Oxford, 1997, 87–94

Pitarakis, B. *Les croix-reliquaires pectorales en bronze: Recherches sur la production des objets métalliques à Byzance*, PhD diss, Paris I University, Paris, 1996

Polychroniadis, H. *Benaki Museum: Greek embroideries*, Benaki Museum, Athens, 1980

Polychronopoulou, N. *Intelligentsia Ionienne, XIe–XVIIIe s*, PhD diss, Paris I University, Paris, 1987

Poulou-Papadimitriou, N. 'Ορθογωνικός πήλινος δίσκος του Μουσείου Μπενάκη', in *Αντίφωνον: Αφιέρωμα στον καθηγητή Ν Β Δρανδάκη*, P Pournaras Editions, Thessaloniki, 1994, 354–360, 634–635 (in Greek with English summary)

Richter-Siebels, I. *Die palästinischen Weihrauchgefäße mit Reliefszenen aus dem Leben Christi*, Freien Universität Berlin, Berlin, 1990

Rizopoulou-Egoumenidou, E. *Η αστική ενδυμασία της Κύπρου κατά τον 18ο και τον 19ο αιώνα*, Bank of Cyprus Cultural Foundation, Nicosia, 1996

Rutschowscaya, M-H. *Musée du Louvre: Catalogue des bois de l'Égypte copte*, Réunion des musées nationaux, Paris, 1986

Sabetai, V. *CVA*, Athens, Benaki Museum (forthcoming)

Salomonson, J W. 'Kunstgeschichtliche und ikonographische Untersuchungen zu einem Tonfragment der Sammlung Benaki in Athen', *BABesch* 48 (1973), 3–82

Sampson, A. 'Η λαϊκή φορεσιά της Σκοπέλου και Αλοννήσου', *Αρχείον Θεσσαλικών Μελετών* 5 (1979), 95–137

Sanders, G D R. 'Παραγωγή των εργαστηρίων της Κορίνθου', in *Βυζαντινά εφυαλωμένα κεραμικά: Η τέχνη των εγχαράκτων* (see Exhibition Catalogues),159–186

Sapouna-Sakellaraki, E. 'Η Σκύρος στην Πρώιμη Εποχή του Σιδήρου: Νέα στοιχεία', *Αρχείον Ευβοϊκών Μελετών* 34 (2001–2002), 163–192

Saraphoglou, I. 'Περιγραφή της Αδριανουπόλεως', *Θρακικά* 2 (1929), 66–82

Scarisbrick, D. *Jewellery*, Batsford, London, 1984

SCE: Dikaios, P and Stewart, J R. *The Swedish Cyprus Expedition: The Stone Age and the Early Bronze Age in Cyprus*, vol IV, Part 1A, Lund, 1962

Schmidt, E M. *Martin-von-Wagner-Museum der Universität Würzburg: Katalog der antiken Terrakotten, I. Die figürlichen Terrakotten*, Philipp von Zabern, Mainz on Rhine, 1994

Schürmann, W. 'Katalog der antiken Terrakotten im Badischen Landesmuseum Karlsruhe', *SIMA* 84 (1989)

Segall, B. *Museum Benaki, Athen: Katalog der Goldschmiede-Arbeiten*, Pyrsos, Athens, 1938

Sicilianos, D. *Έλληνες αγιογράφοι μετά την Άλωσιν (1450–1800)*, Pyrsos, Athens, 1935

Simon, E. *Festivals of Attica: An archaeological commentary*, Wisconsin University Press, London/Wisconsin, 1983

Smithson, E L. 'A Geometric cemetery on the Areopagus: 1897, 1932, 1947', *Hesperia* 43 (1974), 325–390

Sotiriou, G and Sotiriou, M. *Εικόνες της Μονής Σινά*, 2 vols, Collection de l'Institut Français d'Athènes, Athens, 1956–58

Stewart, J R. *Corpus of Cypriot artefacts: Corpus artefacts of the Early Bronze Age*, Part III, *SIMA* III: 3 (1999)

Strzygowski, J. *Catalogue général des antiquités égyptiennes du Musée du Caire: Koptische Kunst*, Service des Antiquités de l'Egypte, Vienna, 1904

Tarsouli, A. *Δωδεκάνησα*, vol B, ALPHA (I M Skaziki), Athens, 1948

Taylor, R. *Embroidery of the Greek islands*, Interlink Books, New York/London, 1998

The Kyriazopoulos Collection of Greek commemoratives, Mykonos Folklore Museum, Mykonos, 1975

Theocharis, D R. *Neolithic Greece*, National Bank of Greece, Athens, 1973

Tiverios, M. *Ελληνική τέχνη: Αρχαία αγγεία*, Ekdotike Athenon, Athens, 1996

Török, L. *Late antique Nubia*, Archaeological Institute of the Hungarian Academy of Sciences, Antaeus 16, Budapest, 1988

Touloumis, K and Peristeri, K. 'Ανασκαφή στον Αρκαδικό Δράμας 1991: Προκαταρκτικές παρατηρήσεις για την οργάνωση και τη χρήση του χώρου με βάση τη διάκριση εσωτερικών και εξωτερικών χώρων', *ΑΕΜΘ* 5 (1991)

Tselikas, A. *Δέκα αιώνες ελληνικής γραφής (9ος–10ος αι.),* Benaki Museum, Athens, 1977

Tsigakou, F-M. *The rediscovery of Greece: Travellers and painters of the Romantic era*, Thames & Hudson, London, 1981

Tsitselis, E. *Κεφαλληνιακά Σύμμικτα,* vol 1, P Leonis Editions, Athens, 1904

Tsourinaki, S. 'Ένας κοπτικός χιτώνας στην κοπτική συλλογή του Μουσείου Μπενάκη', *Αρχαιολογία* 83 (2002), 29–36

Underwood, A P. *The Kariye Djami*, vols 1–3, Bollingen Foundation, New York, 1966

Vassilaki, M. 'Νεώτερα στοιχεία για το ζωγράφο Άγγελο Ακοτάντο', in *Ροδωνιά: Τιμή στον Μ Ι Μανούσακα,* vol 1, University of Crete, Rethymnon, 1994a, 87–96

Vassilaki, M. 'Η αποκατάσταση ενός τριπτύχου', in *Θυμίαμα στη μνήμη της Λασκαρίνας Μπούρα,* vol I, Benaki Museum, Athens, 1994b, 325–336

Vassilaki, M. *Από τους εικονογραφικούς οδηγούς στα σχέδια εργασίας των μεταβυζαντινών ζωγράφων*, Goulandri-Horn Foundation, Athens, 1995

Vassilaki-Mavrakaki, M. 'Ο ζωγράφος Άγγελος Ακοτάντος: Το έργο και η διαθήκη του (1436)', *Θησαυρίσματα* 18 (1981), 290–298

Vassilatos, N. *Όπλα: 1790–1860. Μνημεία ελληνικής ιστορίας και τέχνης,* EOMMEX, Athens, 1989 (in Greek with English summary)

Vei-Chatzidaki, E. *Εκκλησιαστικά κεντήματα,* Benaki Museum, Athens, 1953

Velmans, T. *L'art medieval de l'orient chrétien*, LIK, Sofia, 2002²

Vian, F. *Répertoire des gigantomachies figurées dans l'art grec et romain*, Klincksieck Editions, Paris, 1951

Vikan, G. 'Art, medicine and magic in early Byzantium', *DOP* 38 (1984), 65–86

Vikan, G. '"Guided by land and sea": Pilgrim art and pilgrim travel in early Byzantium', in *Festschrift für Josef Engemann, JbAC* 19 (1991), 74–92

Vikan, G. 'Byzantine pilgrims' art', in L Safran ed, *Heaven on earth: Art and the Church in Byzantium*, Pennsylvania State University Press, Pennsylvania, 1998

Vlachopoulou-Karabina, E. *Χρυσοκέντητα άμφια και πέπλα: Ιερά Μονή Ιβήρων*, Iviron Monastery-Mount Athos,

Mount Athos, 1998

Vranousi, E. 'Notes sur quelques actes suspects ou faux de l'époque byzantine', in *La paléographie grecque et byzantine: Colloques Internationaux du CNRS, no 559, Paris 21–25 Oct. 1974*, Editions CNRS, Paris, 1977, 505–517

Vranousi, E. 'Ένας ανέκδοτος αργυρόβουλλος ορισμός του Δημητρίου Παλαιολόγου και τα προβλήματά του', *Βυζαντινά* 10 (1980), 347–359

Wace, A J B. 'Prehistoric stone figurines from the mainland: Commemorative studies in honor of T L Shear', *Hesperia* suppl. 8 (1949), 423–426

Wace, A J B. 'Broderies grecques des XVIe, XVIIe, XVIIIe siècles', in *Collection H Stathatos: Les objets byzantins et post-byzantins*, II, n p, Limoges, 1957, 91–96

Walter, O. 'Archäologische Funde in Griechenland von Frühjahr 1939 bis Frühjahr 1940', *AA* 55 (1940), 140–143

Walter, Chr. 'The origins of the cult of Saint George', *REB* 53 (1995), 295–326

Walter, Chr. *The warrior saints in Byzantine art and tradition*, Ashgate, Aldershot, 2003a

Walter, Chr. 'Saint Theodore and the dragon', in Chr. Entwistle ed, *Through a glass brightly: Studies in Byzantine and Medieval art and archaeology presented to David Buckton*, Oxbow Books, London, 2003b, 95–106

Weale-Badieritaki, A. . *Το γυναικείο παραδοσιακό πουκάμισο της ηπειρωτικής Ελλάδας,* n p, Athens, 1980 (in Greek with English summary)

Weitzmann, K et al, *Les Icones*, Fernand Nathan, Paris, 1982 (orig. ed Milan, 1981)

Welters, L. *Women's traditional costume in Attica, Greece*, Peloponnesian Folklore Foundation-Nafplion, Athens, 1986

Wessel, K. *Byzantine enamels from the 5th to the 13th century*, Bongers,

Greenwich Connecticut, 1967

Williams, D and Ogden, J. *Greek gold: Jewellery of the classical world* (see Exhibition Catalogues)

Xanthopoulou, M. *Les luminaires en bronze et fer aux époques paléochrétienne et byzantine: Typologie, technologie, utilisation*, PhD diss, Paris 1 University, Paris 1997

Xyngopoulos, A. *Μουσείον Μπενάκη: Κατάλογος των εικόνων*, Benaki Museum, Athens, 1936

Xyngopoulos, A. *Συλλογή Ελένης Α. Σταθάτου: Κατάλογος περιγραφικός των εικόνων, των ξυλογλύπτων και των μετάλλινων έργων των βυζαντινών και των μετά την Άλωσιν χρόνων,* Athens Archaeological Society, Athens, 1951

Yeroulanou, Aim. 'Παλαιοχριστιανικά καλυκόμορφα δακτυλίδια', in *Θυμίαμα στη μνήμη της Λασκαρίνας Μπούρα,* vol I, Benaki Museum, Athens, 1994, 101–105

Yeroulanou, Aim. *Diatrita: Gold pierced-work jewellery from the 3rd to the 7th century*, Benaki Museum, Athens, 1999

Zaïri, M. 'Η παραδοσιακή γυναικεία φορεσιά της Αστυπάλαιας', *Καλυμνιακά Χρονικά* 14 (2001), 53–76

Zervoudaki, E. 'Ραβδωτά αγγεία με έκτυπα εμβλήματα και μελανόγραφες υδρίες Hadra από τις συλλογές του Εθνικού Αρχαιολογικού Μουσείου', in *Ελληνιστική κεραμική από την Κρήτη,* Greek Ministry of Culture/22nd Ephorate of Prehistoric and Classical Antiquities, Chania, 1997, 107–146

Zora, P. 'Η γοργόνα εις την ελληνικήν λαϊκήν τέχνην', *Παρνασσός* 2 (1960), 331–365

Zora, P. *Ελληνική τέχνη: Λαϊκή τέχνη,* Ekdotike Athenon, Athens, 1994

Exhibition Catalogues

Aegean crossroads: Greek island embroideries in the Textile Museum, J Trilling ed, The Textile Museum, Washington DC, 1983

Age of spirituality: Late antique and early Christian art, third to seventh century, K Weitzmann ed, Princeton University Press, New York, 1979

The Anatolian Civilisations, 18th Exhibition of the Council of Europe, F Edgü ed, vol II, Turkish Ministry of Culture and Tourism, Istanbul, 1983

Ancient faces: Mummy portraits from Roman Egypt, S Walker and M Bierbrier, British Museum Press, London, 1997

Art and culture of the Cyclades in the third millennium BC, J Thimme ed, C F Müller, Karlsruhe, 1977

Art and holy powers in the early Christian house, E Dautermann Maguire et al, University of Illinois Press, Urbana/Chicago, 1989

Arte y culto después de Bizancio, M Acheimastou-Potamianou ed, Greek Ministry of Culture, Athens, 1995

Athens from the end of the ancient era to Greek Independence, F-M Tsigakou ed, Greek Ministry of Culture, Athens, 1985

Benaki Museum Greek Jewellery: Greek jewellery from the Benaki Museum collections, E Georgoula ed, Benaki Museum/ADAM Editions, Athens, 1999

Beyond the Pharaohs: Egypt and the Copts in the 2nd to 7th centuries AD, F Friedman ed, Rhode Island School of Design, Providence, 1989

Bronzen von der Antike bis zur Gegenwart: Eine Ausstellung der Stiftung Preußischer Kulturbesitz, P Bloch ed, D Reimer, Berlin, 1983

Byzance: L'art byzantin dans les collections publiques françaises, J Durand et al eds, Réunion des musées nationaux, Paris, 1992

Βυζαντινά εφυαλωμένα κεραμικά: Η τέχνη των εγχαράκτων, D Papanikola-Bakirtzi ed, Archaeological Receipts Fund, Athens, 1999

Byzantine art: An European art, 9th Exhibition of the Council of Europe, M Chatzidakis ed, Office of the Minister to the Prime Minister of the Greek Government/Department of Antiquities and Archaeological Restoration, Athens, 1964

Byzantine art: Byzantine and post-Byzantine art, M Acheimastou-Potamianou ed, Archaeological Receipts Fund, Athens, 1986

Byzantine figural processional crosses, J Cotsonis, Dumbarton Oaks Byzantine Collection Publications 10, Washington DC, 1994

Byzantium: An oecumenical empire, J Albani ed, Greek Ministry of Culture, Athens, 2002

Byzantium: Faith and power (1261–1557), H C Evans ed, The Metropolitan Museum of Art/Yale University Press, New York, 2004

Byzantium: Treasures of Byzantine art and culture from British collections, D Buckton ed, British Museum Press, London, 1994

Ceremony and faith: Byzantine art and the divine liturgy, J Albani and Y Vitaliotis eds, Greek Ministry of Culture, Athens, 1999

Collection of Christos G Bastis: Antiquities from the Collection of Christos G Bastis, E Swan Hall ed, Philipp von Zabern, New York/Mainz on Rhine, 1987

Collection of Stavros Niarchos: Ancient Greek Art: From the Collection of Stavros S Niarchos, L I Marangou et al, N P Goulandris Foundation – Museum of Cycladic Art, Athens, 1995

Coins and costume in late antiquity, J A Bruhn, Dumbarton Oaks Byzantine Collection Publications 9, Washington DC, 1993

Cosmèsis: La parure féminine en Grèce à l'époque post-byzantine, E Georgoula ed, Musée d'art et d'histoire de Fribourg, Fribourg (Swiss), 1984

Cradle of Christianity, Y Israeli and D Menorah, Jerusalem Israel Museum, Jerusalem, 2000

Cycladic art: Ancient sculpture and pottery from the N P Goulandris Collection, Chr. Doumas, British Museum Press, London, 1983

Di terra in terra: Nuove scoperte archeologiche nella provincia di Palermo, A Marotta et al eds, Soprintendenza per i Beni Culturali e Ambientali di Palermo/Museo Archeologico Regionale di Palermo, Palermo, 1991

Early Christian and Byzantine art, R Temple ed, The Temple Gallery/Element Books, London, 1990

Eikones Kritikis Technis: Εικόνες της Κρητικής τέχνης: Από τον Χάνδακα ως την Μόσχα και την Αγία Πετρούπολη, M Borboudakis ed, Vikelaia Library/Crete University Press, Herakleion, 1993

Everyday life in Byzantium, D Papanikola-Bakirtzi ed, Greek Ministry of Culture, Athens, 2002

From Byzantium to El Greco: Greek frescoes and icons, M Acheimastou-Potamianou ed, Greek Ministry of Culture/Byzantine Museum of Athens, Athens, 1987

Gli ori di Taranto in età ellenistica, E M De Juliis et al eds, Arnoldo Mondadori Editore Arte, Venice, 1989

The Glory of Byzantium: Art and culture of the middle Byzantine era AD 843–1261, H Evans and W D Wixom eds, The Metropolitan Museum of Art/Abrams, New York, 1997

Greece and the sea, A Delivorrias ed, Greek Ministry of Culture/Benaki Museum, Athens, 1987

Greek gold: Jewellery from the age of Alexander, H Hoffmann and P Davidson, Philipp von Zabern, Mainz on Rhine, 1965

Greek gold: Jewellery of the classical world, D Williams and J Ogden, British Museum Press, London, 1994

Greek jewellery: 6000 years of tradition, E Kypraiou ed, Archaeological Receipts Fund, Athens, 1997

Holy image, holy space: Icons and frescoes from Greece, M Acheimastou-Potamianou ed, Greek Ministry of Culture/Byzantine Museum of Athens, Athens, 1988

Icone di Puglia e Basilicata dal medioevo al Settecento, P Belli d'Elia ed, Mazzotta, Milan, 1988

Icons of the Cretan School, N Chatzidakis, Benaki Museum, Athens, 1983

Ikonen Bilder in Gold: Sakrale Kunst aus Griechenland, H Egger ed, Akademische Druck- und Verlanganstalt, Graz, 1993

In pursuit of the absolute: Art in the ancient world. The George Ortiz Collection, G Ortiz ed, Benteli-Werd Publications, Bern, 1996

Isskustvo Bizantii v Sobraniyakh SSSR, 3 vols, A Bank and O S Popovoj eds, Sovetskij Hudožnik, Moscow, 1977

L'art copte en Égypte: 2000 ans de christianisme, M-H Rutschowscaya and D Bénazeth eds, Institut du Monde Arabe/Gallimard, Paris, 2000

L'art des icônes en Crète et dans les îles après Byzance, Th. Chatzidakis, Palais des Beaux-Arts, Charleroi, 1982

La Grèce en révolte: Delacroix et les peintres français (1815–1848), C Constans ed, Réunion des musées nationaux, Paris, 1996

Master bronzes from the classical world, D G Mitten and S F Doeringer, Philipp von Zabern, Mainz on Rhine, 1968

Mother of God: Representations of the Virgin in Byzantine art, M Vassilaki ed, Benaki Museum/Skira, Milan, 2000

Neolithic culture in Greece, G A Papathanassopoulos ed, N P Goulandris Foundation –

Museum of Cycladic Art, Athens, 1996

Niccolò Tommaseo e il suo mondo: Tsigakou, F-M, 'La Grecia nelle imagini dei pittori filelleni Italiani nel Museo Benaki di Atene', in F Bruni ed, *Niccolò Tommaseo e il suo mondo: Patrie e nazioni*, Edizioni della Laguna, Venice, 2003, 141–143

Oi pyles tou mysteriou: Οι Πύλες του Μυστηρίου: Θησαυροί της Ορθοδοξίας από την Ελλάδα, M Borboudakis ed, National Gallery – Alexandros Soutzos Museum/Bastas-Plessas, Athens, 1994

Risorgimento Greco e Filellenismo Italiano, C Spetsieri-Beschi and E Lucarelli eds, Edizioni Del Sole, Rome, 1986

Roma-Armenia, C Mutafian ed, Edizioni de Luca, Rome, 1999

Rom und Byzanz: Archäologische Kostbarkeiten aus Bayern, G Wamser and G Zahlhaas eds, Hirmer Verlag/Prähistorische Staatssammlung, Munich, 1999

Silent witnesses: Early Cycladic art of the third millennium BC, Chr. Doumas (with contribution by J R Mertens), Alexander S Onassis Public Benefit Foundation, New York, 2002

Sinai, Byzantium, Russia: Orthodox art from the sixth to the twentieth century, Y Piatnitsky et al eds, Saint Catherine Foundation/ State Hermitage Museum, London, 2000

Splendeur de Byzance, J Lafontaine-Dosogne ed, Musées royaux d'art et d'histoire, Brussels, 1982

Sylloges Evangelou Averoff: Συλλογές Ευάγγελου Αβέρωφ: Ταξιδεύοντας στο χρόνο, O Mentzafou-Polyzou ed, Evangelos Averoff-Tossizza Foundation, Athens, 2000

The city beneath the city: Finds from excavations for the metropolitan railway of Athens, L Parlama and N Chr. Stampolidis eds, Greek Ministry of Culture/N P Goulandris Foundation – Museum of Cycladic Art, Athens, 2000

Through romantic eyes: European images of nineteenth-century Greece from the Benaki Museum, F-M Tsigakou, Art Services International, Alexandria Virginia, 1991

Treasures of Armenian Church from the Collection of the Holy Etchmiadzin, O Fedosseyenko ed, Slaviâ, St Petersburg, 2000

Vestments of the Eastern Orthodox Church: Amphia: Vestments of the Eastern Orthodox Church, A Ballian ed, Peloponnesian Folklore Foundation-Nafplion, Athens, 1999

Wealth of the Roman world: Gold and silver, AD 300–700, J P C Kent and K S Painter eds, British Museum Press, London, 1977

GLOSSARY

addorsed back-to-back

aegis scaly breastplate of the goddess Athena, covered with goatskin, bordered with snakes and bearing the head of the Gorgon Medusa at the centre

agonistic decisive and determined spirit of noble contest

amuletic of a charm worn against evil

aryballoid reminiscent in shape of an aryballos, a small, spherical vase for oils or ointments

apotropaic averting evil

autochthonous native, indigenous

chiton long tunic with or without sleeves

chthonic hypostasis quality associated with the underworld

chthonic worship cults of deities of the underworld

colonnette small, slender column

confronted face to face

contrapposto a twisting of the figure in its own axis; a pose in which the upper body turns away strongly from the lower

cortex outer layer of a stone

dodecatheon pantheon of twelve gods of Olympus

ephebe adolescent male

emerald plasma a translucent green stone, which is found associated with common chalcedony, valued as a semiprecious stone

eudemonic philosophy philosophical theory that man's highest aim is to accumulate possessions in order to gain happiness

ex-voto official dedication in the sanctuary of a deity

feudatory owner of a feudal estate

flabellum (pl. flabella) metal liturgical fan symbolising the seraphim and the cherubim, the celestial beings who hymn and protect the Lord around his heavenly throne

Gospel book book which contains the complete text of the four Gospels, in the same order as in the New Testament, but with the beginning and end of each passage to be read indicated in the margin, and numbered

guilloche regular braid pattern formed of two or more interwoven or plaited bands, usually as a filler or border ornament

hagiographical related to hagiography, term used for a genre of Byzantine literature which provides information on the *vitae* (lives) of the saints

herm rectangular, often tapering, stone post bearing a carved head or bust, usually of Hermes, used as a boundary marker in ancient Greece and for decorative purposes in later times

himation oblong piece of cloth worn as an outer garment over a chiton

homonymous of the same name

Iconoclasm religious movement in Byzantium, in the 8th and 9th centuries, that denied the holiness of icons and rejected their veneration (iconolatry)

iconographic convention standard way of representing subjects in the visual arts

imbricated covered by overlapping scales

lectionary general term for various liturgical books containing lections (liturgical readings) intended for reading in church services. There are two major types of lectionary, one with Gospel passages and the other with New Testament passages. Most lectionaries have lists appended indicating the fixed and moveable feasts of the Church calendar, with their appropriate lections

lekythos vase with narrow mouth and one vertical handle, for containing oil

locus sanctus sacred place

maenads ecstatic women in Dionysos' retinue, in frenzied state due to his inspiring power

mandorla conventional term for the aureole, usually almond-shaped, which is shown surrounding an entire figure to indicate the presence of the power of God

martial hypostasis a nature appropriate to warfare

niello matt black substance composed of metal sulphides, used for the decoration of silver or other metal objects

palmette ornament derived from vegetal forms consisting of petals radiating from a calyx-shaped base, used alone or in repeated pattern to form a border or frieze

parure set of jewels or other ornaments intended to be worn together

peplos long garment worn by women

piriform pear-shaped

precipitate (pose) rushing (pose)

protome representation in the round of the forepart of an animal

pyxis vase without handles, container for cosmetics or jewellery

revet to clad furniture and objects with another material, usually precious, for decoration

revetment, metal the metal sheet, often decorated, used to clad domestic and ecclesiastical furniture and objects, including icons

rinceau (pl. rinceaux) scroll pattern or ornament

roulette (potter's) revolving toothed wheel for indenting a pottery surface with decorative lines or dots

rubric written or printed text in distinctive, especially red, lettering

satyrs hybrid companions of Dionysos, represented as eternally young men with long tails and budding horns. They were great lovers of wine, and along with the maenads, dancing and singing, formed the god's ecstatic entourage, the *thiasos*

sepulchral deposition the placement of offerings in a grave

sileni another type of mythological being closely associated with Dionysos. They are usually depicted as older than the satyrs, whom they resemble in appearance and behaviour

spandrel the space between the outer curve of an arch and the rectangle formed by the mouldings enclosing it, frequently filled with decoration

symposium (pl. symposia) convivial meeting held by ancient Greek men for drinking, conversation and philosophical discussion

terra sigillata type of Roman and Early Christian pottery, of fine earthenware, usually red in colour, with a shiny red slip

tondo representation within a circular frame

tumulus ancient burial mound

Vlachs a European people constituting the major element in the populations of Romania and Moldavia, as well as smaller groups located throughout the Balkan Peninsula, south and west of the River Danube. Their neighbours gave them the name Vlachs but they call themselves Romani, Romeni, Rumeni, or Aromani

volute scroll-like ornament

PHOTO CREDITS

CONTRIBUTORS

EDITOR

Electra Georgoula is Head of the Exhibitions and Publications Department of the Benaki Museum. She has coordinated many international shows at the Benaki Museum, in cooperation with the leading European and American museums and institutions, and has organised the Benaki Museum's major touring exhibitions abroad. She has participated as manager, contributor or editor on several Benaki Museum publications and exhibition catalogues.

ESSAY AUTHORS

Irini Papageorgiou is the Curator of the Prehistoric, Ancient Greek and Roman Collections in the Benaki Museum. A specialist in prehistoric art, she has published articles on artefacts dating from the Neolithic Age to the Geometric Period in Greece and has contributed to several exhibition catalogues. For several years she has collaborated in the excavation of the Late Bronze Age city at Akrotiri, Thera (mod. Santorini), and is preparing the publication of important wall-painting ensembles from a public building uncovered there.

Anastasia Drandaki is the Curator of the Byzantine Collection in the Benaki Museum. She has published a monograph on Byzantine and post-Byzantine icons, and several articles on icons and Byzantine bronze and silver artefacts. She has contributed to major exhibition catalogues including the *Glory of Byzantium* and *Byzantium: faith and power* published by Metropolitan Museum of Art, New York.

Dr Anna Ballian is the Curator of the Islamic Collection and of post-Byzantine metalwork in the Benaki Museum. She has published extensively on church silver of the late Byzantine and Ottoman periods, and has developed a special interest in the cross-cultural relations between Byzantium and Islam. She lately contributed, with an introductory essay entitled 'Liturgical implements', to the catalogue of the exhibition *Byzantium: faith and power* published by the Metropolitan Museum of Art, New York 2004.

Kate Synodinou is the Curator of the Neohellenic Culture and Art Collections in the Benaki Museum and a member of the board of several Greek cultural institutions. She has been involved in the museum's major exhibition activities and has contributed to several exhibition catalogues. She has given a number of lectures and seminar papers, and published articles in Greek and foreign periodicals on various aspects of Neohellenic culture and art, and a monograph on European jewellery of the 19th century.

Dr Dimitris Arvanitakis is a historian and scientific collaborator of the Benaki Museum. He has served as research fellow in the Istituto Ellenico di Studi Bizantini e Postbizantini in Venice (1995-99) and has participated in research programs of the Ionian University on relations between Greece and Italy (1999-2001). His scholarly interests and publications focus on the history of social movements and ideas (17th-19th century), and on the relationship between Greek lands and western Europe.

AUTHORS OF ENTRIES

IP Irini Papageorgiou: nos 1-11, 13-38

NM Nicoletta Menti: no 12

AZ Angeliki Ziva: nos 40-49, 51-59

DD Dimitris Damaskos: nos 39, 50

AD Anastasia Drandaki: nos 60-82, 84-88, 91-92, 94, 96, 98-111

PT Pitsa Tsakona: nos 89-90

AB Anna Ballian: nos 83, 93, 95, 97, 112-119

KS Kate Synodinou: nos 120-134, 136-138, 140-144, 146-150

EG Electra Georgoula: nos 135, 139, 151-153

F-MT Fani-Maria Tsigakou: nos 145, 154-163